PEN

NE
AN
AN
WIT

Asa
edu
hist
and
rec
his
ma

Pr
ni
or
*Pe*
v

*Bc*

# WILLIAM MORRIS ❧
# NEWS FROM NOWHERE
# AND SELECTED WRITINGS
# AND DESIGNS

EDITED WITH AN INTRODUCTION BY
ASA BRIGGS

WITH A SUPPLEMENT BY GRAEME SHANKLAND
ON WILLIAM MORRIS, DESIGNER
ILLUSTRATED BY TWENTY-FOUR PLATES

PUBLISHED BY PENGUIN BOOKS

Penguin Books Ltd, Harmondsworth, Middlesex, England
Viking Penguin Inc., 40 West 23rd Street, New York, New York 10010, U.S.A.
Penguin Books Australia Ltd, Ringwood, Victoria, Australia
Penguin Books Canada Ltd, 2801 John Street, Markham, Ontario, Canada L3R 1B4
Penguin Books (N.Z.) Ltd, 182–190 Wairau Road, Auckland 10, New Zealand

First published as *William Morris: Selected Writings and Designs* 1962
Reprinted 1968, 1973, 1977, 1980
Reprinted in Penguin English Library
as *William Morris: News from Nowhere and Selected Writings and Designs* 1984 (twice)

Copyright © Asa Briggs, 1962
Text of 'William Morris, Designer' copyright © Graeme Shankland, 1962
All rights reserved

Made and printed in Great Britain by
Richard Clay (The Chaucer Press) Ltd, Bungay, Suffolk
Set in Monotype Bembo

# CONTENTS

5

# ACKNOWLEDGEMENTS

To the Victoria and Albert Museum, London, for Plates 5, 6, 7, 10, 11, 12, 15, 16, 17, 18, 19, 20; to the William Morris Gallery, Walthamstow, London, for Plates 2, 3, 8, 9, 13, 14, 21; to the Birmingham City Museum and Art Gallery for Plate 4; to *Country Life*, London, for Plate 1.

Grateful acknowledgements are also made to the Society of Antiquaries for permission to include material in their copyright, and also to Philip Henderson, from whose *Letters of William Morris to his Family* the letters printed here have been reproduced.

... I THINK that this blindness to beauty will draw down a kind of revenge one day: who knows? Years ago men's minds were full of art and the dignified shows of life, and they had but little time for justice and peace; and the vengeance on them was not increase of the violence they did not heed, but destruction of the art they heeded. So perhaps the gods are preparing troubles and terrors for the world (or our small corner of it) again, that it may become beautiful and dramatic withal: for I do not believe that they will have it dull and ugly for ever ...

(From a letter of August 1874)

# INTRODUCTION

WILLIAM MORRIS was one of the most searching critics of British society in the nineteenth century. He cared nothing for its institutions, questioned its achievements, and scorned its values. As a young man at Oxford he joined with Edward Burne-Jones in the life of a 'Brotherhood', dedicated to a 'Crusade and Holy Warfare against the age': in years of full maturity he gave all his exceptional energies to the infant socialist movement, holding it to be a 'Cause' which demanded sacrifice while at the same time it offered fellowship and hope. He refused all forms of easy compromise. He was an angry young man and an angry old man, but he always knew what he was angry about. He hated both squalor and shoddiness, dullness and display, the tastelessness of the middle classes and the exploitation of the poor. He made no qualifications, and talked not of the pride but of the 'filth' of civilization. 'Was it all to end in a counting-house on the top of a cinder heap, with Podsnap's drawing-room in the offing, and a Whig committee dealing out champagne to the rich and margarine to the poor in such convenient proportions as would make all men contented together, though the pleasure of the eyes was gone from the world, and the place of Homer was to be taken by Huxley?'

There were three possible reactions to this assessment of the Victorian situation – cynicism, escape, and commitment. Morris was too active and exuberant to be a cynic, and too much aware as a working craftsman of the sense of the honest and the genuine. Like Cobbett, he was forthright and full-blooded. Escape he tried. Much of his poetry was deliberately escapist, particularly *The Earthly Paradise*, which was hailed by his contemporaries as a necessary retreat from the stresses and anxieties of the ugly world to a remote romantic world of dreams. In the best-known line of his poems he called himself 'a dreamer of dreams, born out of my due time' and warned his readers that he could not 'ease the burden of your fears'. Yet escape was an expression of despair, not a way to peace of mind or heart. Commitment came relatively late in Morris's life, but it shaped the contribution which he made both to his own time and to ours. In 1876 he began to interest

13

himself in politics, becoming one of the leaders of the popular Liberal agitation against Disraeli's foreign policy: a year later, on what appeared to be a very different front of action, he founded the Society for the Protection of Ancient Buildings ('Anti-Scrape') and gave his first public lecture on the Decorative Arts. The two forms of commitment, however different they seem, led in the same direction. Neither Liberalism nor Radicalism satisfied him: they bore the marks of the age and, in his view, petered out in half-truths, evasions, and rhetoric. Similarly, any satisfactory theory of art, whether viewed historically or in its contemporary setting, could not remain a theory of 'mere art': it depended on a theory of society. In the early 1880s Morris jettisoned Radicalism and turned to Socialism. It provided him with both an analysis and a 'Cause'. The 'innate socialism', as his biographer calls it, of some of his early lectures on the arts, became conscious and purposive Socialism. In terms of action, commitment meant selling working-class magazines at street corners, trekking the country on arduous lecturing engagements, appearing in police courts. Many myths have been woven around Morris's Socialism. It was as full-blooded as he was and as analytical as he learned to be. It was centred on belief in the class struggle, a sense of history, a conviction of the inadequacy of legislative and administrative improvements, and a view of revolution. Not even the bickerings and intrigues of socialist politics diverted Morris from it: he saw it as a 'matter of religion', and never allowed 'politics' to disturb his vision of a 'society of equality'.

To understand Morris's development, therefore, and his place in history it is necessary to study the chronology of his life, the impact of Rossetti at one stage, of Marx at another, the sequence of events and impressions which he described in his last years under the heading 'how I became a Socialist'. The bare facts are set out in the chronological table which follows this introduction and in the brief autobiographical sketches which make up the Prologue. This selection of his writings is, indeed, roughly in historical order.

The section called 'Romance', which follows the Prologue, consists of Morris's poems. They reflect his changing moods between 1856 and 1870. The first poem is taken from one of the prose romances which he contributed to the *Oxford and Cambridge Magazine* while he

was still an undergraduate. The next batch of poems from the *Death of Guenevere* transports the reader into a land of knights and ladies, painted drawbridges, and 'shields before the sun': they are more vigorous and lively than the poems from *The Earthly Paradise*, which provide a decorative surface to Morris's shifting moods. Romance meant action as well as escape, even if it was action long ago. *The Earthly Paradise* has an autobiographical underpinning: loneliness and melancholy break through, just as anger and rage often broke through in the real world in which he lived:

> Ah! life of all the year, why yet do I
> Amid thy snowy blossoms' fragrant drift,
> Still long for that which never draweth nigh,
> Striving my pleasure from my pain to sift,
> Some weight from off my fluttering mirth to lift?
> – Now, when far bells are ringing, 'Come again,
> Come back, past years! why will ye pass in vain?'*

The short poem *The Doomed Ship*, which he never published, has an even deeper note, not of nostalgia but of despair. Morris's marriage seems to have been causing him great concern at this time: the beautiful Jane Morris, whose praises are sung in the poem 'My lady seems of ivory' (with the refrain *Beata mea Domina*) may have been an enigma not only to Morris's friends but to Morris himself. There is a marked shift of mood in the Icelandic poems which close this section. Iceland fascinated Morris so that, in a phrase of W. H. Auden, he dropped 'the frills and the fuss', the 'harps and arbours' for 'a land of rocks and sagas'. He admired the courage and tenacity of the heroes of Northern legend, their sense of freedom, their 'utter unconventionality'. 'This is the great story of the North,' he wrote in the preface to his translation of the *Volsunga Saga*, 'which should be to all our race what the Tale of Troy was to the Greeks – to all our race first, and afterwards, when the change of the world has made our race nothing more than a name of what has been – a story too – then should it be to those who come after us no less than the Tale of Troy has been to us.' It meant as much to him personally as he hoped it would mean for the 'race'. In his envoi to *The Eyrbyggja Saga* he thanked the ancient 'tale-teller' for

* *The Earthly Paradise*, lines for April.

providing a spell 'whereby the mist of fear was melted' and he had been helped 'at my need'.

The section called 'Commitment' seeks to put together some (but not all) of the pieces in Morris's new round of public activities. To understand the change it is necessary to study Morris's life in detail. One general point, however, is plain enough. Morris's work as a craftsman and a designer prepared him for the change far more than his work as a poet. Before he expressed in words his rebellion against age he expressed it in his art. Red House, into which he moved in 1860, marked a deliberate break with 'Victorianism'. His workshop was a challenge to the Victorian factory. His experiments with designs, fabrics, and dyes not only enlivened the practice of his craft but sharpened his interest in history. Learning much from Ruskin, he approached the basic problems of society through his knowledge of art and architecture. He regarded architecture as the master art, 'the moulding and altering to human needs of the very face of the earth itself'. His lecture on the Decorative Arts, later called *The Lesser Arts*, is printed in full in this selection, mainly for what it says, partly because it illustrates Morris's method of argument. Commerce figures in it as 'greed of money', Nature and History are held up as teachers, and there is talk of 'changes political and social'. 'I do not want art for a few, any more than education for a few, or freedom for a few,' Morris exclaims, and in an extremely powerful passage, which anticipates his later writings, adds:

No, rather than art should live this poor thin life among a few exceptional men, despising those beneath them for an ignorance for which they themselves are responsible . . . I would that the world should sweep away all art for a while . . . rather than the wheat should rot in the miser's granary, I would that the earth had it, that it might yet have a chance to quicken in the dark.

Morris was beginning to peer into the darkness of the future, concerning which he had many searching and some inadequate intimations. He was also discovering reserves of hope which made him supremely confident when many of his contemporaries were afraid.

The section called 'Socialism' necessarily picks out only a few of the voluminous poems, letters, and articles in which he stated his beliefs. He could be quiet as well as aggressive, but he was always

direct whether he was writing to a friend or addressing a meeting. He felt himself to be no longer alone, and wrote feelingly in *The Pilgrims of Hope*, which contrasts at every point with *The Earthly Paradise*:

> And now the streets seem gay and the high stars glittering bright;
> And for me, I sing amongst them, for my heart is full and light.
> I see the deeds to be done and the day to come on the earth,
> And riches vanished away and sorrow turned to mirth;
> I see the city squalor and the country stupor gone.
> And we a part of it all – we twain no longer alone
> In the days to come of the pleasure, in the days that are of the fight –
> I was born once long ago: I am born again tonight.

To understand not only Morris's excitement and enthusiasm but the practical contribution he made to the complicated Socialist story of the 1880s it is necessary again to study his life in detail. Perhaps two main general points can be made about it. First, he did not seek to stand aloof, wise, and superior: he served his apprenticeship. This is clearly revealed in the extract from his Socialist diary, originally printed in *Commonweal*. Second, his Socialism rested on moral as much as on theoretical foundations. One of the reasons why his writings are relevant in the twentieth century – in some ways more relevant than they were in the late nineteenth century – is that they provide the materials for a critique of twentieth-century Socialism (and Communism) as much as for a critique of nineteenth-century capitalism. Morris foresaw many of the problems and difficulties of introducing Socialism by instalments, although he was less successful in foreseeing the problems and difficulties of achieving Socialism by revolution. In the last resort, he would have wished to judge both kinds of Socialism by the same criteria – their success in creating 'a society of equality', by the kind of people they produced. As far as capitalism was concerned, he did not foresee the economic growth of the last fifty years – with all its social consequences – but he always refused to put his trust in the beneficent effects of material prosperity.

*News from Nowhere*, a large part of which is printed in this selection and which makes up the fifth section of the book, sets out his Socialist criteria, particularly the equal relationships between people in a socialist society. It is in no sense of the word a literal picture of the

future, and it bears all the marks not only of its nineteenth-century origins but also of the fact that Morris was its creator. None the less, it is a work of power as well as of charm. It was fashioned from three elements – Morris's knowledge of the past, particularly of the Middle Ages (as he and many of his contemporaries saw them); his concern for the present, which impinges at many points in the narrative; and his 'hope for the days to be', a hope which was directed by his general interpretation of the conflicts of his own age and his prediction of the shape of things to come. Bits and pieces of his own experience are embedded in almost every chapter – he could think of no better setting to conclude his account than his lovely old house at Kelmscott – but at every point he genuinely sought to transcend his own experience. He did not always succeed, and, as in all Utopias, the things which he most missed in the real world were super-abundant in the paradise of his imagination. He did not rest his account, however, on his imagination alone, nor was he simply concerned, as he had been in *The Earthly Paradise*, with escape. He juxtaposed the ugly world of his own times, as he saw it, with his Utopia: he never allowed himself to shake off the nineteenth century. Furthermore, in describing how his own ugly world was transformed into a Utopia he sketched a sequence of events which his social and political theories suggested to him was likely to happen. His chapter 'How the Change Came' is a fascinating exercise in Socialist prediction. It is easy enough in the light of what has happened since 1890 to see where *News from Nowhere* misleads. when it is read as a whole.

In making this selection I chose to include it rather than the more difficult *A Dream of John Ball*, a sermon about the past, and to print the first section of it in full rather than to cull extracts from the two books taken together. The analysis of the growth and development of capitalist society, the delight in the medieval landscape, and the stress on simple human values are common to them both.

The last section of this book is brief. It begins with his last article, published in *Justice*, and continues with a letter written by Morris in 1895 where he talks lovingly of the Epping Forest he had known as a child and damningly of the 'experts' who were sitting in judgement on its future. Morris loved natural beauty. His descriptions of it are

always sensitive and frequently enthusiastic. He was in a quieter mood, however, when he wrote many of his last prose romances and the little poem for his bed with its simple and serene ending:

> No tale I tell
> Of ill or well,
> But this I say:
> Night treadeth on day,
> And for worst or best
> Right good is rest.

The sentiments may be deceptive. The poem was written in 1891, and five years later when he died, Morris was only sixty-two years old. When he died, one doctor diagnosed his disease as 'simply being William Morris and having done more work than most men'.

When the chronology is set on one side, the question remains what kind of a man was William Morris. His energy impressed all his contemporaries: so did his knowledge. He busied himself at many things, and he was a worker by hand as well as by brain. He could be brusque and he could be boisterous: his talk of fellowship masked his loneliness; he could be aloof and melancholy, or jovial and high-spirited. In other words, although he was all of one piece, the piece was complex. What no one could deny, was that, in Sir Sydney Cockerell's words, 'he was wholly without pose, fustian, or pretence'. In an age when it was the fashion for artists to flaunt their poses Morris pleaded for direct communication. 'It is good for a man who thinks seriously,' he wrote in *The Art of the People*, 'seriously to face his fellows, and speak out whatever really burns in him, so that men may seem less strange to one another, and misunderstanding, the fruitful cause of aimless strife, may be avoided.'

Morris employed his energies in many different ways, not least, for all his practical gifts, in dreaming. In the last years of his life he was as concerned with the Kelmscott Chaucer as with Socialism. He never made great claims for his own poetry, treating it as 'a mere matter of craftsmanship'. 'If a chap can't compose an epic poem while he's weaving tapestry he had better shut up; he'll never do any good at all,' he once said. His poems have never commanded the same interest as his wallpapers or his fabrics. Recently his lectures and critical essays, usually neglected, seldom discussed, have come more into their own

again, and he has been hailed by Mr Raymond Williams as a 'pivotal figure' in the development of the modern conception of culture. A flourishing William Morris Society perpetuates his work. This selection from his writings omits much which I would have wished to include had there been more space. It should be thought of rather as an introduction than as an anthology, an introduction which can be both filled out and deepened from Morris's own writings and the powerful interpretations of his achievement.

He himself would have argued that his work had relevance outside the century against which he was rebelling. Before listening to a sermon from John Ball in his vision of the lost past, he pondered 'how men fight and lose the battle, and the thing that they fought for comes about in spite of their defeat, and when it comes turns out not to be what they meant, and other men have to fight for what they meant under another name'.

ASA BRIGGS

# NOTE ON BOOKS

*The Collected Works of William Morris*, with an introduction by his daughter May Morris, are in 24 volumes (London, 1910–15). A collection of his letters has been edited with an introduction by Philip Henderson with the title *The Letters of William Morris to his Family and Friends* (London, 1950). Professor G. D. H. Cole has edited with an introduction the Nonesuch Press centenary edition of a selection of Morris's works (London, 1948).

The standard life of Morris is that of J. W. Mackail, 2 vols. (London, 1899). It has been reprinted as a single volume in the World's Classics series, with an introduction by Sir Sydney Cockerell (London, 1950). Among the many interesting books on Morris, special attention should be paid to May Morris, *William Morris; Artist, Writer, Socialist*, 2 vols. (Oxford, 1936); Aymer Vallance, *William Morris, His Art, His Writings, and His Public Life* (London, 1897); J. Bruce Glasier, *William Morris and the Early Days of the Socialist Movement* (London, 1921); G. Crow, *William Morris, Designer* (London 1934); H. Sparling, *The Kelmscott Press and William Morris, Master-Craftsman* (London, 1924); E. P. Thompson, *William Morris, Romantic to Revolutionary* (London, 1955); and P. Thompson (ed.), *The Work of William Morris* (London, 1967).

Morris's place in relation to the work of other people is discussed in W. Crane, *William Morris to Whistler* (1921); W. R. Lethaby, *Philip Webb and His Work* (1935); N. Pevsner, *Pioneers of the Modern Movement from William Morris to Walter Gropius* (London, 1936; re-issued as *Pioneers of Modern Design*, Penguin Books, Harmondsworth, 1960); M. R. Grennan, *William Morris, Medievalist and Revolutionary* (New York, 1945); Graham Hough, *The Last Romantics* (London, 1949); and Raymond Williams, *Culture and Society 1780–1950* (London, 1958, Penguin Books, Harmondsworth, 1961).

# CHRONOLOGICAL TABLE OF WILLIAM MORRIS'S LIFE AND CHIEF PUBLICATIONS

1834    (24 March) Born at Elm House, Clay Hill, Walthamstow.

1840    Family moved to Woodford Hall, Woodford.

1847    Death of his father.

1848–51 Family moved to Water House, Walthamstow. At school at Marlborough.

1853–5  At Exeter College, Oxford. Beginnings of 'The Brotherhood'.

1854    Visit to Belgium and Northern France: Amiens, Beauvais, Rouen.

1855–6  Associated with Edward Burne-Jones and other contemporaries in the launching of the *Oxford and Cambridge Magazine* (first number, January 1856).

1856    Articled to G. E. Street, the architect, where he met Philip Webb. Moved to London with Burne-Jones. Decided at the end of the year (under the influence of D. G. Rossetti) to abandon architecture as a profession and to become a painter.

1857    Joined a group of friends in painting frescoes for the Oxford Union. Met Jane Burden and painted her as Iseult.

1858    Publication of *The Defence of Guenevere and Other Poems*.

1859    Married Jane Burden. Began to build Red House, Upton. This project led to the formation of the 'Firm'.

1860    Moved into Red House.

1861    Began *Troy* poem. Jane (Jenny) Morris born.

1862    Mary (May) Morris born. The first Morris wallpapers. The 'Firm' exhibited at the London International Exhibition of Art and Industry,

1865    Moved with the 'Firm' to Queen Square, Bloomsbury. 'Living above his shop.' Red House sold.

1866    The 'Firm' decorated the Armoury and Tapestry Room at St James's Palace.

1867    Publication of *The Life and Death of Jason*. The 'Firm' decorated the green Dining Room at the Victoria and Albert Museum.

1868–70 Publication of *The Earthly Paradise*.

1868    Began his first Icelandic translations (in cooperation with Eiríkr Magnússon).

1869    *The Eyrbyggja Saga. The Story of Grettir the Strong.*

1870    Publication of a prose translation of the *Volsunga Saga*. Began his illuminated manuscripts.

1871    Along with Rossetti acquired the lease of Kelmscott Manor, Oxfordshire. Visited Iceland for the first time.

1872    Left Queen Square for Horrington House, Turnham Green. Publication of *Love is Enough*.

1873    Visited Italy and Iceland.

1874    Rossetti left Kelmscott. Morris took his family to Belgium.

1875    The 'Firm' dissolved. Morris and Company reorganized under his sole control. Took up dyeing and carpet weaving. Publication of *Three Northern Love Stories* and his verse translation of the *Aeneid*.

1876    Appointed Examiner at the School of Art, South Kensington. Jenny's health broke down. Publication of *Sigurd the Volsung and the Fall of the Niblungs*. First letter to the Press on a political subject, 'England and the Turks'. Became Treasurer of the Eastern Question Association.

1877    Wrote a manifesto *To the Working-men of England*. Founded the Society for the Protection of Ancient Buildings, known as 'Anti-Scrape'. Gave his first public lecture on the Decorative Arts, published as a pamphlet and later reprinted as 'The Lesser Arts'. Refused to accept nomination for the Chair of Poetry at Oxford University. Opened showroom in Oxford Street.

1878    Wrote his first political poem, 'Wake, London lads'. Visited Italy. Moved to Kelmscott House, Hammersmith. Began high-warp tapestry weaving.

1879    Treasurer of the National Liberal League.

1880    His firm decorated the Throne Room at St James's Palace.

1881    Moved Morris & Company's works to Merton Abbey, Surrey.

1882    Worked for Iceland Famine Relief Committee. Published a volume of lectures, *Hopes and Fears for Art*. Gave evidence before the Royal Commission on Technical Education. Death of Rossetti.

1883    Made an Honorary Fellow of Exeter College, Oxford. Joined the Democratic Federation, which later became the Social Democratic Federation. Lectured in Manchester on 'Art, Wealth, and Riches' and in Oxford on 'Art and Democracy'.

Reading Marx's *Capital* in French. Openly declared himself a Socialist, became an active public lecturer on Socialism, joined the Executive of the S.D.F., and wrote the first of his *Chants for Socialists*.

1884 Contributed frequently to the new S.D.F. journal, *Justice*, helped it financially, and sold it in the streets. Formed Hammersmith branch of S.D.F. Spoke at street corners and lectured in the provinces and Scotland. Schism in the S.D.F., leading to Morris's resignation (December).Helped to found the Socialist League. Foundation of the Art Workers' Guild.

1885 Edited and contributed regularly to the new S.L. journal, *Commonweal*. Published in it his poem *The Pilgrims of Hope*, printed in instalments. Arrested in police-court disturbance at a trial of Socialists after an open-air meeting, but discharged.

1886 More 'free-speech disturbances'. Morris fined a shilling and costs. Trafalgar Square 'riots'. *A Dream of John Ball* appeared in *Commonweal*.

1887 'Bloody Sunday' (13 November): Trafalgar Square demonstration broken up by the police. Joined in the work of the Law and Liberty League. Acted as pall-bearer and spoke at the funeral of Alfred Linnell, who died from injuries received on 20 November, and wrote 'Death Song'. Published a verse translation of the *Odyssey*, and wrote a play, in which he took part, *The Tables Turned, or Nupkins Awakened*. Foundation of the Arts and Crafts Exhibition Society.

1888 Published in book form *A Dream of John Ball* and *A King's Lesson*. Followed by a volume of lectures and addresses, *Signs of Change*, and the first of a series of prose romances, *The House of the Wolfings*. Lectured on tapestry-weaving at the first exhibition of the Arts and Crafts Exhibition Society. Delegate at Socialist Congress in Paris.

1889 London Dock Strike. Published *The Roots of the Mountains*. Wrote a lecture on the Art of Dyeing for the second exhibition of the Arts and Crafts Exhibition Society, and lectured on Gothic Architecture. The Edinburgh Art Congress. Wrote *Under an Elm-Tree; or Thoughts in the Countryside*, later published in pamphlet form in 1891.

1890 Ejected from the editorship of *Commonweal*, where he continued to publish (in instalments) *News from Nowhere*, which later appeared in book form in 1891. Left the Socialist League.

The Hammersmith branch of the League renamed the Hammersmith Socialist Society. Finished the *Adoration of the Magi* tapestry for Exeter College Chapel, Oxford. Founded the Kelmscott Press. Wrote *The Story of the Glittering Plain*, the first book to be printed by the Press (1891).

1891    The Press started working. Serious illness, after which he never completely recovered his health. Published *News from Nowhere* and his collected verses, *Poems by the Way*. Volume I of the Saga Library.

1892    Wrote a preface to the Kelmscott Press edition of 'The Nature of Gothic', a chapter from Ruskin's *The Stones of Venice*. Elected Master of the Art Workers' Guild. Disclaimed all interest in the Poet Laureateship vacant on Tennyson's death.

1893    Published, in collaboration with E. B. Bax, a volume of articles, *Socialism, Its Growth and Outcome*. Helped to draft a joint *Manifesto of English Socialists*. Wrote a letter on the Miners' Lockout, 'The Deeper Meaning of the Struggle'.

1894    Published *The Wood Beyond the World*. Reconciliation with the S.D.F.

1895    Completed, in collaboration with Magnússon, the translation of the *Heimskringla*. Published *The Water of the Wondrous Isles*. Published his translation of *Beowulf*.

1896    Published *The Well at the World's End*, begun in 1892, and the last of his finished prose romances, *The Sundering Flood*. Last public speech at a meeting of the Society for Checking the Abuses of Public Advertising. Contributed to the May Day number of *Justice*. Publication of the Kelmscott edition of Chaucer. Died 3 October. Buried at Kelmscott.

# ONE ❧ PROLOGUE: ELEMENTS OF AUTOBIOGRAPHY

# 1: 'A RATHER LONG-WINDED SKETCH OF MY VERY UNEVENTFUL LIFE'

I WAS born at Walthamstow in Essex in March 1834, a suburban village on the edge of Epping Forest, and once a pleasant place enough, but now terribly cocknified and choked up by the jerry-builder.

My Father was a business man in the city, and well-to-do; and we lived in the ordinary bourgeois style of comfort; and since we belonged to the evangelical section of the English Church I was brought up in what I should call rich establishmentarian puritanism; a religion which even as a boy I never took to.

I went to school at Marlborough College, which was then a new and very rough school. As far as my school instruction went, I think I may fairly say I learned next to nothing there, for indeed next to nothing was taught; but the place is in very beautiful country, thickly scattered over with prehistoric monuments, and I set myself eagerly to studying these and everything else that had any history in it, and so perhaps learned a good deal, especially as there was a good library at the school to which I sometimes had access. I should mention that ever since I could remember I was a great devourer of books. I don't remember being taught to read, and by the time I was seven years old I had read a very great many books good, bad, and indifferent.

My Father died in 1847 a few months before I went to Marl-borough; but as he had engaged in a fortunate mining speculation before his death, we were left very well off, rich in fact.

I went to Oxford in 1853 as a member of Exeter College; I took very ill to the studies of the place; but fell-to very vigorously on history and especially mediaeval history, all the more perhaps because at this time I fell under the influence of the High Church or Puseyite school; this latter phase however did not last me long, as it was corrected by the books of John Ruskin which were at the time a sort of revelation to me; I was also a good deal influenced by the works of Charles Kingsley, and got into my head therefrom some socio-political ideas which would have developed probably but for the

attractions of art and poetry. While I was still an undergraduate, I discovered that I could write poetry, much to my own amazement; and about that time being very intimate with other young men of enthusiastic ideas, we got up a monthly paper which lasted (to my cost) for a year; it was called the *Oxford and Cambridge Magazine*, and was very *young* indeed. When I had gone through my schools at Oxford, I who had been originally intended for the Church!!! made up my mind to take to art in some form, and so articled myself to G. E. Street (the architect of the new Law Courts afterwards) who was then practising in Oxford; I only stayed with him nine months however; when being in London and having been introduced by Burne-Jones, the painter, who was my great college friend, to Dante Gabriel Rossetti, the leader of the Pre-Raphaelite School, I made up my mind to turn painter, and studied the art but in a very desultory way for some time.

At this time the revival of Gothic architecture was making great progress in England and naturally touched the Pre-Raphaelite movement also; I threw myself into these movements with all my heart: got a friend to build me a house very mediaeval in spirit in which I lived for five years, and set myself to decorating it; we found, I and my friend the architect especially, that all the minor arts were in a state of complete degradation especially in England, and accordingly in 1861 with the conceited courage of a young man I set myself to re-forming all that: and started a sort of firm for producing decorative articles. D. G. Rossetti, Ford Madox Brown, Burne-Jones, and P. Webb the architect of my house were the chief members of it as far as designing went. Burne-Jones was beginning to have a reputation at that time; he did a great many designs for us for stained glass, and entered very heartily into the matter; and we made some progress before long, though we were naturally much ridiculed. I took the matter up as a business and began in the teeth of difficulties not easy to imagine to make some money in it: about ten years ago the firm broke up, leaving me the only partner, though I still receive help and designs from P. Webb and Burne-Jones.

Meantime in 1858 I published a volume of poems *The Defence of Guenevere*; exceedingly young also and very mediaeval; and then after a lapse of some years conceived the idea of my *Earthly Paradise*.

and fell to work very hard at it. I had about this time extended my historical reading by falling in with translations from the old Norse literature, and found it a good corrective to the maundering side of mediaevalism. In 1866 (I think) I published the *Life and Death of Jason*, which, originally intended for one of the tales of the *Earthly Paradise*, had got too long for the purpose. To my surprise the book was very well received both by reviewers and the public, who were kinder still to my next work, *The Earthly Paradise*, the first series of which I published in 1868. In 1872 I published a fantastic little book chiefly lyrical called *Love is Enough*. Meantime about 1870 I had made the acquaintance of an Icelandic gentleman, Mr E. Magnússon, of whom I learned to read the language of the North, and with whom I studied most of the works of that literature; the delightful freshness and independence of thought of them, the air of freedom which breathes through them, their worship of courage (the great virtue of the human race), their utter unconventionality took my heart by storm. I translated with Mr Magnússon's help, and published, *The Story of Grettir the Strong*, a set of Sagas (about six) under the title of *Northern Love Stories*, and finally the Icelandic version of the *Niblung Tale*, called the *Volsunga Saga*.

In 1871 I went to Iceland with Mr Magnússon, and, apart from my pleasure in seeing that romantic desert, I learned one lesson there, thoroughly I hope, that the most grinding poverty is a trifling evil compared with the inequality of classes. In 1873 I went to Iceland again. In 1876 I published a translation of the Aeneid of Virgil, which was fairly well received. In 1877 I began my last poem, an Epic of the Niblung Story founded chiefly on the Icelandic version. I published this in 1878 under the title of *Sigurd the Volsung and the Fall of the Niblungs*.

Through all this time I have been working hard at my business, in which I have had a considerable success even from the commercial side; I believe that if I had yielded on a few points of principle I might have become a positively rich man; but even as it is I have nothing to complain of, although the last few years have been so slack in business.

Almost all the designs we use for surface decoration, wallpapers, textiles, and the like, I design myself. I have had to learn the theory and to some extent the practice of weaving, dyeing, and textile

printing: all of which I must admit has given me and still gives me a great deal of enjoyment.

But in spite of all the success I have had, I have not failed to be conscious that the art I have been helping to produce would fall with the death of a few of us who really care about it, that a reform in art which is founded on individualism must perish with the individuals who have set it going. Both my historical studies and my practical conflict with the philistinism of modern society have *forced* on me the conviction that art cannot have a real life and growth under the present system of commercialism and profit-mongering. I have tried to develop this view, which is in fact Socialism seen through the eyes of an artist, in various lectures, the first of which I delivered in 1878.

About the time when I was beginning to think so strongly on these points that I felt I must express myself publicly, came the crisis of the Eastern Question and the agitation which ended in the overthrow of the Disraeli government. I joined heartily in that agitation on the Liberal side, because it seemed to me that England risked drifting into a war which would have committed her to the party of reaction: I also thoroughly dreaded the outburst of Chauvinism which swept over the country, and feared that once we were amusing ourselves with an European war no one in this country would listen to anything of social questions; nor could I see in England at any time any party more advanced than the Radicals, who were also it must be remembered hallowed as it were by being in opposition to the party which openly proclaimed themselves reactionists; I was under small illusion as to the result of a victory of the Liberals, except so far as it would stem the torrent of Chauvinism, and check the feeling of national hatred and prejudice for which I shall always feel the most profound contempt. I therefore took an active part in the anti-Turk agitation, was a member of the committee of the Eastern Question Association, and worked hard at it; I made the acquaintance of some of the Trades Union leaders at the time; but found that they were quite under the influence of the Capitalist politicians, and that, the General Election once gained, they would take no forward step whatever. The action and want of action of the new Liberal Parliament, especially the Coercion Bill and the Stockjobber's Egyptian War, quite destroyed any hope I might have had of any good being done

by alliance with the Radical party, however advanced they might call themselves.

I joined a committee (of which Mr Herbert Burrows was Secretary) which tried to stir up some opposition to the course the Liberal government and party were taking in the early days of this parliament; but it speedily fell to pieces, having in fact no sort of practical principles to hold it together; I mention this to show that I was on the look out for joining any body which seemed likely to push forward matters.

It must be understood that I always intended to join anybody who distinctly called themselves Socialists, so when last year I was invited to join the Democratic Federation by Mr Hyndman, I accepted the invitation hoping that it would declare for Socialism, in spite of certain drawbacks that I expected to find in it; concerning which I find on the whole that there are fewer drawbacks than I expected.

I should have written above that I married in 1859 and have two daughters by that marriage very sympathetic with me as to my aims in life.

(From a letter to Andreas Scheu, an Austrian refugee and fellow-Socialist, 5 September 1883)

## 2: HOW I BECAME A SOCIALIST

I AM asked by the Editor to give some sort of a history of the above conversion, and I feel that it may be of some use to do so, if my readers will look upon me as a type of a certain group of people, but not so easy to do clearly, briefly, and truly. Let me, however, try. But first, I will say what I mean by being a Socialist, since I am told that the word no longer expresses definitely and with certainty what it did ten years ago. Well, what I mean by Socialism is a condition of society in which there should be neither rich nor poor, neither master nor master's man, neither idle nor overworked, neither brain-sick brain workers, nor heart-sick hand workers, in a word, in which all men would be living in equality of condition, and would manage

their affairs unwastefully, and with the full consciousness that harm to one would mean harm to all – the realization at last of the meaning of the word COMMONWEALTH.

Now this view of Socialism which I hold today, and hope to die holding, is what I began with; I had no transitional period, unless you may call such a brief period of political radicalism during which I saw my ideal clear enough, but had no hope of any realization of it. That came to an end some months before I joined the (then) Democratic Federation, and the meaning of my joining that body was that I had conceived a hope of the realization of my ideal. If you ask me how much of a hope, or what I thought we Socialists then living and working would accomplish towards it, or when there would be effected any change in the face of society, I must say, I do not know. I can only say that I did not measure my hope, nor the joy that it brought me at the time. For the rest, when I took that step I was blankly ignorant of economics; I had never so much as opened Adam Smith, or heard of Ricardo, or of Karl Marx. Oddly enough, I *had* read some of Mill, to wit, those posthumous papers of his (published, was it, in the *Westminster Review* or the *Fortnightly*?) in which he attacks Socialism in its Fourierist guise. In those papers he put the arguments, as far as they go, clearly and honestly, and the result, so far as I was concerned, was to convince me that Socialism was a necessary change, and that it was possible to bring it about in our own days. Those papers put the finishing touch to my conversion to Socialism. Well, having joined a Socialist body (for the Federation soon became definitely Socialist), I put some conscience into trying to learn the economical side of Socialism, and even tackled Marx, though I must confess that, whereas I thoroughly enjoyed the historical part of *Capital*, I suffered agonies of confusion of the brain over reading the pure economics of that great work. Anyhow, I read what I could, and will hope that some information stuck to me from my reading; but more, I must think, from continuous conversation with such friends as Bax and Hyndman and Scheu, and the brisk course of propaganda meetings which were going on at the time, and in which I took my share. Such finish to what of education in practical Socialism as I am capable of I received afterwards from some of my Anarchist friends, from whom I learned, quite against their intention, that Anarchism

was impossible, much as I learned from Mill against *his* intention that Socialism was necessary.

But in this telling how I fell into *practical* Socialism I have begun, as I perceive, in the middle, for in my position of a well-to-do man, not suffering from the disabilities which oppress a working man at every step, I feel that I might never have been drawn into the practical side of the question if an ideal had not forced me to seek towards it. For politics as politics, i.e., not regarded as a necessary if cumbersome and disgustful means to an end, would never have attracted me, nor when I had become conscious of the wrongs of society as it now is, and the oppression of poor people, could I have ever believed in the possibility of a *partial* setting right of those wrongs. In other words, I could never have been such a fool as to believe in the happy and 'respectable' poor.

If, therefore, my ideal forced me to look for practical Socialism, what was it that forced me to conceive of an ideal? Now, here comes in what I said of my being (in this paper) a type of a certain group of mind.

Before the uprising of *modern* Socialism almost all intelligent people either were, or professed themselves to be, quite contented with the civilization of this century. Again, almost all of these really were thus contented, and saw nothing to do but to perfect the said civilization by getting rid of a few ridiculous survivals of the barbarous ages. To be short, this was the *Whig* frame of mind, natural to the modern prosperous middle-class men, who, in fact, as far as mechanical progress is concerned, have nothing to ask for, if only Socialism would leave them alone to enjoy their plentiful style.

But besides these contented ones there were others who were not really contented, but had a vague sentiment of repulsion to the triumph of civilization, but were coerced into silence by the measureless power of Whiggery. Lastly, there were a few who were in open rebellion against the said Whiggery – a few, say two, Carlyle and Ruskin. The latter, before my days of practical Socialism, was my master towards the ideal aforesaid, and, looking backward, I cannot help saying, by the way, how deadly dull the world would have been twenty years ago but for Ruskin! It was through him that I learned to give form to my discontent, which I must say was not by any means

vague. Apart from the desire to produce beautiful things, the leading passion of my life has been and is hatred of modern civilization. What shall I say of it now, when the words are put into my mouth, my hope of its destruction – what shall I say of its supplanting by Socialism?

What shall I say concerning its mastery of and its waste of mechanical power, its commonwealth so poor, its enemies of the commonwealth so rich, its stupendous organization – for the misery of life! Its contempt of simple pleasures which everyone could enjoy but for its folly? Its eyeless vulgarity which has destroyed art, the one certain solace of labour? All this I felt then as now, but I did not know why it was so. The hope of the past times was gone, the struggles of mankind for many ages had produced nothing but this sordid, aimless, ugly confusion; the immediate future seemed to me likely to intensify all the present evils by sweeping away the last survivals of the days before the dull squalor of civilization had settled down on the world. This was a bad look-out indeed, and, if I may mention myself as a personality and not as a mere type, especially so to a man of my disposition, careless of metaphysics and religion, as well as of scientific analysis, but with a deep love of the earth and the life on it, and a passion for the history of the past of mankind. Think of it! Was it all to end in a counting-house on the top of a cinder-heap, with Podsnap's drawing-room in the offing, and a Whig committee dealing out champagne to the rich and margarine to the poor in such convenient proportions as would make all men contented together, though the pleasure of the eyes was gone from the world, and the place of Homer was to be taken by Huxley? Yet, believe me, in my heart, when I really forced myself to look towards the future, that is what I saw in it, and, as far as I could tell, scarce anyone seemed to think it worth while to struggle against such a consummation of civilization. So there I was in for a fine pessimistic end of life, if it had not somehow dawned on me that amidst all this filth of civilization the seeds of a great change, what we others call Social-Revolution, were beginning to germinate. The whole face of things was changed to me by that discovery, and all I had to do then in order to become a Socialist was to hook myself on to the practical movement, which, as before said, I have tried to do as well as I could.

To sum up, then, the study of history and the love and practice of

art forced me into a hatred of the civilization which, if things were to stop as they are, would turn history into inconsequent nonsense, and make art a collection of the curiosities of the past, which would have no serious relation to the life of the present.

But the consciousness of revolution stirring amidst our hateful modern society prevented me, luckier than many others of artistic perceptions, from crystallizing into a mere railer against 'progress' on the one hand, and on the other from wasting time and energy in any of the numerous schemes by which the quasi-artistic of the middle classes hope to make art grow when it has no longer any root, and thus I became a practical Socialist.

A last word or two. Perhaps some of our friends will say, what have we to do with these matters of history and art? We want by means of Social-Democracy to win a decent livelihood, we want in some sort to live, and that at once. Surely anyone who professes to think that the question of art and cultivation must go before that of the knife and fork (and there are some who do propose that) does not understand what art means, or how that its root must have a soil of a thriving and unanxious life. Yet it must be remembered that civilization has reduced the workman to such a skinny and pitiful existence, that he scarcely knows how to frame a desire for any life much better than that which he now endures perforce. It is the province of art to set the true ideal of a full and reasonable life before him, a life to which the perception and creation of beauty, the enjoyment of real pleasure that is, shall be felt to be as necessary to man as his daily bread, and that no man, and no set of men, can be deprived of this except by mere opposition, which should be resisted to the utmost.

(*Justice*, 16 June 1894. Re-issued as a pamphlet in 1896)

TWO ❧ ROMANCE

**3**

CHRIST keep the Hollow Land
   All the summer-tide;
Still we cannot understand
   Where the waters glide;

Only dimly seeing them
   Coldly slipping through
Many green lipp'd cavern mouths,
   Where the hills are blue.

                (Margaret's Song from *The Hollow
                Land*, 1856)

## 4: SIR GALAHAD, A CHRISTMAS MYSTERY

IT is the longest night in all the year,
   Near on the day when the Lord Christ was born;
Six hours ago I came and sat down here,
   And ponder'd sadly, wearied and forlorn.

The winter wind that pass'd the chapel-door,
   Sang out a moody tune, that went right well
With mine own thoughts: I look'd down on the floor,
   Between my feet, until I heard a bell

Sound a long way off through the forest deep,
   And toll on steadily; a drowsiness
Came on me, so that I fell half asleep,
   As I sat there not moving: less and less

I saw the melted snow that hung in beads
   Upon my steel-shoes; less and less I saw
Between the tiles the bunches of small weeds:
   Heartless and stupid, with no touch of awe

Upon me, half-shut eyes upon the ground,
  I thought; O! Galahad, the days go by,
Stop and cast up now that which you have found,
  So sorely you have wrought and painfully.

Night after night your horse treads down alone
  The sere damp fern, night after night you sit
Holding the bridle like a man of stone,
  Dismal, unfriended, what thing comes of it.

And what if Palomydes also ride,
  And over many a mountain and bare heath
Follow the questing beast with none beside?
  Is he not able still to hold his breath

With thoughts of Iseult? doth he not grow pale
  With weary striving, to seem best of all
To her, 'as she is best,' he saith? to fail
  Is nothing to him, he can never fall.

For unto such a man love sorrow is
  So dear a thing unto his constant heart,
That even if he never win one kiss,
  Or touch from Iseult, it will never part.

And he will never know her to be worse
  Than in his happiest dreams he thinks she is:
Good knight, and faithful, you have 'scaped the curse
  In wonderful-wise; you have great store of bliss.

Yea, what if Father Launcelot ride out,
  Can he not think of Guenevere's arms, round,
Warm and lithe, about his neck, and shout
  Till all the place grows joyful with the sound?

And when he lists can often see her face,
  And think, 'Next month I kiss you, or next week,
And still you think of me': therefore the place
  Grows very pleasant, whatsoever he seek.

But me, who ride alone, some carle shall find
   Dead in my arms in the half-melted snow,
When all unkindly with the shifting wind,
   The thaw comes on at Candlemas: I know

Indeed that they will say: 'This Galahad
   If he had lived had been a right good knight;
Ah! poor chaste body!' but they will be glad,
   Not most alone, but all, when in their sight

That very evening in their scarlet sleeves
   The gay-dress'd minstrels sing; no maid will talk
Of sitting on my tomb, until the leaves,
   Grown big upon the bushes of the walk,

East of the Palace-pleasaunce, make it hard
   To see the minster therefrom: well-a-day!
Before the trees by autumn were well bared,
   I saw a damozel with gentle play,

Within that very walk say last farewell
   To her dear knight, just riding out to find
(Why should I choke to say it?) the Sangreal,
   And their last kisses sunk into my mind,

Yea, for she stood lean'd forward on his breast,
   Rather, scarce stood; the back of one dear hand,
That it might well be kiss'd, she held and press'd
   Against his lips; long time they stood there, fann'd

By gentle gusts of quiet frosty wind,
   Till Mador de la porte a-going by,
And my own horsehoofs roused them; they untwined,
   And parted like a dream. In this way I,

With sleepy face bent to the chapel floor,
   Kept musing half asleep, till suddenly
A sharp bell rang from close beside the door,
   And I leapt up when something pass'd me by,

Shrill ringing going with it, still half blind
　　I stagger'd after, a great sense of awe
At every step kept gathering on my mind,
　　Thereat I have no marvel, for I saw

One sitting on the altar as a throne,
　　Whose face no man could say he did not know,
And though the bell still rang, he sat alone,
　　With raiment half blood-red, half white as snow.

Right so I fell upon the floor and knelt,
　　Not as one kneels in church when mass is said,
But in a heap, quite nerveless, for I felt
　　The first time what a thing was perfect dread.

But mightily the gentle voice came down:
　　'Rise up, and look and listen, Galahad,
Good knight of God, for you will see no frown
　　Upon my face; I come to make you glad.

'For that you say that you are all alone,
　　I will be with you always, and fear not
You are uncared for, though no maiden moan
　　Above your empty tomb; for Launcelot,

'He in good time shall be my servant too,
　　Meantime, take note whose sword first made him knight,
And who has loved him alway, yea, and who
　　Still trusts him alway, though in all men's sight,

'He is just what you know, O Galahad,
　　This love is happy even as you say,
But would you for a little time be glad,
　　To make ME sorry long day after day?

'Her warm arms round his neck half-throttle Me,
　　The hot love-tears burn deep like spots of lead,
Yea, and the years pass quick: right dismally
　　Will Launcelot at one time hang his head;

'Yea, old and shrivell'd he shall win my love.
   Poor Palomydes fretting out his soul!
Not always is he able, son, to move
   His love, and do it honour: needs must roll

'The proudest destrier sometimes in the dust,
   And then 'tis weary work; he strives beside
Seem better than he is, so that his trust
   Is always on what chances may betide;

'And so he wears away, my servant, too,
   When all these things are gone, and wretchedly
He sits and longs to moan for Iseult, who
   Is no care now to Palomydes: see,

'O good son Galahad, upon this day,
   Now even, all these things are on your side,
But these you fight not for; look up, I say,
   And see how I can love you, for no pride

'Closes your eyes, no vain lust keeps them down.
   See now you have ME always; following
That holy vision, Galahad, go on,
   Until at last you come to Me to sing

'In Heaven always, and to walk around
   The garden where I am': he ceased, my face
And wretched body fell upon the ground;
   And when I look'd again, the holy place

Was empty; but right so the bell again
   Came to the chapel-door, there entered
Two angels first, in white, without a stain,
   And scarlet wings, then after them a bed,

Four ladies bore, and set it down beneath
   The very altar-step, and while for fear
I scarcely dared to move or draw my breath,
   These holy ladies gently came a-near,

And quite unarm'd me, saying: 'Galahad,
　　Rest here awhile and sleep, and take no thought
Of any other thing than being glad;
　　Hither the Sangreal will be shortly brought,

'Yet must you sleep the while it stayeth here.'
　　Right so they went away, and I, being weary,
Slept long and dream'd of Heaven: the bell comes near,
　　I doubt it grows to morning. Miserere!

*Enter Two Angels in white, with scarlet wings; also Four
Ladies in gowns of red and green; also an Angel, bearing in his
hands a surcoat of white, with a red cross.*

AN ANGEL

O servant of the high God, Galahad!
　　Rise and be arm'd, the Sangreal is gone forth
Through the great forest, and you must be had
　　Unto the sea that lieth on the north:

There shall you find the wondrous ship wherein
　　The spindles of King Solomon are laid,
And the sword that no man draweth without sin,
　　But if he be most pure: and there is stay'd,

Hard by, Sir Launcelot, whom you will meet
　　In some short space upon that ship: first, though,
Will come here presently that lady sweet,
　　Sister of Percival, whom you well know,

And with her Bors and Percival: stand now,
　　These ladies will to arm you.

　　　　FIRST LADY, *putting on the hauberke.*
　　　　　　　Galahad,
That I may stand so close beneath your brow,
　　I, Margaret of Antioch, am glad.

　　　　SECOND LADY, *girding him with the sword.*
That I may stand and touch you with my hand.
　　O Galahad, I, Cecily, am glad.

**THIRD LADY,** *buckling on the spurs.*

That I may kneel while up above you stand,
   And gaze at me, O holy Galahad,
I, Lucy, am most glad.

**FOURTH LADY,** *putting on the basnet.*
              O gentle knight,
   That you bow down to us in reverence,
We are most glad, I, Katherine, with delight
   Must needs fall trembling.

**ANGEL,** *putting on the crossed surcoat.*
             Galahad, we go hence,
For here, amid the straying of the snow,
   Come Percival's sister, Bors, and Percival.
        *The Four Ladies carry out the bed,*
            *and all go but Galahad.*

GALAHAD

How still and quiet everything seems now;
   They come, too, for I hear the horsehoofs fall.

   *Enter Sir Bors, Sir Percival, and his Sister.*

Fair friends and gentle lady, God you save!
   A many marvels have been here tonight;
Tell me what news of Launcelot you have,
   And has God's body ever been in sight?

SIR BORS

Why, as for seeing that same holy thing,
   As we were riding slowly side by side,
An hour ago, we heard a sweet voice sing,
   And through the bare twigs saw a great light glide,

With many-colour'd raiment, but far off,
   And so pass'd quickly – from the court nought good;
Poor merry Dinadan, that with jape and scoff
   Kept us all merry, in a little wood

Was found all hack'd and dead: Sir Lionel
   And Gauwaine have come back from the great quest,
Just merely shamed; and Lauvaine, who loved well
   Your father Launcelot, at the king's behest

Went out to seek him, but was almost slain,
   Perhaps is dead now; everywhere
The knights come foil'd from the great quest, in vain;
   In vain they struggle for the vision fair

(From *The Defence of Guenevere*, 1858)

## 5: GOLDEN WINGS

MIDWAYS of a walled garden,
   In the happy poplar land,
   Did an ancient castle stand,
With an old knight for a warden.

Many scarlet bricks there were
   In its walls, and old grey stone;
   Over which red apples shone
At the right time of the year.

On the bricks the green moss grew,
   Yellow lichen on the stone,
   Over which red apples shone;
Little war that castle knew.

Deep green water fill'd the moat,
   Each side had a red-brick lip,
   Green and mossy with the drip
Of dew and rain; there was a boat

Of carven wood, with hangings green
   About the stern; it was great bliss
   For lovers to sit there and kiss
In the hot summer noons, not seen.

Across the moat the fresh west wind
 In very little ripples went;
 The way the heavy aspens bent
Towards it, was a thing to mind.

The painted drawbridge over it
 Went up and down with gilded chains,
 'Twas pleasant in the summer rains
Within the bridge-house there to sit.

There were five swans that ne'er did eat
 The water-weeds, for ladies came
 Each day, and young knights did the same,
And gave them cakes and bread for meat.

They had a house of painted wood,
 A red roof gold-spiked over it,
 Wherein upon their eggs to sit
Week after week; no drop of blood,

Drawn from men's bodies by sword-blows,
 Came over there, or any tear;
 Most certainly from year to year
'Twas pleasant as a Provence rose.

The banners seem'd quite full of ease,
 That over the turret-roofs hung down;
 The battlements could get no frown
From the flower-moulded cornices.

Who walked in that garden there?
 Miles and Giles and Isabeau,
 Tall Jehane du Castel beau,
Alice of the golden hair,

Big Sir Gervaise, the good knight,
 Fair Ellayne le Violet,
 Mary, Constance fille de fay,
Many dames with footfall light.

Whosoever wander'd there,
　　Whether it be dame or knight,
　　Half of scarlet, half of white
Their raiment was; of roses fair

Each wore a garland on the head,
　　At Ladies' Gard the way was so:
　　Fair Jehane du Castel beau
Wore her wreath till it was dead.

Little joy she had of it,
　　Of the raiment white and red,
　　Or the garland on her head,
She had none with whom to sit

In the carven boat at noon;
　　None the more did Jehane weep,
　　She would only stand and keep
Saying, 'He will be here soon.'

Many times in the long day
　　Miles and Giles and Gervaise past,
　　Holding each some white hand fast,
Every time they heard her say:

'Summer cometh to an end,
　　Undern cometh after noon;
　　Golden wings will be here soon,
What if I some token send?'

Wherefore that night within the hall,
　　With open mouth and open eyes,
　　Like some one listening with surprise,
She sat before the sight of all.

Stoop'd down a little she sat there
　　With neck stretch'd out and chin thrown up,
　　One hand around a golden cup;
And strangely with her fingers fair

She beat some tune upon the gold;
  The minstrels in the gallery
  Sung: 'Arthur, who will never die,
In Avalon he groweth old.'

And when the song was ended, she
  Rose and caught up her gown and ran;
  None stopp'd her eager face and wan
Of all that pleasant company.

Right so within her own chamber
  Upon her bed she sat; and drew
  Her breath in quick gasps; till she knew
That no man follow'd after her:

She took the garland from her head,
  Loosed all her hair, and let it lie
  Upon the coverlit; thereby
She laid the gown of white and red;

And she took off her scarlet shoon,
  And bared her feet; still more and more
  Her sweet face redden'd; evermore
She murmur'd: 'He will be here soon;

'Truly he cannot fail to know
  My tender body waits him here;
  And if he knows, I have no fear
For poor Jehane du Castel beau.'

She took a sword within her hand,
  Whose hilts were silver, and she sung,
  Somehow like this, wild words that rung
A long way over the moonlit land:

    Gold wings across the sea!
    Grey light from tree to tree,
    Gold hair beside my knee,
    I pray thee come to me,
    Gold wings!

The water slips,
The red-bill'd moorhen dips.
Sweet kisses on red lips;
Alas! the red rust grips,
And the blood-red dagger rips,
Yet, O knight, come to me!

Are not my blue eyes sweet?
The west wind from the wheat
Blows cold across my feet;
Is it not time to meet
Gold wings across the sea?

White swans on the green moat,
Small feathers left afloat
By the blue-painted boat;
Swift running of the stoat;
Sweet gurgling note by note
Of sweet music.
              O gold wings,
Listen how gold hair sings,
And the Ladies' Castle rings
Gold wings across the sea.

I sit on a purple bed,
Outside the wall is red,
Thereby the apple hangs,
And the wasp, caught by the fangs,

Dies in the autumn night.
And the bat flits till light,
And the love-crazed knight

Kisses the long wet grass:
The weary days pass –
Gold wings across the sea!

Gold wings across the sea!
Moonlight from tree to tree,
Sweet hair laid on my knee,
O, sweet knight, come to me!

Gold wings, the short night slips,
The white swan's long neck drips,
I pray thee, kiss my lips,
Gold wings across the sea.

No answer through the moonlit night;
No answer in the cold grey dawn;
No answer when the shaven lawn
Grew green, and all the roses bright.

Her tired feet look'd cold and thin,
Her lips were twitch'd, and wretched tears,
Some, as she lay, roll'd past her ears,
Some fell from off her quivering chin.

Her long throat, stretch'd to its full length,
Rose up and fell right brokenly;
As though the unhappy heart was nigh
Striving to break with all its strength.

And when she slipp'd from off the bed,
Her cramp'd feet would not hold her; she
Sank down and crept on hand and knee,
On the window-sill she laid her head.

There, with crooked arm upon the sill,
She look'd out, muttering dismally:
'There is no sail upon the sea,
No pennon on the empty hill.

'I cannot stay here all alone,
Or meet their happy faces here,
And wretchedly I have no fear;
A little while, and I am gone.'

Therewith she rose upon her feet,
   And totter'd; cold and misery
   Still made the deep sobs come, till she
At last stretch'd out her fingers sweet,

And caught the great sword in her hand;
   And, stealing down the silent stair,
   Barefooted in the morning air,
And only in her smock, did stand

Upright upon the green lawn grass;
   And hope grew in her as she said:
   'I have thrown off the white and red,
And pray God it may come to pass

'I meet him; if ten years go by
   Before I meet him; if, indeed,
   Meanwhile both soul and body bleed,
Yet there is end of misery,

'And I have hope. He could not come,
   But I can go to him and show
   These new things I have got to know,
And make him speak, who has been dumb.'

O Jehane! the red morning sun
   Changed her white feet to glowing gold,
   Upon her smock, on crease and fold,
Changed that to gold which had been dun.

O Miles, and Giles, and Isabeau,
   Fair Ellayne le Violet,
   Mary, Constance fille de fay!
Where is Jehane du Castel beau?

O big Gervaise ride apace!
   Down to the hard yellow sand,
   Where the water meets the land.
This is Jehane by her face;

Why has she a broken sword?
   Mary! she is slain outright;
   Verily a piteous sight;
Take her up without a word!

Giles and Miles and Gervaise there,
   Ladies' Gard must meet the war;
   Whatsoever knights these are,
Man the walls withouten fear!

Axes to the apple trees,
   Axes to the aspens tall!
   Barriers without the wall
May be lightly made of these.

O poor shivering Isabeau;
   Poor Ellayne le Violet,
   Bent with fear! we miss today
Brave Jehane du Castel beau.

O poor Mary, weeping so!
   Wretched Constance fille de fay!
   Verily we miss today
Fair Jehane du Castel beau.

The apples now grow green and sour
   Upon the mouldering castle-wall,
   Before they ripen there they fall:
There are no banners on the tower.

The draggled swans most eagerly eat
   The green weeds trailing in the moat;
   Inside the rotting leaky boat
You see a slain man's stiffen'd feet.

(From *The Defence of Guenevere*, 1858)

## 6: THE HAYSTACK IN THE FLOODS

HAD she come all the way for this,
To part at last without a kiss?
Yea, had she borne the dirt and rain
That her own eyes might see him slain
Beside the haystack in the floods?

Along the dripping leafless woods,
The stirrup touching either shoe,
She rode astride as troopers do;
With kirtle kilted to her knee,
To which the mud splash'd wretchedly;
And the wet dripp'd from every tree
Upon her head and heavy hair,
And on her eyelids broad and fair;
The tears and rain ran down her face.
By fits and starts they rode apace,
And very often was his place
Far off from her; he had to ride
Ahead, to see what might betide
When the roads cross'd; and sometimes, when
There rose a murmuring from his men,
Had to turn back with promises;
Ah me! she had but little ease;
And often for pure doubt and dread
She sobb'd, made giddy in the head
By the swift riding; while, for cold,
Her slender fingers scarce could hold
The wet reins; yea, and scarcely, too,
She felt the foot within her shoe
Against the stirrup: all for this,
To part at last without a kiss
Beside the haystack in the floods.

For when they near'd that old soak'd hay,
They saw across the only way

That Judas, Godmar, and the three
Red running lions dismally
Grinn'd from his pennon, under which,
In one straight line along the ditch,
They counted thirty heads.

                    So then,
While Robert turn'd round to his men,
She saw at once the wretched end,
And, stooping down, tried hard to rend
Her coif the wrong way from her head,
And hid her eyes; while Robert said:
'Nay, love, 'tis scarcely two to one,
At Poictiers where we made them run
So fast – why, sweet my love, good cheer.
The Gascon frontier is so near,
Nought after this.'

                    But, 'O,' she said,
'My God! my God! I have to tread
The long way back without you; then
The court at Paris; those six men;
The gratings of the Chatelet;
The swift Seine on some rainy day
Like this, and people standing by,
And laughing, while my weak hands try
To recollect how strong men swim,
All this, or else a life with him,
For which I should be damned at last,
Would God that this next hour were past!'

He answer'd not, but cried his cry,
'St George for Marny!' cheerily;
And laid his hand upon her rein.
Alas! no man of all his train
Gave back that cheery cry again;
And, while for rage his thumb beat fast
Upon his sword-hilts, some one cast

About his neck a kerchief long,
And bound him.

        Then they went along
To Godmar; who said: 'Now, Jehane,
Your lover's life is on the wane
So fast, that, if this very hour
You yield not as my paramour,
He will not see the rain leave off –
Nay, keep your tongue from gibe and scoff,
Sir Robert, or I slay you now.'

She laid her hand upon her brow,
Then gazed upon the palm, as though
She thought her forehead bled, and – 'No,'
She said, and turn'd her head away,
As there were nothing else to say,
And everything were settled: red
Grew Godmar's face from chin to head:
'Jehane, on yonder hill there stands
My castle, guarding well my lands:
What hinders me from taking you,
And doing that I list to do
To your fair wilful body, while
Your knight lies dead?'

        A wicked smile
Wrinkled her face, her lips grew thin,
A long way out she thrust her chin:
'You know that I should strangle you
While you were sleeping; or bite through
Your throat, by God's help – ah!' she said,
'Lord Jesus, pity your poor maid!
For in such wise they hem me in,
I cannot choose but sin and sin,
Whatever happens: yet I think
They could not make me eat or drink,
And so should I just reach my rest.'
'Nay, if you do not my behest,

O Jehane! though I love you well,'
Said Godmar, 'would I fail to tell
All that I know.' 'Foul lies,' she said.
'Eh? lies my Jehane? by God's head,
At Paris folks would deem them true!
Do you know, Jehane, they cry for you,
"Jehane the brown! Jehane the brown!
Give us Jehane to burn or drown!" –
Eh – gag me Robert! – sweet my friend,
This were indeed a piteous end
For those long fingers, and long feet,
And long neck, and smooth shoulders sweet;
An end that few men would forget
That saw it – So, an hour yet:
Consider, Jehane, which to take
Of life or death!'

        So, scarce awake,
Dismounting, did she leave that place,
And totter some yards: with her face
Turn'd upward to the sky she lay,
Her head on a wet heap of hay,
And fell asleep: and while she slept,
And did not dream, the minutes crept
Round to the twelve again; but she,
Being waked at last, sigh'd quietly,
And strangely childlike came, and said:
'I will not.' Straightway Godmar's head,
As though it hung on strong wires, turn'd
Most sharply round, and his face burn'd.

For Robert – both his eyes were dry,
He could not weep, but gloomily
He seem'd to watch the rain; yea, too,
His lips were firm; he tried once more
To touch her lips; she reach'd out, sore

And vain desire so tortured them,
The poor grey lips, and now the hem
Of his sleeve brush'd them.
                              With a start
Up Godmar rose, thrust them apart;
From Robert's throat he loosed the bands
Of silk and mail; with empty hands
Held out, she stood and gazed, and saw,
The long bright blade without a flaw
Glide out from Godmar's sheath, his hand
In Robert's hair; she saw him bend
Back Robert's head; she saw him send
The thin steel down; the blow told well,
Right backward the knight Robert fell,
And moan'd as dogs do, being half dead,
Unwitting, as I deem: so then
Godmar turn'd grinning to his men,
Who ran, some five or six, and beat
His head to pieces at their feet.

Then Godmar turn'd again and said:
'So, Jehane, the first fitte is read!
Take note, my lady, that your way
Lies backward to the Chatelet!'
She shook her head and gazed awhile
At her cold hands with a rueful smile,
As though this thing had made her mad.

This was the parting that they had
Beside the haystack in the floods.

(From *The Defence of Guenevere*, 1858)

## 7: NEAR AVALON

A SHIP with shields before the sun,
Six maidens round the mast,
A red-gold crown on every one,
A green gown on the last.

The fluttering green banners there
Are wrought with ladies' heads most fair,
And a portraiture of Guenevere
The middle of each sail doth bear.

A ship with sails before the wind,
And round the helm six knights,
Their heaumes are on, whereby, half blind,
They pass by many sights.

The tatter'd scarlet banners there,
Right soon will leave the spear-heads bare,
Those six knights sorrowfully bear
In all their heaumes some yellow hair.

(From *The Defence of Guenevere*, 1858)

## 8: PRAISE OF MY LADY

My lady seems of ivory
Forehead, straight nose, and cheeks that be
Hollow'd a little mournfully.
*Beata mea Domina!*

Her forehead, overshadow'd much
By bows of hair, has a wave such
As God was good to make for me,
*Beata mea Domina!*

Not greatly long my lady's hair,
Nor yet with yellow colour fair,
But thick and crisped wonderfully:
        *Beata mea Domina!*

Heavy to make the pale face sad,
And dark, but dead as though it had
Been forged by God most wonderfully
      *– Beata mea Domina! –*

Of some strange metal, thread by thread,
To stand out from my lady's head,
Not moving much to tangle me.
        *Beata mea Domina!*

Beneath her brows the lids fall slow,
The lashes a clear shadow throw
Where I would wish my lips to be.
        *Beata mea Domina!*

Her great eyes, standing far apart,
Draw up some memory from her heart,
And gaze out very mournfully;
      *– Beata mea Domina! –*

So beautiful and kind they are,
But most times looking out afar,
Waiting for something, not for me.
        *Beata mea Domina!*

I wonder if the lashes long
Are those that do her bright eyes wrong,
For always half tears seem to be
      *– Beata mea Domina! –*

Lurking below the underlid,
Darkening the place where they lie hid –
If they should rise and flow for me!
        *Beata mea Domina!*

Her full lips being made to kiss,
Curl'd up and pensive each one is;
This makes me faint to stand and see.
   *Beata mea Domina!*

Her lips are not contented now,
Because the hours pass so slow
Towards a sweet time: (pray for me),
  – *Beata mea Domina!* –

Nay, hold thy peace! for who can tell;
But this at least I know full well,
Her lips are parted longingly,
  – *Beata mea Domina!* –

So passionate and swift to move,
To pluck at any flying love,
That I grow faint to stand and see.
   *Beata mea Domina!*

Yea! there beneath them is her chin,
So fine and round, it were a sin
To feel no weaker when I see
  – *Beata mea Domina!* –

God's dealings; for with so much care
And troublous, faint lines wrought in there,
He finishes her face for me.
   *Beata mea Domina!*

Of her long neck what shall I say!
What thing about her body's sway,
Like a knight's pennon or slim tree
  – *Beata mea Domina!* –

Set gently waving in the wind;
Or her long hands that I may find
On some day sweet to move o'er me?
   *Beata mea Domina!*

God pity me though, if I miss'd
The telling, how along her wrist
The veins creep, dying languidly
      – *Beata mea Domina!* –

Inside her tender palm and thin.
Now give me pardon, dear, wherein
My voice is weak and vexes thee.
      *Beata mea Domina!*

All men that see her any time,
I charge you straightly in this rhyme,
What, and wherever you may be,
      – *Beata mea Domina!* –

To kneel before her; as for me,
I choke and grow quite faint to see
My lady moving graciously.
      *Beata mea Domina!*

(From *The Defence of Guenevere*, 1858)

## 9

... SHALL I say, Paris, that my heart is faint,
And my head sick? I grow afraid of death:
The gods are all against us, and some day
The long black ships rowed equal on each side
Shall throng the Trojan bay, and I shall walk
From off the green earth to the straining ship;
Cold Agamemnon with his sickly smile
Shall go before me, and behind shall go
My old chain Menelaus: we shall sit
Under the deck amid the oars, and hear
From day to day to their wretched measured beat
Against the washing surges; they shall sit

There in that twilight, with their faces turned
Away from mine, and we shall say no word;
And I shall be too sick at heart to sing,
Though the dirt-grimed mariners may sing
Through all their weariness their rowing-song
Of Argo and the Golden Fleece, and Her
That made and marred them all in a short while,
As any potter might do with his clay,
Medea the Colchian . . .

(From the unfinished *Scenes from the
Fall of Troy*, 1857)

## 10: A GARDEN BY THE SEA

I KNOW a little garden-close,
Set thick with lily and red rose,
Where I would wander if I might
From dewy morn to dewy night,
And have one with me wandering.

And though within it no birds sing,
And though no pillared house is there,
And though the apple-boughs are bare
Of fruit and blossom, would to God
Her feet upon the green grass trod,
And I beheld them as before.

There comes a murmur from the shore,
And in the close two fair streams are,
Drawn from the purple hills afar,
Drawn down unto the restless sea:
Dark hills whose heath-bloom feeds no bee,
Dark shore no ship has ever seen,
Tormented by the billows green
Whose murmur comes unceasingly
Unto the place for which I cry.

For which I cry both day and night,
For which I let slip all delight,
Whereby I grow both deaf and blind,
Careless to win, unskilled to find,
And quick to lose what all men seek.

Yet tottering as I am and weak,
Still have I left a little breath
To seek within the jaws of death
An entrance to that happy place,
To seek the unforgotten face,
Once seen, once kissed, once reft from me
Anigh the murmuring of the sea.

(From *The Life and Death of Jason*, 1867)

## 11

OF Heaven or Hell I have no power to sing,
I cannot ease the burden of your fears,
Or make quick-coming death a little thing,
Or bring again the pleasure of past years,
Nor for my words shall ye forget your tears,
Or hope again for aught that I can say,
The idle singer of an empty day.

But rather, when aweary of your mirth,
From full hearts still unsatisfied ye sigh,
And, feeling kindly unto all the earth,
Grudge every minute as it passes by,
Made the more mindful that the sweet days die –
Remember me a little then I pray,
The idle singer of an empty day.

The heavy trouble, the bewildering care
That weighs us down who live and earn our bread,
These idle verses have no power to bear;

So let me sing of names remembered,
Because they, living not, can ne'er be dead,
Or long time take their memory quite away
From us poor singers of an empty day.

Dreamer of dreams, born out of my due time,
Why should I strive to set the crooked straight?
Let it suffice me that my murmuring rhyme
Beats with light wing against the ivory gate,
Telling a tale not too importunate
To those who in the sleepy region stay,
Lulled by the singer of an empty day.

Folk say, a wizard to a northern king
At Christmas-tide such wondrous things did show,
That through one window men beheld the spring,
And through another saw the summer glow,
And through a third the fruited vines a-row,
While still, unheard, but in its wonted way,
Piped the drear wind of that December day.

So with this Earthly Paradise it is,
If ye will read aright, and pardon me,
Who strive to build a shadowy isle of bliss
Midmost the beating of the steely sea,
Where tossed about all hearts of men must be;
Whose ravening monsters mighty men shall slay,
Not the poor singer of an empty day.

(Envoi to *The Earthly Paradise*, 1868-70)

## 12

FORGET six counties overhung with smoke,
Forget the snorting steam and piston stroke,
Forget the spreading of the hideous town;
Think rather of the pack-horse on the down,
And dream of London, small, and white, and clean,
The clear Thames bordered by its gardens green;
Think, that below bridge the green lapping waves
Smite some few keels that bear Levantine staves,
Cut from the yew wood on the burnt-up hill,
And pointed jars that Greek hands toiled to fill,
And treasured scanty spice from some far sea,
Florence gold cloth, and Ypres napery,
And cloth of Bruges, and hogsheads of Guienne;
While nigh the thronged wharf Geoffrey Chaucer's pen
Moves over bills of lading – mid such times
Shall dwell the hollow puppets of my rhymes.

A nameless city in a distant sea,
White as the changing walls of faërie,
Thronged with much people clad in ancient guise
I now am fain to set before your eyes;
There, leave the clear green water and the quays,
And pass betwixt its marble palaces,
Until ye come unto the chiefest square;
A bubbling conduit is set midmost there,
And round about it now the maidens throng,
With jest and laughter, and sweet broken song,
Making but light of labour new begun
While in their vessels gleams the morning sun. . . .

(First lines from the Prologue to *The
Earthly Paradise*)

## 13: OCTOBER

O LOVE, turn from the unchanging sea, and gaze
Down these grey slopes upon the year grown old,
A-dying mid the autumn-scented haze,
That hangeth o'er the hollow in the wold,
Where the wind-bitten ancient elms enfold
Grey church, long barn, orchard, and red-roofed stead,
Wrought in dead days for men a long while dead.

Come down, O love; may not our hands still meet,
Since still we live today, forgetting June,
Forgetting May, deeming October sweet –
– O hearken, hearken! through the afternoon,
The grey tower sings a strange old tinkling tune!
Sweet, sweet, and sad, the toiling year's last breath,
Too satiate of life to strive with death.

And we too – will it not be soft and kind,
That rest from life, from patience and from pain;
That rest from bliss we know not when we find;
That rest from Love which ne'er the end can gain? –
Hark, how the tune swells, that erewhile did wane!
Look up, love! – ah, cling close and never move!
How can I have enough of life and love?

(From *The Earthly Paradise*)

## 14: NOVEMBER

ARE thine eyes weary! is thy heart too sick
To struggle any more with doubt and thought,
Whose formless veil draws darkening now and thick
Across thee, e'en as smoke-tinged mist-wreaths brought
Down a fair dale to make it blind and nought?

Art thou so weary that no world there seems
Beyond these four walls, hung with pain and dreams?

Look out upon the real world, where the moon,
Half-way 'twixt root and crown of these high trees,
Turns the dead midnight into dreamy noon,
Silent and full of wonders, for the breeze
Died at the sunset, and no images,
No hopes of day, are left in sky or earth –
Is it not fair, and of most wondrous worth?

Yea, I have looked, and seen November there;
The changeless seal of change it seemed to be,
Fair death of things that, living once, were fair;
Bright sign of loneliness too great for me,
Strange image of the dread eternity,
In whose void patience how can these have part,
These outstretched feverish hands, this restless heart?

(From *The Earthly Paradise*)

## 15: THE DOOMED SHIP

THE doomed ship drives on helpless through the sea,
All that the mariners may do is done
And death is left for men to gaze upon,
While side by side two friends sit silently;
Friends once, foes once, and now by death made free
Of Love and Hate, of all things lost or won;
Yet still the wonder of that strife bygone
Clouds all the hope or horror that may be.

Thus, Sorrow, are we sitting side by side
Amid this welter of the grey despair,
Nor have we images of foul or fair
To vex, save of thy kissed face of a bride,

Thy scornful face of tears when I was tried,
And failed 'neath pain I was not made to bear.

<div align="right">(Unpublished by Morris; written <i>c</i>. 1867–70)</div>

## 16

A LIFE scarce worth the living, a poor fame
Scarce worth the winning, in a wretched land,
Where fear and pain go upon either hand,
As toward the end men fare without an aim
Unto the dull grey dark from whence they came:
Let them alone, the unshadowed sheer rocks stand
Over the twilight graves of that poor band,
Who count so little in the great world's game!

Nay, with the dead I deal not; this man lives,
And that which carried him through good and ill,
Stern against fate while his voice echoed still
From rock to rock, now he lies silent, strives
With wasting time, and through its long lapse gives
Another friend to me, life's void to fill.

<div align="right">(Prefatory Sonnet to <i>The Story of<br>Grettir the Strong</i>, 1869)</div>

## 17: ICELAND FIRST SEEN

Lo from our loitering ship
a new land at last to be seen;
Toothed rocks down the side of the firth
on the east guard a weary wide lea,

And black slope the hillsides above,
striped adown with their desolate green:
And a peak rises up on the west
from the meeting of cloud and of sea,
Foursquare from base unto point
like the building of Gods that have been,
The last of that waste of the mountains
all cloud-wreathèd and snow-flecked and grey,
And bright with the dawn that began
just now at the ending of day.

Ah! what came we forth for to see
that our hearts are so hot with desire?
Is it enough for our rest,
the sight of this desolate strand,
And the mountain-waste voiceless as death
but for winds that may sleep not nor tire?
Why do we long to wend forth
through the length and breadth of a land,
Dreadful with grinding of ice,
and record of scarce hidden fire,
But that there 'mid the grey grassy dales
sore scarred by the ruining streams
Lives the tale of the Northland of old
and the undying glory of dreams?

O land, as some cave by the sea
where the treasures of old have been laid,
The sword it may be of a king
whose name was the turning of fight:
Or the staff of some wise of the world
that many things made and unmade.
Or the ring of a woman maybe
whose woe is grown wealth and delight.
No wheat and no wine grows above it,
no orchard for blossom and shade;

The few ships that sail by its blackness
but deem it the mouth of a grave;
Yet sure when the world shall awaken,
this too shall be mighty to save.

Or rather, O land, if a marvel
it seemeth that men ever sought
Thy wastes for a field and a garden
fulfilled of all wonder and doubt,
And feasted amidst of the winter
when the fight of the year had been fought,
Whose plunder all gathered together
was little to babble about;
Cry aloud from thy wastes, O thou land,
'Not for this nor for that was I wrought
Amid waning of realms and of riches
and death of things worshipped and sure,
I abide here the spouse of a God,
and I made and I make and endure.'

O Queen of the grief without knowledge,
of the courage that may not avail,
Of the longing that may not attain,
of the love that shall never forget,
More joy than the gladness of laughter
thy voice hath amidst of its wail:
More hope than of pleasure fulfilled
amidst of thy blindness is set;
More glorious than gaining of all
thine unfaltering hand that shall fail:
For what is the mark on thy brow
but the brand that thy Brynhild doth bear?
Lone once, and loved and undone
by a love that no ages outwear.

Ah! when thy Balder comes back,
and bears from the heart of the Sun
Peace and the healing of pain,

and the wisdom that waiteth no more;
And the lilies are laid on thy brow
'mid the crown of the deeds thou hast done;
And the roses spring up by thy feet
that the rocks of the wilderness wore.
Ah! when thy Balder comes back
and we gather the gains he hath won,
Shall we not linger a little
to talk of thy sweetness of old,
Yea, turn back awhile to thy travail
whence the Gods stood aloof to behold?

(From *Poems by the Way*, 1891)

## 18

Lo here an ancient chronicle
Recording matters that befell
A folk, whose life and death and pain
Might touch the great world's loss and gain
Full little: yet such might had they
They could not wholly pass away:
From mouth to mouth they sent a tale,
That yet for something may avail;
For midst them all a man they wrought,
Who all these worlds together brought,
Made shadows breathe, quickened the dead,
And knew what silent mouths once said,
Till with the life his life might give
These lived again, and yet shall live.

Where art thou, O thou nameless one?
And dost thou laugh to look upon
My eagerness thy tale to read
Midst such changed hope and fear and need?

Or somewhere near me dost thou stand,
And through the dark reach out thine hand?
Yea, are we friends? Draw nigher then,
Thou tale-teller of vanished men,
For we are of one company
To link the dull years straggling by,
Their lonely hopes and griefs grown cold,
Into a chain of tear-washed gold
That yet shall cling about the Earth
In dawning of her second birth.

Tale-teller, who 'twixt fire and snow
Had heart to turn about and show
With faint half-smile things great and small
That in thy fearful land did fall,
Thou and thy brethren sure did gain
That thing for which I long in vain,
The spell, whereby the mist of fear
Was melted, and your ears might hear
Earth's voices as they are indeed.
Well ye have helped me at my need.

(Envoi to *The Eyrbyggja Saga*, 1870)

# 19

THERE was a dwelling of Kings ere the world was waxen old;
Dukes were the door-wards there, and the roofs were thatched with
    gold;
Earls were the wrights that wrought it, and silver nailed its doors,
Earls' wives were the weaving-women, queens' daughters strewed its
    floors,
And the masters of its song-craft were the mightiest men that cast
The sails of the storm of battle adown the bickering blast.

There dwelt men merry-hearted, and in hope exceeding great
Met the good days and the evil as they went the way of fate:
There the Gods were unforgotten, yea whiles they walked with men,
Though e'en in that world's beginning rose a murmur now and again
Of the midward time and the fading and the last of the latter days,
And the entering in of the terror and the death of the People's Praise.

(Opening lines from *Sigurd the Volsung*, 1876)

## 20: IN PRISON

WEARILY, drearily,
Half the day long,
Flap the great banners
High over the stone;
Strangely and eerily
Sounds the wind's song,
Bending the banner-poles.

While, all alone,
Watching the loophole's spark,
Lie I, with life all dark,
Feet tether'd, hands fetter'd
Fast to the stone,
The grim walls, square letter'd
With prison'd men's groan.
Still strain the banner-poles
Through the wind's song,
Westward the banner rolls
Over my wrong.

(1858)

# THREE ❧ COMMITMENT

## 21: DISCONTENT, PERSONAL AND SOCIAL

... YESTERDAY ... was May's birthday, mine was on Tuesday, on which sad occasion I was forty. Yet in spite of that round number I don't feel any older than I did in that ancient time of the sunflowers. I very much long to have a spell of the country this spring, but I suppose I hardly shall. I have so many things to do in London. Monday was a day here to set one longing to get away: as warm as June: yet the air heavy as it often is in England: though town looks rather shocking on such days, and then instead of the sweet scents one gets an extra smell of dirt. Surely if people lived five hundred years instead of threescore and ten they would find some better way of living than in such a sordid loathsome place, but now it seems to be nobody's business to try to better things – isn't mine you see in spite of all my grumblings – but look, suppose people lived in little communities among gardens and green fields, so that you could be in the country in five minutes' walk, and had few wants, almost no furniture for instance, and no servants, and studied the (difficult) arts of enjoying life, and finding out what they really wanted: then I think one might hope civilization had really begun. But as it is, the best thing one can wish for this country at least is, meseems, some great and tragical circumstances, so that if they cannot have pleasant life, which is what one means by civilization, they may at least have a history and something to think of – all of which won't happen in our time. Sad grumbling – but do you know, I have to go to a wedding next Tuesday: and it enrages me to think that I lack courage to say, I don't care for either of you, and you neither of you care for me, and I won't waste a day of my precious life in grinning a company grin at you two. ...

(From a letter of 26 March 1874 to
Mrs Alfred Baldwin)

## 22: THE EASTERN QUESTION

WHO are they that are leading us into war? Greedy gamblers on the Stock Exchange, idle officers of the army and navy (poor fellows!), worn-out mockers of the clubs, desperate purveyors of exciting war-news for the comfortable breakfast-tables of those who have nothing to lose by war; and lastly, in the place of honour, the Tory Rump, that we fools, weary of peace, reason, and justice, chose at the last election to represent us. Shame and double shame, if we march under such leadership as this in an unjust war against a people who are not our enemies, against Europe, against freedom, against nature, against the hope of the world.

Working men of England, one word of warning yet: I doubt if you know the bitterness of hatred against freedom and progress that lies at the hearts of a certain part of the richer classes in this country: their newspapers veil it in a kind of decent language; but do but hear them talking among themselves, as I have often, and I know not whether scorn or anger would prevail in you at their folly and insolence. These men cannot speak of your order, of its aims, of its leaders, without a sneer or an insult: these men, if they had the power (may England perish rather!), would thwart your just aspirations, would silence you, would deliver you bound hand and foot for ever to irresponsible capital. Fellow citizens, look to it, and if you have any wrongs to be redressed, if you cherish your most worthy hope of raising your whole order peacefully and solidly, if you thirst for leisure and know-ledge, if you long to lessen these inequalities which have been our stumbling-block since the beginning of the world, then cast aside sloth and cry out against an Unjust War, and urge us of the middle classes to do no less . . .

(From Morris's manifesto *To the Working-men of England*, May 1877)

# 23: 'ANTI-SCRAPE' ❧ (a) THE NEED FOR AN ASSOCIATION

SIR,

My eye just now caught the word 'restoration' in the morning paper, and, on looking closer, I saw that this time it is nothing less than the minster of Tewkesbury that is to be destroyed by Sir Gilbert Scott. Is it altogether too late to do something to save it – it and whatever else of beautiful or historical is still left us on the sites of the ancient buildings we were once so famous for? Would it not be of some use once for all, and with the least delay possible, to set on foot an association for the purpose of watching over and protecting these relics, which, scanty as they are now become, are still wonderful treasures, all the more priceless in this age of the world, when the newly-invented study of living history is the chief joy of so many of our lives?

Your paper has so steadily and courageously opposed itself to those acts of barbarism which the modern architect, parson, and squire call 'restoration', that it would be waste of words to enlarge here on the ruin that has been wrought by their hands; but, for the saving of what is left, I think I may write a word of encouragement, and say that you by no means stand alone in the matter, and that there are many thoughtful people who would be glad to sacrifice time, money, and comfort in defence of those ancient monuments: besides, though I admit that the architects are, with very few exceptions, hopeless, because interest, habit, and ignorance bind them, and that the clergy are hopeless, because their order, habit, and an ignorance yet grosser, bind them; still there must be many people whose ignorance is accidental rather than inveterate, whose good sense could surely be touched if it were clearly put to them that they were destroying what they, or, more surely still, their sons and sons' sons, would one day fervently long for, and which no wealth or energy could ever buy again for them.

What I wish for, therefore, is that an association should be set on foot to keep a watch on old monuments, to protest against all 'restoration' that means more than keeping out wind and weather, and, by

all means, literary and other, to awaken a feeling that our ancient buildings are not mere ecclesiastical toys, but sacred monuments of the nation's growth and hope.

(From *The Athenaeum*, 10 March 1877)

## (b) THE VULGARIZATION OF OXFORD

SIR,

I have just read your too true article on the vulgarization of Oxford, and I wish to ask if it is too late to appeal to the mercy of the 'dons' to spare the few specimens of ancient town architecture which they have not yet had time to destroy, such, for example, as the little plaster houses in front of Trinity College or the beautiful houses left on the north side of Holywell Street. These are in their way as important as the more majestic buildings to which all the world makes pilgrimage. Oxford thirty years ago, when I first knew it, was full of these treasures; but Oxford 'culture', cynically contemptuous of the knowledge which it does not know, and steeped to the lips in the commercialism of the day, has made a clean sweep of most of them; but those that are left are of infinite value, and still give some character above that of Victoria Street or Bayswater to modern Oxford. Is it impossible, Sir, to make the authorities of Oxford, town and gown, see this, and stop the destruction? The present theory of the use to which Oxford should be put appears to be that it should be used as a huge upper public school for fitting lads of the upper and middle class for their laborious future of living on other people's labour. For my part I do not think this a lofty conception of the function of a University; but if it be the only admissible one nowadays, it is at least clear that it does not need the history and art of our forefathers which Oxford still holds to develop it. London, Manchester, Birmingham, or perhaps a rising city of Australia would be a fitter place for the experiment, which it seems to me is too rough a one for Oxford. In sober truth, what speciality has Oxford if it is not the genius loci which our modern commercial dons are doing their best to destroy? One word on the subject of Dr Hornby and Eton. Is there no appeal against a brutality of which I

dare not trust myself to write further? Is it impossible that the opinions of distinguished men of all kinds might move him? Surely a memorial might be got up which would express those opinions.

(From the *Daily News*, 20 November 1885)

## (c) STRATFORD-ON-AVON CHURCH

SIR,

My attention has been called to a letter from the vicar of Stratford-on-Avon appearing in your issue of July 28, and appealing for funds generally towards the completion of the restoration. In this letter occurs the following sentence: 'Under the stalls sufficient of the ancient reredos has been found to make Mr Garner think he can give us a drawing of what it was when the church was built. We shall hope, then, that somebody will provide the funds to erect a copy of it in the old place.'

I am glad that the vicar talks about a 'copy' of the reredos, and not a 'restoration' of it: but may I ask why a copy of it should be 'erected in the old place'? Will not every fresh piece of modern work make 'the old place' (the church, I mean) look less old and more like a nine-teenth-century mediaeval furniture-dealer's warehouse? There has been a great deal too much modernization of this fine church of Stratford-on-Avon already, and it is more than time that it should come to an end. Once for all I protest against the trick which clergy-men and restoration committees have of using an illustrious name as a bait wherewith to catch subscriptions. Shakespeare's memory is best honoured by reading his works intelligently; and it is no honour to him to spend money in loading the handsome mediaeval church which contains his monument with trash which can claim none of the respect due to either an ancient or a modern work of art.

(From *The Times*, 15 August 1890)

## 24: INNATE SOCIALISM*

HEREAFTER I hope in another lecture to have the pleasure of laying before you an historical survey of the lesser, or as they are called the Decorative Arts, and I must confess it would have been pleasanter to me to have begun my talk with you by entering at once upon the subject of the history of this great industry; but, as I have something to say in a third lecture about various matters connected with the practice of Decoration among ourselves in these days, I feel that I should be in a false position before you, and one that might lead to confusion, or overmuch explanation, if I did not let you know what I think on the nature and scope of these arts, on their condition at the present time, and their outlook in times to come. In doing this it is like enough that I shall say things with which you will very much disagree; I must ask you therefore from the outset to believe that whatever I may blame or whatever I may praise, I neither, when I think of what history has been, am inclined to lament the past, to despise the present, or despair of the future; that I believe all the change and stir about us is a sign of the world's life, and that it will lead – by ways, indeed, of which we have no guess – to the bettering of all mankind.

Now as to the scope and nature of these Arts I have to say, that though when I come more into the details of my subject I shall not meddle much with the great art of Architecture, and less still with the great arts commonly called Sculpture and Painting, yet I cannot in my own mind quite sever them from those lesser so-called Decorative Arts, which I have to speak about: it is only in latter times, and under the most intricate conditions of life, that they have fallen apart from one another; and I hold that, when they are so parted, it is ill for the Arts altogether: the lesser ones become trivial, mechanical, unintelligent, incapable of resisting the changes pressed upon them by fashion or dishonesty; while the greater, however they may be practised for a while by men of great minds and wonder-working hands, unhelped by the lesser, unhelped by each other, are sure to lose their dignity of

* This lecture was first published in pamphlet form with the title 'The Decorative Arts'. It was Morris's first public lecture.

popular arts, and become nothing but dull adjuncts to unmeaning pomp, or ingenious toys for a few rich and idle men.

However, I have not undertaken to talk to you of Architecture, Sculpture, and Painting, in the narrower sense of those words, since, most unhappily as I think, these master-arts, these arts more specially of the intellect, are at the present day divorced from decoration in its narrower sense. Our subject is that great body of art, by means of which men have at all times more or less striven to beautify the familiar matters of everyday life: a wide subject, a great industry; both a great part of the history of the world, and a most helpful instrument to the study of that history.

A very great industry indeed, comprising the crafts of house-building, painting, joinery and carpentry, smiths' work, pottery and glass-making, weaving, and many others: a body of art most important to the public in general, but still more so to us handicraftsmen; since there is scarce anything that they use, and that we fashion, but it has always been thought to be unfinished till it has had some touch or other of decoration about it. True it is that in many or most cases we have got so used to this ornament, that we look upon it as if it had grown of itself, and note it no more than the mosses on the dry sticks with which we light our fires. So much the worse! for there *is* the decoration, or some pretence of it, and it has, or ought to have, a use and a meaning. For, and this is at the root of the whole matter, everything made by man's hands has a form, which must be either beautiful or ugly; beautiful if it is in accord with Nature, and helps her; ugly if it is discordant with Nature, and thwarts her; it cannot be indifferent: we, for our parts, are busy or sluggish, eager or unhappy, and our eyes are apt to get dulled to this eventfulness of form in those things which we are always looking at. Now it is one of the chief uses of decoration, the chief part of its alliance with nature, that it has to sharpen our dulled senses in this matter: for this end are those wonders of intricate patterns interwoven, those strange forms invented, which men have so long delighted in: forms and intricacies that do not necessarily imitate nature, but in which the hand of the craftsman is guided to work in the way that she does, till the web, the cup, or the knife, look as natural, nay as lovely, as the green field, the river bank, or the mountain flint.

To give people pleasure in the things they must perforce *use*, that is one great office of decoration; to give people pleasure in the things they must perforce *make*, that is the other use of it.

Does not our subject look important enough now? I say that without these arts, our rest would be vacant and uninteresting, our labour mere endurance, mere wearing away of body and mind.

As for that last use of these arts, the giving us pleasure in our work, I scarcely know how to speak strongly enough of it; and yet if I did not know the value of repeating a truth again and again, I should have to excuse myself to you for saying any more about this, when I remember how a great man now living has spoken of it: I mean my friend Professor John Ruskin: if you read the chapter in the second volume of his *Stones of Venice* entitled, 'On the Nature of Gothic, and the Office of the Workman therein,' you will read at once the truest and the most eloquent words that can possibly be said on the subject. What I have to say upon it can scarcely be more than an echo of his words, yet I repeat there is some use in reiterating a truth, lest it be forgotten; so I will say this much further: we all know what people have said about the curse of labour, and what heavy and grievous nonsense are the more part of their words thereupon; whereas indeed the real curses of craftsmen have been the curse of stupidity, and the curse of injustice from within and from without: no, I cannot suppose there is anybody here who would think it either a good life, or an amusing one, to sit with one's hands before one doing nothing – to live like a gentleman, as fools call it.

Nevertheless there *is* dull work to be done, and a weary business it is setting men about such work, and seeing them through it, and I would rather do the work twice over with my own hands than have such a job: but now only let the arts which we are talking of beautify our labour, and be widely spread, intelligent, well understood both by the maker and the user, let them grow in one word *popular*, and there will be pretty much an end of dull work and its wearing slavery; and no man will any longer have an excuse for talking about the curse of labour, no man will any longer have an excuse for evading the blessing of labour. I believe there is nothing that will aid the world's progress so much as the attainment of this; I protest there is nothing in the world that I desire so much as this, wrapped up, as I am

sure it is, with changes political and social, that in one way or another we all desire.

Now if the objection be made, that these arts have been the hand-maids of luxury, of tyranny, and of superstition, I must needs say that it is true in a sense; they have been so used, as many other excellent things have been. But it is also true that, among some nations, their most vigorous and freest times have been the very blossoming times of art: while at the same time, I must allow that these decorative arts have flourished among oppressed peoples, who have seemed to have no hope of freedom: yet I do not think that we shall be wrong in thinking that at such times, among such peoples, art, at least, was free; when it has not been, when it has really been gripped by super-stition, or by luxury, it has straightway begun to sicken under that grip. Nor must you forget that when men say popes, kings, and em-perors built such and such buildings, it is a mere way of speaking. You look in your history-books to see who built Westminster Abbey, who built St Sophia at Constantinople, and they tell you, Henry III, Justinian the Emperor. Did they? or, rather, men like you and me, handicraftsmen, who have left no names behind them, nothing but their work?

Now as these arts call people's attention and interest to the matters of everyday life in the present, so also, and that I think is no little matter, they call our attention at every step to that history, of which, I said before, they are so great a part; for no nation, no state of society, however rude, has been wholly without them: nay, there are peoples not a few, of whom we know scarce anything, save that they thought such and such forms beautiful. So strong is the bond between history and decoration, that in the practice of the latter we cannot, if we would, wholly shake off the influence of past times over what we do at present. I do not think it is too much to say that no man, however original he may be, can sit down today and draw the ornament of a cloth, or the form of an ordinary vessel or piece of furniture, that will be other than a development or a degradation of forms used hundreds of years ago; and these, too, very often, forms that once had a serious meaning, though they are now become little more than a habit of the hand; forms that were once perhaps the mysterious symbols of wor-ships and beliefs now little remembered or wholly forgotten. Those

who have diligently followed the delightful study of these arts are able as if through windows to look upon the life of the past – the very first beginnings of thought among nations whom we cannot even name; the terrible empires of the ancient East; the free vigour and glory of Greece; the heavy weight, the firm grasp of Rome; the fall of her temporal Empire which spread so wide about the world all that good and evil which men can never forget, and never cease to feel, the clashing of East and West, South and North, about her rich and fruitful daughter Byzantium; the rise, the dissensions, and the waning of Islam; the wanderings of Scandinavia; the Crusades; the foundation of the States of modern Europe; the struggles of free thought with ancient dying system – with all these events and their meaning is the history of popular art interwoven; with all this, I say, the careful student of decoration as an historical industry must be familiar. When I think of this, and the usefulness of all this knowledge, at a time when history has become so earnest a study among us as to have given us, as it were, a new sense: at a time when we so long to know the reality of all that has happened, and are to be put off no longer with the dull records of the battles and intrigues of kings and scoundrels – I say when I think of all this, I hardly know how to say that this interweaving of the Decorative Arts with the history of the past is of less importance than their dealings with the life of the present: for should not these memories also be a part of our daily life?

And now let me recapitulate a little before I go further, before we begin to look into the condition of the arts at the present day. These arts, I have said, are part of a great system invented for the expression of a man's delight in beauty: all peoples and times have used them; they have been the joy of free nations, and the solace of oppressed nations; religion has used and elevated them, has abused and degraded them; they are connected with all history, and are clear teachers of it; and, best of all, they are the sweeteners of human labour, both to the handicraftsman, whose life is spent in working in them, and to people in general who are influenced by the sight of them at every turn of the day's work: they make our toil happy, our rest fruitful.

And now if all I have said seems to you but mere open-mouthed

praise of these arts, I must say that it is not for nothing that what I have hitherto put before you has taken that form.

It is because I must now ask you this question: All these good things – will you have them? will you cast them from you?

Are you surprised at my question – you, most of whom, like myself, are engaged in the actual practice of the arts that are, or ought to be, popular?

In explanation, I must somewhat repeat what I have already said. Time was when the mystery and wonder of handicrafts were well acknowledged by the world, when imagination and fancy mingled with all things made by man; and in those days all handicraftsmen were *artists*, as we should now call them. But the thought of man became more intricate, more difficult to express; art grew a heavier thing to deal with, and its labour was more divided among great men, lesser men, and little men; till that art, which was once scarce more than a rest of body and soul, as the hand cast the shuttle or swung the hammer, became to some men so serious a labour, that their working lives have been one long tragedy of hope and fear, joy and trouble. This was the growth of art: like all growth, it was good and fruitful for a while; like all fruitful growth, it grew into decay; like all decay of what was once fruitful, it will grow into something new.

Into decay; for as the art sundered into the greater and the lesser, contempt on one side, carelessness on the other arose, both begotten of ignorance of that *philosophy* of the Decorative Arts, a hint of which I have tried just now to put before you. The artist came out from the handicraftsmen, and left them without hope of elevation, while he himself was left without the help of intelligent, industrious sympathy. Both have suffered; the artist no less than the workman. It is with art as it fares with a company of soldiers before a redoubt, when the captain runs forward full of hope and energy, but looks not behind him to see if his men are following, and they hang back, not knowing why they are brought there to die. The captain's life is spent for nothing, and his men are sullen prisoners in the redoubt of Unhappiness and Brutality.

I must in plain words say of the Decorative Arts, of all the arts, that it is not so much that we are inferior in them to all who have gone

before us, but rather that they are in a state of anarchy and disorganization, which makes a sweeping change necessary and certain.

So that again I ask my question, All that good fruit which the arts should bear, will you have it? will you cast it from you? Shall that sweeping change that must come, be the change of loss or of gain?

We who believe in the continuous life of the world, surely we are bound to hope that the change will bring us gain and not loss, and to strive to bring that gain about.

Yet how the world may answer my question, who can say? A man in his short life can see but a little way ahead, and even in mine, wonderful and unexpected things have come to pass. I must needs say that therein lies my hope rather than in all I see going on round about us. Without disputing that if the imaginative arts perish, some new thing, at present unguessed of, *may* be put forward to supply their loss in men's lives, I cannot feel happy in that prospect, nor can I believe that mankind will endure such a loss for ever: but in the meantime the present state of the arts and their dealings with modern life and progress seem to me to point, in appearance at least, to this immediate future; that the world, which has for a long time busied itself about other matters than the arts, and has carelessly let them sink lower and lower, till many not uncultivated men, ignorant of what they once were, and hopeless of what they might yet be, look upon them with mere contempt; that the world, I say, thus busied and hurried, will one day wipe the slate, and be clean rid in her impatience of the whole matter with all this tangle and trouble.

And then – what then?

Even now amid the squalor of London it is hard to imagine what it will be. Architecture, Sculpture, Painting, with the crowd of lesser arts that belong to them, these, together with Music and Poetry, will be dead and forgotten, will no longer excite or amuse people in the least: for, once more, we must not deceive ourselves; the death of one art means the death of all; the only difference in their fate will be that the luckiest will be eaten the last – the luckiest, or the unluckiest: in all that has to do with beauty the invention and ingenuity of man will have come to a dead stop; and all the while Nature will go on with her eternal recurrence of lovely changes – spring, summer, autumn, and winter; sunshine, rain, and snow; storm and fair weather; dawn,

noon, and sunset; day and night – ever bearing witness against man that he has deliberately chosen ugliness instead of beauty, and to live where he is strongest amidst squalor or blank emptiness.

You see, sirs, we cannot quite imagine it; any more, perhaps, than our forefathers of ancient London, living in the pretty, carefully whitened houses, with the famous church and its huge spire rising above them – than they, passing about the fair gardens running down to the broad river, could have imagined a whole county or more covered over with hideous hovels, big, middle-sized, and little, which should one day be called London.

Sirs, I say that this dead blank of the arts that I more than dread is difficult even now to imagine; yet I fear that, I must say that if it does not come about, it will be owing to some turn of events which we cannot at present foresee: but I hold that if it does happen, it will only last for a time, that it will be but a burning up of the gathered weeds, so that the field may bear more abundantly. I hold that men would wake up after a while, and look round and find the dullness unbearable, and begin once more inventing, imitating, and imagining, as in earlier days.

That faith comforts me, and I can say calmly, if the blank space must happen, it must, and amidst its darkness the new seed must sprout. So it has been before: first comes birth, and hope scarcely conscious of itself; then the flower and fruit of mastery, with hope more than conscious enough, passing into insolence, as decay follows ripeness; and then – the new birth again.

Meantime it is the plain duty of all who look seriously on the arts to do their best to save the world from what at the best will be a loss, the result of ignorance and unwisdom; to prevent, in fact, that most discouraging of all changes, the supplying the place of an extinct brutality by a new one; nay, even if those who really care for the arts are so weak and few that they can do nothing else, it may be their business to keep alive some tradition, some memory of the past, so that the new life when it comes may not waste itself more than enough in fashioning wholly new forms for its new spirit.

To what side then shall those turn for help, who really understand the gain of a great art in the world, and the loss of peace and good life that must follow from the lack of it? I think that they must begin by

acknowledging that the ancient art, the art of unconscious intelligence, as one should call it, which began without a date, at least so long ago as those strange and masterly scratchings on mammoth-bones and the like found but the other day in the drift – that this art of unconscious intelligence is all but dead; that what little of it is left lingers among half-civilized nations, and is growing coarser, feebler, less intelligent year by year; nay, it is mostly at the mercy of some commercial accident, such as the arrival of a few shiploads of European dye-stuffs or a few dozen orders from European merchants: this they must recognize, and must hope to see in time its place filled by a new art of conscious intelligence, the birth of wiser, simpler, freer ways of life than the world leads now, than the world has ever led.

I said, *to see* this in time; I do not mean to say that our own eyes will look upon it: it may be so far off, as indeed it seems to some, that many would scarcely think it worth while thinking of: but there are some of us who cannot turn our faces to the wall, or sit heedless because our hope seems somewhat dim; and, indeed, I think that while the signs of the last decay of the old art with all the evils that must follow in its train are only too obvious about us, so on the other hand there are not wanting signs of the new dawn beyond that possible night of the arts, of which I have before spoken; this sign chiefly, that there are some few at least, who are heartily discontented with things as they are, and crave for something better, or at least some promise of it – this best of signs: for I suppose that if some half-dozen men at any time earnestly set their hearts on something coming about which is not discordant with nature, it will come to pass one day or other; because it is not by accident that an idea comes into the heads of a few; rather they are pushed on, and forced to speak or act by something stirring in the heart of the world which would otherwise be left without expression.

By what means then shall those work who long for reform in the arts, and who shall they seek to kindle into eager desire for possession of beauty, and better still, for the development of the faculty that creates beauty?

People say to me often enough: If you want to make your art succeed and flourish, you must make it the fashion: a phrase which I con-

fess annoys me; for they mean by it that I should spend one day over my work to two days in trying to convince rich, and supposed influential people, that they care very much for what they really do not care in the least, so that it may happen according to the proverb: *Bell-wether took the leap, and we all went over.* Well, such advisers are right if they are content with the thing lasting but a little while; say till you can make a little money – if you don't get pinched by the door shutting too quickly: otherwise they are wrong: the people they are thinking of have too many strings to their bow, and can turn their backs too easily on a thing that fails, for it to be safe work trusting to their whims: it is not their fault, they cannot help it, but they have no chance of spending time enough over the arts to know anything practical of them, and they must of necessity be in the hands of those who spend their time in pushing fashion this way and that for their own advantage.

Sirs, there is no help to be got out of these latter, or those who let themselves be led by them: the only real help for the decorative arts must come from those who work in them; nor must they be led, they must lead.

You whose hands make those things that should be works of art, you must be all artists, and good artists too, before the public at large can take real interest in such things; and when you have become so, I promise you that you shall lead the fashion; fashion shall follow your hands obediently enough.

That is the only way in which we can get a supply of intelligent popular art: a few artists of the kind so-called now, what can they do working in the teeth of difficulties thrown in their way by what is called Commerce, but which should be called greed of money? working helplessly among the crowd of those who are ridiculously called manufacturers, i.e., handicraftsmen, though the more part of them never did a stroke of hand-work in their lives, and are nothing better than capitalists and salesmen. What can these grains of sand do, I say, amidst the enormous mass of work turned out every year which professes in some way to be decorative art, but the decoration of which no one heeds except the salesmen who have to do with it, and are hard put to it to supply the cravings of the public for something new, not for something pretty?

The remedy, I repeat, is plain if it can be applied; the handicrafts-man, left behind by the artist when the arts sundered, must come up with him, must work side by side with him: apart from the difference between a great master and a scholar, apart from the differences of the natural bent of men's minds, which would make one man an imita-tive, and another an architectural or decorative artist, there should be no difference between those employed on strictly ornamental work; and the body of artists dealing with this should quicken with their art all makers of things into artists also, in proportion to the necessities and uses of the things they would make.

I know what stupendous difficulties, social and economical, there are in the way of this; yet I think that they seem to be greater than they are: and of one thing I am sure, that no real living decorative art is possible if this is impossible.

It is not impossible, on the contrary it is certain to come about, if you are at heart desirous to quicken the arts; if the world will, for the sake of beauty and decency, sacrifice some of the things it is so busy over (many of which I think are not very worthy of its trouble), art will begin to grow again; as for those difficulties above mentioned, some of them I know will in any case melt away, before the steady change of the relative conditions of men; the rest, reason, and resolute attention to the laws of nature, which are also the laws of art, will dispose of little by little: once more, the way will not be far to seek, if the will be with us.

Yet, granted the will, and though the way lies ready to us, we must not be discouraged if the journey seem barren enough at first, nay, not even if things seem to grow worse for a while: for it is natural enough that the very evil which has forced on the beginning of reform should look uglier, while on the one hand life and wisdom are building up the new, and on the other folly and deadness are hugging the old to them.

In this, as in all other matters, lapse of time will be needed before things seem to straighten, and the courage and patience that does not despise small things lying ready to be done; and care and watchful-ness, lest we begin to build the wall ere the footings are well in; and always through all things much humility that is not easily cast down by failure, that seeks to be taught, and is ready to learn.

For your teachers, they must be Nature and History: as for the first, that you must learn of it is so obvious that I need not dwell upon that now: hereafter, when I have to speak more of matters of detail, I may have to speak of the manner in which you must learn of Nature. As to the second I do not think that any man but one of the highest genius could do anything in these days without much study of ancient art, and even he would be much hindered if he lacked it. If you think that this contradicts what I said about the death of that ancient art, and the necessity I implied for an art that should be characteristic of the present day, I can only say that, in these times of plenteous knowledge and meagre performance, if we do not study the ancient work directly and learn to understand it, we shall find ourselves influenced by the feeble work all round us, and shall be copying the better work through the copyists and *without* understanding it, which will by no means bring about intelligent art. Let us therefore study it wisely, be taught by it, kindled by it; all the while determining not to imitate or repeat it; to have either no art at all, or an art which we have made our own.

Yet I am almost brought to a standstill when bidding you to study nature and the history of art, by remembering that this is London, and what it is like: how can I ask working-men passing up and down these hideous streets day by day to care about beauty? If it were politics, we must care about that; or science, you could wrap yourselves up in the study of facts, no doubt, without much caring what goes on about you – but beauty! do you not see what terrible difficulties beset art, owing to a long neglect of art – and neglect of reason, too, in this matter? It is such a heavy question by what effort, by what dead-lift, you can thrust this difficulty from you, that I must perforce set it aside for the present, and must at least hope that the study of history and its monuments will help you somewhat herein. If you can really fill your minds with memories of great works of art, and great times of art, you will, I think, be able to a certain extent to look through the aforesaid ugly surroundings, and will be moved to discontent of what is careless and brutal now, and will, I hope, at last be so much discontented with what is bad, that you will determine to bear no longer that shortsighted, reckless brutality of squalor that so disgraces our intricate civilization.

Well, at any rate, London is good for this, that it is well off for museums – which I heartily wish were to be got at seven days in the week instead of six, or at least on the only day on which an ordinarily busy man, one of the taxpayers who support them, can as a rule see them quietly – and certainly any of us who may have any natural turn for art must get more help from frequenting them than one can well say. It is true, however, that people need some preliminary instruction before they can get all the good possible to be got from the prodigious treasures of art possessed by the country in that form: there also one sees things in a piecemeal way: nor can I deny that there is something melancholy about a museum, such a tale of violence, destruction, and carelessness, as its treasured scraps tell us.

But moreover you may sometimes have an opportunity of studying ancient art in a narrower but a more intimate, a more kindly form, the monuments of our own land. Sometimes only, since we live in the middle of this world of brick and mortar, and there is little else left us amidst it, except the ghost of the great church at Westminster, ruined as its exterior is by the stupidity of the restoring architect, and insulted as its glorious interior is by the pompous undertakers' lies, by the vainglory and ignorance of the last two centuries and a half – little besides that and the matchless Hall near it: but when we can get beyond that smoky world, there, out in the country we may still see the works of our fathers yet alive amidst the very nature they were wrought into, and of which they are so completely a part: for there indeed if anywhere, in the English country, in the days when people cared about such things, was there a full sympathy between the works of man and the land they were made for: – the land is a little land; too much shut up within the narrow seas, as it seems, to have much space for swelling into hugeness; there are no great wastes overwhelming in their dreariness, no great solitudes of forests, no terrible untrodden mountain-walls: all is measured, mingled, varied, gliding easily one thing into another: little rivers, little plains, swelling, speedily-changing up-lands, all beset with handsome orderly trees; little hills, little mountains, netted over with the walls of sheep-walks: all is little; yet not foolish and blank, but serious rather, and abundant of meaning for such as choose to seek it: it is neither prison nor palace, but a decent home.

All which I neither praise nor blame, but say that so it is: some people praise this homeliness overmuch, as if the land were the very axle-tree of the world; so do not I, nor any unblinded by pride in themselves and all that belongs to them: others there are who scorn it and the tameness of it: not I any the more: though it would indeed be hard if there were nothing else in the world, no wonders, no terrors, no unspeakable beauties: yet when we think what a small part of the world's history, past, present, and to come, is this land we live in, and how much smaller still in the history of the arts, and yet how our forefathers clung to it, and with what care and pains they adorned it, this unromantic, uneventful-looking land of England, surely by this too our hearts may be touched, and our hope quickened.

For as was the land, such was the art of it while folk yet troubled themselves about such things; it strove little to impress people either by pomp or ingenuity: not unseldom it fell into commonplace, rarely it rose into majesty; yet was it never oppressive, never a slave's nightmare nor an insolent boast: and at its best it had an inventiveness, an individuality that grander styles have never overpassed: its best too, and that was in its very heart, was given as freely to the yeoman's house, and the humble village church, as to the lord's palace or the mighty cathedral: never coarse, though often rude enough, sweet, natural, and unaffected, an art of peasants rather than of merchant-princes or courtiers, it must be a hard heart, I think, that does not love it: whether a man has been born among it like ourselves, or has come wonderingly on its simplicity from all the grandeur over-seas. A peasant art, I say, and it clung fast to the life of the people, and still lived among the cottagers and yeomen in many parts of the country while the big houses were being built 'French and fine': still lived also in many a quaint pattern of loom and printing-block, and embroiderer's needle, while over-seas stupid pomp had extinguished all nature and freedom, and art was become, in France especially, the mere expression of that successful and exultant rascality, which in the flesh no long time afterwards went down into the pit for ever.

Such was the English art, whose history is in a sense at your doors, grown scarce indeed, and growing scarcer year by year, not only through greedy destruction, of which there is certainly less than there

used to be, but also through the attacks of another foe, called nowadays 'restoration'.

I must not make a long story about this, but also I cannot quite pass it over, since I have pressed on you the study of these ancient monuments. Thus the matter stands: these old buildings have been altered and added to century after century, often beautifully, always historically; their very value, a great part of it, lay in that: they have suffered almost always from neglect also, often from violence (that latter a piece of history often far from uninteresting), but ordinary obvious mending would almost always have kept them standing, pieces of nature and of history.

But of late years a great uprising of ecclesiastical zeal, coinciding with a great increase of study, and consequently of knowledge of mediaeval architecture, has driven people into spending their money on these buildings, not merely with the purpose of repairing them, of keeping them safe, clean, and wind- and water-tight, but also of 're-storing' them to some ideal state of perfection; sweeping away if possible all signs of what has befallen them at least since the Reformation, and often since dates much earlier: this has sometimes been done with much disregard of art and entirely from ecclesiastical zeal, but oftener it has been well meant enough as regards art: yet you will not have listened to what I have said tonight if you do not see that from my point of view this restoration must be as impossible to bring about, as the attempt at it is destructive to the buildings so dealt with: I scarcely like to think what a great part of them have been made nearly useless to students of art and history: unless you knew a great deal about architecture you perhaps would scarce understand what terrible damage has been done by that dangerous 'little knowledge' in this matter: but at least it is easy to be understood, that to deal recklessly with valuable (and national) monuments which, when once gone, can never be replaced by any splendour of modern art, is doing a very sorry service to the State.

You will see by all that I have said on this study of ancient art that I mean by education herein something much wider than the teaching of a definite art in schools of design, and that it must be something that we must do more or less for ourselves: I mean by it a systematic concentration of our thoughts on the matter, a studying of it in all

ways, careful and laborious practice of it and a determination to do nothing but what is known to be good in workmanship and design.

Of course, however, both as an instrument of that study we have been speaking of, as well as of the practice of the arts, all handicraftsmen should be taught to draw very carefully; as indeed all people should be taught drawing who are not physically incapable of learning it: but the art of drawing so taught would not be the art of designing, but only a means towards *this* end, *general capability in dealing with the arts*.

For I wish specially to impress this upon you, that *designing* cannot be taught at all in a school: continued practice will help a man who is naturally a designer, continual notice of nature and of art: no doubt those who have some faculty for designing are still numerous, and they want from a school certain technical teaching, just as they want tools: in these days also, when the best school, the school of successful practice going on around you, is at such a low ebb, they do undoubtedly want instruction in the history of the arts: these two things schools of design can give: but the royal road of a set of rules deduced from a sham science of design, that is itself not a science but another set of rules, will lead nowhere – or, let us rather say, to beginning again.

As to the kind of drawing that should be taught to men engaged in ornamental work, there is only *one best* way of teaching drawing, and that is teaching the scholar to draw the human figure: both because the lines of a man's body are much more subtle than anything else, and because you can more surely be found out and set right if you go wrong. I do think that such teaching as this, given to all people who care for it, would help the revival of the arts very much: the habit of discriminating between right and wrong, the sense of pleasure in drawing a good line, would really, I think, be education in the due sense of the word for all such people as had the germs of invention in them; yet as aforesaid, in this age of the world it would be mere affectation to pretend to shut one's eyes to the art of past ages: that also we must study. If other circumstances, social and economical, do not stand in our way, that is to say, if the world is not too busy to allow us to have Decorative Arts at all, these two are the *direct* means by

which we shall get them; that is, general cultivation of the powers of the mind, general cultivation of the powers of the eye and hand.

Perhaps that seems to you very commonplace advice and a very roundabout road; nevertheless 'tis a certain one, if by any road you desire to come to the new art, which is my subject tonight: if you do not, and if those germs of invention, which, as I said just now, are no doubt still common enough among men, are left neglected and undeveloped, the laws of Nature will assert themselves in this as in other matters, and the faculty of design itself will gradually fade from the race of man. Sirs, shall we approach nearer to perfection by casting away so large a part of that intelligence which makes us *men*?

And now before I make an end, I want to call your attention to certain things, that, owing to our neglect of the arts for other business, bar that good road to us and are such an hindrance, that, till they are dealt with, it is hard even to make a beginning of our endeavour. And if my talk should seem to grow too serious for our subject, as indeed I think it cannot do, I beg you to remember what I said earlier, of how the arts all hang together. Now there is one art of which the old architect of Edward the Third's time was thinking – he who founded New College at Oxford, I mean – when he took this for his motto: 'Manners maketh man': he meant by manners the art of morals, the art of living worthily, and like a man. I must needs claim this art also as dealing with my subject.

There is a great deal of sham work in the world, hurtful to the buyer, more hurtful to the seller, if he only knew it; most hurtful to the maker: how good a foundation it would be towards getting good Decorative Art, that is ornamental workmanship, if we craftsmen were to resolve to turn out nothing but excellent workmanship in all things, instead of having, as we too often have now, a very low average standard of work, which we often fall below.

I do not blame either one class or another in this matter, I blame all: to set aside our own class of handicraftsmen, of whose shortcomings you and I know so much that we need talk no more about it, I know that the public in general are set on having things cheap, being so ignorant that they do not know when they get them nasty also; so ignorant that they neither know nor care whether they give a man his

due: I know that the manufacturers (so called) are so set on carrying out competition to its utmost, competition of cheapness, not of excellence, that they meet the bargain-hunters half way, and cheerfully furnish them with nasty wares at the cheap rate they are asked for, by means of what can be called by no prettier name than fraud. England has of late been too much busied with the counting-house and not enough with the workshop: with the result that the counting-house at the present moment is rather barren of orders.

I say all classes are to blame in this matter, but also I say that the remedy lies with the handicraftsmen, who are not ignorant of these things like the public, and who have no call to be greedy and isolated like the manufacturers or middlemen; the duty and honour of educating the public lies with them, and they have in them the seeds of order and organization which make that duty the easier.

When will they see to this and help to make men of us all by insisting on this most weighty piece of manners; so that we may adorn life with the pleasure of cheerfully *buying* goods at their due price; with the pleasure of *selling* goods that we could be proud of both for fair price and fair workmanship: with the pleasure of working soundly and without haste at *making* goods that we could be proud of? – much the greatest pleasure of the three is that last, such a pleasure as, I think, the world has none like it.

You must not say that this piece of manners lies out of my subject: it is essentially a part of it and most important: for I am bidding you learn to be artists, if art is not to come to an end amongst us: and what is an artist but a workman who is determined that, whatever else happens, his work shall be excellent? or, to put it in another way: the decoration of workmanship, what is it but the expression of man's pleasure in successful labour? But what pleasure can there be in *bad* work, in *un*successful labour; why should we decorate *that*? and how can we bear to be always unsuccessful in our labour?

As greed of unfair gain, wanting to be paid for what we have not earned, cumbers our path with this tangle of bad work, of sham work, so that heaped-up money which this greed has brought us (for greed will have its way, like all other strong passions), this money, I say, gathered into heaps little and big, with all the false distinction which so unhappily it yet commands among us, has raised up against the arts

a barrier of the love of luxury and show, which is of all obvious hindrances the worst to overpass: the highest and most cultivated classes are not free from the vulgarity of it, the lower are not free from its pretence. I beg you to remember both as a remedy against this, and as explaining exactly what I mean, that nothing can be a work of art which is not useful; that is to say, which does not minister to the body when well under command of the mind, or which does not amuse, soothe, or elevate the mind in a health state. What tons upon tons of unutterable rubbish pretending to be works of art in some degree would this maxim clear out of our London houses, if it were understood and acted upon! To my mind it is only here and there (out of the kitchen) that you can find in a well-to-do house things that are of any use at all: as a rule all the decoration (so called) that has got there is there for the sake of show, not because anybody likes it. I repeat, this stupidity goes through all classes of society: the silk curtains in my lord's drawing-room are no more a matter of art to him than the powder in his footman's hair; the kitchen in a country farmhouse is most commonly a pleasant and homelike place, the parlour dreary and useless.

Simplicity of life, begetting simplicity of taste, that is, a love for sweet and lofty things, is of all matters most necessary for the birth of the new and better art we crave for; simplicity everywhere, in the palace as well as in the cottage.

Still more is this necessary, cleanliness and decency everywhere, in the cottage as well as in the palace: the lack of that is a serious piece of *manners* for us to correct: that lack and all the inequalities of life, and the heaped-up thoughtlessness and disorder of so many centuries that cause it: and as yet it is only a very few men who have begun to think about a remedy for it in its widest range: even in its narrower aspect, in the defacements of our big towns by all that commerce brings with it, who heeds it? who tries to control their squalor and hideousness? there is nothing but thoughtlessness and recklessness in the matter: the helplessness of people who don't live long enough to do a thing themselves, and have not manliness and foresight enough to begin the work, and pass it on to those that shall come after them.

Is money to be gathered? cut down the pleasant trees among the

houses, pull down ancient and venerable buildings for the money that a few square yards of London dirt will fetch; blacken rivers, hide the sun and poison the air with smoke and worse, and it's nobody's business to see to it or mend it: that is all that modern commerce, the counting-house forgetful of the workshop, will do for us herein.

And Science – we have loved her well, and followed her diligently, what will she do? I fear she is so much in the pay of the counting-house, the counting-house and the drill-sergeant, that she is too busy, and will for the present do nothing. Yet there are matters which I should have thought easy for her; say for example teaching Manchester how to consume its own smoke, or Leeds how to get rid of its superfluous black dye without turning it into the river, which would be as much worth her attention as the production of the heaviest of heavy black silks, or the biggest of useless guns. Anyhow, however it be done, unless people care about carrying on their business without making the world hideous, how can they care about Art? I know it will cost much both of time and money to better these things even a little; but I do not see how these can be better spent than in making life cheerful and honourable for others and for ourselves; and the gain of good life to the country at large that would result from men seriously setting about the bettering of the decency of our big towns would be priceless, even if nothing specially good befell the arts in consequence: I do not know that it would; but I should begin to think matters hopeful if men turned their attention to such things, and I repeat that, unless they do so, we can scarcely even begin with any hope our endeavours for the bettering of the arts.

Unless something or other is done to give all men some pleasure for the eyes and rest for the mind in the aspect of their own and their neighbours' houses, until the contrast is less disgraceful between the fields where beasts live and the streets where men live, I suppose that the practice of the arts must be mainly kept in the hands of a few highly cultivated men, who can go often to beautiful places, whose education enables them, in the contemplation of the past glories of the world, to shut out from their view the everyday squalors that the most of men move in. Sirs, I believe that art has such sympathy with cheerful freedom, open-heartedness and reality, so much she sickens

under selfishness and luxury, that she will not live thus isolated and exclusive. I will go further than this and say that on such terms I do not wish her to live. I protest that it would be a shame to an honest artist to enjoy what he had huddled up to himself of such art, as it would be for a rich man to sit and eat dainty food among starving soldiers in a beleaguered fort.

I do not want art for a few, any more than education for a few, or freedom for a few.

No, rather than art should live this poor thin life among a few exceptional men, despising those beneath them for an ignorance for which they themselves are responsible, for a brutality that they will not struggle with – rather than this, I would that the world should indeed sweep away all art for awhile, as I said before I thought it possible she might do; rather than the wheat should rot in the miser's granary, I would that the earth had it, that it might yet have a chance to quicken in the dark.

I have a sort of faith, though, that this clearing away of all art will not happen, that men will get wiser, as well as more learned; that many of the intricacies of life, on which we now pride ourselves more than enough, partly because they are new, partly because they have come with the gain of better things, will be cast aside as having played their part, and being useful no longer. I hope that we shall have leisure from war – war commercial, as well as war of the bullet and the bayonet; leisure from the knowledge that darkens counsel; leisure above all from the greed of money, and the craving for that overwhelming distinction that money now brings; I believe that as we have even now partly achieved LIBERTY, so we shall one day achieve EQUALITY, which, and which only, means FRATERNITY, and so have leisure from poverty and all its griping, sordid cares.

Then having leisure from all these things, amidst renewed simplicity of life we shall have leisure to think about our work, that faithful daily companion, which no man any longer will venture to call the Curse of labour: for surely then we shall be happy in it, each in his place, no man grudging at another; no one bidden to be any man's *servant*, everyone scorning to be any man's *master*: men will then assuredly be happy in their work, and that happiness will assuredly bring forth decorative, noble, *popular* art.

That art will make our streets as beautiful as the woods, as elevating as the mountain-sides: it will be a pleasure and a rest, and not a weight upon the spirits to come from the open country into a town; every man's house will be fair and decent, soothing to his mind and helpful to his work: all the works of man that we live among and handle will be in harmony with nature, will be reasonable and beautiful: yet all will be simple and inspiriting, not childish nor enervating; for as nothing of beauty and splendour that man's mind and hand may compass shall be wanting from our public buildings, so in no private dwelling will there be any signs of waste, pomp, or insolence, and every man will have his share of the *best*.

It is a dream, you may say, of what has never been and never will be; true, it has never been, and therefore, since the world is alive, and moving yet, my hope is the greater that it one day will be: true, it is a dream; but dreams have before now come about of things so good and necessary to us, that we scarcely think of them more than of the daylight, though once people had to live without them, without even the hope of them.

Anyhow, dream as it is, I pray you to pardon my setting it before you, for it lies at the bottom of all my work in the Decorative Arts, nor will it ever be out of my thoughts: and I am here with you tonight to ask you to help me in realizing this dream, this *hope*.

(From a lecture, *The Lesser Arts*, 1878)

## 25: CIVILIZATION

... I HAD thought that civilization meant the attainment of peace and order and freedom, of goodwill between man and man, of the love of truth and the hatred of injustice ... a life free from craven fear, but full of incident: that was what I thought it meant, not more stuffed chairs and more cushions, and more carpets and gas, and more dainty meat and drink – and therewithal more and sharper differences between class and class. ...

. . . If civilization is to go no further than this, it had better not have gone so far: if it does not aim at getting rid of this misery and giving some share in the happiness and dignity of life to *all* the people that it has created . . . it is simply an organized injustice, a mere instrument for oppression, so much the worse than that which has gone before it, as its pretensions are higher, its slavery subtler, its mastery harder to overthrow, because supported by such a dense mass of commonplace well-being and comfort. . . .

> (From *The Beauty of Life*, 1880, a lecture delivered in Birmingham with the original title, *Labour and Pleasure versus Labour and Sorrow*)

## 26: POPULAR ART

. . . Every real work of art, even the humblest, is inimitable. I am most sure that all the heaped-up knowledge of modern science, all the energy of modern commerce, all the depth and spirituality of modern thought, cannot reproduce so much as the handicraft of an ignorant, superstitious Berkshire peasant of the fourteenth century; nay, of a wandering Kurdish shepherd, or of a skin-and-bone oppressed Indian ryot. This, I say, I am sure of; and to me the certainty is not depressing, but inspiriting, for it bids us remember that the world has been noteworthy for more than one century and one place, a fact which we are pretty much apt to forget. . . .

. . . I have had to talk to you tonight about popular art, the foundation on which all art stands. I could not go through the dreary task of speaking to you of a phantom of bygone times, of a thing with no life in it; I must speak of a living thing with hope in it, or hold my peace; and most deeply am I convinced that popular art cannot live if labour is to be for ever the thrall of muddle, dishonesty, and disunion. Cheerfully I admit that I see signs about us of a coming time of order, goodwill, and union, and it is that which has given me the courage to

say to you these few last words, and to hint to you what in my poor judgement we each and all of us who have the cause at heart may do to further the cause. . . .

(From *Some Hints on Pattern Designing*, 1881, a lecture delivered at the Working Men's College, London)

# FOUR ✦ SOCIALISM

## 27: 'THE CAUSE'

... By union I mean a very serious matter, I mean sacrifice to the Cause of leisure, pleasure, and money, each according to his means: I mean sacrifice of individual whims and vanity, of individual misgivings, even though they may be founded on reason, as to the means which the organizing body may be forced to use: remember without organization the cause *is* but a vague dream, which may lead to revolt, to violence and disorder, but which will be speedily repressed by those who are blindly interested in sustaining the present anarchical tyranny which is misnamed Society: remember also that no organization is possible without the sacrifices I have been speaking of; without obedience to the necessities of the Cause. ...

(From *Art and the People*, 1883)

## 28: THE MESSAGE OF THE MARCH WIND

FAIR now is the springtide, now earth lies beholding
   With the eyes of a lover the face of the sun;
Long lasteth the daylight, and hope is enfolding
   The green-growing acres with increase begun.

Now sweet, sweet it is through the land to be straying
   Mid the birds and the blossoms and the beasts of the field;
Love mingles with love, and no evil is weighing
   On thy heart or mine, where all sorrow is healed.

From township to township, o'er down and by tillage
   Far, far have we wandered and long was the day,
But now cometh eve at the end of the village,
   Where over the grey wall the church riseth grey.

There is wind in the twilight; in the white road before us
   The straw from the ox-yard is blowing about;
The moon's rim is rising, a star glitters o'er us,
   And the vane on the spire-top is swinging in doubt.

Down there dips the highway, toward the bridge crossing over
   The brook that runs on to the Thames and the sea.
Draw closer, my sweet, we are lover and lover;
   This eve art thou given to gladness and me.

Shall we be glad always? Come closer and hearken:
   Three fields further on, as they told me down there,
When the young moon has set, if the March sky should darken,
   We might see from the hill-top the great city's glare.

Hark, the wind in the elm-boughs! From London it bloweth,
   And telling of gold, and of hope and unrest;
Of power that helps not; of wisdom that knoweth,
   But teacheth not aught of the worst and the best.

Of the rich men it telleth, and strange is the story
   How they have, and they hanker, and grip far and wide;
And they live and they die, and the earth and its glory
   Has been but a burden they scarce might abide.

Hark! the March wind again of a people is telling;
   Of the life that they live there, so haggard and grim,
That if we and our love amidst them had been dwelling
   My fondness had faltered, thy beauty grown dim.

This land we have loved in our love and our leisure
   For them hangs in heaven, high out of their reach;
The wide hills o'er the sea-plain for them have no pleasure,
   The grey homes of their fathers no story to teach.

The singers have sung and the builders have builded,
   The painters have fashioned their tales of delight;
For what and for whom hath the world's book been gilded,
   When all is for these but the blackness of night?

How long and for what is their patience abiding?
   How oft and how oft shall their story be told,
While the hope that none seeketh in darkness is hiding
   And in grief and in sorrow the world groweth old?

Come back to the inn, love, and the lights and the fire,
   And the fiddler's old tune and the shuffling of feet;
For there in a while shall be rest and desire,
   And there shall the morrow's uprising be sweet.

Yet, love, as we wend the wind bloweth behind us
   And beareth the last tale it telleth tonight,
How here in the springtide the message shall find us;
   For the hope that none seeketh is coming to light.

Like the seed of midwinter, unheeded, unperished,
   Like the autumn-sown wheat 'neath the snow lying green,
Like the love that o'ertook us, unawares and uncherished,
   Like the babe 'neath thy girdle that groweth unseen,

So the hope of the people now buddeth and groweth –
   Rest fadeth before it, and blindness and fear;
It biddeth us learn all the wisdom it knoweth;
   It hath found us and held us, and biddeth us hear:

For it beareth the message: 'Rise up on the morrow
   And go on your ways toward the doubt and the strife;
Join hope to our hope and blend sorrow with sorrow,
   And seek for men's love in the short days of life.'

But lo, the old inn, and the lights and the fire,
   And the fiddler's old tune and the shuffling of feet;
Soon for us shall be quiet and rest and desire,
   And tomorrow's uprising to deeds shall be sweet.

(From *The Pilgrims of Hope*, 1885)

## 29: THE MARCH OF THE WORKERS

WHAT is this, the sound and rumour? What is this that all men hear,
Like the wind in hollow valleys when the storm is drawing near,
Like the rolling on of ocean in the eventide of fear?
     'Tis the people marching on.

Whither go they, and whence come they? What are these of whom
  ye tell?
In what country are they dwelling 'twixt the gates of heaven and
  hell?
Are they mine or thine for money? Will they serve a master well?
     Still the rumour's marching on.

   Hark the rolling of the thunder!
   Lo the sun! and lo thereunder
   Riseth wrath, and hope, and wonder,
     And the host comes marching on.

Forth they come from grief and torment; on they wend toward
  health and mirth,
All the wide world is their dwelling, every corner of the earth.
Buy them, sell them for thy service! Try the bargain what 'tis worth,
     For the days are marching on.

These are they who build thy houses, weave thy raiment, win thy
  wheat,
Smooth the rugged, fill the barren, turn the bitter into sweet,
All for thee this day – and ever. What reward for them is meet
     Till the host comes marching on?

   Hark the rolling of the thunder!
   Lo the sun! and lo thereunder
   Riseth wrath, and hope, and wonder,
     And the host comes marching on.

Many a hundred years passed over have they laboured deaf and blind
Never tidings reached their sorrow, never hope their toil might find.
Now at last they've heard and hear it, and the cry comes down the
    wind,
                    And their feet are marching on.

O ye rich men hear and tremble! for with words the sound is rife:
'Once for you and death we laboured; changed henceforward is the
    strife.
We are men, and we shall battle for the world of men and life;
                    And our host is marching on.'

      Hark the rolling of the thunder!
      Lo the sun! and lo thereunder
      Riseth wrath, and hope, and wonder,
              And the host comes marching on.

'Is it war, then? Will ye perish as the dry wood in the fire?
Is it peace? Then be ye of us, let your hope be our desire.
Come and live! for life awaketh, and the world shall never tire;
                  And hope is marching on.

'On we march then, we the workers, and the rumour that ye hear
Is the blended sound of battle and deliv'rance drawing near;
For the hope of every creature is the banner that we bear,
              And the world is marching on.'

      Hark the rolling of the thunder!
      Lo the sun! and lo thereunder
      Riseth wrath, and hope, and wonder,
              And the host comes marching on.

             (From *Chants for Socialists*, 1885)

## 30: PREACHING SOCIALISM

I GAVE two lectures at Sheffield on Sunday, February 28th, in the Socialist Hall: both were well attended, although I was told that the religious rancour which runs high in Sheffield would keep many people away from the Secularist Hall. Both lectures were very well received, the evening one, the more plain spoken and less historical of the two particularly so: indeed I have never stood before a more sympathetic audience; and it seemed to me that the interest in the subject had much increased since I was in Sheffield about a year and a half ago. . . .

From Sheffield I went to Liverpool, and delivered my lecture at the Concert Room in Nelson Street, on March 2nd. The hall was crowded with an audience mostly of working men, who not only listened with very great attention, but took up all the points which they caught and understood with very hearty applause. After the lecture I had the group round the platform eager to ask questions, which one always encounters in these more northern towns, and there could be no doubt of their eagerness to learn. . . .

On the 8th of March I went to Norwich and lectured to a good audience, some 800 I should think, at the Victoria Hall. Again the audience was mostly working-class, and was or seemed to be quite in sympathy with the movement. . . .

It was strange to me for once to be preaching Socialism in a city like Norwich, with its beautiful architecture and strange half-foreign old-world aspect. But from all I can learn it seems as likely a place as any in England for the spread of Socialism. . . .

Altogether it is not as a partisan but as an observer that I say that everywhere people are willing and eager to listen to Socialists, and that the doctrines will take root; and as a last word I appeal to all who are not afraid of the expression of opinion, to help us, whether they call themselves Socialists or not. . . .

(From an article in *Commonweal*, April 1886)

# 31: USEFUL WORK VERSUS USELESS TOIL

THE above title may strike some of my readers as strange. It is assumed by most people nowadays that all work is useful, and by most *well-to-do* people that all work is desirable. Most people, well-to-do or not, believe that, even when a man is doing work which appears to be useless, he is earning his livelihood by it – he is 'employed', as the phrase goes; and most of those who are well-to-do cheer on the happy worker with congratulations and praises, if he is only 'industrious' enough and deprives himself of all pleasure and holidays in the sacred cause of labour. In short, it has become an article of the creed of modern morality that all labour is good in itself – a convenient belief to those who live on the labour of others. But as to those on whom they live, I recommend them not to take it on trust, but to look into the matter a little deeper.

Let us grant, first, that the race of man must either labour or perish. Nature does not give us our livelihood gratis; we must win it by toil of some sort or degree. Let us see, then, if she does not give us some compensation for this compulsion to labour, since certainly in other matters she takes care to make the acts necessary to the continuance of life in the individual and the race not only endurable, but even pleasurable.

You may be sure that she does so, that it is of the nature of man, when he is not diseased, to take pleasure in his work under certain conditions. And, yet, we must say in the teeth of the hypocritical praise of all labour, whatsoever it may be, of which I have made mention, that there is some labour which is so far from being a blessing that it is a curse; that it would be better for the community and for the worker if the latter were to fold his hands and refuse to work, and either die or let us pack him off to the workhouse or prison – which you will.

Here, you see, are two kinds of work – one good, the other bad; one not far removed from a blessing, a lightening of life; the other a mere curse, a burden to life.

What is the difference between them, then? This: one has hope in

it, the other has not. It is manly to do the one kind of work, and manly also to refuse to do the other.

What is the nature of the hope which, when it is present in work, makes it worth doing?

It is threefold, I think – hope of rest, hope of product, hope of pleasure in the work itself; and hope of these also in some abundance and of good quality; rest enough and good enough to be worth having; product worth having by one who is neither a fool nor an ascetic; pleasure enough for all of us to be conscious of it while we are at work; not a mere habit, the loss of which we shall feel as a fidgety man feels the loss of the bit of string he fidgets with.

I have put the hope of rest first because it is the simplest and most natural part of our hope. Whatever pleasure there is in some work, there is certainly some pain in all work, the beast-like pain of stirring up our slumbering energies to action, the beast-like dread of change when things are pretty well with us; and the compensation for this animal pain in animal rest. We must feel while we are working that the time will come when we shall not have to work. Also the rest, when it comes, must be long enough to allow us to enjoy it; it must be longer than is merely necessary for us to recover the strength we have expended in working, and it must be animal rest also in this, that it must not be disturbed by anxiety, else we shall not be able to enjoy it. If we have this amount and kind of rest we shall, so far, be no worse off than the beasts.

As to the hope of product, I have said that Nature compels us to work for that. It remains for *us* to look to it that we *do* really produce something, and not nothing, or at least nothing that we want or are allowed to use. If we look to this and use our wills we shall, so far, be better than machines.

The hope of pleasure in the work itself: how strange that hope must seem to some of my readers – to most of them! Yet I think that to all living things there is a pleasure in the exercise of their energies, and that even beasts rejoice in being lithe and swift and strong. But a man at work, making something which he feels will exist because he is working at it and wills it, is exercising the energies of his mind and soul as well as of his body. Memory and imagination help him as he works. Not only his own thoughts, but the thoughts of the men of

past ages guide his hands; and, as a part of the human race, he creates. If we work thus we shall be men, and our days will be happy and eventful.

Thus worthy work carries with it the hope of pleasure in rest, the hope of the pleasure in our using what it makes, and the hope of pleasure in our daily creative skill.

All other work but this is worthless; it is slaves' work – mere toiling to live, that we may live to toil.

Therefore, since we have, as it were, a pair of scales in which to weigh the work now done in the world, let us use them. Let us estimate the worthiness of the work we do, after so many thousand years of toil, so many promises of hope deferred, such boundless exultation over the progress of civilization and the gain of liberty.

Now, the first thing as to the work done in civilization and the easiest to notice is that it is portioned out very unequally amongst the different classes of society. First, there are people – not a few – who do no work, and make no pretence of doing any. Next, there are people, and very many of them, who work fairly hard, though with abundant easements and holidays, claimed and allowed; and lastly, there are people who work so hard that they may be said to do nothing else than work, and are accordingly called 'the working classes', as distinguished from the middle classes and the rich, or aristocracy, whom I have mentioned above.

It is clear that this inequality presses heavily upon the 'working' class, and must visibly tend to destroy their hope of rest at least, and so, in that particular, make them worse off than mere beasts of the field; but that is not the sum and end of our folly of turning useful work into useless toil, but only the beginning of it.

For first, as to the class of rich people doing no work, we all know that they consume a great deal while they produce nothing. Therefore, clearly, they have to be kept at the expense of those who do work, just as paupers have, and are a mere burden on the community. In these days there are many who have learned to see this, though they can see no further into the evils of our present system, and have formed no idea of any scheme for getting rid of this burden; though perhaps they have a vague hope that changes in the system of voting

for members of the House of Commons, may, as if by magic, tend in that direction. With such hopes or superstitions we need not trouble ourselves. Moreover, this class, the aristocracy, once thought most necessary to the State, is scant of numbers, and has now no power of its own, but depends on the support of the class next below it – the middle class. In fact, it is really composed either of the most successful men of that class, or of their immediate descendants.

As to the middle class, including the trading, manufacturing, and professional people of our society, they do, as a rule, seem to work quite hard enough, and so at first sight might be thought to help the community, and not burden it. But by far the greater part of them, though they work, do not produce, and even when they do produce, as in the case of those engaged (wastefully indeed) in the distribution of goods, or doctors, or (genuine) artists and literary men, they consume out of all proportion to their due share. The commercial and manufacturing part of them, the most powerful part, spend their lives and energies in fighting among themselves for their respective shares of the wealth which they *force* the genuine workers to provide for them; the others are almost wholly the hangers-on of these; they do not work for the public, but a privileged class: they are the parasites of property, sometimes, as in the case of lawyers, undisguisedly so; sometimes, as the doctors and others above mentioned, professing to be useful, but too often of no use save as supporters of the system of folly, fraud, and tyranny of which they form a part. And all these we must remember have, as a rule, one aim in view; not the production of utilities, but the gaining of a position either for themselves or their children in which they will not have to work at all. It is their ambition and the end of their whole lives to gain, if not for themselves yet at least for their children, the proud position of being obvious burdens on the community. For their work itself, in spite of the sham dignity with which they surround it, they care nothing: save a few enthusiasts, men of science, art, or letters, who, if they are not the salt of the earth, are at least (and oh, the pity of it!) the salt of the miserable system of which they are the slaves, which hinders and thwarts them at every turn, and even sometimes corrupts them.

Here then is another class, this time very numerous and all-powerful, which produces very little and consumes enormously, and

is therefore in the main supported, as paupers are, by the real producers. The class that remains to be considered produces all that is produced, and supports both itself and the other classes, though it is placed in a position of inferiority to them; real inferiority, mind you, involving a degradation both of mind and body. But it is a necessary consequence of this tyranny and folly that again many of these workers are not producers. A vast number of them once more are merely parasites of property, some of them openly so, as the soldiers by land and sea who are kept on foot for the perpetuating of national rivalries and enmities, and for the purposes of the national struggle for the share of the product of unpaid labour. But besides this obvious burden on the producers and the scarcely less obvious one of domestic servants, there is first the army of clerks, shop-assistants, and so forth, who are engaged in the service of the private war for wealth, which, as above said, is the real occupation of the well-to-do middle class. This is a larger body of workers than might be supposed, for it includes among others all those engaged in what I should call competitive salesmanship, or, to use a less dignified word, the puffery of wares, which has now got to such a pitch that there are many things which cost far more to sell than they do to make.

Next there is the mass of people employed in making all those articles of folly and luxury, the demand for which is the outcome of the existence of the rich non-producing classes; things which people leading a manly and uncorrupted life would not ask for or dream of. These things, whoever may gainsay me, I will for ever refuse to call wealth: they are not wealth, but waste. Wealth is what Nature gives us and what a reasonable man can make out of the gifts of Nature for his reasonable use. The sunlight, the fresh air, the unspoiled face of the earth, food, raiment, and housing necessary and decent; the storing up of knowledge of all kinds, and the power of disseminating it; means of free communication between man and man; works of art, the beauty which man creates when he is most a man, most aspiring and thoughtful – all things which serve the pleasure of people, free, manly, and uncorrupted. This is wealth. Nor can I think of anything worth having which does not come under one or other of these heads. But think, I beseech you, of the product of England, the workshop of the world, and will you not be bewildered, as I am, at the thought of

the mass of things which no sane man could desire, but which our useless toil makes – and sells?

Now, further, there is even a sadder industry yet, which is forced on many, very many, of our workers – the making of wares which are necessary to them and their brethren, *because they are an inferior class*. For if many men live without producing, nay, must live lives so empty and foolish that they *force* a great part of the workers to produce wares which no one needs, not even the rich, it follows that most men must be poor; and, living as they do on wages from those whom they support, cannot get for their use the *goods* which men naturally desire, but must put up with miserable makeshifts for them, with coarse food that does not nourish, with rotten raiment which does not shelter, with wretched houses which may well make a town-dweller in civilization look back with regret to the tent of the nomad tribe, or the cave of the pre-historic savage. Nay, the workers must even lend a hand to the great industrial invention of the age – adulteration, and by its help produce for their own use shams and mockeries of the luxury of the rich; for the wage-earners must always live as the wage-payers bid them, and their very habits of life are *forced* on them by their masters.

But it is waste of time to try to express in words due contempt of the production of the much-praised cheapness of our epoch. It must be enough to say that this cheapness is necessary to the system of exploiting on which modern manufacture rests. In other words, our society includes a great mass of slaves, who must be fed, clothed, housed, and amused as slaves, and that their daily necessity compels them to make the slave-wares whose use is the perpetuation of their slavery.

To sum up, then, concerning the manner of work in civilized States, these States are composed of three classes – a class which does not even pretend to work, a class which pretends to work but which produces nothing, and a class which works, but is compelled by the other two classes to do work which is often unproductive.

Civilization therefore wastes its own resources, and will do so as long as the present system lasts. These are cold words with which to describe the tyranny under which we suffer; try then to consider what they mean.

There is a certain amount of natural material and of natural forces in the world, and a certain amount of labour-power inherent in the persons of the men that inhabit it. Men urged by their necessities and desires have laboured for many thousands of years at the task of subjugating the forces of Nature and of making the natural material useful to them. To our eyes, since we cannot see into the future, that struggle with Nature seems nearly over, and the victory of the human race over her nearly complete. And, looking backwards to the time when history first began, we note that the progress of that victory has been far swifter and more startling within the last two hundred years than ever before. Surely, therefore, we moderns ought to be in all ways vastly better off than any who have gone before us. Surely we ought, one and all of us, to be wealthy, to be well furnished with the good things which our victory over Nature has won for us.

But what is the real fact? Who will dare to deny that the great mass of civilized men are poor? So poor are they that it is mere childishness troubling ourselves to discuss whether perhaps they are in some ways a little better off than their forefathers. They are poor; nor can their poverty be measured by the poverty of a resourceless savage, for he knows of nothing else than his poverty; that he should be cold, hungry, houseless, dirty, ignorant, all that is to him as natural as that he should have a skin. But for us, for the most of us, civilization has bred desires which she forbids us to satisfy, and so is not merely a niggard but a torturer also.

Thus then have the fruits of our victory over Nature been stolen from us, thus has compulsion by Nature to labour in hope of rest, gain, and pleasure been turned into compulsion by man to labour in hope – of living to labour!

What shall we do then, can we mend it?

Well, remember once more that it is not our remote ancestors who achieved the victory over Nature, but our fathers, nay, our very selves. For us to sit hopeless and helpless then would be a strange folly indeed: be sure that we can amend it. What, then, is the first thing to be done?

We have seen that modern society is divided into two classes, one of which is *privileged* to be kept by the labour of the other – that is, it

forces the other to work for it and takes from this inferior class everything that it *can* take from it, and uses the wealth so taken to keep its own members in a superior position, to make them beings of a higher order than the others: longer lived, more beautiful, more honoured, more refined than those of the other class. I do not say that it troubles itself about its members being *positively* long lived, beautiful or refined, but merely insists that they shall be so *relatively* to the inferior class. As also it cannot use the labour-power of the inferior class fairly in producing real wealth, it wastes it wholesale in the production of rubbish.

It is this robbery and waste on the part of the minority which keeps the majority poor; if it could be shown that it is necessary for the preservation of society that this should be submitted to, little more could be said on the matter, save that the despair of the oppressed majority would probably at some time or other destroy Society. But it has been shown, on the contrary, even by such incomplete experiments, for instance, as Cooperation (so called), that the existence of a privileged class is by no means necessary for the production of wealth, but rather for the 'government' of the producers of wealth, or, in other words, for the upholding of privilege.

The first step to be taken then is to abolish a class of men privileged to shirk their duties as men, thus forcing others to do the work which they refuse to do. All must work according to their ability, and so produce what they consume – that is, each man should work as well as he can for his own livelihood, and his livelihood should be assured to him; that is to say, all the advantages which society would provide for each and all of its members.

Thus, at last, would true Society be founded. It would rest on equality of condition. No man would be tormented for the benefit of another – nay, no one man would be tormented for the benefit of Society. Nor, indeed, can that order be called Society which is not upheld for the benefit of every one of its members.

But since men live now, badly as they live, when so many people do not produce at all, and when so much work is wasted, it is clear that, under conditions where all produced and no work was wasted, not only would everyone work with the certain hope of gaining a due share of wealth by his work, but also he could not miss his due share

of rest. Here, then, are two out of the three kinds of hope mentioned above as an essential part of worthy work assured to the worker. When class robbery is abolished, every man will reap the fruits of his labour, every man will have due rest – leisure, that is. Some Socialists might say we need not go any further than this; it is enough that the worker should get the full produce of his work, and that his rest should be abundant. But though the compulsion of man's tyranny is thus abolished, I yet demand compensation for the compulsion of Nature's necessity. As long as the work is repulsive it will still be a burden which must be taken up daily, and even so would mar our life, even though the hours of labour were short. What we want to do is to add to our wealth without diminishing our pleasure. Nature will not be finally conquered till our work becomes a part of the pleasure of our lives.

That first step of freeing people from the compulsion to labour needlessly will at least put us on the way towards this happy end; for we shall then have time and opportunities for bringing it about. As things are now, between the waste of labour-power in mere idleness and its waste in unproductive work, it is clear that the world of civilization is supported by a small part of its people; when *all* were working *usefully* for its support, the share of work which each would have to do would be but small, if our standard of life were about on the footing of what well-to-do and refined people now think desirable. We shall have labour-power to spare, and shall in short, be as wealthy as we please. It will be easy to live. If we were to wake up some morning now, under our present system, and find it 'easy to live', that system would force us to set to work at once and make it hard to live; we should call that 'developing our resources', or some such fine name. The multiplication of labour has become a necessity for us, and as long as that goes on no ingenuity in the invention of machines will be of any real use to us. Each new machine will cause a certain amount of misery among the workers whose special industry it may disturb; so many of them will be reduced from skilled to unskilled workmen, and then gradually matters will slip into their due grooves, and all will work apparently smoothly again; and if it were not that all this is preparing revolution, things would be, for the greater part of men, just as they were before the new wonderful invention.

But when revolution has made it 'easy to live', when all are working harmoniously together and there is no one to rob the worker of his time, that is to say, his life; in those coming days there will be no compulsion on us to go on producing things we do not want, no compulsion on us to labour for nothing; we shall be able calmly and thoughtfully to consider what we shall do with our wealth of labour-power. Now, for my part, I think the first use we ought to make of that wealth, of that freedom, should be to make all our labour, even the commonest and most necessary, pleasant to everybody; for thinking over the matter carefully I can see that the one course which will certainly make life happy in the face of all accidents and troubles is to take a pleasurable interest in all the details of life. And lest perchance you think that an assertion too universally accepted to be worth making, let me remind you how entirely modern civilization forbids it; with what sordid, and even terrible, details it surrounds the life of the poor, what a mechanical and empty life she forces on the rich; and how rare a holiday it is for any of us to feel ourselves a part of Nature, and unhurriedly, thoughtfully, and happily to note the course of our lives amidst all the little links of events which connect them with the lives of others, and build up the great whole of humanity.

But such a holiday our whole lives might be, if we were resolute to make all our labour reasonable and pleasant. But we must be resolute indeed; for no half measures will help us here. It has been said already that our present joyless labour, and our lives scared and anxious as the life of a hunted beast, are forced upon us by the present system of producing for the profit of the privileged classes. It is necessary to state what this means. Under the present system of wages and capital the 'manufacturer' (most absurdly so called, since a manufacturer means a person who makes with his hands) having a monopoly of the means whereby the power to labour inherent in every man's body can be used for production, is the master of those who are not so privileged; he, and he alone, is able to make use of this labour-power, which, on the other hand, is the only commodity by means of which his 'capital', that is to say, the accumulated product of past labour, can be made productive to him. He therefore buys the labour-power of those who are bare of capital and can only live by selling it to him; his pur-

USEFUL WORK VERSUS USELESS TOIL

pose in this transaction is to increase his capital, to make it breed. It is clear that if he paid those with whom he makes his bargain the full value of their labour, that is to say, all that they produced, he would fail in his purpose. But since he is the monopolist of the means of productive labour, he can *compel* them to make a bargain better for him and worse for them than that; which bargain is that after they have earned their livelihood, estimated according to a standard high enough to ensure their peaceable submission to his mastership, the rest (and by far the larger part as a matter of fact) of what they produce shall belong to him, shall be his *property* to do as he likes with, to use or abuse at his pleasure; which property is, as we all know, jealously guarded by army and navy, police and prison; in short, by that huge mass of physical force which superstition, habit, fear of death by starvation – IGNORANCE, in one word, among the propertyless masses enables the propertied classes to use for the subjection of – their slaves.

Now, at other times, other evils resulting from this system may be put forward. What I want to point out now is the impossibility of our attaining to attractive labour under this system, and to repeat that it is this robbery (there is no other word for it) which wastes the available labour-power of the civilized world, forcing many men to do nothing, and many, very many more to do nothing useful; and forcing those who carry on really useful labour to most burdensome overwork. For understand once for all that the 'manufacturer' aims primarily at producing, by means of the labour he has stolen from others, not goods but profits, that is, the 'wealth' that is produced over and above the livelihood of his workmen, and the wear and tear of his machinery. Whether that 'wealth' is real or sham matters nothing to him. If it sells and yields him a 'profit' it is all right. I have said that, owing to there being rich people who have more money than they can spend reasonably, and who therefore buy sham wealth, there is waste on that side; and also that, owing to there being poor people who cannot afford to buy things which are worth making, there is waste on that side. So that the 'demand' which the capitalist 'supplies' is a false demand. The market in which he sells is 'rigged' by the miserable inequalities produced by the robbery of the system of Capital and Wages.

It is this system, therefore, which we must be resolute in getting rid of, if we are to attain to happy and useful work for all. The first step towards making labour attractive is to get the means of making labour fruitful, the Capital, including the land, machinery, factories, etc., into the hands of the community, to be used for the good of all alike, so that we might all work at 'supplying' the real 'demands' of each and all – that is to say, work for livelihood, instead of working to supply the demand of the profit market – instead of working for profit – i.e., the power of compelling other men to work against their will.

When this first step has been taken and men begin to understand that Nature wills all men either to work or starve, and when they are no longer such fools as to allow some the alternative of stealing, when this happy day is come, we shall then be relieved from the tax of waste, and consequently shall find that we have, as aforesaid, a mass of labour-power available, which will enable us to live as we please within reasonable limits. We shall no longer be hurried and driven by the fear of starvation, which at present presses no less on the greater part of men in civilized communities than it does on mere savages. The first and most obvious necessities will be so easily provided for in a community in which there is no waste of labour, that we shall have time to look round and consider what we really do want, that can be obtained without overtaxing our energies; for the often-expressed fear of mere idleness falling upon us when the force supplied by the present hierarchy of compulsion is withdrawn, is a fear which is but generated by the burden of excessive and repulsive labour, which we most of us have to bear at present.

I say once more that, in my belief, the first thing which we shall think so necessary as to be worth sacrificing some idle time for, will be the attractiveness of labour. No very heavy sacrifice will be required for attaining this object, but some *will* be required. For we may hope that men who have just waded through a period of strife and revolution will be the last to put up long with a life of mere utilitarianism, though Socialists are sometimes accused by ignorant persons of aiming at such a life. On the other hand, the ornamental part of modern life is already rotten to the core, and must be utterly swept away before the new order of things is realized. There is nothing of it – there

is nothing which could come of it that could satisfy the aspirations of men set free from the tyranny of commercialism.

We must begin to build up the ornamental part of life – its pleasures, bodily and mental, scientific and artistic, social and individual – on the basis of work undertaken willingly and cheerfully, with the consciousness of benefiting ourselves and our neighbours by it. Such absolutely necessary work as we should have to do would in the first place take up but a small part of each day, and so far would not be burdensome; but it would be a task of daily recurrence, and therefore would spoil our day's pleasure unless it were made at least endurable while it lasted. In other words, all labour, even the commonest, must be made attractive.

How can this be done? – is the question, the answer to which will take up the rest of this paper. In giving some hints on this question, I know that, while all Socialists will agree with many of the suggestions made, some of them may seem to some strange and venturesome. These must be considered as being given without any intention of dogmatizing, and as merely expressing my own personal opinion.

From all that has been said already it follows that labour, to be attractive, must be directed towards some obviously useful end, unless in cases where it is undertaken voluntarily by each individual as a pastime. This element of obvious usefulness is all the more to be counted on in sweetening tasks otherwise irksome, since social morality, the responsibility of man towards the life of man, will, in the new order of things, take the place of theological morality, or the responsibility of man to some abstract idea. Next, the day's work will be short. This need not be insisted on. It is clear that with work unwasted it *can* be short. It is clear also that much work which is now a torment, would be easily endurable if it were much shortened.

Variety of work is the next point, and a most important one. To compel a man to do day after day the same task, without any hope of escape or change, means nothing short of turning his life into a prison-torment. Nothing but the tyranny of profit-grinding makes this necessary. A man might easily learn and practise at least three crafts, varying sedentary occupation with outdoor – occupation calling for the exercise of strong bodily energy for work in which the mind had more to do. There are few men, for instance, who would

not wish to spend part of their lives in the most necessary and plea-santest of all work – cultivating the earth. One thing which will make this variety of employment possible will be the form that education will take in a socially ordered community. At present all education is directed towards the end of fitting people to take their places in the hierarchy of commerce – these as masters, those as workmen. The education of the masters is more ornamental than that of the work-men, but it is commercial still; and even at the ancient universities learning is but little regarded, unless it can in the long run be made *to pay*. Due education is a totally different thing from this, and concerns itself in finding out what different people are fit for, and helping them along the road which they are inclined to take. In a duly ordered society, therefore, young people would be taught such handicrafts as they had a turn for as a part of their education, the discipline of their minds and bodies; and adults would also have opportunities of learn-ing in the same schools, for the development of individual capacities would be of all things chiefly aimed at by education, instead, as now, the subordination of all capacities to the great end of 'money-making' for oneself – or one's master. The amount of talent, and even genius, which the present system crushes, and which would be drawn out by such a system, would make our daily work easy and interesting.

Under this head of variety I will note one product of industry which has suffered so much from commercialism that it can scarcely be said to exist, and is, indeed, so foreign from our epoch that I fear there are some who will find it difficult to understand what I have to say on the subject, which I nevertheless must say, since it is really a most important one. I mean that side of art which is, or ought to be, done by the ordinary workman while he is about his ordinary work, and which has got to be called, very properly, Popular Art. This art, I repeat, no longer exists now, having been killed by commercialism. But from the beginning of man's contest with Nature till the rise of the present capitalistic system, it was alive, and generally flourished. While it lasted, everything that was made by man was adorned by man, just as everything made by Nature is adorned by her. The craftsman, as he fashioned the thing he had under his hand, orna-mented it so naturally and so entirely without conscious effort, that it is often difficult to distinguish where the mere utilitarian part of his

work ended and the ornamental began. Now the origin of this art was the necessity that the workman felt for variety in his work, and though the beauty produced by this desire was a great gift to the world, yet the obtaining variety and pleasure in the work by the workman was a matter of more importance still, for it stamped all labour with the impress of pleasure. All this has now quite disappeared from the work of civilization. If you wish to have ornament, you must pay specially for it, and the workman is compelled to produce ornament, as he is to produce other wares. He is compelled to pretend happiness in his work, so that the beauty produced by man's hand, which was once a solace to his labour, has now become an extra burden to him, and ornament is now but one of the follies of useless toil, and perhaps not the least irksome of its fetters.

Besides the short duration of labour, its conscious usefulness, and the variety which should go with it, there is another thing needed to make it attractive, and that is pleasant surroundings. The misery and squalor which we people of civilization bear with so much complacency as a necessary part of the manufacturing system, is just as necessary to the community at large as a proportionate amount of filth would be in the house of a private rich man. If such a man were to allow the cinders to be raked all over his drawing-room, and a privy to be established in each corner of his dining-room, if he habitually made a dust and refuse heap of his once beautiful garden, never washed his sheets or changed his tablecloth, and made his family sleep five in a bed, he would surely find himself in the claws of a commission *de lunatico*. But such acts of miserly folly are just what our present society is doing daily under the compulsion of a supposed necessity, which is nothing short of madness. I beg you to bring your commission of lunacy against civilization without more delay.

For all our crowded towns and bewildering factories are simply the outcome of the profit system. Capitalistic manufacture, capitalistic land-owning, and capitalistic exchange force men into big cities in order to manipulate them in the interests of capital; the same tyranny contracts the due space of the factory so much that (for instance) the interior of a great weaving-shed is almost as ridiculous a spectacle as it is a horrible one. There is no other necessity for all this, save the necessity for grinding profits out of men's lives, and of producing

cheap goods for the use (and subjection) of the slaves who grind. All labour is not yet driven into factories; often where it is there is no necessity for it, save again the profit-tyranny. People engaged in all such labour need by no means be compelled to pig together in close city quarters. There is no reason why they should not follow their occupations in quiet country homes, in industrial colleges, in small towns, or, in short, where they find it happiest for them to live.

As to that part of labour which must be associated on a large scale, this very factory system, under a reasonable order of things (though to my mind there might still be drawbacks to it), would at least offer opportunities for a full and eager social life surrounded by many pleasures. The factories might be centres of intellectual activity also, and work in them might well be varied very much: the tending of the necessary machinery might to each individual be but a short part of the day's work. The other work might vary from raising food from the surrounding country to the study and practice of art and science. It is a matter of course that people engaged in such work, and being the masters of their own lives, would not allow any hurry or want of foresight to force them into enduring dirt, disorder, or want of room. Science duly applied would enable them to get rid of refuse, to minimize, if not wholly to destroy, all the inconveniences which at present attend the use of elaborate machinery, such as smoke, stench, and noise; nor would they endure that the buildings in which they worked or lived should be ugly blots on the fair face of the earth. Beginning by making their factories, buildings, and sheds decent and convenient like their homes, they would infallibly go on to make them not merely negatively good, inoffensive merely, but even beautiful, so that the glorious art of architecture, now for some time slain by commercial greed, would be born again and flourish.

So, you see, I claim that work in a duly ordered community should be made attractive by the consciousness of usefulness, by its being carried on with intelligent interest, by variety, and by its being exercised amidst pleasurable surroundings. But I have also claimed, as we all do, that the day's work should not be wearisomely long. It may be said, 'How can you make this last claim square with the others? If the work is to be so refined, will not the goods made be very expensive?'

I do admit, as I have said before, that some sacrifice will be necessary in order to make labour attractive. I mean that, if we *could* be contented in a free community to work in the same hurried, dirty, disorderly, heartless way as we do now, we might shorten our day's labour very much more than I suppose we shall do, taking all kinds of labour into account. But if we did, it would mean that our new-won freedom of condition would leave us listless and wretched, if not anxious, as we are now, which I hold is simply impossible. We should be contented to make the sacrifices necessary for raising our condition to the standard called out for as desirable by the whole community. Nor only so. We should, individually, be emulous to sacrifice quite freely still more of our time and our ease towards the raising of the standard of life. Persons, either by themselves or associated for such purposes, would freely, and for the love of the work and for its results – stimulated by the hope of the pleasure of creation – produce those ornaments of life for the service of all, which they are now bribed to produce (or pretend to produce) for the service of a few rich men. The experiment of a civilized community living wholly without art or literature has not yet been tried. The past degradation and corruption of civilization may force this denial of pleasure upon the society which will arise from its ashes. If that must be, we will accept the passing phase of utilitarianism as a foundation for the art which is to be. If the cripple and the starveling disappear from our streets, if the earth nourish us all alike, if the sun shine for all of us alike, if to one and all of us the glorious drama of the earth – day and night, summer and winter – can be presented as a thing to understand and love, we can afford to wait awhile till we are purified from the shame of the past corruption, and till art arises again amongst people freed from the terror of the slave and the shame of the robber.

Meantime, in any case, the refinement, thoughtfulness, and deliberation of labour must indeed be paid for, but not by compulsion to labour long hours. Our epoch has invented machines which would have appeared wild dreams to the men of past ages, and of those machines we have as yet *made no use*.

They are called 'labour-saving' machines – a commonly used phrase which implies what we expect of them; but we do not get what we expect. What they really do is to reduce the skilled labourer

to the ranks of the unskilled, to increase the number of the 'reserve army of labour' – that is, to increase the precariousness of life among the workers and to intensify the labour of those who serve the machines (as slaves their masters). All this they do by the way, while they pile up the profits of the employers of labour, or force them to expend those profits in bitter commercial war with each other. In a true society these miracles of ingenuity would be for the first time used for minimizing the amount of time spent in unattractive labour, which by their means might be so reduced as to be but a very light burden on each individual. All the more as these machines would most certainly be very much improved when it was no longer a question as to whether their improvement would 'pay' the individual, but rather whether it would benefit the community.

So much for the ordinary use of machinery, which would probably, after a time, be somewhat restricted when men found out that there was no need for anxiety as to mere subsistence, and learned to take an interest and pleasure in handiwork which, done deliberately and thoughtfully, could be made more attractive than machine work.

Again, as people freed from the daily terror of starvation find out what they really wanted, being no longer compelled by anything but their own needs, they would refuse to produce the mere inanities which are now called luxuries, or the poison and trash now called cheap wares. No one would make plush breeches when there were no flunkies to wear them, nor would anybody waste his time over making oleomargarine when no one was *compelled* to abstain from real butter. Adulteration laws are only needed in a society of thieves – and in such a society they are a dead letter.

Socialists are often asked how work of the rougher and more repulsive kind could be carried out in the new condition of things. To attempt to answer such questions fully or authoritatively would be attempting the impossibility of constructing a scheme of a new society out of the materials of the old, before we knew which of those materials would disappear and which endure through the evolution which is leading us to the great change. Yet it is not difficult to conceive of some arrangement whereby those who did the roughest work should work for the shortest spells. And again, what is said above of the variety of work applies specially here. Once more I say, that for a

man to be the whole of his life hopelessly engaged in performing one repulsive and never-ending task, is an arrangement fit enough for the hell imagined by theologians, but scarcely fit for any other form of society. Lastly, if this rougher work were of any special kind, we may suppose that special volunteers would be called on to perform it, who would surely be forthcoming, unless men in a state of freedom should lose the sparks of manliness which they possessed as slaves.

And yet if there be any work which cannot be made other than repulsive, either by the shortness of its duration or the intermittency of its recurrence, or by the sense of special and peculiar usefulness (and therefore honour) in the mind of the man who performs it freely – if there be any work which cannot be but a torment to the worker, what then? Well, then, let us see if the heavens will fall on us if we leave it undone, for it were better that they should. The produce of such work cannot be worth the price of it.

Now we have seen that the semi-theological dogma that all labour, under any circumstances, is a blessing to the labourer, is hypocritical and false; that, on the other hand, labour is good when due hope of rest and pleasure accompanies it. We have weighed the work of civilization in the balance and found it wanting, since hope is mostly lacking to it, and therefore we see that civilization has bred a dire curse for men. But we have seen also that the work of the world might be carried on in hope and with pleasure if it were not wasted by folly and tyranny, by the perpetual strife of opposing classes.

It is Peace, therefore, which we need in order that we may live and work in hope and with pleasure. Peace so much desired, if we must trust men's words, but which has been so continually and steadily rejected by them in deeds. But for us, let us set our hearts on it and win it at whatever cost.

What the cost may be, who can tell? Will it be possible to win peace peaceably? Alas, how can it be? We are so hemmed in by wrong and folly, that in one way or other we must always be fighting against them: our own lives may see no end to the struggle, perhaps no obvious hope of the end. It may be that the best we can hope to see is that struggle getting sharper and bitterer day by day, until it breaks out openly at last into the slaughter of men by actual warfare instead

of by the slower and crueller methods of 'peaceful' commerce. If we live to see that, we shall live to see much; for it will mean the rich classes grown conscious of their own wrong and robbery, and consciously defending them by open violence; and then the end will be drawing near.

But in any case, and whatever the nature of our strife for peace may be, if we only aim at it steadily and with singleness of heart, and ever keep it in view, a reflection from that peace of the future will illumine the turmoil and trouble of our lives, whether the trouble be seemingly petty, or obviously tragic; and we shall, in our hopes at least, live the lives of men: nor can the present times give us any reward greater than that.

(1885)

## 32: 'A MATTER OF RELIGION'

I DO not believe in the world being saved by any system – I only assert the necessity of attacking systems grown corrupt, and no longer leading anywhither: that to my mind is the case with the present system of capital and labour: as all my lectures assert, I have personally been gradually driven to the conclusion that art has been handcuffed by it, and will die out of civilization if the system lasts. That of itself does to me carry with it the condemnation of the whole system, and I admit that it has drawn my attention to the subject in general: but furthermore in looking into matters social and political I have but one rule, that in thinking of the condition of any body of men I should ask myself, 'How could you bear it yourself? what would you feel if you were poor against the system under which you live?' I have always been uneasy when I had to ask myself that question, and of late years I have had to ask it so often, that I have seldom had it out of my mind: and the answer to it has more and more made me ashamed of my own position, and more and more made me feel that if I had not been born rich or well-to-do I should have found my position *un*-endurable, and should have been a mere rebel against what would have seemed to me a system of robbery and injustice. Nothing can argue me out of this feeling, which I say plainly is a matter of religion

to me: the contrasts of rich and poor are unendurable and ought not to be endured by either rich or poor. Now it seems to me that, feeling this, I am bound to act for the destruction of the system which seems to me mere oppression and obstruction; such a system can only be destroyed, it seems to me, by the united discontent of numbers; isolated acts of a few persons of the upper and middle classes seeming to me (as I have said before) quite powerless against it: in other words, the antagonism of classes, which the system had bred, is the natural and necessary instrument of its destruction. . . .

(From a letter to C. E. Maurice, 1 July 1883)

## 33: SOCIALISM IN PERSPECTIVE

To make really convinced converts if only one by one: to show even the most ignorant of the 'poor' that we are on their side, and that we are striving to make them gain a better condition of life for themselves – themselves now living, you understand, not the generations a thousand years to come: to infuse hope into the oppressed in fact – that is our business: and I don't think it is possible for us to fail in it, in spite of our own mistakes and weaknesses.

You see what we Socialists aim at is to remove from people the weight of overwork and anxiety which now crushes them: we know that a condition of poverty has not always meant overwork and anxiety, but under modern civilization it does, and with modern civilization we have to deal: we cannot turn our people back into Catholic English peasants and Guild craftsmen, or into heathen Norse bonders, much as may be said for such conditions of life: we have no choice but to accept the task which the centuries have laid on us of using the corruption of 300 years of profit-mongering for the overthrow of that very corruption: commerce has bred the Proletariat and uses it quite blindly, and is still blind to the next move in the game, which will be that the Proletariat will say: We will be *used* no longer, you have organized us for *our own* use. Again it is our business to make

people hope that they can be organized into saying this as if they meant it: in the course of their gathering that hope, it may well be that rough things may befall: but I say plainly that I shrink from no consequences of that gathering hope: for when it begins to realize itself (as it will) there will be an end of overwork and anxiety – and *then* people will find out what kind of education and morals they need and will have them: not unlikely that they may be somewhat different from our preconceptions of them. Meantime to try to settle amidst our present corruption what that education, those morals shall be, except in the most general way seems to me a putting of the cart before the horse.

Second – Whatever Socialism may lead to, our aim, to be always steadily kept in view, is, to obtain for the whole people, duly organized, the possession and control of all the means of production and exchange, destroying at the same time all national rivalries.

The means whereby this is to be brought about is first, educating people into desiring it, next organizing them into claiming it effectually. Whatever happens in the course of this education and organization must be accepted coolly and as a necessary incident, and not disclosed as a matter of essential principle, even if those incidents should mean ruin and war. I mean that we must not say 'We must drop our purpose rather than carry it across this river of violence.' To say that means casting the whole thing into the hands of chance, and we can't do that: we *can't* say, if this is the evolution of history, let it evolve itself, we won't help. The evolution will force us to help: will breed in us passionate desire for action, which will quench the dread of consequences. . . .

(From a letter to Robert Thompson,
24 July 1884)

## 34: ART AND SOCIETY

SIR – It was the purpose of my lecture to raise another question than one of 'mere art'.* I specially wished to point out that the question of popular art was a social question, involving the happiness or misery of the greater part of the community. The absence of popular art from modern times is more disquieting and grievous to bear for this reason than for any other, that it betokens that fatal division of men into the cultivated and the degraded classes which competitive commerce has bred and fosters; popular art has no chance of a healthy life, or, indeed, of a life at all, till we are on the way to fill up this terrible gulf between riches and poverty. Doubtless many things will go to filling it up, and if art must be one of those things, let it go. What business have we with art at all unless all can share it? I am not afraid but that art will rise from the dead, whatever else lies there. For, after all, what is the true end and aim of all politics and commerce? Is it not to bring about a state of things in which all men may live at peace and free from over-burdensome anxiety, provided with work which is pleasant to them and produces results useful to their neighbours?

It may well be a burden to the conscience of an honest man who lives a more manlike life to think of the innumerable lives which are spent in toil unrelieved by hope and uncheered by praise; men who might as well, for all the good they are doing to their neighbours by their work, be turning a crank with nothing at the end of it; but this is the fate of those who are working at the bidding of blind competitive commerce, which still persists in looking at itself as an end, and not as a means.

It has been this burden on my conscience, I do in all sincerity believe, which has urged me on to speak of popular art in Manchester and elsewhere. I could never forget that in spite of all drawbacks my work is little else than pleasure to me; that under no conceivable circumstances would I give it up even if I could. Over and over again have I asked myself why should not my lot be the common lot. My

* Morris had just given a lecture, 'Art, Wealth, and Riches', at Manchester, which had led an angry correspondent to attack him for going beyond 'mere art'.

work is simple work enough; much of it, nor that the least pleasant, any man of decent intelligence could do, if he could but get to care about the work and its results. Indeed I have been ashamed when I have thought of the contrast between my happy working hours and the unpraised, unrewarded, monotonous drudgery which most men are condemned to. Nothing shall convince me that such labour as this is good or necessary to civilization.

(From the *Manchester Examiner*, 14 March 1883)

## 35: THE WORKER'S SHARE OF ART

I CAN imagine some of our comrades smiling bitterly at the above title, and wondering what a Socialist journal can have to do with art; so I begin by saying that I understand only too thoroughly how 'un-practical' the subject is while the present system of capital and wages lasts. Indeed that is my text.

What, however, is art? whence does it spring? Art is man's embodied expression of interest in the life of man; it springs from man's pleasure in his life; pleasure we must call it, taking all human life together, however much it may be broken by the grief and trouble of individuals; and as it is the expression of pleasure in life generally, in the memory of the deeds of the past, and the hope of those of the future, so it is especially the expression of man's pleasure in the deeds of the present; in his work.

Yes, that may well seem strange to us at present! Men today may see the pleasure of unproductive energy – energy put forth in games and sports; but in productive energy – in the task which must be finished before we can eat, the task which will begin again tomorrow, and many a tomorrow without change or end till *we* are ended – pleasure in that?

Yet I repeat that the chief source of art is man's pleasure in his daily necessary work, which expresses itself and is embodied in that work itself; nothing else can make the common surroundings of life beautiful, and whenever they are beautiful it is a sign that men's work has

pleasure in it, however they may suffer otherwise. It is the lack of this pleasure in daily work which has made our towns and habitations sordid and hideous, insults to the beauty of the earth which they disfigure, and all the accessories of life mean, trivial, ugly – in a word, *vulgar*. Terrible as this is to endure in the present, there is hope in it for the future; for surely it is but just that outward ugliness and disgrace should be the result of the slavery and misery of the people; and that slavery and misery once changed, it is but reasonable to expect that external ugliness will give place to beauty, the sign of free and happy work.

Meantime, be sure that nothing else will produce even a reasonable semblance of art; for think of it! the workers, by means of whose hands the mass of art must be made, are forced by the commercial system to live, even at the best, in places so squalid and hideous that no one could live in them and keep his sanity without losing all sense of beauty and enjoyment of life. The advance of the industrial army under its 'captains of industry' (save the mark!) is traced, like the advance of other armies, in the ruin of the peace and loveliness of earth's surface, and nature, who will have us live at any cost, compels us to *get used* to our degradation at the expense of losing our manhood, and producing children doomed to live less like men than ourselves. Men living amidst such ugliness cannot conceive of beauty, and, therefore, cannot express it.

Nor is it only the workers who feel this misery (and I rejoice over that, at any rate). The higher or more intellectual arts suffer with the industrial ones. The artists, the aim of whose lives it is to produce beauty and interest, are deprived of the materials for the works in real life, since all around them is ugly and vulgar. They are driven into seeking their materials in the imaginations of past ages, or into giving the lie to their own sense of beauty and knowledge of it by sentimentalizing and falsifying the life which goes on around them; and so, in spite of all their talent, intellect, and enthusiasm, produce little which is not contemptible when matched against the works of the non-commercial ages. Nor must we forget that whatever is produced that is worth anything is the work of men who are in rebellion against the corrupt society of today – rebellion sometimes open, sometimes veiled under cynicism, but by which in any case lives are wasted in a

struggle, too often vain, against their fellow-men, which ought to be used for the exercise of special gifts for the benefit of the world.

High and low, therefore, slaveholders and slaves, we lack beauty in our lives, or, in other words, man-like pleasure. This absence of pleasure is the second gift to the world which the development of commercialism has added to its first gift of a propertyless proletariat. Nothing else but the grinding of this iron system could have reduced the civilized world to vulgarity. The theory that art is sick *because* people have turned their attention to science is without foundation. It is true that science is allowed to live because profit can be made of her, and men, who must find some outlet for their energies, turn to her, since she exists, though only as the slave (but now the rebellious slave) of capital; whereas when art is fairly in the clutch of profit-grinding she dies, and leaves behind her but her phantom of *sham* art as the futile slave of the capitalist.

Strange as it may seem, therefore, to some people, it is as true as strange, that Socialism, which has been commonly supposed to tend to mere Utilitarianism, is the only hope of the arts. It may be, indeed, that till the social revolution is fully accomplished, and perhaps for a little while afterwards, men's surroundings may go on getting plainer, grimmer, and barer; I say for a little while afterwards, because it may take men some time to shake off the habits of penury on the one hand, and inane luxury on the other, which have been forced on them by commercialism. But even in that there is hope; for it is at least possible that all the old superstitions and conventionalities of art have got to be swept away before art can be born again; that before that new birth we shall have to be left bare of everything that has been called art; that we shall have nothing left us but the materials of art, that is the human race with its aspirations and passions and its home, the earth; on which materials we shall have to use these tools, leisure, and desire.

Yet, though that may be, it is not likely that we shall quite recognize it; it is probable that it will come so gradually that it will not be obvious to our eyes. Maybe, indeed, art is sick to death even now, and nothing but its already half-dead body is left upon the earth: but also, may we not hope that we shall not have to wait for the new birth of

art till we attain the peace of the realized New Order? Is it not at least possible, on the other hand, that what will give the death-blow to the vulgarity of life which enwraps us all now will be the great tragedy of Social Revolution, and that the worker will then once more begin to have a share in art, when he begins to see his aim clear before him – his aim of a share of real life for all men – and when his struggle for that aim has begun? It is not the excitement of battling for a great and worthy end which is the foe to art, but the dead weight of sordid, un-relieved anxiety, the anxiety for the daily earning of a wretched pit-tance by labour degrading at once to body and mind, both by its excess and by its mechanical nature.

In any case, the leisure which Socialism above all things aims at obtaining for the worker is also the very thing that breeds desire – desire for beauty, for knowledge, for more abundant life, in short. Once more, that leisure and desire are sure to produce art, and without them nothing but sham art, void of life or reason for existence, can be produced: therefore not only the worker, but the world in general, will have no share in art till our present commercial society gives place to real society – to Socialism. I know this subject is too serious and difficult to treat properly in one short article. I will ask our readers, therefore, to consider this as an introduction to the consideration of the relations of industrial labour to art.

(Article in *Commonweal*, April 1885)

## 36: ART AND THE FUTURE ❧ 'THE DEEPER MEANING OF THE STRUGGLE'

Sir,

May I be allowed to say a word in supplement to your paragraph about my opinions on the future of the fine arts? You rather imply that I am a pessimist on this matter. This is not the case; but I am anxious that there should be no illusions as to the future of art. I do not believe in the possibility of keeping art vigorously alive by the action, however energetic, of a few groups of specially gifted men and their small circle of admirers amidst a general public incapable of

understanding and enjoying their work. I hold firmly to the opinion that all worthy schools of art must be in the future, as they have been in the past, the outcome of the aspirations of the people towards the beauty and true pleasure of life. And further, now that democracy is building up a new order, which is slowly emerging from the confusion of the commercial period, these aspirations of the people towards beauty can only be born from a condition of practical equality of economical condition amongst the whole population. Lastly, I am so confident that this equality will be gained, that I am prepared to accept as a consequence of the process of that gain, the seeming disappearance of what art is now left us; because I am sure that that will be but a temporary loss, to be followed by a genuine new birth of art, which will be the spontaneous expression of the pleasure of life innate in the whole people.

This, I say, is the art which I look forward to, not as a vague dream, but as a practical certainty, founded on the general well-being of the people. It is true that the blossom of it I shall not see; therefore I may be excused if, in common with other artists, I try to express myself through the art of today, which seems to us to be only a survival of the organic art of the past, in which the people shared, whatever the other drawbacks of their condition might have been. For the feeling for art in us artists is genuine, though we have to work in the midst of the ignorance of those whose whole life ought to be spent in the production of works of art (the makers of wares to wit), and of the fatuous pretence of those who, making no utilities, are driven to 'make-believe'.

Yet if we shall not (those of us who are as old I am) see the New Art, the expression of the general pleasure of life, we are even now seeing the seed of it beginning to germinate. For if genuine art be impossible without the help of the useful classes, how can these turn their attention to it if they are living amidst sordid cares, which press upon them day in, day out? The first step, therefore, towards the new birth of art must be a definite rise in the condition of the workers; their livelihood must (to say the least of it) be less niggardly and less precarious, and their hours of labour shorter; and this improvement must be a general one, and confirmed against the chances of the market by legislation. But again this change for the better can only be realized

WILLIAM MORRIS ❧ DESIGNER
BY GRAEME SHANKLAND

THE achievements of great men always escape final assessment. Succeeding generations feel bound to reinterpret their work. For the Victorians, Morris was above all a poet. For many today he is a forerunner of contemporary design. Tomorrow may remember him best as a social and moral critic of capitalism and pioneer of a society of equality.

Morris is all these things and more. Yet when he signed his membership card of the Democratic Federation he wrote one word on it, 'Designer'. His work as designer and craftsman lies at the centre of his personality. It was this work which throughout his life absorbed most of his energies and his time.

Pattern designing gave him an intense lyrical pleasure and his struggles to master by personal experiment one craft after another offered the exacting kind of work he needed to realize his gifts and to create an astonishing number of works of great beauty ranging over the whole field of the decorative arts. It was from this experience that his ideas about life and society came, while from his practice and its influence a great deal has sprung which, often ignorant of its origins, we now take for granted, but which still has more to offer us.

Architecture, as 'the moulding and altering to human needs of the very face of the earth itself', he always regarded as the master art. Yet, after barely a year in an architect's office on leaving Oxford, he gave it up for the 'lesser' arts. Architecture, he found, had to be done at second hand. To achieve what he sought he needed the control of the whole process of design and production that first-hand experience afforded. 'The beauty of the handicrafts of the Middle Ages came from this,' he wrote in a lecture in later years to a socialist audience, 'that the workman had control over his material, tools and time.'

He sought this control, not only to maintain the unity of the design process, between drawing-board and loom, but to create a workshop where the work itself could be enjoyed. As he believed, with Ruskin, that beauty was unattainable except as the expression of man's joy in everyday work, he saw these conditions as a necessity, no mere philanthropy, which he scorned. From the outset 'The Firm' was a group of artists producing together what most interested them. In later years he created and sustained at Queens Square, Merton Abbey,

and Hammersmith these oases of handicraft work within the boundless desert of mid and late Victorian mass-production for the market. Limited only by the extent of his private income which he used to provide the initial finance for these enterprises, he gained these victories, not only for himself and his fellow workman, but for the many colleagues and collaborators who were encouraged by his example.

Not all the products sold through the Firm were made by hand, or in 'The Firm's' workshops. Where he could find a manufacturer prepared to take the trouble needed to achieve his own exacting standards he contracted out the work concerned. Warner of Jeffrey & Company printed all the wallpapers. Morris's attitude to the division of labour and to the uses of machinery is often misrepresented. He used simple machinery and designed for machine production (see Plate 16). Serial hand production was in general use at Merton Abbey. It was not machinery or the division of labour as such he objected to, but the use to which capitalism put them. 'It is not this or that tangible steel and brass machine which we want to get rid of, but the great intangible machine of commercial tyranny, which oppresses the lives of all of us.' He wanted to end capitalism and struggled to bring socialism about so that men could decide how their work should be done and what should be made by machines. 'In short,' this same speech continues, 'we should be masters of our machines and not their slaves, as we are now.'

The use of hand workmanship and simple machines left Morris free to design as it pleased him and to do battle with his materials in the most direct way. This suited his fighting personality. As he believed that you could not design anything without understanding intimately how it was to be made, he taught himself one process after another. In art, as later in politics, it was the struggle which roused him, the challenge of solving a new problem. When he had mastered a new craft he was eager to turn to the next one. This explains why he took up so many different crafts in succession. The list is formidable and includes oil painting, mural decoration, calligraphy, illumination, embroidery, dyeing, and the weaving of tapestries, carpets, and silk and cotton textiles. For these media, for stained glass, wallpapers, and even linoleum, he produced over six hundred designs, quite apart from the books he designed.

He was a designer in two dimensions and in pattern. 'The greatest

pattern designer we have ever had or ever can have, for a man of his scale will not again be working in the minor arts,' wrote Lethaby some fifty years ago. Nothing since has happened to cause the revision of this opinion. In his own work he never overstepped the discipline of pattern into Victorian literary symbolism or into three dimensions beyond the limits of the material. Neither was he interested in abstract pattern as such. He greatly admired Persian art but he regarded its preoccupation with abstraction as a shortcoming. For himself he sought meaning in his patterns, but by suggestion rather than illustration, and by the cultivation of a 'certain mystery'. 'I, as a Western man and a picture-lover, must insist on plenty of meaning in your patterns; I must have unmistakable suggestions of gardens and fields, and strange trees, boughs, and tendrils or I can't do with your patterns.' Compared with the completely flat designs of most of his best predecessors and contemporaries, the patterns of his wallpapers seem to move and grow, and this sense of growth is contained within a limited but visible depth of foreground, suggested by colour, the weight of his line and the use of such devices as dotted backgrounds appropriate to a printed material (Plate 10). To prevent the effect of restlessness which this movement might create he chose patterns which mastered but did not mask 'the obvious presence of geometrical order in the construction lines of design'.

A craftsman first, he knew the qualities of different media. He revelled in the freedom which embroidery offered (Plate 5), but in carpet design respected his maxim that 'the more mechanical the process, the less direct should be the imitation of natural forms' (Plate 16). At a time when respect to material was little heeded and decorative dexterity was greatly admired he warned against it, advising designers rather to 'try to get the most out of your material, but always in such a way as honours it most. Not only should it be obvious what your material is, but something should be done with it which is specially natural to it, something that could not be done with any other.'

His experience in designing in one craft led him into another; carpet-weaving to tapestry. At the same time, ideas developed in the study of designs in one medium often influenced his designs in another. There is something of the woodcut in the 'Honeysuckle' chintz (Plate 8), and when, in the later seventies, he became absorbed with the technical problems of weaving and studied Sicilian, Elizabethan,

and early Italian Renaissance examples, the influence of their symmetry and formality can be seen in his wallpapers.

Through all modifications in his style it is the vigour and clarity of his designs in all periods which is most striking. Their astonishing richness never confuses. He had no time for vagueness in designing or in politics, and he was able time and again to achieve results of great splendour because in designing he employed the simplest of methods. His firm, clear calligraphic line is highly characteristic, and he used it as he advised: 'Run any risk of failure rather than involve yourself in a tangle of poor, weak lines that people can't make out. Definite form bounded by firm outline is a necessity for all ornament.'

Today it may be the flowing naturalism of his earliest wallpapers (Plate 4) that most appeals. With smaller repeats they are more in scale with modern rooms. The formal and stately papers of the middle period, designed for the greater reception rooms of Webb's country houses, have been used to effect in modern school assembly halls. He could work at the scale of the throne room in St James's Palace or with the intimate delicacy of a design for a book binding (Plate 21). This should not surprise us, for he regarded decoration as functional: 'What we call decoration is, in many cases, but a device or way we have learned for making necessary things reasonable as well as pleasant to us. The pattern becomes part of the thing we make, its exponent, a mode of expressing itself to us, and by it we often form our opinions not only of the shape, but of the strength and uses of a thing.'

Though abstract and non-representational art had little appeal to him as a designer and decorator it was one of the most exacting abstract applied arts – typography and book design – which captured the enthusiasm of his last years. What attracted him was the architectural possibilities of the book in its completeness. 'The only work of art which surpasses a complete Mediaeval book is a complete Mediaeval building.' Though more than doubtful about the possibility of fine architecture in the nineteenth century, he designed fine books that could be made on hand presses as a largely self-contained operation.

The influence which the Kelmscott books have had and still sustain, long after his death, arises from Morris's care to master every significant formal detail of the book. The form of the type, the spacing of the letters and words and lines, the placing of the body of the type

on the page, the width and proportion of margins, the design of the pairs of pages in the open book, the decoration of the book, the choice of paper, ink, binding, and cover, all were subject to his closest scrutiny. The book had always had an appeal to Morris, not only because he wrote books, but as a necessary everyday thing which had 'a tendency to be a beautiful object'. Just as thirty years earlier Red House furniture had to be specially designed, so, when it came to the making of books, Morris and his immediate successors had to design their own types.

Though books and periodicals were being produced in vastly increased numbers in the eighties and nineties, book design and typography were at a low ebb, lacking not only good types, but accepted standards of good typographical practice. It is Morris's great achievement that by his insistence that the best books are 'always beautiful by force of the mere typography', all this was changed. 'It was the essence of my undertaking to produce books which it would be a pleasure to look upon as pieces of printing and arrangement of type,' he explained and to this end designed two alphabets and produced over six hundred designs for initials, borders, and ornaments. In the six years of the Kelmscott Press fifty-two books were produced.

What began as almost a personal indulgence, he pursued with his customary passionate zeal and attentive craftsmanship. Soon he found himself publishing as well as making books. The immediate influence of the Kelmscott Press was to stimulate others during the next twenty years to start their own private presses and set in train a whole number of typographical experiments. More gradually, through the art and printing schools, individual printers and publishers, there followed a quickening of interest and appreciation of fine printing which has led directly to the transformation of commercial printing in the countries where his influence has been most felt – Britain, Scandinavia, Germany, Holland, and the United States.

It is the discovery and rediscovery of principles in designing that accounts for the persistence of Morris's influence. From Cobden-Sanderson to Stanley Morrison typographers whose practice has often been very different to that of Morris have gladly acknowledged their debt to him.

The same can be said of his influence in domestic design. 'The revival of decorative honesty in Morris's designs,' Pevsner concludes,

'counts for more in the history of the Modern Movement than their connexion with bygone styles.'* This medieval flavour which infuses his own work was the subject of comment even in his own lifetime. None the less, there is today a new interest in his designs, many of which have become popular and even fashionable. From these pages of illustration it is not difficult to see why, for they have a timeless beauty which will always stimulate rediscovery.

* Pioneers of Modern Design (Penguin Books, 1960).

1. The drawing-room at 'Clouds', East Knoyle, Wiltshire. Designed by Philip Webb, the architect partner of Morris & Company, for the Wyndham family as 'a palace of weekending for our politicians'. This great house with stables and garden was built between 1881 and 1886. Three years later it was gutted by fire, and was rebuilt in 1890–1, costing £27,000. Webb personally detailed all the interior, including the fireplace, frieze, ceiling, and bookcases in the illustration. Morris chintzes cover the settles and chairs. Webb practised between 1859 and 1900, and this light, white-painted interior shows the distance he had travelled since the dark Gothic interiors of the Red House which he and Morris designed in 1859.

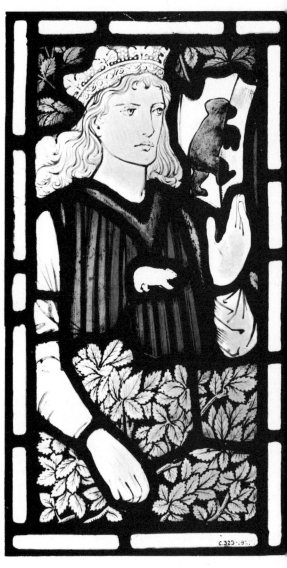

2 and 3. 'King and Queen', probably identifiable as Arthur and Guenevere. This pair of small stained-glass panels (5 × 10 ins. each) was designed by Burne-Jones in 1861 and executed in the workshops of Morris, Marshall, Faulkner & Co. (as the firm was known from 1861–75). Morris designed a number of windows himself, but the

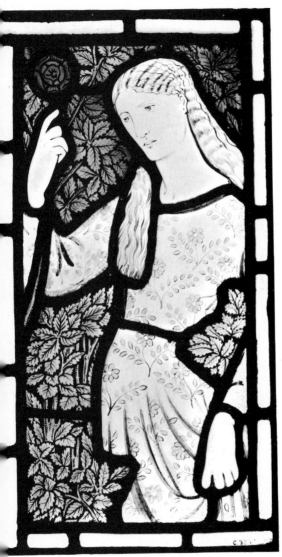

reat majority of the firm's stained glass was designed by Burne-
nes, with Morris providing drawings for the foliage and back-
round details. Morris was also responsible for choosing the exact
olours of the glass used and for supervising the cutting, painting and
ading processes.

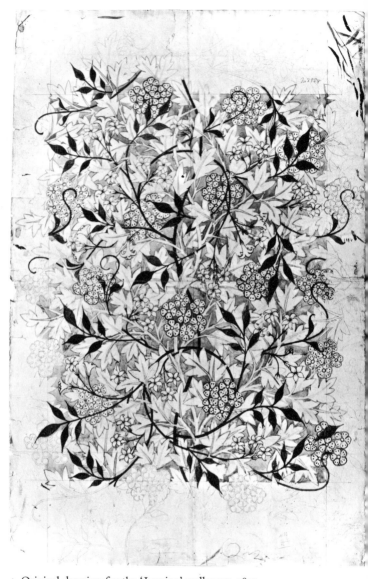

4. Original drawing for the 'Jasmine' wallpaper, 1872.

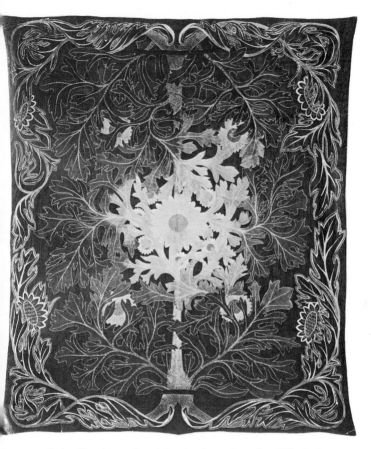

5. Embroidered coverlet, 6 ft 3 ins. by 5 ft 5½ ins. Silk, in browns, pinks, and yellows, on indigo-dyed linen. Designed by Morris about 1876 and probably worked by Mrs Catherine Holiday. Morris was greatly impressed by Mrs Holiday's workmanship and designed specially for her, dyeing the silks she was to use in his works. The freedom and flowing line of this astonishing design equals that achieved later by *art nouveau* designers, while retaining the structural pattern Morris always insisted upon.

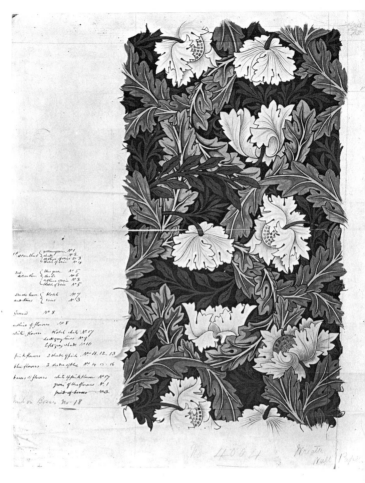

6. Working drawing for the 'Wreath' wallpaper, 1876. One of Morris's most luxuriant designs, with very subtle gradations of tone and colour. The different colours to be used are numbered and set out in the margin.

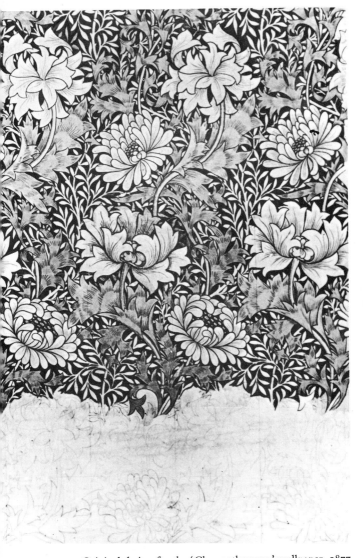

7. Original design for the 'Chrysanthemum' wallpaper, 1877.

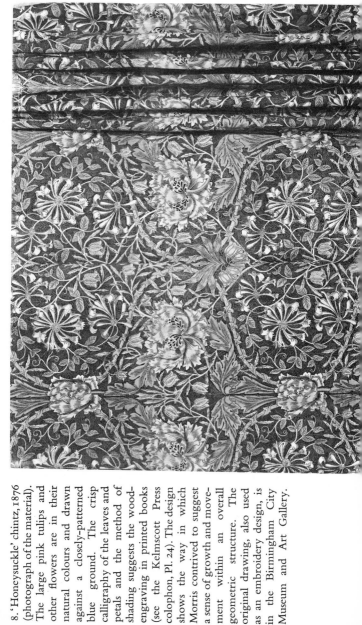

8. 'Honeysuckle' chintz, 1876 (photograph of the material). The large pink tulips and other flowers are in their natural colours and drawn against a closely-patterned blue ground. The crisp calligraphy of the leaves and petals and the method of shading suggests the wood-engraving in printed books (see the Kelmscott Press colophon, Pl. 24). The design shows the way in which Morris contrived to suggest a sense of growth and movement within an overall geometric structure. The original drawing, also used as an embroidery design, is in the Birmingham City Museum and Art Gallery.

by the efforts of the workers themselves. 'By us, and not for us', must be their motto. That they are finding this out for themselves and acting on it makes this year a memorable one indeed, small as is the actual gain which they are claiming. So, Sir, I not only 'admit' but joyfully insist on the fact 'that the miners are laying the foundation of something better.' The struggle against the terrible power of the profit-grinder is now practically proclaimed by them a matter of principle, and no longer a mere chance-hap business dispute, and though the importance of this is acknowledged here and there, I think it is even yet underrated. For my part I look upon the swift progress towards equality as now certain; what these staunch miners have been doing in the face of such tremendous odds, other workmen can and will do; and when life is easier and fuller of pleasure, people will have time to look round them and find out what they desire in the matter of art, and will also have power to compass their desires. No one can tell now what form that art will take; but as it is certain that it will not depend on the whim of a few persons, but on the will of all, so it may be hoped that it will at least not lag behind that of past ages, but will outgo the art of the past in the degree that life will be more pleasurable from the absence of bygone violence and tyranny, *in spite* and not *because* of which our forefathers produced the wonders of popular art, some few of which time has left us. I am, Sir, yours obediently

> (Letter to the *Daily Chronicle*,
> 10 November 1893)

## 37: MY TIME AND YOURS ❦ THE LIGHTER SURFACE OF THE STORY

J.F. [*Jack Freeman, a socialist accused of conspiracy, sedition, and obstruction of the highway*]: MY lord, have you been present, in disguise, at a meeting of the Socialist League in 13 Farringdon Road?

LORD TENNYSON: What's that to you? What do you want to know for? Yes, I have if it comes to that.

J.F.: Who brought you there?

LORD T.: A policeman: one Potlegoff. I thought he was a Russian by his name, but it seems he is an Englishman – and a liar. He said it would be exciting: so I went.

J. F.: And was it exciting?

LORD T.: No: it was dull.

J. F.: How many were present?

LORD T.: Seventeen: I counted them, because I hadn't got anything else to do.

J. F.: Did they plot anything dreadful?

LORD T.: Not that I could hear. They sat and smoked; and one fool was in the chair, and another fool read letters; and then they were worried till I was sick of it as to where such and such fools should go to spout folly next week; and now and then an old bald-headed fool and a stumpy little fool in blue made jokes, at which they laughed a good deal; but I couldn't understand the jokes – and I came away.

J. F.: Thank you, my lord.

MR HUNGARY [*Counsel for the Prosecution*]: My Lord Tennyson, I wish to ask you a question. You say that you couldn't understand their jokes: but could you understand them when they were in earnest?

LORD T.: No, I couldn't: I can't say I tried. I don't want to understand Socialism: it doesn't belong to my time.

(From the play, *The Tables Turned, or Nupkins Awakened*, 1887)

## 38: EDUCATION TODAY

JUST as the capitalists would at once capture education in craftsmanship, seek out what little advantage there is in it, and then throw it away, so they do with all other education. A superstition still remains from the times when 'education' was a rarity that it is a means for earning a superior livelihood; but as soon as it has ceased to be a rarity, competition takes care that education shall not raise wages; that general education shall be worth nothing, and that special educa-

tion shall be worth just no more than a tolerable return on the money and time spent in acquiring it. . . . As to the pleasure to be derived from education at present by hard-working men, a bookish man is apt to think that even the almighty capitalist can hardly take away from his slave if he has really learned to enjoy reading and to understand books, and that whatever happens he must have an hour in a day (or if it were only half an hour) to indulge himself in this pleasure. But then does the average hard-working man (of any grade) really acquire this capacity by means of the short period of education which he is painfully dragged through? I doubt it. Though even our mechanical school system cannot crush out a natural bent towards literature (with all the pleasures of thought and imagination which that word means) yet certainly its dull round will hardly implant such a taste in anyone's mind. . . . I must say in passing that on the few occasions that I have been inside a Board-school, I have been much depressed by the mechanical drill that was too obviously being applied there to all the varying capacities and moods. My heart sank before Mr M'Choakumchild and his method, and I thought how much luckier I was to have been born well enough off to be sent to a school where I was *taught* – nothing, but *learned* archaeology and romance on the Wiltshire downs.

And then supposing the worker to be really educated, to have acquired both the information and the taste for reading which Mr M'Choakumchild's dole will allow to him under the most favourable circumstances, how will this treasure of knowledge and sympathy accord with his daily life? Will it not make his dull task seem duller? Will it not increase the suffering of the workshop or the factory to him? And if so, may he not strive to forget rather than strive to remember . . .?

Then there is the enormous mass of printed paper which is not books or literature, but which the public pays for every day, since I suppose a faculty once acquired produces a habit and must be exercised even when it is the mechanical one of reading print. No adventure in this kind of wares has any chance of success if it has more than the merest suspicion of a flavour of literature or thoughtfulness, as we have often been told when the prospects of the *Commonweal* have

been under discussion. I will not say that the worse a periodical is the better chance it has of success, but that if it intends to succeed it must appeal to habits that are as much akin to the reasonable aims of education as is the twiddling of a bit of string by a fidgeting person. I believe, indeed, it is thought by some that this habit of the consumption of newspapers is the first step in education. Good! the second step, I take it, will be the end of that habit.

(From an article in *Commonweal*, June 1888)

## 39: EDUCATION FOR TOMORROW

AT the risk of being misunderstood by hot-heads, I say that our business is more than ever in *Education*.

The gospel of Discontent is in a fair way towards forcing itself on the whole of the workers; how can that discontent be used so as to bring about the New Birth of Society? That is the question we must always have before us. It is too much to hope that the *whole* working class can be educated in the aims of Socialism in due time, before other surprises take place. But we *must* hope that a strong party can be so educated in economics, in organization, and in administration. To such a body of men all the aspirations and vague opinions of the oppressed multitudes would drift, and little by little they would be educated by them, if the march of events should give us time; or if not, even half-educated they would follow them in any action which it was necessary to take.

(From an article in *Commonweal*, March 1886)

# 40: SELF-HELP NO REMEDY

... Now much as I want to see workmen escape from their slavish position, I don't at all want to see a few individuals more creep out of their class into the middle class; this will only make the poor poorer still: and this effect I repeat of multiplying the capitalist class (every member of which you must remember is engaged in fierce private commercial war with his fellows) is the utmost that could result from even a large number of the employers giving up their profits to their workmen – even supposing such a wild dream could be realized. The utmost, I say, because the greater number of the men kept down by years of slavery would not know how to spend their newly gained wealth but would let it slip through their fingers to swell the gains of the exploiting tradesmen who are on the look out for such soft-heads. If you doubt this remember that even now there are at times artisans who receive very high wages, but that their exceptional good luck has no influence over the general army of wage earners, and that they themselves have in consequence only two choices: the first to rise out of their class as above, the second to squander their high earnings and remain in the long run at the ordinary low standard of life of their less lucky brethren: the really desirable thing that being still workmen they should rise in culture and refinement they can *only* attain to by their whole class rising.

This, as things go, especially since England has lost her monopoly of trade and manufacture is *impossible*: the competition for subsistence among workmen forbids the serious rise of the standard of life for any long period, taking labour all round: it is true that the Trades Unions by combination did manage to raise that standard for skilled labour; but their combination as on the one hand it was not international and so allowed other nations to undersell us and so reduce wages or threaten reduction of wages even for them (which will certainly come), so on the other hand it did not take in the unskilled labourers, who are scarcely in any better position than they were fifty years ago – and in any case in a condition which makes one almost ashamed to live – in spite of the enormous increased wealth of the country in general. ...

... You may be sure that the capitalist class as a class will struggle as the representative of the old or conservative idea against the working class as the representative of the new or reconstructive idea: will, nay does and I repeat cannot help doing so. ...

(From a letter to Mrs Burne-Jones,
1 June 1884)

## 41: GOOD-WILL NO REMEDY

... WHERE I think I differ from you of the means whereby revolution may be attained is this: if I do not misrepresent your views, you think that *individuals* of good will belonging to all classes of men can, if they be numerous and strenuous enough, bring about the change. I on the contrary think that the basis of all change must be, as it has always been, the antagonism of classes: I mean that though here and there a few men of the upper and middle classes, moved by their conscience and insight, may and doubtless will throw in their lot with the working classes, the upper and middle classes as a body will by the very nature of their existence, and like a plant grows, resist the abolition of classes: neither do I think that any amelioration of the condition of the poor on the only lines which the rich *can* go upon will advance us on the road; save that it will put more power into the hands of the lower class and so strengthen both their discontent and their means of showing it: for I do not believe that starvelings can bring about a revolution. I do not say that there is not a terrible side to this: but how can it be otherwise? Commercialism, competition, has sown the wind recklessly, and must reap the whirlwind: it has created the proletariat for its own interest, and its creation will and must destroy it: there is no other force which can do so. For my part I have never underrated the power of the middle classes, whom, in spite of their individual good nature and banality, I look upon as a most terrible and implacable force: so terrible that I think it not unlikely that their resistance to inevitable change may, if the beginnings of change are too long delayed, ruin all civilization for a time. Meantime I must tell you that among the discontented, discontent unlighted

by hope is in many places taking the form of a passionate desire for mere anarchy, so that it becomes a pressing duty for those who, not believing in the stability of the present system, have any hopes for the future, to lay before the world those hopes founded on *constructive* revolution.

(From a letter to T. C. Horsfall, 25 October 1883)

## 42: 'A THEORY OF LIFE'

SOCIALISM is a theory of life, taking for its starting point the evolution of society; or, let us say, of man as a social being.

Since man has certain material *necessities* as an animal, Society is founded on man's attempts to satisfy those necessities; and Socialism, or social consciousness, points out to him the way of doing so which will interfere least with the development of his specially human capacities, and the satisfaction of what, for lack of better words, I will call his spiritual and mental necessities.

The foundation of Socialism, therefore, is economical. Man as a social animal tends to the acquirement of power over nature, and to the beneficent use of that power, which again implies a condition of society in which everyone is able to satisfy his needs in return for the due exercise of his capacities for the benefit of the race. But this economical aim which, to put it in another way, is the fair apportionment of labour and the results of labour, must be accompanied by an ethical or religious sense of the responsibility of each man to each and all of his fellows.

Socialism aims, therefore, at realizing equality of condition as its economical goal, and the habitual love of humanity as its rule of ethics.

Properly speaking in a condition of equality politics would no longer exist; but, to use the word as distinguishing the social habits that have not to do directly with production, the political position of Socialism is to substitute the relation of persons to persons, for the relation of things to persons. A man, I mean, would no longer take

his position as the dweller in such and such a place, or the filler of such and such an office, or (as now) the owner of such and such property, but as being such and such a man. In such a state of Society laws of repression would be minimized, and the whole body of law which now deals with things and their domination over persons would cease to exist. In a condition of personal equality, also, there could no longer be rivalry between those inhabiting different places. Nationality, except as a geographical or ethnological expression, would have no meaning.

Equality as to livelihood, mutual respect, and responsibility, and complete freedom within those limits – which would, it must be remembered, be accepted voluntarily, and indeed habitually – are what Socialism looks forward to.

But there would be few, if any, Socialists, who would not admit that between this condition of things and our present Society there must be a transitional condition, during which we must waive the complete realization of our ideal.

This transitional condition is what we socialists of today believe will be gradually brought about in our times. It will be brought about partly we think by the further development of democracy, and partly by the conscious attempts of the Socialists themselves.

The democracy have yet to get rid of certain survivals and superstitions. They will also be forced to deal with the circumstances produced by the gradual decline of the commercial system which has created democracy; as, for instance, the lack of employment for a large part of the population; their lack of leisure; their wretched housing, and so forth. The democracy by such action will improve the position of the working classes, or at least they will put them into such a position as will increase their discontent by making them conscious of possible remedies for their inferior position. But as constitutional democrats they can go no further than this: they must take the present relations between wage earners and capitalists as a basis for improvement and on that basis improvement must be very limited. It is the Socialists only who can claim a measure which will realize a new basis of society; that measure is the *abolition of private ownership in the means of production*. The land, factories, machinery, means of transit, and whatever wealth of any sort is used for the reproduction

of wealth, and which therefore is necessary to labour and can only be *used* by it, must be *owned* by the nation only, to be *used* by the workers (who will then include all honest men) according to their capacity.

This claim for the abolition of the monopoly in the means of production is made by all socialists of every shade; it forms the political platform of the party, and nothing short of this is a definite socialist claim. It is true that some of us (myself amongst others) look further than this, as the first part of my paper indicates; but we are all prepared to accept whatever consequences may follow the realization of this claim; and for my part I believe that whatever struggle or violence there may be in the realization of Socialism will all take place in the carrying out of this initial step; that after that the class struggle, now thousands of years old, having come to an end, no new class will arise to dominate the workers; and that whatever steps may be necessary to bring us to the fullness of the fellowship, which, as you justly say, is the aim of Socialism, there will be no serious contest over them; they will come of themselves until the habit of Socialism will be thoroughly formed, and no one will have to use the word any more, as it will embrace the whole of human life. What further fullness of the consciousness of life may follow on that none can say. Only this remains to be said: that Socialism does not recognize any finality in the progress and aspirations of humanity; and that we clearly understand that the furthest we can now conceive of is only a stage of the great journey of evolution that joins the future and the past to the present.

This seems to me to be a fair sketch of what Socialists wish to see brought about. I have not attempted to go into details as to the means and so forth because I suppose what you wanted was just the root principles, and the necessary actions resulting from them.

(From *Four Letters on Socialism*, privately printed, 1894)

## 43: 'A SOCIETY OF EQUALITY'

WHILE I think that the hope of the new-birth of society is certainly growing, and that speedily, I must confess myself puzzled about the means towards that end which are mostly looked after now; and I am doubtful if some of the measures which are pressed, mostly, I think, with all honesty of purpose, and often with much ability, would, if gained, bring us any further on the direct road to a really new-born society, the only society which can be a new birth, a society of practical equality. Not to make any mystery about it, I mean that the great mass of what most non-Socialists at least consider at present to be Socialism, seems to me nothing more than a *machinery* of Socialism. . . . Who can quarrel with the attempts to relieve the sordidness of civilized town life by the public acquirement of parks and other open spaces, planting of trees, establishment of free libraries, and the like? . . . More time might be insisted on for the education of children; and so on, and so on. In all this I freely admit a great gain, and am glad to see schemes tried which would lead to it. But great as the gain would be, the ultimate good of it, the amount of progressive force that might be in such things would, I think, depend on *how* such reforms were done; in what spirit; or rather what else was being done, while these were going on, which would make people long for equality of condition; which would give them faith in the possibility and workableness of Socialism. . . . If the sum of them should become vast and deep reaching enough to give to the useful or working classes intelligence enough to conceive of a life of equality and cooperation; courage enough to accept it and to bring the necessary skill to bear on working it; and power enough to force its acceptance on the stupid and the interested, the war of classes would speedily end in the victory of the useful class, which would then become the new Society of Equality. . . . Here again come in those doubts and the puzzlement I began by talking about. . . . Whether the Society of Inequality might not accept the quasi-Socialist machinery above mentioned, and work it for the purpose of upholding that society in a somewhat shorn condition, maybe, but a safe one. That seems to me possible, and means the other side of the view: instead of the useless classes being swept away by the

useful, the useless classes gaining some of the usefulness of the workers, and *so* safeguarding their privilege. The workers better treated, better organized, helping to govern themselves, but with no more pretence to equality with the rich, nor any more hope for it than they have now. But if this be possible, it will only be so on the grounds that the working people have ceased to desire real Socialism and are contented with some outward show of it joined to an increase in prosperity enough to satisfy the cravings of men who do not know what the pleasures of life might be....

(From *Communism*, 1893, published as Fabian Tract 113, with a preface by George Bernard Shaw, in 1903)

## 44: SOCIALIST MORALITY

... I ASK you to think with me that the worst which can happen to us is to endure tamely the evils that we see; that no trouble or turmoil is so bad as that; that the necessary destruction which reconstruction bears with it must be taken calmly; that everywhere – in State, in Church, in the household – we must be resolute to endure no tyranny, accept no lie, quail before no fear, although they may come before us disguised as piety, duty, or affection, as useful opportunity and good-nature, as prudence or kindness. The world's roughness, falseness, and injustice will bring about their natural consequences, and we and our lives are part of those consequences; but since we inherit also the consequences of old resistance to those curses, let us each look to it to have our fair share of that inheritance also, which, if nothing else come of it, will at least bring to us courage and hope; that is, eager life while we live, which is above all things the Aim of Art....

(From *The Aims of Art*, 1887)

## 45: CAPITALIST MORALITY

A CASE of white-lead poisoning reported in the press this week is worth a little notice by workmen generally. Stripped of verbiage it amounts to this, that a man was killed by being compelled to work in a place where white-lead was flying about, and that no precautions were taken to prevent his dying speedily. A shilling-a-week extra was the handsome sum given to the poor man thus murdered in compensation for his being killed. It is quite impossible that the man's employers did not know the risk he ran of this speedier death, and the certainty of his being poisoned later, and yet all that the jury durst say about the matter was 'to express a hope that Mr Lakeman (the factory inspector) would be able to make representations to the Home Office with reference to the case, to show the necessity for some extra precautions being taken for people working in mixing factories'.

Yet further this is only an exaggerated example of the way in which the lives of working-people are played with. Under present conditions, almost the whole labour imposed by civilization on the 'lower classes' is unwholesome; that is to say that people's lives are shortened by it; and yet because we don't see people's throats cut before our eyes we think nothing of it.

(From an article in *Commonweal*,
October 1886)

## 46: A DEATH SONG

WHAT cometh here from west to east awending?
And who are these, the marchers stern and slow?
We bear the message that the rich are sending
Aback to those who bade them wake and know.
*Not one, not one, nor thousands must they slay,*
*But one and all if they would dusk the day.*

We asked them for a life of toilsome earning,
They bade us bide their leisure for our bread;

We craved to speak to tell our woeful learning:
We come back speechless, bearing back our dead.
*Not one, not one, nor thousands must they slay,*
*But one and all if they would dusk the day.*

They will not learn; they have no ears to hearken.
They turn their faces from the eyes of fate;
Their gay-lit halls shut out the skies that darken.
But, lo! this dead man knocking at the gate.
*Not one, not one, nor thousands must they slay,*
*But one and all if they would dusk the day.*

Here lies the sign that we shall break our prison;
Amidst the storm he won a prisoner's rest;
But in the cloudy dawn the sun arisen
Brings us our day of work to win the best.
*Not one, not one, nor thousands must they slay,*
*But one and all if they would dusk the day.*

(Written for the funeral of Alfred Linnell, 1887)

## 47: THE DAY THAT YET SHALL BE

... BUT those days we lived, as I tell you, a life that was not our
    own;
And we saw but the hope of the world, and the seed that the ages had
    sown,
Spring up now a fair-blossomed tree from the earth lying over the
    dead;
Earth quickened, earth kindled to spring-tide with the blood that her
    lovers have shed,
With the happy days cast off for the sake of her happy day,
With the love of women foregone, and the bright youth worn away,
With the gentleness stripped from the lives thrust into the jostle of
    war,
With the hope of the hardy heart forever dwindling afar.

O Earth, Earth, look on thy lovers, who knew all thy gifts and thy
    gain,
But cast them aside for thy sake, and caught up a barren pain!
Indeed of some art thou mindful, and ne'er shall forget their tale,
Till shrunk are the floods of thine ocean and thy sun is waxen pale.
But rather I bid thee remember e'en those of the latter days,
Who were fed by no fair promise and made drunken by no praise . . .
Their life was thy deliverance, O Earth, and for thee they fought;
Mid the jeers of the happy and deedless, mid failing friends they went
To their foredoomed fruitful ending on the love of thee intent.
Yea and we were a part of it all, the beginning of the end,
The first fight of the uttermost battle whither all the nations wend;
And yet could I tell you its story, you might think it little and mean.
For few of you now will be thinking of the day that might have been,
And fewer still meseemeth of the day that yet shall be,
That shall light up that first beginning and its tangled misery . . .

(From *The Pilgrims of Hope*, XII,
'Meeting the War-Machine'.)

## 48: HOW WE LIVE AND HOW WE MIGHT LIVE

THE word Revolution, which we Socialists are so often forced to
use, has a terrible sound in most people's ears, even when we have
explained to them that it does not necessarily mean a change accom-
panied by riot and all kinds of violence, and cannot mean a change
made mechanically and in the teeth of opinion by a group of men
who have somehow managed to seize on the executive power for the
moment. Even when we explain that we use the word revolution in
its etymological sense, and mean by it a change in the basis of society,
people are scared at the idea of such a vast change, and beg that you
will speak of reform and not revolution. As, however, we Socialists
do not at all mean by our word revolution what these worthy people
mean by their word reform, I can't help thinking that it would be a
mistake to use it, whatever projects we might conceal beneath its

harmless envelope. So we will stick to our word, which means a change of the basis of society; it may frighten people, but it will at least warn them that there is something to be frightened about, which will be no less dangerous for being ignored; and also it may encourage some people, and will mean to them at least not a fear, but a hope.

Fear and Hope – those are the names of the two great passions which rule the race of man, and with which revolutionists have to deal; to give hope to the many oppressed and fear to the few oppressors, that is our business; if we do the first and give hope to the many, the few *must* be frightened by their hope; otherwise we do not want to frighten them; it is not revenge we want for poor people, but happiness; indeed, what revenge can be taken for all the thousands of years of the sufferings of the poor?

However, many of the oppressors of the poor, most of them, we will say, are not conscious of their being oppressors (we shall see why presently); they live in an orderly, quiet way themselves, as far as possible removed from the feelings of a Roman slave-owner or a Legree; they know that the poor exist, but their sufferings do not present themselves to them in a trenchant and dramatic way; they themselves have troubles to bear, and they think doubtless that to bear trouble is the lot of humanity; nor have they any means of comparing the troubles of their lives with those of people lower in the social scale; and if ever the thought of those heavier troubles obtrudes itself upon them, they console themselves with the maxim that people do get used to the troubles they have to bear, whatever they may be.

Indeed, as far as regards individuals at least, that is but too true, so that we have as supporters of the present state of things, however bad it may be, first those comfortable unconscious oppressors who think that they have everything to fear from any change which would involve more than the softest and most gradual of reforms, and secondly those poor people who, living hard and anxiously as they do, can hardly conceive of any change for the better happening to them, and dare not risk one tittle of their poor possessions in taking any action towards a possible bettering of their condition; so that while we can do little with the rich save inspire them with fear, it is hard indeed to give the poor any hope. It is, then, no less than reasonable that those whom we try to involve in the great struggle for a better form of life

than that which we now lead should call on us to give them at least some idea of what that life may be like.

A reasonable request, but hard to satisfy, since we are living under a system that makes conscious effort towards reconstruction almost impossible: it is not unreasonable on our part to answer, 'There are certain definite obstacles to the real progress of man; we can tell you what these are; take them away, and then you shall see.'

However, I purpose now to offer myself as a victim for the satisfaction of those who consider that as things now go we have at least got something, and are terrified at the idea of losing their hold of that, lest they should find they are worse off than before, and have nothing. Yet in the course of my endeavour to show how we might live, I must more or less deal in negatives. I mean to say I must point out where in my opinion we fall short in our present attempt at decent life. I must ask the rich and well-to-do what sort of a position it is which they are so anxious to preserve at any cost? and, if after all, it will be such a terrible loss to them to give it up? and I must point out to the poor that they, with capacities for living a dignified and generous life, are in a position which they cannot endure without continued degradation.

How do we live, then, under our present system? Let us look at it a little.

And first, please to understand that our present system of Society is based on a state of perpetual war. Do any of you think that this is as it should be? I know that you have often been told that the competition, which is at present the rule of all production, is a good thing, and stimulates the progress of the race; but the people who tell you this should call competition by its shorter name of *war* if they wish to be honest, and you would then be free to consider whether or no war stimulates progress, otherwise than as a mad bull chasing you over your own garden may do. War, or competition, whichever you please to call it, means at the best pursuing your own advantage at the cost of someone else's loss, and in the process of it you must not be sparing of destruction even of your own possessions, or you will certainly come by the worse in the struggle. You understand that perfectly as to the kind of war in which people go out to kill and be killed; that sort of war in which ships are commissioned, for instance,

'to sink, burn, and destroy'; but it appears that you are not so conscious of this waste of goods when you are only carrying on that other war called *commerce*; observe, however, that the waste is there all the same.

Now let us look at this kind of war a little closer, run through some of the forms of it, that we may see how the 'burn, sink, and destroy' is carried on in it.

First, you have that form of it called national rivalry, which in good truth is nowadays the cause of all gunpowder and bayonet wars which civilized nations wage. For years past we English have been rather shy of them, except on those happy occasions when we could carry them on at no sort of risk to ourselves, when the killing was all on one side, or at all events when we hoped it would be. We have been shy of gunpowder war with a respectable enemy for a long while, and I will tell you why: It is because we have had the lion's share of the world-market; we didn't want to fight for it as a nation, for we had got it; but now this is changing in a most significant, and, to a Socialist, a most cheering way; we are losing or have lost that lion's share; it is now a desperate 'competition' between the great nations of civilization for the world market, and tomorrow it may be a desperate war for that end. As a result, the furthering of war (if it be not on too large a scale) is no longer confined to the honour-and-glory kind of old Tories, who if they meant anything at all by it meant that a Tory war would be a good occasion for damping down democracy; we have changed all that, and now it is quite another kind of politician that is wont to urge us on to 'patriotism' as 'tis called. The leaders of the Progressive Liberals, as they would call themselves, long-headed persons who know well enough that social movements are going on, who are not blind to the fact that the world will move with their help or without it; these have been the Jingoes of these later days. I don't mean to say they know what they are doing: politicians, as you well know, take good care to shut their eyes to everything that may happen six months ahead; but what is being done is this: that the present system, which always must include national rivalry, is pushing us into a desperate scramble for the markets on more or less equal terms with other nations, because, once more, we have lost that command of them which we once had. Desperate is not too strong a word. We

shall let this impulse to snatch markets carry us whither it will, whither it must. Today it is successful burglary and disgrace, tomorrow it may be mere defeat and disgrace.

Now this is not a digression, although in saying this I am nearer to what is generally called politics than I shall be again. I only want to show you what commercial war comes to when it has to do with foreign nations, and that even the dullest can see how mere waste must go with it. That is how we live now with foreign nations, prepared to ruin them without war if possible, with it if necessary, let alone meantime the disgraceful exploiting of savage tribes and barbarous peoples on whom we force at once our shoddy wares and our hypocrisy at the cannon's mouth.

Well, surely Socialism can offer you something in the place of all that. It can; it can offer you peace and friendship instead of war. We might live utterly without national rivalries, acknowledging that while it is best for those who feel that they naturally form a community under one name to govern themselves, yet that no community in civilization should feel that it had interests opposed to any other, their economical condition being at any rate similar; so that any citizen of one community could fall to work and live without disturbance of his life when he was in a foreign country, and would fit into his place quite naturally; so that all civilized nations would form one great community, agreeing together as to the kind and amount of production and distribution needed; working at such and such production where it could be best produced; avoiding waste by all means. Please to think of the amount of waste which they would avoid, how much such a revolution would add to the wealth of the world! What creature on earth would be harmed by such a revolution? Nay, would not everybody be the better for it? And what hinders it? I will tell you presently.

Meantime let us pass from this 'competition' between nations to that between 'the organizers of labour', great firms, joint-stock companies; capitalists in short, and see how competition 'stimulates production' among them: indeed it does do that; but what kind of production? Well, production of something to sell at a profit, or say production of profits: and note how war commercial stimulates that: a certain market is demanding goods; there are, say, a hundred manu-

facturers who make that kind of goods, and every one of them would if he could keep that market to himself, and struggles desperately to get as much of it as he can, with the obvious result that presently the thing is overdone, and the market is glutted, and all that fury of manufacture has to sink into cold ashes. Doesn't that seem something like war to you? Can't you see the waste of it – waste of labour, skill, cunning, waste of life in short? Well you may say, but it cheapens the goods. In a sense it does; and yet only apparently, as wages have a tendency to sink for the ordinary worker in proportion as prices sink; and at what a cost do we gain this appearance of cheapness! Plainly speaking, at the cost of cheating the consumer and starving the real producer for the benefit of the gambler, who uses both consumer and producer as his milch cows. I needn't go at length into the subject of adulteration, for everyone knows what kind of a part it plays in this sort of commerce; but remember that it is an absolutely necessary incident to the production of profit out of wares, which is the business of the so-called manufacturer; and this you must understand, that, taking him in the lump, the consumer is perfectly helpless against the gambler; the goods are forced on him by their cheapness, and with them a certain kind of life which that energetic, that aggressive cheapness determines for him: for so far-reaching is this curse of commercial war that no country is safe from its ravages; the traditions of a thousand years fall before it in a month; it overruns a weak or semi-barbarous country, and whatever romance or pleasure or art existed there, is trodden down into a mire of sordidness and ugliness; the Indian or Javanese craftsman may no longer ply his craft leisurely, working a few hours a day, in producing a maze of strange beauty on a piece of cloth: a steam-engine is set a-going at Manchester, and that victory over nature and a thousand stubborn difficulties is used for the base work of producing a sort of plaster of china-clay and shoddy, and the Asiatic worker, if he is not starved to death outright, as plentifully happens, is driven himself into a factory to lower the wages of his Manchester brother worker, and nothing of character is left him except, most like, an accumulation of fear and hatred of that to him most unaccountable evil, his English master. The South Sea Islander must leave his canoe-carving, his sweet rest, and his graceful dances and become the slave of a slave: trousers, shoddy, rum, missionary,

and fatal disease – he must swallow all this civilization in the lump, and neither himself nor we can help him now till social order displaces the hideous tyranny of gambling that has ruined him.

Let those be types of the consumer: but now for the producer; I mean the real producer, the worker; how does this scramble for the plunder of the market affect him? The manufacturer, in the eagerness of his war, has had to collect into one neighbourhood a vast army of workers, he has drilled them till they are as fit as may be for his special branch of production, that is, for making a profit out of it, and with the result of their being fit for nothing else: well, when the glut comes in that market he is supplying, what happens to this army, every private in which has been depending on the steady demand in that market, and acting, as he could not choose but act, as if it were to go on for ever? You know well what happens to these men: the factory door is shut on them; on a very large part of them often, and at the best on the reserve army of labour, so busily employed in the time of inflation. What becomes of them? Nay, we know that well enough just now. But what we don't know, or don't choose to know, is that this reserve army of labour is an absolute necessity for commercial war; if *our* manufacturers had not got these poor devils whom they could draft on to their machines when the demand swelled, other manufacturers in France, or Germany, or America, would step in and take the market from them.

So you see, as we live now, it is necessary that a vast part of the industrial population should be exposed to the danger of periodical semi-starvation, and that, not for the advantage of the people in another part of the world, but for their degradation and enslavement.

Just let your minds run for a moment on the kind of waste which this means, this opening up of new markets among savage and barbarous countries which is the extreme type of the force of the profit-market on the world, and you will surely see what a hideous nightmare that profit-market is: it keeps us sweating and terrified for our livelihood, unable to read a book, or look at a picture, or have pleasant fields to walk in, or to lie in the sun, or to share in the knowledge of our time, to have in short either animal or intellectual pleasure, and for what? that we may go on living the same slavish life till we die, in order to provide for a rich man what is called a life of

ease and luxury; that is to say, a life so empty, unwholesome, and degraded, that perhaps, on the whole, he is worse off than we the workers are: and as to the result of all this suffering, it is luckiest when it is nothing at all, when you can say that the wares have done nobody any good; for oftenest they have done many people harm, and we have toiled and groaned and died in making poison and destruction for our fellow-men.

Well, I say all this is war, and the result of war, the war this time, not of competing nations, but of competing firms or capitalist units: and it is this war of the firms which hinders the peace between nations which you surely have agreed with me in thinking is so necessary; for you must know that war is the very breath of the nostrils of these fighting firms, and they have now, in our times, got into their hands nearly all the political power, and they band together in each country in order to make their respective governments fulfil just two functions: the first is at home to act as a strong police force, to keep the ring in which the strong are beating down the weak; the second is to act as a piratical bodyguard abroad, a petard to explode the doors which lead to the markets of the world: markets at any price abroad, uninterfered-with privilege, falsely called *laissez-faire*,★ at any price at home, to provide these is the sole business of a government such as our industrial captains have been able to conceive of. I must now try to show you the reason of all this, and what it rests on, by trying to answer the question, Why have the profit-makers got all this power, or at least why are they able to keep it?

That takes us to the third form of war commercial: the last, and the one which all the rest is founded on. We have spoken first of the war of rival nations; next of that of rival firms: we have now to speak of rival men. As nations under the present system are driven to compete with one another for the markets of the world, and as firms or the captains of industry have to scramble for their share of the profits of the markets, so also have the workers to compete with each other – for livelihood; and it is this constant competition or war amongst them which enables the profit-grinders to make their profits, and by means

---

★ Falsely; because the privileged classes have at their back the force of the Executive by means of which to compel the unprivileged to accept the terms. If this is 'free competition' there is no meaning in words.

of the wealth so acquired to take all the executive power of the country into their hands. But here is the difference between the position of the workers and the profit-makers: to the latter, the profit-grinders, war is necessary; you cannot have profit-making without competition, individual, corporate, and national; but you may work for a livelihood without competing; you may combine instead of competing.

I have said war was the life-breath of the profit-makers; in like manner, combination is the life of the workers. The working classes or proletariat cannot even exist as a class without combination of some sort. The necessity which forced the profit-grinders to collect their men first into workshops working by the division of labour, and next into great factories worked by machinery, and so gradually draw them into the great towns and centres of civilization, gave birth to a distinct working class or proletariat: and this it was which gave them their *mechanical* existence, so to say. But note, that they are indeed combined into social groups for the production of wares, but only as yet mechanically; they do not know what they are working at, nor whom they are working for, because they are combining to produce wares of which the profit of a master forms an essential part, instead of goods for their own use: as long as they do this, and compete with each other for leave to do it, they will be, and will feel themselves to be, simply a part of those competing firms I have been speaking of; they will be in fact just a part of the machinery for the production of profit; and so long as this lasts it will be the aim of the masters or profit-makers to decrease the market value of this human part of the machinery; that is to say, since they already hold in their hands the labour of dead men in the form of capital and machinery, it is their interest, or we will say their necessity, to pay as little as they can help for the labour of living men which they have to buy from day to day: and since the workmen they employ have nothing but their labour-power, they are compelled to underbid one another for employment and wages, and so enable the capitalist to play his game.

I have said that, as things go, the workers are a part of the competing firms, an adjunct of capital. Nevertheless, they are only so by compulsion; and, even without their being conscious of it, they struggle against that compulsion and its immediate results, the lowering of their wages, of their standard of life: and this they do, and must

do, both as a class and individually: just as the slave of the great Roman lord, though he distinctly felt himself to be a part of the household, yet collectively was a force in reserve for its destruction, and individually stole from his lord whenever he could safely do so. So, here, you see, is another form of war necessary to the way we live now, the war of class against class, which, when it rises to its height, and it seems to be rising at present, will destroy those other forms of war we have been speaking of; will make the position of the profit-makers, of perpetual commercial war, untenable; will destroy the present system of competitive privilege, or commercial war.

Now observe, I said that to the existence of the workers it was combination, not competition, that was necessary, while to that of the profit-makers combination was impossible, and war necessary. The present position of the workers is that of the machinery of commerce, or in plainer words its slaves; when they change that position and become free, the class of profit-makers must cease to exist; and what will then be the position of the workers? Even as it is they are the one necessary part of society, the life-giving part; the other classes are but hangers-on who live on them. But what should they be, what will they be, when they, once for all, come to know their real power, and cease competing with one another for livelihood? I will tell you: they will be society, they will be the community. And being society – that is, there being no class outside them to contend with – they can then regulate their labour in accordance with their own real needs.

There is much talk about supply and demand, but the supply and demand usually meant is an artificial one; it is under the sway of the gambling market; the demand is forced, as I hinted above, before it is supplied; nor, as each producer is working against all the rest, can the producers hold their hands, till the market is glutted and the workers, thrown out on the streets, hear that there has been over-production, amidst which over-plus of unsaleable goods they go ill-supplied with even necessaries, because the wealth which they themselves have created is 'ill-distributed', as we call it – that is, unjustly taken away from them.

When the workers are society they will regulate their labour, so that the supply and demand shall be genuine, not gambling; the two

will then be commensurate, for it is the same society which demands that also supplies; there will be no more artificial famines then, no more poverty amidst over-production, amidst too great a stock of the very things which should supply poverty and turn it into well-being. In short, there will be no waste and therefore no tyranny.

Well, now, what Socialism offers you in place of these artificial famines, with their so-called over-production, is, once more, regulation of the markets; supply and demand commensurate; no gambling, and consequently (once more) no waste; not overwork and weariness for the worker one month, and the next no work and terror of starvation, but steady work and plenty of leisure every month; not cheap market wares, that is to say, adulterated wares, with scarcely any *good* in them, mere scaffold-poles for building up profits; no labour would be spent on such things as these, which people would cease to want when they ceased to be slaves. Not these, but such goods as best fulfilled the real uses of the consumers would labour be set to make; for, profit being abolished, people could have what they wanted, instead of what the profit-grinders at home and abroad forced them to take.

For what I want you to understand is this: that in every civilized country at least there is plenty for all – is, or at any rate might be. Even with labour so misdirected as it is at present, an equitable distribution of the wealth we have would make all people comparatively comfortable; but that is nothing to the wealth we might have if labour were not misdirected.

Observe, in the early days of the history of man he was the slave of his most immediate necessities; Nature was mighty and he was feeble, and he had to wage constant war with her for his daily food and such shelter as he could get. His life was bound down and limited by this constant struggle; all his morals, laws, religion, are in fact the outcome and the reflection of this ceaseless toil of earning his livelihood. Time passed, and little by little, step by step, he grew stronger, till now after all these ages he has almost completely conquered Nature, and one would think should now have leisure to turn his thoughts towards higher things than procuring tomorrow's dinner. But, alas! his progress has been broken and halting; and though he has indeed conquered Nature and has her forces under his control to do what he will

with, he still has himself to conquer, he still has to think how he will best use those forces which he has mastered. At present he uses them blindly, foolishly, as one driven by mere fate. It would almost seem as if some phantom of the ceaseless pursuit of food which was once the master of the savage was still hunting the civilized man; who toils in a dream, as it were, haunted by mere dim unreal hopes, borne of vague recollections of the days gone by. Out of that dream he must wake, and face things as they really are. The conquest of Nature is complete, may we not say? and now our business is and has for long been the organization of man, who wields the forces of Nature. Nor till this is attempted at least shall we ever be free of that terrible phantom of fear of starvation which, with its brother devil, desire of domination, drives us into injustice, cruelty, and dastardliness of all kinds: to cease to fear our fellows and learn to depend on them, to do away with competition and build up cooperation, is our one necessity.

Now, to get closer to details; you probably know that every man in civilization is worth, so to say, more than his skin; working, as he must work, socially, he can produce more than will keep himself alive and in fair condition; and this has been so for many centuries, from the time, in fact, when warring tribes began to make their conquered enemies slaves instead of killing them; and of course his capacity of producing these extras has gone on increasing faster and faster, till today one man will weave, for instance, as much cloth in a week as will clothe a whole village for years; and the real question of civilization has always been what are we to do with this extra produce of labour – a question which the phantom, fear of starvation, and its fellow, desire of domination, has driven men to answer pretty badly always, and worst of all perhaps in these present days, when the extra produce has grown with such prodigious speed. The practical answer has always been for man to struggle with his fellow for private possession of undue shares of these extras, and all kinds of devices have been employed by those who found themselves in possession of the power of taking them from others to keep those whom they had robbed in perpetual subjection; and these latter, as I have already hinted, had no chance of resisting this fleecing as long as they were few and scattered, and consequently could have little sense of their

common oppression. But now that, owing to the very pursuit of these undue shares of profit, or extra earnings, men have become more dependent on each other for production, and have been driven, as I said before, to combine together for that end more completely, the power of the workers – that is to say, of the robbed or fleeced class – has enormously increased, and it only remains for them to understand that they have this power. When they do that they will be able to give the right answer to the question what is to be done with the extra products of labour over and above what will keep the labourer alive to labour: which answer is, that the worker will have all that he produces, and not be fleeced at all: and remember that he produces collectively, and therefore he will do effectively what work is required of him according to his capacity, and of the produce of that work he will have what he needs; because, you see, he cannot *use* more than he needs – he can only *waste* it.

If this arrangement seems to you preposterously ideal, as it well may, looking at our present condition, I must back it up by saying that when men are organized so that their labour is not wasted, they will be relieved from the fear of starvation and the desire of domination, and will have freedom and leisure to look round and see what they really do need.

Now something of that I can conceive for my own self, and I will lay my ideas before you, so that you may compare them with your own, asking you always to remember that the very differences in men's capacities and desires, after the common need of food and shelter is satisfied, will make it easier to deal with their desires in a communal state of things.

What is it that I need, therefore, which my surrounding circumstances can give me – my dealings with my fellow-men – setting aside inevitable accidents which cooperation and forethought cannot control, if there be such?

Well, first of all I claim good health; and I say that a vast proportion of people in civilization scarcely even know what that means. To feel mere life a pleasure; to enjoy the moving of one's limbs and exercising one's bodily powers; to play, as it were, with sun and wind and rain; to rejoice in satisfying the due bodily appetites of a human animal without fear of degradation or sense of wrong-doing: yes, and

therewithal to be well-formed, straight-limbed, strongly knit, expressive of countenance – to be, in a word, beautiful – that also I claim. If we cannot have this claim satisfied, we are but poor creatures after all; and I claim it in the teeth of those terrible doctrines of asceticism, which, born of the despair of the oppressed and degraded, have been for so many ages used as instruments for the continuance of that oppression and degradation.

And I believe that this claim for a healthy body for all of us carries with it all other due claims: for who knows where the seeds of disease which even rich people suffer from were first sown: from the luxury of an ancestor, perhaps; yet often, I suspect, from his poverty. And for the poor: a distinguished physicist has said that the poor suffer always from one disease – hunger; and at least I know this, that if a man is overworked in any degree he cannot enjoy the sort of health I am speaking of; nor can he if he is continually chained to one dull round of mechanical work, with no hope at the other end of it; nor if he lives in continual sordid anxiety for his livelihood, nor if he is ill-housed, nor if he is deprived of all enjoyment of the natural beauty of the world, nor if he has no amusement to quicken the flow of his spirits from time to time: all these things, which touch more or less directly on his bodily condition, are born of the claim I make to live in good health; indeed, I suspect that these good conditions must have been in force for several generations before a population in general will be really healthy, as I have hinted above; but also I doubt not that in the course of time they would, joined to other conditions, of which more hereafter, gradually breed such a population, living in enjoyment of animal life at least, happy therefore, and beautiful according to the beauty of their race. On this point I may note that the very variations in the races of men are caused by the conditions under which they live, and though in these rougher parts of the world we lack some of the advantages of climate and surroundings, yet, if we were working for livelihood and not for profit, we might easily neutralize many of the disadvantages of our climate, at least enough to give due scope to the full development of our race.

Now the next thing I claim is education. And you must not say that every English child is educated now; that sort of education will

not answer my claim, though I cheerfully admit it is something: something, and yet after all only class education. What I claim is liberal education; opportunity, that is, to have my share of whatever knowledge there is in the world according to my capacity or bent of mind, historical or scientific; and also to have my share of skill of hand which is about in the world, either in the industrial handicrafts or in the fine arts; picture-painting, sculpture, music, acting, or the like: I claim to be taught, if I can be taught, more than one craft to exercise for the benefit of the community. You may think this a large claim, but I am clear it is not too large a claim if the community is to have any gain out of my special capacities, if we are not all to be beaten down to a dull level of mediocrity as we are now, all but the very strongest and toughest of us.

But also I know that this claim for education involves one for public advantages in the shape of public libraries, schools, and the like, such as no private person, not even the richest, could command: but these I claim very confidently, being sure that no reasonable community could bear to be without such helps to a decent life.

Again, the claim for education involves a claim for abundant leisure, which once more I make with confidence; because when once we have shaken off the slavery of profit, labour would be organized so unwastefully that no heavy burden would be laid on the individual citizens; every one of whom as a matter of course would have to pay his toll of some obviously useful work. At present you must note that all the amazing machinery which we have invented has served only to increase the amount of profit-bearing wares; in other words, to increase the amount of profit pouched by individuals for their own advantage, part of which profit they use as capital for the production of more profit, with ever the same waste attached to it; and part as private riches or means for luxurious living, which again is sheer waste – is in fact to be looked on as a kind of bonfire on which rich men burn up the product of the labour they have fleeced from the workers beyond what they themselves can use. So I say that, in spite of our inventions, no worker works under the present system an hour the less on account of those labour-saving machines, so-called. But under a happier state of things they would be used simply for saving labour, with the result of a vast amount of leisure gained for the community

to be added to that gained by the avoidance of the waste of useless luxury, and the abolition of the service of commercial war.

And I may say that as to that leisure, as I should in no case do any harm to anyone with it, so I should often do some direct good to the community with it, by practising arts or occupations for my hands or brain which would give pleasure to many of the citizens; in other words, a great deal of the best work done would be done in the leisure time of men relieved from any anxiety as to their livelihood, and eager to exercise their special talent, as all men, nay, all animals are.

Now, again this leisure would enable me to please myself and expand my mind by travelling if I had a mind to it; because, say, for instance, that I were a shoemaker; if due social order were established, it by no means follows that I should always be obliged to make shoes in one place; a due amount of easily conceivable arrangement would enable me to make shoes in Rome, say, for three months, and to come back with new ideas of building, gathered from the sight of the works of past ages, amongst other things which would perhaps be of service in London.

But now, in order that my leisure might not degenerate into idleness and aimlessness, I must set up a claim for due work to do. Nothing to my mind is more important than this demand, and I must ask your leave to say something about it. I have mentioned that I should probably use my leisure for doing a good deal of what is now called work; but it is clear that if I am a member of a Socialist Community I must do my due share of rougher work than this – my due share of what my capacity enables me to do, that is; no fitting of me to a Procrustean bed; but even that share of work necessary to the existence of the simplest social life must, in the first place, whatever else it is, be reasonable work; that is, it must be such work as a good citizen can see the necessity for; as a member of the community, I must have agreed to do it.

To take two strong instances of the contrary, I won't submit to be dressed up in red and marched off to shoot at my French or German or Arab friend in a quarrel that I don't understand; I will rebel sooner than do that.

Nor will I submit to waste my time and energies in making some

trifling toy which I know only a fool can desire; I will rebel sooner than do that.

However, you may be sure that in a state of social order I shall have no need to rebel against any such pieces of unreason; only I am forced to speak from the way we live to the way we might live.

Again, if the necessary reasonable work be of a mechanical kind, I must be helped to do it by a machine, not to cheapen my labour, but so that as little time as possible may be spent upon it, and that I may be able to think of other things while I am tending the machine. And if the work be specially rough or exhausting, you will, I am sure, agree with me in saying that I must take turns in doing it with other people; I mean I mustn't, for instance, be expected to spend my working hours always at the bottom of a coal pit. I think such work as that ought to be largely volunteer work, and done, as I say, in spells. And what I say of very rough work I say also of nasty work. On the other hand, I should think very little of the manhood of a stout and healthy man who did not feel a pleasure in doing rough work; always supposing him to work under the conditions I have been speaking of – namely, feeling that it was useful (and consequently honoured), and that it was not continuous or hopeless, and that he was really doing it of his own free will.

The last claim I make for my work is that the places I worked in, factories or workshops, should be pleasant, just as the fields where our most necessary work is done are pleasant. Believe me there is nothing in the world to prevent this being done, save the necessity of making profits on all wares; in other words, the wares are cheapened at the expense of people being forced to work in crowded, unwholesome, squalid, noisy dens: that is to say, they are cheapened at the expense of the workman's life.

Well, so much for my claims as to my *necessary* work, my tribute to the community. I believe people would find, as they advanced in their capacity for carrying on social order, that life so lived was much less expensive than we now can have any idea of, and that, after a little, people would rather be anxious to seek work than to avoid it; that our working hours would rather be merry parties of men and maids, young men and old enjoying themselves over their work, than

the grumpy weariness it mostly is now. Then would come the time for the new birth of art, so much talked of, so long deferred; people could not help showing their mirth and pleasure in their work, and would be always wishing to express it in a tangible and more or less enduring form, and the workshop would once more be a school of art, whose influence no one could escape from.

And, again, that word art leads me to my last claim, which is that the material surroundings of my life should be pleasant, generous, and beautiful; that I know is a large claim, but this I will say about it, that if it cannot be satisfied, if every civilized community cannot provide such surroundings for all its members, I do not want the world to go on; it is a mere misery that man has ever existed. I do not think it possible under the present circumstances to speak too strongly on this point. I feel sure that the time will come when people will find it difficult to believe that a rich community such as ours, having such command over external Nature, could have submitted to live such a mean, shabby, dirty life as we do.

And once for all, there is nothing in our circumstances save the hunting of profit that drives us into it. It is profit which draws men into enormous unmanageable aggregations called towns, for instance; profit which crowds them up when they are there into quarters without gardens or open spaces; profit which won't take the most ordinary precautions against wrapping a whole district in a cloud of sulphurous smoke; which turns beautiful rivers into filthy sewers; which condemns all but the rich to live in houses idiotically cramped and confined at the best, and at the worst in houses for whose wretchedness there is no name.

I say it is almost incredible that we should bear such crass stupidity as this; nor should we if we could help it. We shall not bear it when the workers get out of their heads that they are but an appendage to profit-grinding, that the more profits that are made the more employment at high wages there will be for them, and that therefore all the incredible filth, disorder, and degradation of modern civilization are signs of their slavery. When they are no longer slaves they will claim as a matter of course that every man and every family should be generously lodged; that every child should be able to play in a garden close to the place his parents live in; that the houses should by their

obvious decency and order be ornaments to Nature, not disfigurements of it; for the decency and order above-mentioned when carried to the due pitch would most assuredly lead to beauty in building. All this, of course, would mean the people – that is, all society – duly organized, having in its own hands the means of production, to be *owned* by no individual, but used by all as occasion called for its use, and can only be done on those terms; on any other terms people will be driven to accumulate private wealth for themselves, and thus, as we have seen, to waste the goods of the community and perpetuate the division into classes, which means continual war and waste.

As to what extent it may be necessary or desirable for people under social order to live in common, we may differ pretty much according to our tendencies towards social life. For my part I can't see why we should think it a hardship to eat with the people we work with; I am sure that as to many things, such as valuable books, pictures, and splendour of surroundings, we shall find it better to club our means together; and I must say that often when I have been sickened by the stupidity of the mean idiotic rabbit warrens that rich men build for themselves in Bayswater and elsewhere, I console myself with visions of the noble communal hall of the future, unsparing of materials, generous in worthy ornament, alive with the noblest thoughts of our time, and the past, embodied in the best art which a free and manly people could produce; such an abode of man as no private enterprise could come anywhere near for beauty and fitness, because only collective thought and collective life could cherish the aspirations which would give birth to its beauty, or have the skill and leisure to carry them out. I for my part should think it much the reverse of a hardship if I had to read my books and meet my friends in such a place; nor do I think I am better off to live in a vulgar stuccoed house crowded with upholstery that I despise, in all respects degrading to the mind and enervating to the body to live in, simply because I call it my own, or my house.

It is not an original remark, but I make it here, that my home is where I meet people with whom I sympathize, whom I love.

Well, that is my opinion as a middle-class man. Whether a working-class man would think his family possession of his wretched little

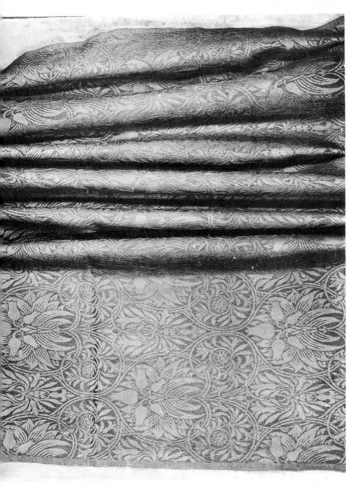

9. 'Crown Imperial' damask, 1876 (photograph of material). This design is based on a Rhenish fifteenth-century printed linen which Morris studied in the Victoria and Albert Museum.

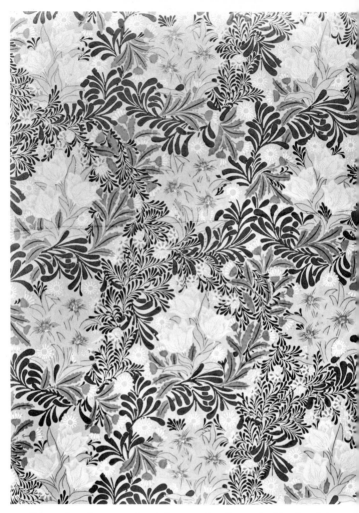

10. 'Bower' wallpaper, 1877 (photograph of paper). Mostly pink flowers, green leaves on a light green ground, this paper contains eleven colours, including four greens.

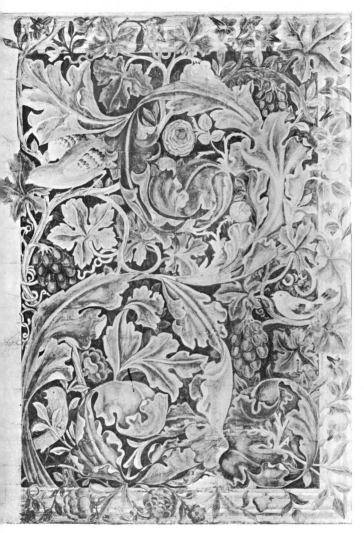

11. Morris's original coloured drawing for the 'Vine and Acanthus' tapestry woven by himself in 1879 for his own house.

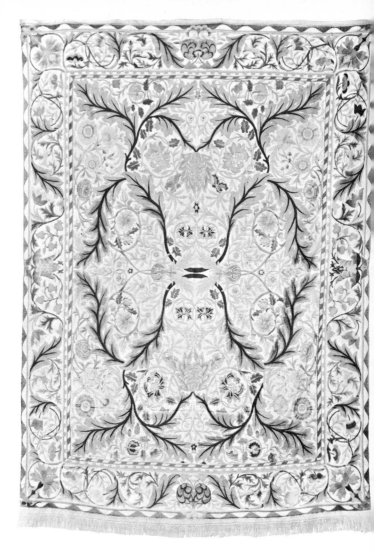

12. Embroidered wall-hanging, 9 ft by 6 ft 8 ins. Wool on linen and cotton twill. Designed about 1880 by Morris for Rounton Grange (architect Philip Webb), and probably worked by Margaret, the wife of Sir Lowthian Bell, the owner. It dates from the period when even Morris's embroidery designs were influenced by his study of woven textiles and their symmetrical repeating patterns.

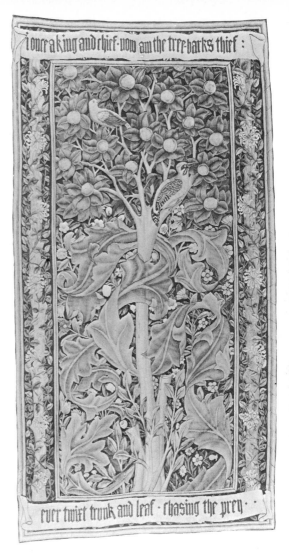

13. 'Woodpecker' tapestry, 9 ft 7 ins. by 5 ft, 1885. A high-warp woollen tapestry designed by Morris except for the birds (by Philip Webb), and woven at the Merton Abbey works. Morris despised the late Gobelin form of tapestry with its photographic reproduction of the chiaroscuro of oil painting as 'an upholsterer's toy'. He sought the sharp silhouette and subtle gradation of tone and colour found in the best late medieval tapestries, as have twentieth-century designers.

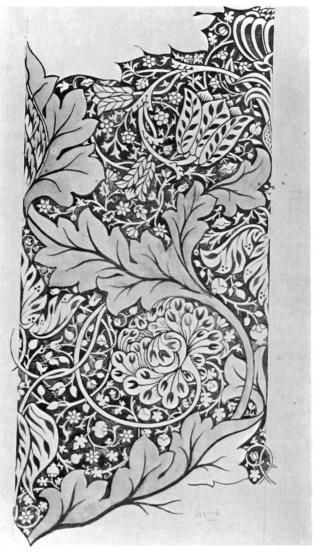

14. Morris's original design for the 'Avon' chintz, *circa* 1886. The design shows, even without colour, how Morris was able to suggest limited depth in his flat patterns without making them three-dimensional. It also shows his charming use of the non-naturalistic convention of the drawing on the petals of the flowers, also used in another late chintz design, the 'Daffodil' (Pl. 19).

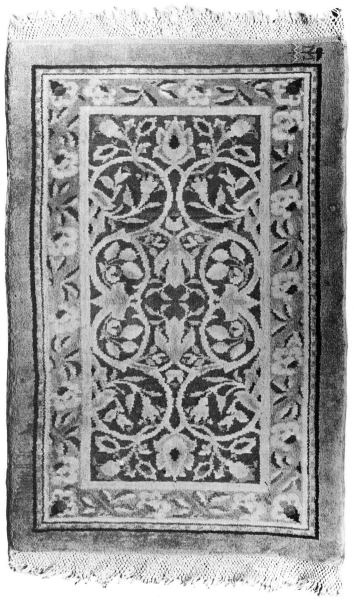

15. Hand-knotted woollen pile 'Hammersmith' rug, 8 ft 2 ins. by 4 ft 5½ ins., 1888. Made for Margaret Burne-Jones and given to her by Morris as a wedding present.

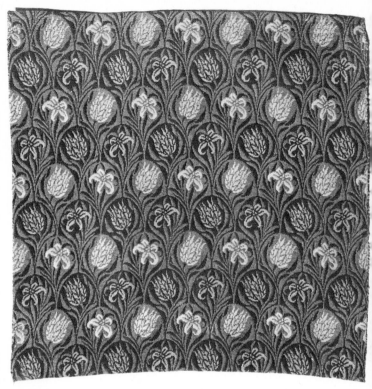

16. 'Lily' woollen machine-woven ingrain 'Kidderminster' carpeting. Contrary to belief, Morris did design for machine production. This carpet, made to Morris's design by the Heckmondwike Company in Yorkshire, was used in the single (32-ins.) width for staircarpeting and joined in the piece for bedrooms.

17. A bedroom in 'Bullerswood', Kent, a country house designed by the architect Ernest Newton and decorated by Morris & Company in 1889. The 'Lily' Wilton carpet is used on the floor and the 'Trent' chintz on the walls. The hanging of the chintzes folded as a wall decoration was the favourite practice of 'The Firm', Morris using it in his own house at Kelmscott.

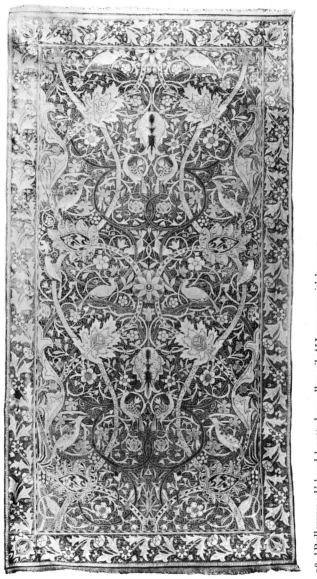

18. 'Bullerswood' hand-knotted woollen pile 'Hammersmith' carpet, 25 ft 1 in. by 13 ft 1 in., 1889. Commissioned for the house illustrated in Pl. 17. Morris studied Persian carpet design with the greatest care

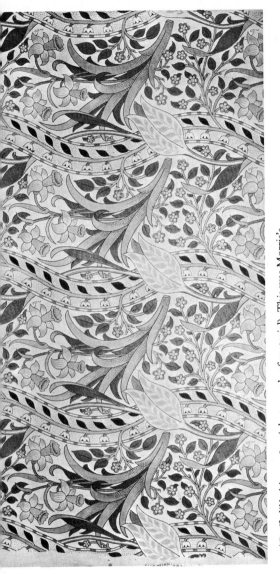

19. 'Daffodil' chintz, 1891 (photograph of material). This was Morris's last design exclusively for a chintz. One of a group of designs which combine a curious mixture of formalized motifs (the sinuous vertical bands) and naturalistic drawing. Contemporary with the first *art nouveau* designs, it is perhaps the nearest Morris ever came to this style. It was also one of the few to be printed in chemical dyes.

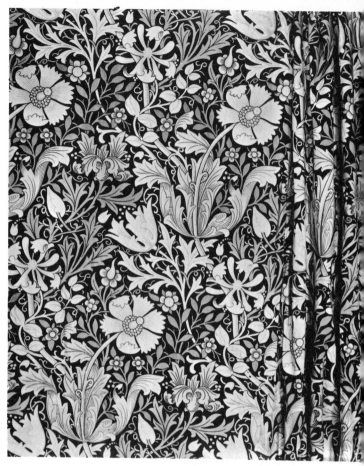

20. 'Compton' chintz, 1896 (photograph of material). This version is printed on a blue ground; it was also printed on white. This, the last pattern designed by Morris, was also used as a wallpaper. One of his most magnificent and popular designs, with very large flowers and repeats, it marks a return to the freely-flowing style of his earlier designs such as the 'Jasmine' (see Pl. 4)

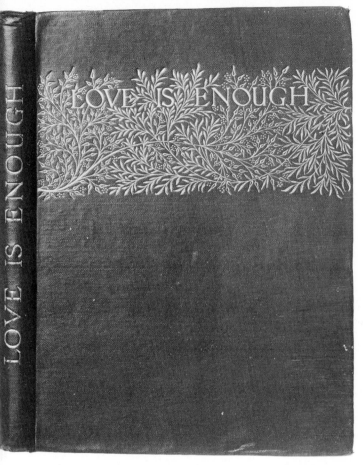

21. Cover design for *Love is Enough*, 1873. Green cloth binding with stamped gold pattern after design by Morris.

**Sense of the lack of Art**

us; but clearly in the present it indicates a transference of the interest of civilised men from the development of the human & intellectual energies of the race to the development of its mechanical energies. If this tendency is to go along the logical road of development, it must be said that it will destroy the arts of design and all that is analogous to them in literature; but the logical outcome of obvious tendencies is often thwarted by the historical development; that is, by what I can call by no better name than the collective will of mankind; and unless my hopes deceive me, I should say that this process has already begun, that there is a revolt on foot against

4

**Revolt against Utilitarianism**

the utilitarianism which threatens to destroy the Arts; and that it is deeper rooted than a mere passing fashion. For myself I do not indeed believe that this revolt can effect much, so long as the present state of society lasts; but as I am sure that great changes which will bring about a new state of society are rapidly advancing upon us, I think it a matter of much importance that these two revolts should join hands, or at least should learn to understand one another. If the New society when it comes (itself the result of the ceaseless evolution of countless years of tradition) should find the world cut off from all tradition of art, all aspiration towards

5

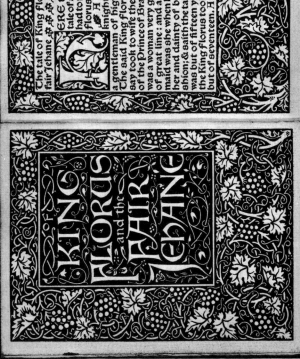

23. Title and facing page from *The Tale of King Florus and the Fair Jehane*, Kelmscott Press, 1893. Printed in the 'Troy' Gothic type face. Note Morris's use of a solid block of type, without indentions, and the 'pairing' of two pages designed to be seen together in the open book.

24. (Overleaf) Colophon of the Kelmscott Press, as used on the last printed page of *The Story of the Glittering Plain*, 1894. Morris designed the types and marginal ornaments used by the Press as well as the appearance of the books as a whole.

room better than his share of the palace of which I have spoken, I must leave to his opinion, and to the imaginations of the middle class, who perhaps may sometimes conceive the fact that the said worker is cramped for space and comfort – say on washing-day.

Before I leave this matter of the surroundings of life, I wish to meet a possible objection. I have spoken of machinery being used freely for releasing people from the more mechanical and repulsive part of necessary labour; and I know that to some cultivated people, people of the artistic turn of mind, machinery is particularly distasteful, and they will be apt to say you will never get your surroundings pleasant so long as you are surrounded by machinery. I don't quite admit that; it is the allowing machines to be our masters and not our servants that so injures the beauty of life nowadays. In other words, it is the token of the terrible crime we have fallen into of using our control of the powers of Nature for the purpose of enslaving people, we care less meantime of how much happiness we rob their lives of.

Yet for the consolation of the artists I will say that I believe indeed that a state of social order would probably lead at first to a great development of machinery for really useful purposes, because people will still be anxious about getting through the work necessary to holding society together; but that after a while they will find that there is not so much work to do as they expected, and that then they will have leisure to reconsider the whole subject; and if it seems to them that a certain industry would be carried on more pleasantly as regards the worker, and more effectually as regards the goods, by using hand-work rather than machinery, they will certainly get rid of their machinery, because it will be possible for them to do so. It isn't possible now; we are not at liberty to do so; we are slaves to the monsters which we have created. And I have a kind of hope that the very elaboration of machinery in a society whose purpose is not the multiplication of labour, as it now is, but the carrying on of a pleasant life, as it would be under social order – that the elaboration of machinery, I say, will lead to the simplification of life, and so once more to the limitation of machinery.

Well, I will now let my claims for decent life stand as I have made them. To sum them up in brief, they are: First, a healthy body; second, an active mind in sympathy with the past, the present, and

the future; thirdly, occupation fit for a healthy body and an active mind; and fourthly, a beautiful world to live in.

These are the conditions of life which the refined man of all ages has set before him as the thing above all others to be attained. Too often he has been so foiled in their pursuit that he has turned longing eyes backward to the days before civilization, when man's sole business was getting himself food from day to day, and hope was dormant in him, or at least could not be expressed by him.

Indeed, if civilization (as many think) forbids the realization of the hope to attain such conditions of life, then civilization forbids mankind to be happy; and if that be the case, then let us stifle all aspirations towards progress – nay, all feelings of mutual goodwill and affection between men – and snatch each one of us what we can from the heap of wealth that fools create for rogues to grow fat on; or better still, let us as speedily as possible find some means of dying like men, since we are forbidden to live like men.

Rather, however, take courage, and believe that we of this age, in spite of all its torment and disorder, have been born to a wonderful heritage fashioned of the work of those that have gone before us; and that the day of the organization of man is dawning. It is not we who can build up the new social order; the past ages have done the most of that work for us; but we can clear our eyes to the signs of the times, and we shall then see that the attainment of a good condition of life is being made possible for us, and that it is now our business to stretch out our hands to take it.

And how? Chiefly, I think, by educating people to a sense of their real capacities as men, so that they may be able to use to their own good the political power which is rapidly being thrust upon them; to get them to see that the old system of organizing labour *for industrial profit* is becoming unmanageable, and that the whole people have now got to choose between the confusion resulting from the break-up of that system and the determination to take in hand the labour now organized for profit, and use its organization for the livelihood of the community: to get people to see that individual profit-makers are not a necessity for labour but an obstruction to it, and that not only or chiefly because they are the perpetual pensioners of labour, as they are, but rather because of the waste which their existence as a

class necessitates. All this we have to teach people, when we have taught ourselves; and I admit that the work is long and burdensome; as I began by saying, people have been made so timorous of change by the terror of starvation that even the unluckiest of them are stolid and hard to move. Hard as the work is, however, its reward is not doubtful. The mere fact that a body of men, however small, are banded together as Socialist missionaries shows that the change is going on. As the working-classes, the real organic part of society, take in these ideas, hope will arise in them, and they will claim changes in society, many of which doubtless will not tend directly towards their emancipation, because they will be claimed without due knowledge of the one thing necessary to claim, *equality of condition*; but which indirectly will help to break up our rotten sham society, while that claim for equality of condition will be made constantly and with growing loudness till it *must* be listened to, and then at last it will only be a step over the border, and the civilized world will be socialized; and, looking back on what has been, we shall be astonished to think of how long we submitted to live as we live now.

(1888)

## 49: FACING THE WORST

THOUGH we Socialists have full faith in the certainty of the great change coming about, it would be idle for any one of us to attempt to prophesy as to the date of the realization of our hopes; and it is well for us not to be too sanguine, since overweening hope is apt to give birth to despair if it meets with check or disappointment. . . .

There are two streams of the force which is meeting the new order of things, and which, already visible to thoughtful persons, will one day rise into a great flood-tide of change visible to everyone, and make a new world. On the one hand the system under which we now live and which is, we are firmly convinced, the last development of the oppression of privilege, is of its own weight pushing onwards towards its destruction. The energy and ceaseless activity which made its success so swift and startling, are now hurrying towards its end;

there is no turning back possible . . . it is not only that its goal is ruin but the goal is now in sight. . . .

At the same time though commercial ruin *must* be the main stream of the force for bringing about revolution, we must not forget the other stream, which is the *conscious* hope of the oppressed classes, forced into union and antagonism by the very success of the commercial system which their hope now threatens with destruction. The commercial or capitalistic system is being eaten out by its own energy; but that energy may on the one hand create practically new conditions for it, yet, on the other hand, in doing so it will stimulate the energy which is consciously attacking it. . . .

Besides . . . obvious resources of the system we are attacking, there are less obvious possibilities about which one may speculate perhaps with some profit; these more speculative possibilities point to attempts of capitalism at avoiding its doom, which would lead to more ruin and suffering than are likely to be involved in even the above mentioned. . . . Our part as acknowledged and organized Socialists is, while we watch keenly the development of the causes which would lead to the destruction of the present system, even if there were no acknowledged Socialists at all, to do all we can to aid the *conscious* attacks on the system by all those who find themselves wronged by it. It is possible that we may live to see times in which it will be easier than now for the labourer to live as a labourer and not as a man, and there is a kind of utilitarian sham Socialism which would be satisfied by such an outcome of times of prosperity. It is very much our business to meet this humbug by urging the workers to sustain steadily their due claim to that fullness of life which no class system can give them.

(From an article in *Commonweal*,
February 1887)

# FIVE ❧ UTOPIA

CHAPTER I : DISCUSSION AND BED

Up at the League, says a friend, there had been one night a brisk conversational discussion, as to what would happen on the Morrow of the Revolution, finally shading off into a vigorous statement by various friends of their views on the future of the full-developed new society.

Says our friend: Considering the subject, the discussion was good-tempered; for those present being used to public meetings and after-lecture debates, if they did not listen to each others' opinions (which could scarcely be expected of them), at all events did not always attempt to speak all together, as is the custom of people in ordinary polite society when conversing on a subject which interests them. For the rest, there were six persons present, and consequently six sections of the party were represented, four of which had strong but divergent Anarchist opinions. One of the sections, says our friend, a man whom he knows very well indeed, sat almost silent at the beginning of the discussion, but at last got drawn into it, and finished by roaring out very loud, and damning all the rest for fools; after which befell a period of noise, and then a lull, during which the aforesaid section, having said good night very amicably, took his way home by himself to a western suburb, using the means of travelling which civilization has forced upon us like a habit. As he sat in that vapour-bath of hurried and discontented humanity, a carriage of the underground railway, he, like others, stewed discontentedly, while in self-reproachful mood he turned over the many excellent and conclusive arguments which, though they lay at his fingers' ends, he had forgotten in the just past discussion. But this frame of mind he was so used to, that it didn't last him long, and after a brief discomfort, caused by disgust with himself for having lost his temper (which he was also well used to), he found himself musing on the subject-matter of discussion, but still discontentedly and unhappily. 'If I could but see a day of it,' he said to himself; 'if I could but see it!'

As he formed the words, the train stopped at his station, five

minutes' walk from his own house, which stood on the banks of the Thames, a little way above an ugly suspension bridge. He went out of the station, still discontented and unhappy, muttering 'If I could but see it! if I could but see it!' but had not gone many steps towards the river before (says our friend who tells the story) all that discontent and trouble seemed to slip off him.

It was a beautiful night of early winter, the air just sharp enough to be refreshing after the hot room and the stinking railway carriage. The wind, which had lately turned a point or two north of west, had blown the sky clear of all cloud save a light fleck or two which went swiftly down the heavens. There was a young moon halfway up the sky, and as the home farer caught sight of it, tangled in the branches of a tall old elm, he could scarce bring to his mind the shabby London suburb where he was, and he felt as if he were in a pleasant country place – pleasanter, indeed, than the deep country was as he had known it.

He came right down to the riverside, and lingered a little, looking over the low wall to note the moonlit river, near upon high water, go swirling and glittering up to Chiswick Eyot; as for the ugly bridge below, he did not notice it or think of it, except when for a moment (says our friend) it struck him that he missed the row of lights downstream. Then he turned to his house door and let himself in; and even as he shut the door to, disappeared all remembrance of that brilliant logic and foresight which had so illuminated the recent discussion; and of the discussion itself there remained no trace, save a vague hope, that was now become a pleasure, for days of peace and rest, and cleanness and smiling goodwill.

In this mood he tumbled into bed, and fell asleep after his wont, in two minutes' time; but (contrary to his wont) woke up again not long after in that curiously wide-awake condition which sometimes surprises even good sleepers; a condition under which we feel all our wits preternaturally sharpened, while all the miserable muddles we have ever got into, all the disgraces and losses of our lives, will insist on thrusting themselves forward for the consideration of those sharpened wits.

In this state he lay (says our friend) till he had almost begun to enjoy it: till the tale of his stupidities amused him, and the entangle-

ments before him, which he saw so clearly, began to shape themselves into an amusing story for him.

He heard one o'clock strike, then two and then three; after which he fell asleep again. Our friend says that from that sleep he awoke once more, and afterwards went through such surprising adventures that he thinks that they should be told to our comrades and indeed the public in general, and therefore proposes to tell them now. But, says he, I think it would be better if I told them in the first person, as if it were myself who had gone through them; which, indeed, will be the easier and more natural to me, since I understand the feelings and desires of the comrade of whom I am telling better than anyone else in the world does.

## CHAPTER 2: A MORNING BATH

WELL, I awoke, and found that I had kicked my bedclothes off; and no wonder, for it was hot and the sun shining brightly. I jumped up and washed and hurried on my clothes, but in a hazy and half-awake condition, as if I had slept for a long, long while, and could not shake off the weight of slumber. In fact, I rather took it for granted that I was at home in my own room than saw that it was so.

When I was dressed, I felt the place so hot that I made haste to get out of the room and out of the house; and my first feeling was a delicious relief caused by the fresh air and pleasant breeze; my second, as I began to gather my wits together, mere measureless wonder: for it was winter when I went to bed the last night, and now, by witness of the riverside trees, it was summer, a beautiful bright morning seemingly of early June. However, there was still the Thames sparkling under the sun, and near high water, as last night I had seen it gleaming under the moon.

I had by no means shaken off the feeling of oppression, and wherever I might have been should scarce have been quite conscious of the place; so it was no wonder that I felt rather puzzled in despite of the familiar face of the Thames. Withal I felt dizzy and queer; and

remembering that people often got a boat and had a swim in mid-stream, I thought I would do no less. It seems very early, quoth I to myself, but I daresay I shall find someone at Biffin's to take me. However, I didn't get as far as Biffin's, or even turn to my left thitherward, because just then I began to see that there was a landing-stage right before me in front of my house: in fact, on the place where my next-door neighbour had rigged one up, though somehow it didn't look like that either. Down I went on to it, and sure enough among the empty boats moored to it lay a man on his sculls in a solid-looking tub of a boat clearly meant for bathers. He nodded to me, and bade me good morning as if he expected me, so I jumped in without any words, and he paddled away quietly as I peeled for my swim. As we went, I looked down on the water, and couldn't help saying:

'How clear the water is this morning!'

'Is it?' said he; 'I didn't notice it. You know the flood-tide always thickens it a bit.'

'H'm,' said I, 'I have seen it pretty muddy even at half-ebb.'

He said nothing in answer, but seemed rather astonished; and as he now lay just stemming the tide, and I had my clothes off, I jumped in without more ado. Of course when I had my head above water again I turned towards the tide, and my eyes naturally sought for the bridge, and so utterly astonished was I by what I saw, that I forgot to strike out, and went spluttering under water again, and when I came up made straight for the boat; for I felt that I must ask some questions of my waterman, so bewildering had been the half-sight I had seen from the face of the river with the water hardly out of my eyes; though by this time I was quit of the slumbrous and dizzy feeling, and was wide-awake and clear-headed.

As I got in up the steps which he had lowered, and he held out his hand to help me, we went drifting speedily up towards Chiswick; but now he caught up the sculls and brought her head round again, and said:

'A short swim, neighbour; but perhaps you find the water cold this morning, after your journey. Shall I put you ashore at once, or would you like to go down to Putney before breakfast?'

He spoke in a way so unlike what I should have expected from a

Hammersmith waterman, that I stared at him, as I answered, 'Please to hold her a little; I want to look about me a bit.'

'All right,' he said; 'it's no less pretty in its way here than it is off Barn Elms; it's jolly everywhere this time in the morning. I'm glad you got up early; it's barely five o'clock yet.'

If I was astonished with my sight of the river banks, I was no less astonished at my waterman, now that I had time to look at him and see him with my head and eyes clear.

He was a handsome young fellow, with a peculiarly pleasant and friendly look about his eyes – an expression which was quite new to me then, though I soon became familiar with it. For the rest, he was dark-haired and berry-brown of skin, well-knit and strong, and obviously used to exercising his muscles, but with nothing rough or coarse about him, and clean as might be. His dress was not like any modern work-a-day clothes I had seen, but would have served very well as a costume for a picture of fourteenth-century life: it was of dark blue cloth, simple enough, but of fine web, and without a stain on it. He had a brown leather belt round his waist, and I noticed that its clasp was of damascened steel beautifully wrought. In short, he seemed to be like some specially manly and refined young gentleman, playing waterman for a spree, and I concluded that this was the case.

I felt that I must make some conversation; so I pointed to the Surrey bank, where I noticed some light plank stages running down the foreshore, with windlasses at the landward end of them, and said, 'What are they doing with those things here? If we were on the Tay, I should have said that they were for drawing the salmon-nets; but here –'

'Well,' said he, smiling, 'of course that is what they *are* for. Where there are salmon, there are likely to be salmon-nets, Tay or Thames; but of course they are not always in use; we don't want salmon *every* day of the season.'

I was going to say, 'But is this the Thames?' but held my peace in my wonder, and turned my bewildered eyes eastward to look at the bridge again, and thence to the shores of the London river; and surely there was enough to astonish me. For though there was a bridge across the stream and houses on its banks, how all was changed from last

night! The soap-works with their smoke-vomiting chimneys were gone; the engineer's works gone; the lead-works gone; and no sound of riveting and hammering came down the west wind from Thorney-croft's. Then the bridge! I had perhaps dreamed of such a bridge, but never seen such an one out of an illuminated manuscript; for not even the Ponte Vecchio at Florence came anywhere near it. It was of stone arches, splendidly solid, and as graceful as they were strong; high enough also to let ordinary river traffic through easily. Over the para-pet showed quaint and fanciful little buildings, which I supposed to be booths or shops, beset with painted and gilded vanes and spirelets. The stone was a little weathered, but showed no marks of the grimy sootiness which I was used to on every London building more than a year old. In short, to me a wonder of a bridge.

The sculler noted my eager astonished look, and said, as if in answer to my thoughts:

'Yes, it *is* a pretty bridge, isn't it? Even the up-stream bridges, which are so much smaller, are scarcely daintier, and the down-stream ones are scarcely more dignified and stately.'

I found myself saying, almost against my will, 'How old is it?'

'O, not very old,' he said: 'it was built, or at least opened, in 2003. There used to be a rather plain timber bridge before then.'

The date shut my mouth as if a key had been turned in a padlock fixed to my lips; for I saw that something inexplicable had happened, and that if I said much, I should be mixed up in a game of cross ques-tions and crooked answers. So I tried to look unconcerned, and to glance in a matter-of-course way at the banks of the river, though this is what I saw up to the bridge and a little beyond; say as far as the site of the soap-works. Both shores had a line of very pretty houses, low and not large, standing back a little way from the river; they were mostly built of red brick and roofed with tiles, and looked, above all, comfortable, and as if they were, so to say, alive and sympathetic with the life of the dwellers in them. There was a continuous garden in front of them, going down to the water's edge, in which the flowers were now blooming luxuriantly, and sending delicious waves of summer scent over the eddying stream. Behind the houses, I could see great trees rising, mostly planes, and looking down the water there were the reaches towards Putney almost as if they were a lake with a

forest shore, so thick were the big trees; and I said aloud, but as if to myself:

'Well, I'm glad that they have not built over Barn Elms.'

I blushed for my fatuity as the words slipped out of my mouth, and my companion looked at me with a half smile which I thought I understood; so to hide my confusion I said, 'Please take me ashore now: I want to get my breakfast.'

He nodded, and brought her head round with a sharp stroke, and in a trice we were at the landing-stage again. He jumped out and I followed him; and of course I was not surprised to see him wait, as if for the inevitable after-piece that follows the doing of a service to a fellow-citizen. So I put my hand into my waistcoat-pocket, and said, 'How much?' though still with the uncomfortable feeling that perhaps I was offering money to a gentleman.

He looked puzzled, and said, 'How much? I don't quite understand what you are asking about. Do you mean the tide? If so, it is close on the turn now.'

I blushed, and said, stammering, 'Please don't take it amiss if I ask you; I mean no offence: but what ought I to pay you? You see I am a stranger, and don't know your customs – or your coins.'

And therewith I took a handful of money out of my pocket, as one does in a foreign country. And by the way, I saw that the silver had oxydized, and was like a black-leaded stove in colour.

He still seemed puzzled, but not at all offended; and he looked at the coins with some curiosity. I thought, Well after all, he *is* a waterman, and is considering what he may venture to take. He seems such a nice fellow that I'm sure I don't grudge him a little over-payment. I wonder, by the way, whether I couldn't hire him as a guide for a day or two, since he is so intelligent.

Therewith my new friend said thoughtfully:

'I think I know what you mean. You think that I have done you service; so you feel yourself bound to give me something which I am not to give to a neighbour, unless he has done something special for me. I have heard of this kind of thing: but pardon me for saying, that it seems to us a troublesome and roundabout custom; and we don't know how to manage it. And you see this ferrying and giving people casts about the water is my *business*, which I would do for anybody;

so to take gifts in connexion with it would look very queer. Besides, if one person gave me something, then another might, and another, and so on; and I hope you won't think me rude if I say that I shouldn't know where to stow away so many mementos of friendship.'

And he laughed loud and merrily, as if the idea of being paid for his work was a very funny joke. I confess I began to be afraid that the man was mad, though he looked sane enough; and I was rather glad to think that I was a good swimmer, since we were so close to a deep swift stream. However, he went on by no means like a madman:

'As to your coins, they are curious, but not very old; they seem to be all of the reign of Victoria; you might give them to some scantily-furnished museum. Ours has enough of such coins, besides a fair number of earlier ones, many of which are beautiful, whereas these nineteenth century ones are so beastly ugly, ain't they? We have a piece of Edward III, with the king in a ship, and little leopards and fleurs-de-lys all along the gunwale, so delicately worked. You see,' he said, with something of a smirk, 'I am fond of working in gold and fine metals; this buckle here is an early piece of mine.'

No doubt I looked a little shy of him under the influence of that doubt as to his sanity. So he broke off short, and said in a kind voice:

'But I see that I am boring you, and I ask your pardon. For, not to mince matters, I can tell that you *are* a stranger, and must come from a place very unlike England. But also it is clear that it won't do to overdose you with information about this place, and that you had best suck it in little by little. Further, I should take it as very kind in you if you would allow me to be the showman of our new world to you, since you have stumbled on me first. Though indeed it will be a mere kindness on your part, for almost anybody would make as good a guide, and many much better.'

There certainly seemed no flavour in him of Colney Hatch; and besides I thought I could easily shake him off if it turned out that he really was mad; so I said:

'It is a very kind offer, but it is difficult for me to accept it, unless –' I was going to say, Unless you will let me pay you properly; but

fearing to stir up Colney Hatch again, I changed the sentence into, 'I fear I shall be taking you away from your work – or your amusement.'

'O,' he said, 'don't trouble about that, because it will give me an opportunity of doing a good turn to a friend of mine, who wants to take my work here. He is a weaver from Yorkshire, who has rather overdone himself between his weaving and his mathematics, both indoor work, you see; and being a great friend of mine, he naturally came to me to get him some outdoor work. If you think you can put up with me, pray take me as your guide.'

He added presently: 'It is true that I have promised to go up-stream to some special friends of mine, for the hay-harvest; but they won't be ready for us for more than a week: and besides, you might go with me, you know, and see some very nice people, besides making notes of our ways in Oxfordshire. You could hardly do better if you want to see the country.'

I felt myself obliged to thank him, whatever might come of it; and he added eagerly:

'Well, then, that's settled. I will give my friend a call; he is living in the Guest House like you, and if he isn't up yet, he ought to be this fine summer morning.'

Therewith he took a little silver bugle-horn from his girdle and blew two or three sharp but agreeable notes on it; and presently from the house which stood on the site of my old dwelling (of which more hereafter) another young man came sauntering towards us. He was not so well-looking or so strongly made as my sculler friend, being sandy-haired, rather pale, and not stout-built; but his face was not wanting in that happy and friendly expression which I had noticed in his friend. As he came up smiling towards us, I saw with pleasure that I must give up the Colney Hatch theory as to the waterman, for no two madmen ever behaved as they did before a sane man. His dress also was of the same cut as the first man's, though somewhat gayer, the surcoat being light green with a golden spray embroidered on the breast, and his belt being of filigree silver-work.

He gave me good-day very civilly, and greeting his friend joyously, said:

'Well, Dick, what is it this morning? Am I to have my work, or

rather your work? I dreamed last night that we were off up the river fishing.'

'All right, Bob,' said my sculler; 'you will drop into my place, and if you find it too much, there is George Brightling on the look-out for a stroke of work, and he lives close handy to you. But see, here is a stranger who is willing to amuse me today by taking me as his guide about our countryside, and you may imagine I don't want to lose the opportunity; so you had better take to the boat at once. But in any case I shouldn't have kept you out of it for long, since I am due in the hayfields in a few days.'

The newcomer rubbed his hands with glee, but turning to me, said in a friendly voice:

'Neighbour, both you and friend Dick are lucky, and will have a good time today, as indeed I shall too. But you had better both come in with me at once and get something to eat, lest you should forget your dinner in your amusement. I suppose you came into the Guest House after I had gone to bed last night?'

I nodded, not caring to enter into a long explanation which would have led to nothing, and which in truth by this time I should have begun to doubt myself. And we all three turned towards the door of the Guest House.

CHAPTER 3: THE GUEST HOUSE AND BREAKFAST THEREIN

I LINGERED a little behind the others to have a stare at this house, which, as I have told you, stood on the site of my old dwelling.

It was a longish building with its gable ends turned away from the road, and long traceried windows coming rather low down set in the wall that faced us. It was very handsomely built of red brick with a lead roof; and high up above the windows there ran a frieze of figure subjects in baked clay, very well executed, and designed with a force and directness which I had never noticed in modern work before. The subjects I recognized at once, and indeed was very particularly familiar with them.

However, all this I took in in a minute; for we were presently

within doors, and standing in a hall with a floor of marble mosaic and an open timber roof. There were no windows on the side opposite to the river, but arches below leading into chambers, one of which showed a glimpse of a garden beyond, and above them a long space of wall gaily painted (in fresco, I thought) with similar subjects to those of the frieze outside; everything about the place was handsome and generously solid as to material; and though it was not very large (somewhat smaller than Crosby Hall perhaps), one felt in it that exhilarating sense of space and freedom which satisfactory architecture always gives to an unanxious man who is in the habit of using his eyes.

In this pleasant place, which of course I knew to be the hall of the Guest House, three young women were flitting to and fro. As they were the first of the sex I had seen on this eventful morning, I naturally looked at them very attentively, and found them at least as good as the gardens, the architecture, and the male men. As to their dress, which of course I took note of, I should say that they were decently veiled with drapery, and not bundled up with millinery; that they were clothed like women, not upholstered like arm-chairs, as most women of our time are. In short, their dress was somewhat between that of the ancient classical costume and the simpler forms of the fourteenth-century garments, though it was clearly not an imitation of either: the materials were light and gay to suit the season. As to the women themselves, it was pleasant indeed to see them, they were so kind and happy-looking in expression of face, so shapely and well-knit of body, and thoroughly healthy-looking and strong. All were at least comely, and one of them very handsome and regular of feature. They came up to us at once merrily and without the least affectation of shyness, and all three shook hands with me as if I were a friend newly come back from a long journey: though I could not help noticing that they looked askance at my garments; for I had on my clothes of last night, and at the best was never a dressy person.

A word or two from Robert the weaver, and they bustled about on our behoof, and presently came and took us by the hands and led us to a table in the pleasantest corner of the hall, where our breakfast was spread for us; and, as we sat down, one of them hurried out by the

chambers aforesaid, and came back again in a little while with a great bunch of roses, very different in size and quality to what Hammersmith had been wont to grow, but very like the produce of an old country garden. She hurried back thence into the buttery, and came back once more with a delicately made glass, into which she put the flowers and set them down in the midst of our table. One of the others, who had run off also, then came back with a big cabbage-leaf filled with strawberries, some of them barely ripe, and said as she set them on the table, 'There, now; I thought of that before I got up this morning; but looking at the stranger here getting into your boat, Dick, put it out of my head; so that I was not before *all* the blackbirds: however, there are a few about as good as you will get them anywhere in Hammersmith this morning.'

Robert patted her on the head in a friendly manner; and we fell to on our breakfast, which was simple enough, but most delicately cooked, and set on the table with much daintiness. The bread was particularly good, and was of several different kinds, from the big, rather close, dark-coloured, sweet-tasting farmhouse loaf, which was most to my liking, to the thin pipe-stems of wheaten crust, such as I have eaten in Turin.

As I was putting the first mouthfuls into my mouth, my eye caught a carved and gilded inscription on the panelling, behind what we should have called the High Table in an Oxford college hall, and a familiar name in it forced me to read it through. Thus it ran:

> *Guests and neighbours, on the site of this Guest-hall*
> *once stood the lecture room of the Hammersmith Socialists.*
> *Drink a glass to the memory! May 1962.*

It is difficult to tell you how I felt as I read these words, and I suppose my face showed how much I was moved, for both my friends looked curiously at me, and there was silence between us for a little while.

Presently the weaver, who was scarcely so well mannered a man as the ferryman, said to me rather awkwardly:

'Guest, we don't know what to call you: is there any indiscretion in asking you your name?'

'Well,' said I, 'I have some doubts about it myself; so suppose you

call me Guest, which is a family name, you know, and add William to it if you please.'

Dick nodded kindly to me; but a shade of anxiousness passed over the weaver's face, and he said:

'I hope you don't mind my asking, but would you tell me where you come from? I am curious about such things for good reasons, literary reasons.'

Dick was clearly kicking him underneath the table; but he was not much abashed, and awaited my answer somewhat eagerly. As for me, I was just going to blurt out 'Hammersmith,' when I bethought me what an entanglement of cross purposes that would lead us into; so I took time to invent a lie with circumstance, guarded by a little truth, and said:

'You see, I have been such a long time away from Europe that things seem strange to me now; but I was born and bred on the edge of Epping Forest; Walthamstow and Woodford, to wit.'

'A pretty place too,' broke in Dick; 'a very jolly place, now that the trees have had time to grow again since the great clearing of houses in 1955.'

Quoth the irrepressible weaver: 'Dear neighbour, since you knew the Forest some time ago, could you tell me what truth there is in the rumour that in the nineteenth century the trees were all pollards?'

This was catching me on my archaeological natural-history side, and I fell into the trap without any thought of where and when I was; so I began on it, while one of the girls, the handsome one, who had been scattering little twigs of lavender and other sweet-smelling herbs about the floor, came near to listen, and stood behind me with her hand on my shoulder, in which she held some of the plant that I used to call balm: its strong sweet smell brought back to my mind my very early days in the kitchen-garden at Woodford, and the large blue plums which grew on the wall beyond the sweet-herb patch – a connexion of memories which all boys will see at once.

I started off: 'When I was a boy, and for long after, except for a piece about Queen Elizabeth's Lodge, and for the part about High Beech, the Forest was almost wholly made up of pollard hornbeams mixed with holly thickets. But when the Corporation of London took it over about twenty-years ago, the topping and lopping, which was

a part of the old commoners' rights, came to an end, and the trees were let to grow. But I have not seen the place now for many years, except once, when we Leaguers went a-pleasuring to High Beech. I was very much shocked then to see how it was built-over and altered; and the other day we heard that the philistines were going to landscape-garden it. But what you were saying about the building being stopped and the trees growing is only too good news; – only you know –'

At that point I suddenly remembered Dick's date, and stopped short rather confused. The eager weaver didn't notice my confusion, but said hastily, as if he were almost aware of his breach of good manners, 'But, I say, how old are you?'

Dick and the pretty girl both burst out laughing, as if Robert's conduct were excusable on the grounds of eccentricity; and Dick said amidst his laughter:

'Hold hard, Bob; this questioning of guests won't do. Why, much learning is spoiling you. You remind me of the radical cobblers in the silly old novels, who, according to the authors, were prepared to trample down all good manners in the pursuit of utilitarian knowledge. The fact is, I begin to think that you have so muddled your head with mathematics, and with grubbing into those idiotic old books about political economy (he he!), that you scarcely know how to behave. Really, it is about time for you to take to some open-air work, so that you may clear away the cobwebs from your brain.'

The weaver only laughed good-humouredly; and the girl went up to him and patted his cheek and said laughingly, 'Poor fellow! he was born so.'

As for me, I was a little puzzled, but I laughed also, partly for company's sake, and partly with pleasure at their unanxious happiness and good temper; and before Robert could make the excuse to me which he was getting ready, I said:

'But, neighbours' (I had caught up that word), 'I don't in the least mind answering questions, when I can do so: ask me as many as you please; it's fun for me. I will tell you all about Epping Forest when I was a boy, if you please; and as to my age, I'm not a fine lady, you know, so why shouldn't I tell you? I'm hard on fifty-six.'

In spite of the recent lecture on good manners, the weaver could

not help giving a long 'whew' of astonishment, and the others were so amused by his *naïveté* that the merriment flitted all over their faces, though for courtesy's sake they forbore actual laughter; while I looked from one to the other in a puzzled manner, and at last said:

'Tell me, please, what is amiss: you know I want to learn from you. And please laugh; only tell me.'

Well, they *did* laugh, and I joined them again, for the above-stated reasons. But at last the pretty woman said coaxingly:

'Well, well, he *is* rude, poor fellow! but you see I may as well tell you what he is thinking about: he means that you look rather old for your age. But surely there need be no wonder in that, since you have been travelling; and clearly from all you have been saying, in unsocial countries. It has often been said, and no doubt truly, that one ages very quickly if one lives amongst unhappy people. Also they say that southern England is a good place for keeping good looks.' She blushed and said: 'How old am I, do you think?'

'Well,' quoth I, 'I have always been told that a woman is as old as she looks, so without offence or flattery, I should say that you were twenty.'

She laughed merrily, and said, 'I am well served out for fishing for compliments, since I have to tell you the truth, to wit, that I am forty-two.'

I stared at her, and drew musical laughter from her again; but I might well stare, for there was not a careful line on her face; her skin was as smooth as ivory, her cheeks full and round, her lips as red as the roses she had brought in; her beautiful arms, which she had bared for her work, firm and well-knit from shoulder to wrist. She blushed a little under my gaze, though it was clear that she had taken me for a man of eighty; so to pass it off I said:

'Well, you see, the old saw is proved right again, and I ought not to have let you tempt me into asking you a rude question.'

She laughed again, and said: 'Well, lads, old and young, I must get to my work now. We shall be rather busy here presently; and I want to clear it off soon, for I began to read a pretty old book yesterday, and I want to get on with it this morning: so good-bye for the present.'

She waved a hand to us, and stepped lightly down the hall, taking (as Scott says) at least part of the sun from our table as she went.

When she was gone, Dick said, 'Now, guest, won't you ask a question or two of our friend here? It is only fair that you should have your turn.'

'I shall be very glad to answer them,' said the weaver.

'If I ask you any questions, sir,' said I, 'they will not be very severe; but since I hear that you are a weaver, I should like to ask you something about that craft, as I am – or was – interested in it.'

'O,' said he, 'I shall not be of much use to you there, I'm afraid. I only do the most mechanical kind of weaving, and am in fact but a poor craftsman, unlike Dick here. Then besides the weaving, I do a little with machine printing and composing, though I am little use at the finer kinds of printing; and moreover machine printing is beginning to die out, along with the waning of the plague of book-making, so I have had to turn to other things that I have a taste for, and have taken to mathematics; and also I am writing a sort of antiquarian book about the peaceable and private history, so to say, of the end of the nineteenth century – more for the sake of giving a picture of the country before the fighting began than for anything else. That was why I asked you those questions about Epping Forest. You have rather puzzled me, I confess, though your information was so interesting. But later on, I hope, we may have some more talk together, when our friend Dick isn't here. I know he thinks me rather a grinder, and despises me for not being very deft with my hands: that's the way nowadays. From what I have read of the nineteenth-century literature (and I have read a good deal), it is clear to me that this is a kind of revenge for the stupidity of that day, which despised everybody who *could* use his hands. But, Dick, old fellow, *Ne quid nimis!* Don't overdo it!'

'Come now,' said Dick, 'am I likely to? Am I not the most tolerant man in the world? Am I not quite contented so long as you don't make me learn mathematics, or go into your new science of aesthetics, and let me do a little practical aesthetics with my gold and steel, and the blowpipe and the nice little hammer? But, hillo! here comes another questioner for you, my poor guest. I say, Bob, you must help me to defend him now.'

'Here, Boffin,' he cried out, after a pause; 'here we are, if you must have it!'

I looked over my shoulder, and saw something flash and gleam in the sunlight that lay across the hall; so I turned round, and at my ease saw a splendid figure slowly sauntering over the pavement; a man whose surcoat was embroidered most copiously as well as elegantly, so that the sun flashed back from him as if he had been clad in golden armour. The man himself was tall, dark-haired, and exceedingly handsome, and though his face was no less kindly in expression than that of the others, he moved with that somewhat haughty mien which great beauty is apt to give to both men and women. He came and sat down at our table with a smiling face, stretching out his long legs and hanging his arm over the chair in the slowly graceful way which tall and well-built people may use without affectation. He was a man in the prime of life, but looked as happy as a child who has just got a new toy. He bowed gracefully to me and said:

'I see clearly that you are the guest, of whom Annie has just told me, who have come from some distant country that does not know of us, or our ways of life. So I daresay you would not mind answering me a few questions; for you see –'

Here Dick broke in: 'No, please, Boffin! let it alone for the present. Of course you want the guest to be happy and comfortable; and how can that be if he has to trouble himself with answering all sorts of questions while he is still confused with the new customs and people about him? No, no: I am going to take him where he can ask questions himself, and have them answered; that is, to my great-grandfather in Bloomsbury: and I am sure you can't have anything to say against that. So instead of bothering, you had much better go out to James Allen's and get a carriage for me, as I shall drive him up myself; and please tell Jim to let me have the old grey, for I can drive a wherry much better than a carriage. Jump up, old fellow, and don't be disappointed; our guest will keep himself for you and your stories.'

I stared at Dick; for I wondered at his speaking to such a dignified-looking personage so familiarly, not to say curtly; for I thought that this Mr Boffin, in spite of his well-known name out of Dickens, must be at the least a senator of these strange people. However, he got up

and said, 'All right, old oar-wearer, whatever you like; this is not one of my busy days; and though' (with a condescending bow to me) 'my pleasure of a talk with this learned guest is put off, I admit that he ought to see your worthy kinsman as soon as possible. Besides, perhaps he will be the better able to answer *my* questions after his own have been answered.'

And therewith he turned and swung himself out of the hall.

When he was well gone, I said: 'Is it wrong to ask what Mr Boffin is? whose name, by the way, reminds me of many pleasant hours passed in reading Dickens.'

Dick laughed. 'Yes, yes,' said he, 'as it does us, I see you take the allusion. Of course his real name is not Boffin, but Henry Johnson; we only call him Boffin as a joke, partly because he is a dustman, and partly because he will dress so showily, and get as much gold on him as a baron of the Middle Ages. And why should he not if he likes? only we are his special friends, you know, so of course we jest with him.'

I held my tongue for some time after that; but Dick went on:

'He is a capital fellow, and you can't help liking him; but he has a weakness: he will spend his time in writing reactionary novels, and is very proud of getting the local colour right, as he calls it; and as he thinks you come from some forgotten corner of the earth, where people are unhappy, and consequently interesting to a story-teller, he thinks he might get some information out of you. O, he will be quite straightforward with you, for that matter. Only for your own comfort beware of him!'

'Well, Dick,' said the weaver, doggedly, 'I think his novels are very good.'

'Of course you do,' said Dick; 'birds of a feather flock together; mathematics and antiquarian novels stand on much the same footing. But here he comes again.'

And in effect the Golden Dustman hailed us from the hall-door; so we all got up and went into the porch, before which, with a strong grey horse in the shafts, stood a carriage ready for us which I could not help noticing. It was light and handy, but had none of that sickening vulgarity which I had known as inseparable from the carriages of our time, especially the 'elegant' ones, but was as graceful and plea-

sant in line as a Wessex wagon. We got in, Dick and I. The girls, who had come into the porch to see us off, waved their hands to us; the weaver nodded kindly; the dustman bowed as gracefully as a troubadour; Dick shook the reins, and we were off.

## CHAPTER 4: A MARKET BY THE WAY

WE turned away from the river at once, and were soon in the main road that runs through Hammersmith. But I should have had no guess as to where I was, if I had not started from the waterside; for King Street was gone, and the highway ran through wide sunny meadows and garden-like tillage. The Creek, which we crossed at once, had been rescued from its culvert, and as we went over its pretty bridge we saw its waters, yet swollen by the tide, covered with gay boats of different sizes. There were houses about, some on the road, some amongst the fields with pleasant lanes leading down to them, and each surrounded by a teeming garden. They were all pretty in design, and as solid as might be, but countrified in appearance, like yeomen's dwellings; some of them of red brick like those by the river, but more of timber and plaster, which were by the necessity of their construction so like mediaeval houses of the same materials that I fairly felt as if I were alive in the fourteenth century; a sensation helped out by the costume of the people that we met or passed, in whose dress there was nothing 'modern'. Almost everybody was gaily dressed, but especially the women, who were so well-looking, or even so handsome, that I could scarcely refrain my tongue from calling my companion's attention to the fact. Some faces I saw that were thoughtful, and in these I noticed great nobility of expression, but none that had a glimmer of unhappiness, and the greater part (we came upon a good many people) were frankly and openly joyous.

I thought I knew the Broadway by the lie of the roads that still met there. On the north side of the road was a range of buildings and courts, low, but very handsomely built and ornamented, and in that way forming a great contrast to the unpretentiousness of the houses

round about; while above this lower building rose the steep lead-covered roof and the buttresses and higher part of the wall of a great hall, of a splendid and exuberant style of architecture, of which one can say little more than that it seemed to me to embrace the best qualities of the Gothic of northern Europe with those of the Saracenic and Byzantine, though there was no copying of any one of these styles. On the other, the south side, of the road was an octagonal building with a high roof, not unlike the Baptistry at Florence in outline, except that it was surrounded by a lean-to that clearly made an arcade or cloisters to it: it also was most delicately ornamented.

This whole mass of architecture which we had come upon so suddenly from amidst the pleasant fields was not only exquisitely beautiful in itself, but it bore upon it the expression of such generosity and abundance of life that I was exhilarated to a pitch that I had never yet reached. I fairly chuckled for pleasure. My friend seemed to understand it, and sat looking on me with a pleased and affectionate interest. We had pulled up amongst a crowd of carts, wherein sat handsome healthy-looking people, men, women, and children very gaily dressed and which were clearly market carts, as they were full of very tempting-looking country produce.

I said, 'I need not ask if this is a market, for I see clearly that it is; but what market is it that it is so splendid? And what is the glorious hall there, and what is the building on the south side?'

'O,' said he, 'it is just our Hammersmith market; and I am glad you like it so much, for we are really proud of it. Of course the hall inside is our winter Mote-House; for in summer we mostly meet in the fields down by the river opposite Barn Elms. The building on our right hand is our theatre: I hope you like it.'

'I should be a fool if I didn't,' said I.

He blushed a little as he said: 'I am glad of that, too, because I had a hand in it; I made the great doors, which are of damascened bronze. We will look at them later in the day, perhaps: but we ought to be getting on now. As to the market, this is not one of our busy days; so we shall do better with it another time, because you will see more people.'

I thanked him, and said: 'Are these the regular country people? What very pretty girls there are amongst them.'

As I spoke, my eye caught the face of a beautiful woman, tall, dark-haired, and white-skinned, dressed in a pretty light-green dress in honour of the season and the hot day, who smiled kindly on me, and more kindly still, I thought, on Dick; so I stopped a minute, but presently went on:

'I ask because I do not see any of the country-looking people I should have expected to see at a market – I mean selling things there.'

'I don't understand,' said he, 'what kind of people you would expect to see; nor quite what you mean by "country" people. These are the neighbours, and that like they run in the Thames valley. There are parts of these islands which are rougher and rainier than we are here, and there people are rougher in their dress; and they themselves are tougher and more hard-bitten than we are to look at. But some people like their looks better than ours; they say they have more character in them – that's the word. Well, it's a matter of taste. Anyhow, the cross between us and them generally turns out well,' added he, thoughtfully.

I heard him, though my eyes were turned away from him, for that pretty girl was just disappearing through the gate with her big basket of early peas, and I felt that disappointed kind of feeling which overtakes one when one has seen an interesting or lovely face in the streets which one is never likely to see again; and I was silent a little. At last I said: 'What I mean is, that I haven't seen any poor people about – not one.'

He knit his brows, looked puzzled, and said: 'No, naturally; if anybody is poorly, he is likely to be within doors, or at best crawling about the garden: but I don't know of any one sick at present. Why should you expect to see poorly people on the road?'

'No, no,' I said; 'I don't mean sick people. I mean poor people, you know; rough people.'

'No,' said he, smiling merrily, 'I really do not know. The fact is, you must come along quickly to my great-grandfather, who will understand you better than I do. Come on, Greylocks!' Therewith he shook the reins, and we jogged along merrily eastward.

## CHAPTER 5: CHILDREN ON THE ROAD

PAST the Broadway there were fewer houses on either side. We presently crossed a pretty little brook that ran across a piece of land dotted over with trees, and awhile after came to another market and town-hall, as we should call it. Although there was nothing familiar to me in its surroundings, I knew pretty well where we were, and was not surprised when my guide said briefly, 'Kensington Market.'

Just after this we came into a short street of houses; or rather, one long house on either side of the way, built of timber and plaster, and with a pretty arcade over the footway before it.

Quoth Dick: 'This is Kensington proper. People are apt to gather here rather thick, for they like the romance of the wood; and naturalists haunt it, too; for it is a wild spot even here, what there is of it; for it does not go far to the south: it goes from here northward and west right over Paddington and a little way down Notting Hill: thence it runs north-east to Primrose Hill, and so on; rather a narrow strip of it gets through Kingsland to Stoke-Newington and Clapton, where it spreads out along the heights above the Lea marshes; on the other side of which, as you know, is Epping Forest holding out a hand to it. This part we are just coming to is called Kensington Gardens; though why "gardens" I don't know.'

I rather longed to say, 'Well, *I* know'; but there were so many things about me which I did *not* know, in spite of his assumptions, that I thought it better to hold my tongue.

The road plunged at once into a beautiful wood spreading out on either side, but obviously much further on the north side, where even the oaks and sweet chestnuts were of a good growth; while the quicker-growing trees (amongst which I thought the planes and syca-mores too numerous) were very big and fine-grown.

It was exceedingly pleasant in the dappled shadow, for the day was growing as hot as need be, and the coolness and shade soothed my excited mind into a condition of dreamy pleasure, so that I felt as if I should like to go on for ever through that balmy freshness. My companion seemed to share in my feelings, and let the horse go slower and

slower as he sat inhaling the green forest scents, chief amongst which was the smell of the trodden bracken near the wayside.

Romantic as this Kensington wood was, however, it was not lonely. We came on many groups both coming and going, or wandering in the edges of the wood. Amongst these were many children from six or eight years old up to sixteen or seventeen. They seemed to me to be especially fine specimens of their race, and were clearly enjoying themselves to the utmost; some of them were hanging about little tents pitched on the greensward, and by some of these fires were burning, with pots hanging over them gipsy fashion. Dick explained to me that there were scattered houses in the forest, and indeed we caught a glimpse of one or two. He said they were mostly quite small, such as used to be called cottages when they were slaves in the land, but they were pleasant enough and fitting for the wood.

'They must be pretty well stocked with children,' said I, pointing to the many youngsters about the way.

'O,' said he, 'these children do not all come from the near houses, the woodland houses, but from the countryside generally. They often make up parties, and come to play in the woods for weeks together in summer-time, living in tents, as you see. We rather encourage them to it; they learn to do things for themselves, and get to notice the wild creatures; and, you see, the less they stew inside houses the better for them. Indeed, I must tell you that many grown people will go to live in the forests through the summer; though they for the most part go to the bigger ones, like Windsor, or the Forest of Dean, or the northern wastes. Apart from the other pleasures of it, it gives them a little rough work, which I am sorry to say is getting somewhat scarce for these last fifty years.'

He broke off, and then said, 'I tell you all this, because I see that if I talk I must be answering questions, which you are thinking, even if you are not speaking them out; but my kinsman will tell you more about it.'

I saw that I was likely to get out of my depth again, and so merely for the sake of tiding over an awkwardness and to say something, I said:

'Well, the youngsters here will be all the fresher for school when the summer gets over and they have to go back again.'

'School?' he said; 'yes, what do you mean by that word? I don't see how it can have anything to do with children. We talk, indeed, of a school of herring, and a school of painting, and in the former sense we might talk of a school of children – but otherwise,' said he, laughing, 'I must own myself beaten.'

Hang it! thought I, I can't open my mouth without digging up some new complexity. I wouldn't try to set my friend right in his etymology; and I thought I had best say nothing about the boy-farms which I had been used to call schools, as I saw pretty clearly that they had disappeared; and so I said after a little fumbling, 'I was using the word in the sense of a system of education.'

'Education?' said he, meditatively, 'I know enough Latin to know that the word must come from *educere*, to lead out; and I have heard it used; but I have never met anybody who could give me a clear explanation of what it means.'

You may imagine how my new friends fell in my esteem when I heard this frank avowal; and I said, rather contemptuously, 'Well, education means a system of teaching young people.'

'Why not old people also?' said he with a twinkle in his eye. 'But,' he went on, 'I can assure you our children learn, whether they go through a "system of teaching" or not. Why, you will not find one of these children about here, boy or girl, who cannot swim, and every one of them has been used to tumbling about the little forest ponies – there's one of them now! They all of them know how to cook; the bigger lads can mow; many can thatch and do odd jobs at carpentering; or they know how to keep shop. I can tell you they know plenty of things.'

'Yes, but their mental education, the teaching of their minds,' said I, kindly translating my phrase.

'Guest,' said he, 'perhaps you have not learned to do these things I have been speaking about; and if that's the case, don't you run away with the idea that it doesn't take some skill to do them, and doesn't give plenty of work for one's mind: you would change your opinion if you saw a Dorsetshire lad thatching, for instance. But, however, I understand you to be speaking of book-learning; and as to that, it is a simple affair. Most children, seeing books lying about, manage to read by the time they are four years old; though I am told it has not

always been so. As to writing, we do not encourage them to scrawl too early (though scrawl a little they will), because it gets them into a habit of ugly writing; and what's the use of a lot of ugly writing being done, when rough printing can be done so easily. You understand that handsome writing we like, and many people will write their books out when they make them, or get them written; I mean books of which only a few copies are needed – poems, and such like, you know. However, I am wandering from my lambs; but you must excuse me, for I am interested in this matter of writing, being myself a fair writer.'

'Well,' said I, 'about the children; when they know how to read and write, don't they learn something else – languages, for instance?'

'Of course,' he said; 'sometimes even before they can read, they can talk French, which is the nearest language talked on the other side of the water; and they soon get to know German also, which is talked by a huge number of communes and colleges on the mainland. These are the principal languages we speak in these islands, along with English or Welsh, or Irish, which is another form of Welsh; and children pick them up very quickly, because their elders all know them ; and besides our guests from oversea often bring their children with them, and the little ones get together, and rub their speech into one another.'

'And the older languages?' said I.

'O yes,' said he, 'they mostly learn Latin and Greek along with the modern ones, when they do anything more than merely pick up the latter.'

'And history?' said I; 'how do you teach history?'

'Well,' said he, 'when a person can read, of course he reads what he likes to; and he can easily get someone to tell him what are the best books to read on such or such a subject, or to explain what he doesn't understand in the books when he is reading them.'

'Well,' said I, 'what else do they learn? I suppose they don't all learn history?'

'No, no,' said he; 'some don't care about it; in fact, I don't think many do. I have heard my great-grandfather say that it is mostly in periods of turmoil and strife and confusion that people care much about history; and you know,' said my friend, with an amiable smile,

'we are not like that now. No; many people study facts about the make of things and the matters of cause and effect, so that knowledge increases on us, if that be good; and some, as you heard about friend Bob yonder, will spend time over mathematics. 'Tis no use forcing people's tastes.'

Said I: 'But you don't mean that children learn all these things?'

Said he: 'That depends on what you mean by children; and also you must remember how much they differ. As a rule, they don't do much reading, except for a few story-books, till they are about fifteen years old; we don't encourage early bookishness, though you will find some children who *will* take to books very early; which perhaps is not good for them; but it's no use thwarting them; and very often it doesn't last long with them, and they find their level before they are twenty years old. You see, children are mostly given to imitating their elders, and when they see most people about them engaged in genuinely amusing work, like house-building and street-paving, and gardening, and the like, that is what they want to be doing; so I don't think we need fear having too many book-learned men.'

What could I say? I sat and held my peace, for fear of fresh entanglements. Besides, I was using my eyes with all my might, wondering as the old horse jogged on, when I should come into London proper, and what it would be like now.

But my companion couldn't let his subject quite drop, and went on meditatively:

'After all, I don't know that it does them much harm, even if they do grow up book-students. Such people as that, 'tis a great pleasure seeing them so happy over work which is not much sought for. And besides, these students are generally such pleasant people; so kind and sweet-tempered; so humble, and at the same time so anxious to teach everybody all that they know. Really, I like those that I have met prodigiously.'

This seemed to me such *very* queer talk that I was on the point of asking him another question; when just as we came to the top of a rising ground, down a long glade of the wood on my right I caught sigh of a stately building whose outline was familiar to me, and I cried out, 'Westminster Abbey!'

'Yes,' said Dick, 'Westminster Abbey – what there is left of it.'

'Why, what have you done with it?' quoth I in terror.

'What have *we* done with it?' said he; 'nothing much, save clean it. But you know the whole outside was spoiled centuries ago: as to the inside, that remains in its beauty after the great clearance, which took place over a hundred years ago, of the beastly monuments to fools and knaves, which once blocked it up, as great-grandfather says.'

We went on a little further, and I looked to the right again, and said, in rather a doubtful tone of voice, 'Why there are the Houses of Parliament! Do you still use them?'

He burst out laughing, and was some time before he could control himself; then he clapped me on the back and said:

'I take you, neighbour; you may well wonder at our keeping them standing, and I know something about that, and my old kinsman has given me books to read about the strange game that they played there. Use them! Well, yes, they are used for a sort of subsidiary market, and a storage place for manure, and they are handy for that, being on the waterside. I believe it was intended to pull them down quite at the beginning of our days; but there was, I am told, a queer antiquarian society, which had done some service in past times, and which straightway set up its pipe against their destruction, as it has done with many other buildings, which most people looked upon as worthless, and public nuisances; and it was so energetic, and had such good reasons to give, that it generally gained its point; and I must say that when all is said I am glad of it: because you know at the worst these silly old buildings serve as a kind of foil to the beautiful ones which we build now. You will see several others in these parts; the place my great-grandfather lives in, for instance, and a big building called St Paul's. And you see, in this matter we need not grudge a few poorish buildings standing, because we can always build elsewhere; nor need we be anxious as to the breeding of pleasant work in such matters, for there is always room for more and more work in a new building, even without making it pretentious. For instance, elbow-room *within* doors is to me so delightful that if I were driven to it I would almost sacrifice outdoor space to it. Then, of course, there is the ornament, which, as we must all allow, may easily be overdone in mere living houses, but can hardly be in mote-halls and markets, and so forth. I must tell

you, though, that my great-grandfather sometimes tells me I am a little cracked on this subject of fine building; and indeed I *do* think that the energies of mankind are chiefly of use to them for such work; for in that direction I can see no end to the work, while in many others a limit does seem possible.'

## CHAPTER 6: A LITTLE SHOPPING

As he spoke, we came suddenly out of the woodland into a short street of handsomely built houses, which my companion named to me at once as Piccadilly: the lower part of these I should have called shops, if it had not been that, as far as I could see, the people were ignorant of the arts of buying and selling. Wares were displayed in their finely designed fronts, as if to tempt people in, and people stood and looked at them, or went in and came out with parcels under their arms, just like the real thing. On each side of the street ran an elegant arcade to protect foot-passengers, as in some of the old Italian cities. About halfway down, a huge building of the kind I was now prepared to expect told me that this also was a centre of some kind, and had its special public buildings.

Said Dick: 'Here, you see, is another market on a different plan from most others: the upper stories of these houses are used for guest-houses; for people from all about the country are apt to drift up hither from time to time, as folk are very thick upon the ground, which you will see evidence of presently, and there are people who are fond of crowds, though I can't say that I am.'

I couldn't help smiling to see how long a tradition would last. Here was the ghost of London still asserting itself as a centre – an intellectual centre, for aught I knew. However, I said nothing, except that I asked him to drive very slowly, as the things in the booths looked exceedingly pretty.

'Yes,' said he, 'this is a very good market for pretty things, and is mostly kept for the handsomer goods, as the Houses-of-Parliament market, where they set out cabbages and turnips and such like things, along with beer and the rougher kind of wine, is so near.'

Then he looked at me curiously, and said, 'Perhaps you would like to do a little shopping, as 'tis called?'

I looked at what I could see of my rough blue duds, which I had plenty of opportunity of contrasting with the gay attire of the citizens we had come across; and I thought that if, as seemed likely, I should presently be shown about as a curiosity for the amusement of this most unbusinesslike people, I should like to look a little less like a discharged ship's purser. But in spite of all that had happened, my hand went down into my pocket again, where to my dismay it met nothing metallic except two rusty old keys, and I remembered that amidst our talk in the guest hall at Hammersmith I had taken the cash out of my pocket to show to the pretty Annie, and had left it lying there. My face fell fifty per cent, and Dick, beholding me, said rather sharply:

'Hilloa, Guest! what's the matter now? Is it a wasp?'

'No,' said I, 'but I've left it behind.'

'Well,' said he, 'whatever you have left behind, you can get in this market again, so don't trouble yourself about it.'

I had come to my senses by this time, and remembering the astounding customs of this country, had no mind for another lecture on social economy and the Edwardian coinage; so I said only:

'My clothes – Couldn't I? You see – What do you think could be done about them?'

He didn't seem in the least inclined to laugh, but said quite gravely:

'O don't get new clothes yet. You see, my great-grandfather is an antiquarian, and he will want to see you just as you are. And, you know, I mustn't preach to you, but surely it wouldn't be right for you to take away people's pleasure of studying your attire, by just going and making yourself like everybody else. You feel that, don't you?' said he, earnestly.

I did *not* feel it my duty to set myself up for a scarecrow amidst this beauty-loving people, but I saw I had got across some ineradicable prejudice, and that it wouldn't do to quarrel with my new friend. So I merely said, 'O certainly, certainly.'

'Well,' said he, pleasantly, 'you may as well see what the inside of these booths is like: think of something you want.'

Said I: 'Could I get some tobacco and a pipe?'

'Of course,' said he; 'what was I thinking of, not asking you before? Well, Bob is always telling me that we non-smokers are a selfish lot, and I'm afraid he is right. But come along; here is a place just handy.'

Therewith he drew rein and jumped down, and I followed. A very handsome woman, splendidly clad in figured silk, was slowly passing by, looking into the windows as she went. To her quoth Dick: 'Maiden, would you kindly hold our horse while we go in for a little?' She nodded to us with a kind smile, and fell to patting the horse with her pretty hand.

'What a beautiful creature!' said I to Dick as we entered.

'What, old Greylocks?' said he, with a sly grin.

'No, no,' said I; 'Goldylocks – the lady.'

'Well, so she is,' said he. ''Tis a good job there are so many of them that every Jack may have his Jill: else I fear that we should get fighting for them. Indeed,' said he, becoming very grave, 'I don't say that it does not happen even now, sometimes. For you know love is not a very reasonable thing, and perversity and self-will are commoner than some of our moralists think.' He added, in a still more sombre tone: 'Yes, only a month ago there was a mishap down by us, that in the end cost the lives of two men and a woman, and, as it were, put out the sunlight for us for a while. Don't ask me about it just now; I may tell you about it later on.'

By this time we were within the shop or booth, which had a counter, and shelves on the walls, all very neat, though without any pretence of showiness, but otherwise not very different to what I had been used to. Within were a couple of children – a brown-skinned boy of about twelve, who sat reading a book, and a pretty little girl of about a year older, who was sitting also reading behind the counter; they were obviously brother and sister.

'Good morning, little neighbours,' said Dick. 'My friend here wants tobacco and a pipe; can you help him?'

'O yes, certainly,' said the girl with a sort of demure alertness which was somewhat amusing. The boy looked up, and fell to staring at my outlandish attire, but presently reddened and turned his head, as if he knew that he was not behaving prettily.

'Dear neighbour,' said the girl, with the most solemn countenance

of a child playing at keeping shop, 'what tobacco is it you would like?'

'Latakia,' quoth I, feeling as if I were assisting at a child's game, and wondering whether I should get anything but make-believe.

But the girl took a dainty little basket from a shelf beside her, went to a jar, and took out a lot of tobacco and put the filled basket down on the counter before me, where I could both smell and see that it was excellent Latakia.

'But you haven't weighed it,' said I, 'and – and how much am I to take?'

'Why,' she said, 'I advise you to cram your bag, because you may be going where you can't get Latakia. Where is your bag?'

I fumbled about, and at last pulled out my piece of cotton print which does duty with me for a tobacco pouch. But the girl looked at it with some disdain, and said:

'Dear neighbour, I can give you something much better than that cotton rag.' And she tripped up the shop and came back presently, and as she passed the boy, whispered something in his ear, and he nodded and got up and went out. The girl held up in her finger and thumb a red morocco bag, gaily embroidered, and said, 'There, I have chosen one for you, and you are to have it: it is pretty, and will hold a lot.'

Therewith she fell to cramming it with the tobacco, and laid it down by me and said, 'Now for the pipe: that also you must let me choose for you; there are three pretty ones just come in.'

She disappeared again, and came back with a big-bowled pipe in her hand, carved out of some hard wood very elaborately, and mounted in gold sprinkled with little gems. It was, in short, as pretty and gay a toy as I had ever seen; something like the best kind of Japanese work, but better.

'Dear me!' said I, when I set eyes on it, 'this is altogether too grand for me, or for anybody but the Emperor of the World. Besides, I shall lose it: I always lose my pipes.'

The child seemed rather dashed, and said, 'Don't you like it, neighbour?'

'O yes,' I said, 'of course I like it.'

'Well, then, take it,' said she, 'and don't trouble about losing it.

What will it matter if you do? Somebody is sure to find it, and he will use it, and you can get another.'

I took it out of her hand to look at it, and while I did so, forgot my caution, and said, 'But however am I to pay for such a thing as this?'

Dick laid his hand on my shoulder as I spoke, and turning I met his eyes with a comical expression in them, which warned me against another exhibition of extinct commercial morality; so I reddened and held my tongue, while the girl simply looked at me with the deepest gravity, as if I were a foreigner blundering in my speech, for she clearly didn't understand me a bit.

'Thank you so very much,' I said at last, effusively, as I put the pipe in my pocket, not without a qualm of doubt as to whether I shouldn't find myself before a magistrate presently.

'O, you are so very welcome,' said the little lass, with an affectation of grown-up manners at their best which was very quaint. 'It is such a pleasure to serve dear old gentlemen like you; specially when one can see at once that you have come from far oversea.'

'Yes, my dear,' quoth I, 'I have been a great traveller.'

As I told this lie from pure politeness, in came the lad again, with a tray in his hands, on which I saw a long flask and two beautiful glasses. 'Neighbours,' said the girl (who did all the talking, her brother being very shy, clearly), 'please to drink a glass to us before you go, since we do not have guests like this every day.'

Therewith the boy put the tray on the counter and solemnly poured out a straw-coloured wine into the long bowls. Nothing loth, I drank, for I was thirsty with the hot day; and, thinks I, I am yet in the world, and the grapes of the Rhine have not yet lost their flavour; for if ever I drank good Steinberg, I drank it that morning; and I made a mental note to ask Dick how they managed to make fine wine when there were no longer labourers compelled to drink rot-gut instead of the fine wine which they themselves made.

'Don't you drink a glass to us, dear little neighbours?' said I.

'I don't drink wine,' said the lass; 'I like lemonade better: but I wish your health!'

'And I like ginger-beer better,' said the little lad.

Well, well, thought I, neither have children's tastes changed much. And therewith we gave them good day and went out of the booth.

To my disappointment, like a change in a dream, a tall old man was holding our horse instead of the beautiful woman. He explained to us that the maiden could not wait, and that he had taken her place; and he winked at us and laughed when he saw how our faces fell, so that we had nothing for it but to laugh also.

'Where are you going?' said he to Dick.

'To Bloomsbury,' said Dick.

'If you two don't want to be alone, I'll come with you,' said the old man.

'All right,' said Dick, 'tell me when you want to get down and I'll stop for you. Let's get on.'

So we got under way again; and I asked if children generally waited on people in the markets. 'Often enough,' said he, 'when it isn't a matter of dealing with heavy weights, but by no means always. The children like to amuse themselves with it, and it is good for them, because they handle a lot of diverse wares and get to learn about them, how they are made, and where they come from, and so on. Besides, it is such very easy work that anybody can do it. It is said that in the early days of our epoch there were a good many people who were hereditarily afflicted with a disease called Idleness, because they were the direct descendants of those who in the bad times used to force other people to work for them – the people, you know, who are called slave-holders or employers of labour in the history books. Well, these Idleness-stricken people used to serve booths *all* their time, because they were fit for so little. Indeed, I believe that at one time they were actually *compelled* to do some such work, because they, especially the women, got so ugly and produced such ugly children if their disease was not treated sharply, that the neighbours couldn't stand it. However, I am happy to say that all that is gone by now; the disease is either extinct, or exists in such a mild form that a short course of aperient medicine carries it off. It is sometimes called the Blue-devils now, or the Mulleygrubs. Queer names, ain't they?'

'Yes,' said I, pondering much. But the old man broke in:

'Yes, all that is true, neighbour; and I have seen some of those poor women grown old. But my father used to know some of them when they were young; and he said that they were as little like young women as might be: they had hands like bunches of skewers, and

wretched little arms like sticks; and waists like hour glasses, and thin lips and peaked noses and pale cheeks; and they were always pretending to be offended at anything you said or did to them. No wonder they bore ugly children, for no one except men like them could be in love with them – poor things!'

He stopped, and seemed to be musing on his past life, and then said:

'And do you know, neighbours, that once on a time people were still anxious about that disease of Idleness: at one time we gave ourselves a great deal of trouble in trying to cure people of it. Have you not read any of the medical books on the subject?'

'No,' said I; for the old man was speaking to me.

'Well,' said he, 'it was thought at the time that it was the survival of the old mediaeval disease of leprosy: it seems it was very catching, for many of the people afflicted by it were much secluded, and were waited upon by a special class of diseased persons, queerly dressed up, so that they might be known. They wore amongst other garments, breeches made of worsted velvet, that stuff which used to be called plush some years ago.'

All this seemed very interesting to me, and I should like to have made the old man talk more. But Dick got rather restive under so much ancient history: besides, I suspect he wanted to keep me as fresh as he could for his great-grandfather. So he burst out laughing at last, and said: 'Excuse me, neighbours, but I can't help it. Fancy people not liking to work! – it's too ridiculous. Why, even you like to work, old fellow – sometimes,' said he, affectionately patting the old horse with the whip. 'What a queer disease! it may well be called Mulleygrubs!'

And he laughed out again most boisterously; rather too much so, I thought, for his usual good manners; and I laughed with him for company's sake, but from the teeth outward only; for *I* saw nothing funny in people not liking to work, as you may well imagine.

## CHAPTER 7: TRAFALGAR SQUARE

AND now again I was busy looking about me, for we were quite clear of Piccadilly Market, and were in a region of elegantly-built much ornamented houses, which I should have called villas if they had been ugly and pretentious, which was very far from being the case. Each house stood in a garden carefully cultivated, and running over with flowers. The blackbirds were singing their best amidst the garden-trees, which, except for a bay here and there, and occasional groups of limes, seemed to be all fruit trees: there were a great many cherry trees, now all laden with fruit, and several times as we passed by a garden we were offered baskets of fine fruit by children and young girls. Amidst all these gardens and houses it was of course impossible to trace the sites of the old streets, but it seemed to me that the main roadways were the same as of old.

We came presently into a large open space, sloping somewhat towards the south, the sunny site of which had been taken advantage of for planting an orchard, mainly, as I could see, of apricot trees, in the midst of which was a pretty gay little structure of wood, painted and gilded, that looked like a refreshment stall. From the southern side of the said orchard ran a long road, chequered over with the shadow of tall old pear trees, at the end of which showed the high tower of the Parliament House, or Dung Market.

A strange sensation came over me; I shut my eyes to keep out the sight of the sun glittering on this fair abode of gardens, and for a moment there passed before them a phantasmagoria of another day. A great space surrounded by tall ugly houses, with an ugly church at the corner and a nondescript ugly cupolaed building at my back; the roadway thronged with a sweltering and excited crowd, dominated by omnibuses crowded with spectators. In the midst a paved be-fountained square, populated only by a few men dressed in blue, and a good many singularly ugly bronze images (one on top of a tall column). The said square guarded up to the edge of the roadway by a fourfold line of big men clad in blue, and across the southern

roadway the helmets of a band of horse-soldiers, dead white in the greyness of the chilly November afternoon –

I opened my eyes to the sunlight again and looked round me, and cried out among the whispering trees and odorous blossoms, 'Trafalgar Square!'

'Yes,' said Dick, who had drawn rein again, 'so it is. I don't wonder at your finding the name ridiculous: but after all, it was nobody's business to alter it, since the name of a dead folly doesn't bite. Yet sometimes I think we might have given it a name which would have commemorated the great battle which was fought on the spot itself in 1952 – *that* was important enough, if the historians don't lie.'

'Which they generally do, or at least did,' said the old man. 'For instance, what can you make of this, neighbours? I have read a muddled account in a book – O a stupid book – called James' Social Democratic History, of a fight which took place here in or about the year 1887 (I am bad at dates). Some people, says this story, were going to hold a ward-mote here, or some such thing, and the Government of London, or the Council, or the Commission, or what not other barbarous half-hatched body of fools, fell upon these citizens (as they were then called) with the armed hand. That seems too ridiculous to be true; but according to this version of the story, nothing much came of it, which certainly *is* too ridiculous to be true.'

'Well,' quoth I, 'but after all your Mr James is right so far, and it *is* true; except that there was no fighting, merely unarmed and peaceable people attacked by ruffians armed with bludgeons.'

'And they put up with that?' said Dick, with the first unpleasant expression I had seen on his good-tempered face.

Said I, reddening: 'We *had* to put up with it; we couldn't help it.'

The old man looked at me keenly, and said: 'You seem to know a great deal about it, neighbour! And is it really true that nothing came of it?'

'This came of it,' said I, 'that a good many people were sent to prison because of it.'

'What, of the bludgeoners?' said the old man. 'Poor devils!'

'No, no,' said I, 'of the bludgeoned.'

Said the old man rather severely: 'Friend, I expect that you have

been reading some rotten collection of lies, and have been taken in by it too easily.'

'I assure you,' said I, 'what I have been saying is true.'

'Well, well, I am sure you think so, neighbour,' said the old man, 'but I don't see why you should be so cocksure.'

As I couldn't explain why, I held my tongue. Meanwhile Dick, who had been sitting with knit brows, cogitating, spoke at last, and said gently and rather sadly:

'How strange to think that there have been men like ourselves, and living in this beautiful and happy country, who I suppose had feelings and affections like ourselves, who could yet do such dreadful things.'

'Yes,' said I, in a didactic tone; 'yet after all, even those days were a great improvement on the days that had gone before them. Have you not read of the Mediaeval period, and the ferocity of its criminal laws; and how in those days men fairly seemed to have enjoyed tormenting their fellow-men? – nay, for the matter of that, they made their God a tormentor and a jailer rather than anything else.'

'Yes,' said Dick, 'there are good books on that period also, some of which I have read. But as to the great improvement of the nineteenth century, I don't see it. After all, the Mediaeval folk acted after their conscience, as your remark about their God (which is true) shows, and they were ready to bear what they inflicted on others; whereas the nineteenth-century ones were hypocrites and pretended to be humane, and yet went on tormenting those whom they dared to treat so by shutting them up in prison, for no reason at all, except that they were what they themselves, the prison-masters, had forced them to be. O, it's horrible to think of!'

'But perhaps,' said I, 'they did not know what the prisons were like.'

Dick seemed roused, and even angry. 'More shame for them,' said he, 'when you and I know it all these years afterwards. Look you, neighbour, they couldn't fail to know what a disgrace a prison is to the Commonwealth at the best, and that their prisons were a good step on towards being at the worst.'

Quoth I: 'But have you no prisons at all now?'

As soon as the words were out of my mouth, I felt that I had made a mistake, for Dick flushed red and frowned, and the old man looked

surprised and pained; and presently Dick said angrily, yet as if restraining himself somewhat:

'Man alive! how can you ask such a question? Have I not told you that we know what a prison means by the undoubted evidence of really trustworthy books, helped out by our own imaginations? And haven't you specially called me to notice that the people about the roads and streets look happy? and how could they look happy if they knew that their neighbours were shut up in prison, while they bore such things quietly? And if there were people in prison, you couldn't hide it from folk, like you may an occasional man-slaying; because that isn't done of set purpose, with a lot of people backing up the slayer in cold blood, as this prison business is. Prisons, indeed! O no, no!'

He stopped, and began to cool down, and said in a kind voice: 'But forgive me! I needn't be so hot about it, since there are *not* any prisons: I'm afraid you will think the worse of me for losing my temper. Of course, you, coming from the outlands, cannot be expected to know about these things. And now I'm afraid I have made you feel uncomfortable.'

In a way he had; but he was so generous in his heat, that I liked him the better for it, and I said: 'No, really 'tis all my fault for being so stupid. Let me change the subject, and ask you what the stately building is on our left just showing at the end of that grove of plane trees?'

'Ah,' he said, 'that is an old building built before the middle of the twentieth century, and as you see, in a queer fantastic style not over beautiful; but there are some fine things inside it, too, mostly pictures, some very old. It is called the National Gallery; I have sometimes puzzled as to what the name means: anyhow, nowadays wherever there is a place where pictures are kept as curiosities permanently it is called a National Gallery, perhaps after this one. Of course there are a good many of them up and down the country.'

I didn't try to enlighten him, feeling the task too heavy; but I pulled out my magnificent pipe and fell a-smoking, and the old horse jogged on again. As we went, I said:

'This pipe is a very elaborate toy, and you seem so reasonable in this country, and your architecture is so good, that I rather wonder at your turning out such trivialities.'

It struck me as I spoke that this was rather ungrateful of me, after having received such a fine present; but Dick didn't seem to notice my bad manners, but said:

'Well, I don't know; it *is* a pretty thing, and since nobody need make such things unless they like, I don't see why they shouldn't make them, *if* they like. Of course, if carvers were scarce they would all be busy on the architecture, as you call it, and then these "toys" (a good word) would not be made; but since there are plenty of people who can carve – in fact, almost everybody, and as work is somewhat scarce, or we are afraid it may be, folk do not discourage this kind of petty work.'

He mused a little, and seemed somewhat perturbed; but presently his face cleared, and he said: 'After all, you must admit that the pipe is a very pretty thing, with the little people under the trees all cut so clean and sweet – too elaborate for a pipe, perhaps, but – well, it is very pretty.'

'Too valuable for its use, perhaps,' said I.

'What's that?' said he; 'I don't understand.'

I was just going in a helpless way to try to make him understand, when we came by the gates of a big rambling building, in which work of some sort seemed going on. 'What building is that?' said I, eagerly; for it was a pleasure amidst all these strange things to see something a little like what I was used to: 'it seems to be a factory.'

'Yes,' he said, 'I think I know what you mean, and that's what it is; but we don't call them factories now, but Banded-workshops; that is, places where people collect who want to work together.'

'I suppose,' said I, 'power of some sort is used there?'

'No, no,' said he. 'Why should people collect together to use power, when they can have it at the places where they live, or hard by, any two or three of them; or any one, for the matter of that? No; folk collect in these Banded-workshops to do hand-work in which working together is necessary or convenient; such work is often very pleasant. In there, for instance, they make pottery and glass – there, you can see the tops of the furnaces. Well, of course it's handy to have fair-sized ovens and kilns and glass-pots, and a good lot of things to use them for: though of course there are a good many such places, as

it would be ridiculous if a man had a liking for pot-making or glass-blowing that he should have to live in one place or be obliged to forgo the work he liked.'

'I see no smoke coming from the furnaces,' said I.

'Smoke?' said Dick; 'why should you see smoke?'

I held my tongue, and he went on: 'It's a nice place inside, though as plain as you see outside. As to the crafts, throwing the clay must be jolly work: the glass-blowing is rather a sweltering job; but some folk like it very much indeed; and I don't much wonder: there is such a sense of power, when you have got deft in it, in dealing with the hot metal. It makes a lot of pleasant work,' said he, smiling, 'for however much care you take of such goods, break they will, one day or another, so there is always plenty to do.'

I held my tongue and pondered.

We came just here on a gang of men road mending, which delayed us a little; but I was not sorry for it; for all I had seen hitherto seemed a mere part of a summer holiday; and I wanted to see how this folk would set to on a piece of real necessary work. They had been resting, and had only just begun work again as we came up; so that the rattle of the picks was what woke me from my musing. There were about a dozen of them, strong young men, looking much like a boating party at Oxford would have looked in the days I remembered, and not more troubled with their work: their outer raiment lay on the roadside in an orderly pile under the guardianship of a six-year-old boy, who had his arm thrown over the neck of a big mastiff, who was as happily lazy as if the summer day had been made for him alone. As I eyed the pile of clothes, I could see the gleam of gold and silk embroidery on it, and judged that some of these workmen had tastes akin to those of the Golden Dustman of Hammersmith. Beside them lay a good big basket that had hints about it of cold pie and wine: a half-dozen of young women stood by watching the work or the workers, both of which were worth watching, for the latter smote great strokes and were very deft in their labour, and as handsome clean-built fellows as you might find a dozen of in a summer day. They were laughing and talking merrily with each other and the women, but presently their foreman looked up and saw our way stopped. So he stayed his pick and sang out, 'Spell ho, mates! here are neighbours wanting to

get past.' Whereupon the others stopped also, and drawing around us, helped the old horse by easing our wheels over the half undone road, and then, like men with a pleasant task on hand, hurried back to their work, only stopping to give us a smiling good-day; so that the sound of the picks broke out again before Greylocks had taken to his jog-trot. Dick looked back over his shoulder at them and said:

'They are in luck today: it's right down good sport trying how much pick-work one can get into an hour; and I can see those neigh-bours know their business well. It is not a mere matter of strength getting on quickly with such work; is it, Guest?'

'I should think not,' said I, 'but to tell you the truth, I have never tried my hand at it.'

'Really?' said he gravely, 'that seems a pity; it is good work for hardening the muscles, and I like it; though I admit it is pleasanter the second week than the first. Not that I am a good hand at it: the fel-lows used to chaff me at one job where I was working, I remember, and sing out to me, "Well rowed, stroke!" "Put your back into it, bow!"'

'Not much of a joke,' quoth I.

'Well,' said Dick, 'everything seems like a joke when we have a pleasant spell of work on, and good fellows merry about us; we feel so happy, you know.' Again I pondered silently.

## CHAPTER 8: AN OLD FRIEND

WE now turned into a pleasant lane where the branches of great plane trees nearly met overhead, but behind them lay low houses standing rather close together.

'This is Long Acre,' quoth Dick; 'so there must once have been a cornfield here. How curious it is that places change so, and yet keep their old names! Just look how thick the houses stand! and they are still going on building, look you!'

'Yes,' said the old man, 'but I think the cornfields must have been built over before the middle of the nineteenth century. I have heard that about here was one of the thickest parts of the town. But I must

get down here, neighbours; I have got to call on a friend who lives in the gardens behind this Long Acre. Good-bye and good luck, Guest!'

And he jumped down and strode away vigorously, like a young man.

'How old should you say that neighbour will be?' said I to Dick as we lost sight of him; for I saw that he was old, and yet he looked dry and sturdy like a piece of old oak; a type of old man I was not used to seeing.

'O, about ninety, I should say,' said Dick.

'How long-lived your people must be!' said I.

'Yes,' said Dick, 'certainly we have beaten the three-score-and-ten of the old Jewish proverb-book. But then you see that was written of Syria, a hot dry country, where people live faster than in our temperate climate. However, I don't think it matters much, so long as a man is healthy and happy while he *is* alive. But now, Guest, we are so near to my old kinsman's dwelling-place that I think you had better keep all future questions for him.'

I nodded a yes; and therewith we turned to the left, and went down a gentle slope through some beautiful rose-gardens, laid out on what I took to be the site of Endell Street. We passed on, and Dick drew rein an instant as we came across a long straightish road with houses scantily scattered up and down it. He waved his hand right and left, and said, 'Holborn that side, Oxford Road that. This was once a very important part of the crowded city outside the ancient walls of the Roman and Mediaeval burg: many of the feudal nobles of the Middle Ages, we are told, had big houses on either side of Holborn. I daresay you remember that the Bishop of Ely's house is mentioned in Shakespeare's play of King Richard II; and there are some remains of that still left. However, this road is not of the same importance, now that the ancient city is gone, walls and all.'

He drove on again, while I smiled faintly to think how the nineteenth century, of which such big words have been said, counted for nothing in the memory of this man, who read Shakespeare and had not forgotten the Middle Ages.

We crossed the road into a short narrow lane between the gardens, and came out again into a wide road, on one side of which was a great and long building, turning its gables away from the highway, which

I saw at once was another public group. Opposite to it was a wide space of greenery, without any wall or fence of any kind. I looked through the trees and saw beyond them a pillared portico quite familiar to me – no less old a friend, in fact, than the British Museum. It rather took my breath away, amidst all the strange things I had seen; but I held my tongue and let Dick speak. Said he:

'Yonder is the British Museum, where my great-grandfather mostly lives; so I won't say much about it. The building on the left is the Museum Market, and I think we had better turn in there for a minute or two; for Greylocks will be wanting his rest and his oats; and I suppose you will stay with my kinsman the greater part of the day; and to say the truth, there may be someone there whom I particularly want to see, and perhaps have a long talk with.'

He blushed and sighed, not altogether with pleasure, I thought; so of course I said nothing, and he turned the horse under an archway which brought us into a very large paved quadrangle, with a big sycamore tree in each corner and a plashing fountain in the midst. Near the fountain were a few market stalls, with awnings over them of gay striped linen cloth, about which some people, mostly women and children, were moving quietly, looking at the goods exposed there. The ground floor of the building round the quadrangle was occupied by a wide arcade or cloister, whose fanciful but strong architecture I could not enough admire. Here also a few people were sauntering or sitting reading on the benches.

Dick said to me apologetically: 'Here as elsewhere there is little doing today; on a Friday you would see it thronged, and gay with people, and in the afternoon there is generally music about the fountain. However, I daresay we shall have a pretty good gathering at our mid-day meal.'

We drove through the quadrangle and by an archway, into a large handsome stable on the other side, where we speedily stalled the old nag and made him happy with horse-meat, and then turned and walked back again through the market, Dick looking rather thoughtful, as it seemed to me.

I noticed that people couldn't help looking at me rather hard; and considering my clothes and theirs, I didn't wonder; but whenever they caught my eye they made me a very friendly sign of greeting.

We walked straight into the forecourt of the Museum, where, except that the railings were gone, and the whispering boughs of the trees were all about, nothing seemed changed; the very pigeons were wheeling about the building and clinging to the ornaments of the pediment as I had seen them of old.

Dick seemed grown a little absent, but he could not forbear giving me an architectural note, and said:

'It is rather an ugly old building, isn't it? Many people have wanted to pull it down and rebuild it: and perhaps if work does really get scarce we may yet do so. But, as my great-grandfather will tell you, it would not be quite a straightforward job; for there are wonderful collections in there of all kinds of antiquities, besides an enormous library with many exceedingly beautiful books in it, and many most useful ones as genuine records, texts of ancient works and the like; and the worry and anxiety, and even risk, there would be in moving all this has saved the buildings themselves. Besides, as we said before, it is not a bad thing to have some record of what our forefathers thought a handsome building. For there is plenty of labour and material in it.'

'I see there is,' said I, 'and I quite agree with you. But now hadn't we better make haste to see your great-grandfather?'

In fact, I could not help seeing that he was rather dallying with the time. He said, 'Yes, we will go into the house in a minute. My kinsman is too old to do much work in the Museum, where he was a custodian of the books for many years; but he still lives here a good deal; indeed I think,' said he, smiling, 'that he looks upon himself as a part of the books, or the books a part of him, I don't know which.'

He hesitated a little longer, then flushing up, took my hand, and saying, 'Come along, then!' led me towards the door of one of the old official dwellings.

CHAPTER 9: CONCERNING LOVE

'YOUR kinsman doesn't much care for beautiful buildings, then,' said I, as we entered the rather dreary classical house; which indeed was as bare as need be, except for some big pots of the June flowers which stood about here and there: though it was very clean and nicely whitewashed.

'O, I don't know,' said Dick, rather absently. 'He is getting old, certainly, for he is over a hundred and five, and no doubt he doesn't care about moving. But of course he could live in a prettier house if he liked: he is not obliged to live in one place any more than anyone else. This way, Guest.'

And he led the way upstairs, and opening a door we went into a fair-sized room of the old type, as plain as the rest of the house, with a few necessary pieces of furniture, and those very simple and even rude, but solid and with a good deal of carving about them, well designed but rather crudely executed. At the furthest corner of the room at a desk near the window, sat a little old man in a roomy oak chair, well be-cushioned. He was dressed in a sort of Norfolk-jacket of blue serge worn threadbare, with breeches of the same, and grey worsted stockings. He jumped up from his chair, and cried out in a voice of considerable volume for such an old man, 'Welcome, Dick, my lad; Clara is here, and will be more than glad to see you; so keep your heart up.'

'Clara here?' quoth Dick; 'if I had known, I would not have brought – At least, I mean I would –'

He was stuttering and confused, clearly because he was anxious to say nothing to make me feel one too many. But the old man, who had not seen me at first, helped him out by coming forward and saying to me in a kind tone:

'Pray pardon me, for I did not notice that Dick, who is big enough to hide anybody, you know, had brought a friend with him. A most hearty welcome to you! All the more, as I almost hope that you are going to amuse an old man by giving him news from over sea, for I can see that you are come from over the water and far-off countries.'

He looked at me thoughtfully, almost anxiously, as he said in a changed voice, 'Might I ask you where you come from, as you are so clearly a stranger?'

I said in an absent way: 'I used to live in England, and now I am come back again; and I slept last night at the Hammersmith Guest House.'

He bowed gravely, but seemed, I thought, a little disappointed with my answer. As for me, I was now looking at him harder than good manners allowed of, perhaps; for in truth his face, dried-apple-like as it was, seemed strangely familiar to me; as if I had seen it before – in a looking-glass it might be, said I to myself.

'Well,' said the old man, 'wherever you come from, you are come among friends. And I see my kinsman Richard Hammond has an air about him as if he had brought you here for me to do something for you. Is that so, Dick?'

Dick, who was getting still more absent-minded and kept looking uneasily at the door, managed to say, 'Well, yes, kinsman: our guest finds things much altered, and cannot understand it; nor can I; so I thought I would bring him to you, since you know more of all that has happened within the last two hundred years than anybody else does. What's that?'

And he turned towards the door again. We heard footsteps outside; the door opened, and in came a very beautiful young woman, who stopped short on seeing Dick, and flushed as red as a rose, but faced him nevertheless. Dick looked at her hard, and half reached out his hand towards her, and his whole face quivered with emotion.

The old man did not leave them long in this shy discomfort, but said, smiling with an old man's mirth: 'Dick, my lad, and you, my dear Clara, I rather think that we two oldsters are in your way; for I think you will have plenty to say to each other. You had better go into Nelson's room up above; I know he has gone out; and he has just been covering the walls all over with mediaeval books, so it will be pretty enough even for you two and your renewed pleasure.'

The girl reached out her hand to Dick, and taking his led him out of the room, looking straight before her; but it was easy to see that

her blushes came from happiness, not anger; as, indeed, love is far more self-conscious than wrath.

When the door had shut on them the old man turned to me, still smiling, and said:

'Frankly, my dear Guest, you will do me a great service if you are come to set my old tongue wagging. My love of talk still abides with me, or rather grows on me; and though it is pleasant enough to see these youngsters moving about and playing together so seriously, as if the whole world depended on their kisses (as indeed it does somewhat), yet I don't think my tales of the past interest them much. The last harvest, the last baby, the last knot of carving in the market-place, is history enough for them. It was different, I think, when I was a lad, when we were not so assured of peace and continuous plenty as we are now. Well, well! Without putting you to the question, let me ask you this: Am I to consider you as an inquirer who knows a little of our modern ways of life, or as one who comes from some place where the very foundations of life are different from ours – do you know anything or nothing about us?'

He looked at me keenly and with growing wonder in his eyes as he spoke; and I answered in a low voice:

'I know only so much of your modern life as I could gather from using my eyes on the way here from Hammersmith, and from asking some questions of Richard Hammond, most of which he could hardly understand.'

The old man smiled at this. 'Then,' said he, 'I am to speak to you as –'

'As if I were a being from another planet,' said I.

The old man, whose name, by the bye, like his kinsman's, was Hammond, smiled and nodded, and wheeling his seat round to me, bade me sit in a heavy oak chair, and said, as he saw my eyes fix on its curious carving:

'Yes, I am much tied to the past, *my* past, you understand. These very pieces of furniture belong to a time before my early days; it was my father who got them made; if they had been done within the last fifty years they would have been much cleverer in execution; but I don't think I should have liked them the better. We were almost beginning again in those days: and they were brisk, hot-headed times.

But you hear how garrulous I am: ask me questions, ask me questions about anything, dear Guest; since I *must* talk, make my talk profitable to you.'

I was silent for a minute, and then I said, somewhat nervously: 'Excuse me if I am rude; but I am so much interested in Richard, since he has been so kind to me, a perfect stranger, that I should like to ask a question about him.'

'Well,' said old Hammond, 'if he were not "kind", as you call it, to a perfect stranger he would be thought a strange person, and people would be apt to shun him. But ask on, ask on! don't be shy of asking.'

Said I: 'That beautiful girl, is he going to be married to her?'

'Well,' said he, 'yes, he is. He has been married to her once already, and now I should say it is pretty clear that he will be married to her again.'

'Indeed,' quoth I, wondering what that meant.

'Here is the whole tale,' said old Hammond; 'a short one enough; and now I hope a happy one: they lived together two years the first time; were both very young; and then she got it into her head that she was in love with somebody else. So she left poor Dick; I say *poor* Dick, because he had not found anyone else. But it did not last long, only about a year. Then she came to me, as she was in the habit of bringing her troubles to the old carle, and asked me how Dick was, and whether he was happy, and all the rest of it. So I saw how the land lay, and said that he was very unhappy, and not at all well; which last at any rate was a lie. There, you can guess the rest. Clara came to have a long talk with me today, but Dick will serve her turn much better. Indeed, if he hadn't chanced in upon me today I should have had to have sent for him tomorrow.'

'Dear me,' said I. 'Have they any children?'

'Yes,' said he, 'two; they are staying with one of my daughters at present, where, indeed, Clara has mostly been. I wouldn't lose sight of her, as I felt sure they would come together again: and Dick, who is the best of good fellows, really took the matter to heart. You see, he had no other love to run to, as she had. So I managed it all; as I have done with such-like matters before.'

'Ah,' said I, 'no doubt you wanted to keep them out of the Divorce Court: but I suppose it often has to settle such matters.'

'Then you suppose nonsense,' said he. 'I know that there used to be such lunatic affairs as divorce courts. But just consider; all the cases that came into them were matters of property quarrels: and I think, dear Guest,' said he, smiling, 'that though you do come from another planet, you can see from the mere outside look of our world that quarrels about private property could not go on amongst us in our days.'

Indeed, my drive from Hammersmith to Bloomsbury, and all the quiet happy life I had seen so many hints of, even apart from my shopping, would have been enough to tell me that 'the sacred rights of property', as we used to think of them, were now no more. So I sat silent while the old man took up the thread of the discourse again, and said:

'Well, then, property quarrels being no longer possible, what remains in these matters that a court of law could deal with? Fancy a court for enforcing a contract of passion or sentiment! If such a thing were needed as a *reductio ad absurdum* of the enforcement of contract, such a folly would do that for us.'

He was silent again a little, and then said: 'You must understand once for all that we have changed these matters; or rather, that our way of looking at them has changed, as we have changed within the last two hundred years. We do not deceive ourselves, indeed, or believe that we can get rid of all the trouble that besets the dealings between the sexes. We know that we must face the unhappiness that comes of man and woman confusing the relations between natural passion, and sentiment, and the friendship which, when things go well, softens the awakening from passing illusions: but we are not so mad as to pile up degradation on that unhappiness by engaging in sordid squabbles about livelihood and position, and the power of tyrannizing over the children who have been the result of love or lust.'

Again he paused awhile, and again went on: 'Calf love, mistaken for a heroism that shall be life-long, yet early waning into disappointment; the inexplicable desire that comes on a man of riper years to be the all-in-all to some one woman, whose ordinary human kindness and human beauty he has idealized into superhuman perfection, and made the one object of his desire; or lastly the reasonable longing of a

strong and thoughtful man to become the most intimate friend of some beautiful and wise woman, the very type of the beauty and glory of the world which we love so well – as we exult in all the pleasure and exaltation of spirit which goes with these things, so we set ourselves to bear the sorrow which not unseldom goes with them also; remembering those lines of the ancient poet (I quote roughly from memory one of the many translations of the nineteenth century):

> 'For this the Gods have fashioned man's grief and evil day
> That still for man hereafter might be the tale and the lay.'

'Well, well, 'tis little likely anyhow that all tales shall be lacking, or all sorrow cured.'

He was silent for some time, and I would not interrupt him. At last he began again: 'But you must know that we of these generations are strong and healthy of body, and live easily; we pass our lives in reasonable strife with nature, exercising not one side of ourselves only, but all sides, taking the keenest pleasure in all the life of the world. So it is a point of honour with us not to be self-centred; not to suppose that the world must cease because one man is sorry; therefore we should think it foolish, or if you will, criminal, to exaggerate these matters of sentiment and sensibility: we are no more inclined to eke out our sentimental sorrows than to cherish our bodily pains; and we recognize that there are other pleasures besides love-making. You must remember, also, that we are long-lived, and that therefore beauty both in man and woman is not so fleeting as it was in the days when we were burdened so heavily by self-inflicted diseases. So we shake off these griefs in a way which perhaps the sentimentalists of other times would think contemptible and unheroic, but which we think necessary and manlike. As on the other hand, therefore, we have ceased to be commercial in our love-matters, so also we have ceased to be *artificially* foolish. The folly which comes by nature, the un-wisdom of the immature man, or the older man caught in a trap, we must put up with that, nor are we much ashamed of it; but to be conventionally sensitive or sentimental – my friend, I am old and perhaps disappointed, but at least I think we have cast off *some* of the follies of the older world.'

He paused, as if for some words of mine; but I held my peace: then he went on: 'At least, if we suffer from the tyranny and fickleness of nature or our own want of experience, we neither grimace about it, nor lie. If there must be sundering betwixt those who meant never to sunder, so it must be: but there need be no pretext of unity when the reality of it is gone: nor do we drive those who well know that they are incapable of it to profess an undying sentiment which they cannot really feel: thus it is that as that monstrosity of venal lust is no longer possible, so also it is no longer needed. Don't misunderstand me. You did not seem shocked when I told you that there were no law-courts to enforce contracts of sentiment or passion; but so curiously are men made, that perhaps you will be shocked when I tell you that there is no code of public opinion which takes the place of such courts, and which might be as tyrannical and unreasonable as they were. I do not say that people don't judge their neighbours' conduct, sometimes, doubtless, unfairly. But I do say that there is no unvarying conventional set of rules by which people are judged; no bed of Procrustes to stretch or cramp their minds and lives; no hypocritical excommunication which people are *forced* to pronounce, either by unconsidered habit, or by the unexpressed threat of the lesser interdict if they are lax in their hypocrisy. Are you shocked now?'

'N-o – no,' said I, with some hesitation. 'It is all so different.'

'At any rate,' said he, 'one thing I think I can answer for: whatever sentiment there is, it is real – and general; it is not confined to people very specially refined. I am also pretty sure, as I hinted to you just now, that there is not by a great way as much suffering involved in these matters either to men or to women as there used to be. But excuse me for being so prolix on this question! You know you asked to be treated like a being from another planet.'

'Indeed I thank you very much,' said I. 'Now may I ask you about the position of women in your society?'

He laughed very heartily for a man of his years, and said: 'It is not without reason that I have got a reputation as a careful student of history. I believe I really do understand "the Emancipation of Women movement" of the nineteenth century. I doubt if any other man now alive does.'

'Well?' said I, a little bit nettled by his merriment.

'Well,' said he, 'of course you will see that all that is a dead contro-versy now. The men have no longer any opportunity of tyrannizing over the women, or the women over the men; both of which things took place in those old times. The women do what they can do best, and what they like best, and the men are neither jealous of it or in-jured by it. This is such a commonplace that I am almost ashamed to state it.'

I said, 'O; and legislation? Do they take any part in that?'

Hammond smiled and said: 'I think you may wait for an answer to that question till we get on to the subject of legislation. There may be novelties to you in that subject also.'

'Very well,' I said; 'but about this woman question? I saw at the Guest House that the women were waiting on the men: that seems a little like reaction, doesn't it?'

'Does it?' said the old man; 'perhaps you think house-keeping an unimportant occupation, not deserving of respect. I believe that was the opinion of the "advanced" women of the nineteenth century, and their male backers. If it is yours, I recommend to your notice an old Norwegian folk-lore tale called How the Man minded the House, or some such title; the result of which minding was that, after various tribulations, the man and the family cow balanced each other at the end of a rope, the man hanging halfway up the chimney, the cow dangling from the roof, which, after the fashion of the country, was of turf and sloping down low to the ground. Hard on the cow, *I* think. Of course no such mishap could happen to such a superior person as yourself,' he added, chuckling.

I sat somewhat uneasy under this dry gibe. Indeed, his manner of treating this latter part of the question seemed to me a little dis-respectful.

'Come, now, my friend,' quoth he, 'don't you know that it is a great pleasure to a clever woman to manage a house skilfully, and to do it so that all the house-mates about her look pleased, and are grateful to her? And then, you know, everybody likes to be ordered about by a pretty woman: why, it is one of the pleasantest forms of flirtation. You are not so old that you cannot remember that. Why, I remember it well.'

And the old fellow chuckled again, and at last fairly burst out laughing.

'Excuse me,' said he, after a while; 'I am not laughing at anything you could be thinking of, but at that silly nineteenth-century fashion, current amongst rich so-called cultivated people, of ignoring all the steps by which their daily dinner was reached, as matters too low for their lofty intelligence. Useless idiots! Come, now, I am a "literary man", as we queer animals used to be called, yet I am a pretty good cook myself.'

'So am I,' said I.

'Well, then,' said he, 'I really think you can understand me better than you would seem to do, judging by your words and your silence.'

Said I: 'Perhaps that is so; but people putting in practice commonly this sense of interest in the ordinary occupations of life rather startles me. I will ask you a question or two presently about that. But I want to return to the position of women amongst you. You have studied the "emancipation of women" business of the nineteenth century: don't you remember that some of the "superior" women wanted to emancipate the more intelligent part of their sex from the bearing of children?'

The old man grew quite serious again. Said he: 'I *do* remember about that strange piece of baseless folly, the result, like all other follies of the period, of the hideous class tyranny which then obtained. What do we think of it now? you would say. My friend, that is a question easy to answer. How could it possibly be but that maternity should be highly honoured amongst us? Surely it is a matter of course that the natural and necessary pains which the mother must go through form a bond of union between man and woman, an extra stimulus to love and affection between them, and that this is universally recognized. For the rest, remember that all the *artificial* burdens of motherhood are now done away with. A mother has no longer any mere sordid anxieties for the future of her children. They may indeed turn out better or worse; they may disappoint her highest hopes; such anxieties as these are a part of the mingled pleasure and pain which goes to make up the life of mankind. But at least she is spared the fear (it was most commonly the certainty) that artificial disabilities would make her children something less than men and women: she knows

that they will live and act according to the measure of their own faculties. In times past, it is clear that the "Society" of the day helped its Judaic god, and the "Man of Science" of the time, in visiting the sins of the father upon the children. How to reverse this process, how to take the sting out of heredity, has for long been one of the most constant cares of the thoughtful men amongst us. So, that, you see, the ordinarily healthy woman (and almost all our women are both healthy and at least comely), respected as a child-bearer and rearer of children, desired as a woman, loved as a companion, unanxious for the future of her children, has far more instinct for maternity than the poor drudge and mother of drudges of past days could ever have had; or than her sister of the upper classes, brought up in affected ignorance of natural facts, reared in an atmosphere of mingled prudery and prurience.'

'You speak warmly,' I said, 'but I can see that you are right.'

'Yes,' he said, 'and I will point out to you a token of all the benefits which we have gained by our freedom. What did you think of the looks of the people whom you have come across today?'

Said I: 'I could hardly have believed that there could be so many good-looking people in any civilized country.'

He crowed a little, like the old bird he was. 'What! are we still civilized?' said he. 'Well, as to our looks, the English and Jutish blood, which on the whole is predominant here, used not to produce much beauty. But I think we have improved it. I know a man who has a large collection of portraits printed from photographs of the nineteenth century, and going over those and comparing them with the everyday faces in these times, puts the improvement in our good looks beyond a doubt. Now, there are some people who think it not too fantastic to connect this increase of beauty directly with our freedom and good sense in the matters we have been speaking of: they believe that a child born from the natural and healthy love between a man and a woman, even if that be transient, is likely to turn out better in all ways, and especially in bodily beauty, than the birth of the respectable commercial marriage bed, or of the dull despair of the drudge of that system. They say, Pleasure begets pleasure. What do you think?'

'I am much of that mind,' said I.

CHAPTER 10: QUESTIONS AND ANSWERS

'WELL,' said the old man, shifting in his chair, 'you must get on with your questions, Guest; I have been some time answering this first one.'

Said I: 'I want an extra word or two about your ideas of education; although I gathered from Dick that you let your children run wild and didn't teach them anything; and in short, that you have so refined your education, that now you have none.'

'Then you gathered lefthanded,' quoth he. 'But of course I understand your point of view about education, which is that of times past when "the struggle for life", as men used to phrase it (i.e., the struggle for a slave's rations on one side, and for a bouncing share of the slave-holders' privilege on the other), pinched "education" for most people into a niggardly dole of not very accurate information; something to be swallowed by the beginner in the art of living whether he liked it or not, and was hungry for it or not: and which had been chewed and digested over and over again by people who didn't care about it in order to serve it out to other people who didn't care about it.'

I stopped the old man's rising wrath by a laugh, and said: 'Well, *you* were not taught that way, at any rate, so you may let your anger run off you a little.'

'True, true,' said he, smiling. 'I thank you for correcting my ill-temper: I always fancy myself as living in any period of which we may be speaking. But, however, to put it in a cooler way: you expected to see children thrust into schools when they had reached an age conventionally supposed to be the due age, whatever their varying faculties and dispositions might be, and when there, with like disregard to facts, to be subjected to a certain conventional course of "learning". My friend, can't you see that such a proceeding means ignoring the fact of *growth*, bodily and mental? No one could come out of such a mill uninjured; and those only would avoid being crushed by it who would have the spirit of rebellion strong in them. Fortunately most children have had that at all times, or I do not know that we should ever have reached our present position. Now you see what it all comes to. In the old times all this was the result of *poverty*.

In the nineteenth century, society was so miserably poor, owing to the systematized robbery on which it was founded, that real education was impossible for anybody. The whole theory of their so-called education was that it was necessary to shove a little information into a child, even if it were by means of torture, and accompanied by twaddle which it was well known was of no use, or else he would lack information lifelong: the hurry of poverty forbade anything else. All that is past; we are no longer hurried, and the information lies ready to each one's hand when his own inclinations impel him to seek it. In this as in other matters we have become wealthy: we can afford to give ourselves time to grow.'

'Yes,' said I, 'but suppose the child, youth, man, never wants the information, never grows in the direction you might hope him to do: suppose, for instance, he objects to learning arithmetic or mathematics; you can't force him when he *is* grown; can't you force him while he is growing, and oughtn't you to do so?'

'Well,' said he, 'were you forced to learn arithmetic and mathematics?'

'A little,' said I.

'And how old are you now?'

'Say fifty-six,' said I.

'And how much arithmetic and mathematics do you know now?' quoth the old man, smiling rather mockingly.

Said I: 'None whatever, I am sorry to say.'

Hammond laughed quietly, but made no other comment on my admission, and I dropped the subject of education, perceiving him to be hopeless on that side.

I thought a little, and said: 'You were speaking just now of households: that sounded to me a little like the customs of past times; I should have thought you would have lived more in public.'

'Phalangsteries, eh?' said he. 'Well, we live as we like, and we like to live as a rule with certain house-mates that we have got used to. Remember, again, that poverty is extinct, and that the Fourierist phalangsteries and all their kind, as was but natural at the time, implied nothing but a refuge from mere destitution. Such a way of life as that could only have been conceived of by people surrounded by the worst form of poverty. But you must understand therewith, that though

separate households are the rule amongst us, and though they differ in their habits more or less, yet no door is shut to any good-tempered person who is content to live as the other house-mates do: only of course it would be unreasonable for one man to drop into a household and bid the folk of it to alter their habits to please him, since he can go elsewhere and live as he pleases. However, I need not say much about all this, as you are going up the river with Dick, and will find out for yourself by experience how these matters are managed.'

After a pause, I said: 'Your big towns, now; how about them? London, which – which I have read about as the modern Babylon of civilization, seems to have disappeared.'

'Well, well,' said old Hammond, 'perhaps after all it is more like ancient Babylon now than the "modern Babylon" of the nineteenth century was. But let that pass. After all, there is a good deal of population in places between here and Hammersmith; nor have you seen the most populous part of the town yet.'

'Tell me, then,' said I, 'how is it towards the east?'

Said he: 'Time was when if you mounted a good horse and rode straight away from my door here at a round trot for an hour and a half, you would still be in the thick of London, and the greater part of that would be "slums", as they were called; that is to say, places of torture for innocent men and women; or worse, stews for rearing and breeding men and women in such degradation that that torture should seem to them mere ordinary and natural life.'

'I know, I know,' I said, rather impatiently. 'That was what was; tell me something of what is. Is any of that left?'

'Not an inch,' said he; 'but some memory of it abides with us, and I am glad of it. Once a year, on May-day, we hold a solemn feast in those easterly communes of London to commemorate The Clearing of Misery, as it is called. On that day we have music and dancing, and merry games and happy feasting on the site of some of the worst of the old slums, the traditional memory of which we have kept. On that occasion the custom is for the prettiest girls to sing some of the old revolutionary songs, and those which were the groans of the discontent, once so hopeless, on the very spots where those terrible crimes of class-murder were committed day by day for so many years. To a man like me, who has studied the past so diligently, it is a

curious and touching sight to see some beautiful girl, daintily clad, and crowned with flowers from the neighbouring meadows, standing amongst the happy people, on some mound where of old time stood the wretched apology for a house, a den in which men and women lived packed amongst the filth like pilchards in a cask; lived in such a way that they could only have endured it, as I said just now, by being degraded out of humanity – to hear the terrible words of threatening and lamentation coming from her sweet and beautiful lips, and she unconscious of their real meaning: to hear her, for instance, singing Hood's Song of the Shirt, and to think that all the time she does not understand what it is all about – a tragedy grown inconceivable to her and her listeners. Think of that, if you can, and of how glorious life is grown!'

'Indeed,' said I, 'it is difficult for me to think of it.'

And I sat watching how his eyes glittered, and how the fresh life seemed to glow in his face, and I wondered how at his age he should think of the happiness of the world, or indeed anything but his coming dinner.

'Tell me in detail,' said I, 'what lies east of Bloomsbury now?'

Said he: 'There are but few houses between this and the outer part of the old city; but in the city we have a thickly dwelling population. Our forefathers, in the first clearing of the slums were not in a hurry to pull down the houses in what was called at the end of the nineteenth century the business quarter of the town, and what later got to be known as the Swindling Kens. You see, these houses, though they stood hideously thick on the ground, were roomy and fairly solid in building, and clean, because they were not used for living in, but as mere gambling booths; so the poor people from the cleared slums took them for lodgings and dwelt there, till the folk of those days had time to think of something better for them; so the buildings were pulled down so gradually that people got used to living thicker on the ground there than in most places; therefore it remains the most populous part of London, or perhaps of all these islands. But it is very pleasant there, partly because of the splendour of the architecture, which goes further than what you will see elsewhere. However, this crowding, if it may be called so, does not go further than a street called Aldgate, a name which perhaps you may have heard of. Be-

yond that the houses are scattered wide about the meadows there, which are very beautiful, especially when you get on to the lovely river Lea (where old Isaak Walton used to fish, you know) about the places called Stratford and Old Ford, names which of course you will not have heard of, though the Romans were busy there once upon a time.'

Not heard of them! thought I to myself. How strange! that I who had seen the very last remnant of the pleasantness of the meadows by the Lea destroyed, should have heard them spoken of with pleasantness come back to them in full measure.

Hammond went on: 'When you get down to the Thames side you come on the Docks, which are works of the nineteenth century, and are still in use, although not so thronged as they once were, since we discourage centralization all we can, and we have long ago dropped the pretension to be the market of the world. About these Docks are a good few houses, which, however, are not inhabited by many people permanently; I mean, those who use them come and go a good deal, the place being too low and marshy for pleasant dwelling. Past the Docks eastward and landward it is all flat pasture, once marsh, except for a few gardens, and there are very few permanent dwellings there: scarcely anything but a few sheds, and cots for the men who come to look after the great herds of cattle pasturing there. But however, what with the beasts and the men, and the scattered red-tiled roofs and the big hayricks, it does not make a bad holiday to get a quiet pony and ride about there on a sunny afternoon of autumn, and look over the river and the craft passing up and down, and on to Shooters' Hill and the Kentish uplands, and then turn round to the wide green sea of the Essex marshland, with the great domed line of the sky, and the sun shining down in one flood of peaceful light over the long distance. There is a place called Canning's Town, and further out, Silvertown, where the pleasant meadows are at their pleasantest: doubtless they were once slums, and wretched enough.'

The names grated on my ear, but I could not explain why to him. So I said: 'And south of the river, what is it like?'

He said: 'You would find it much the same as the land about Hammersmith. North, again, the land runs up high, and there is an agreeable and well-built town called Hampstead, which fitly ends

London on that side. It looks down on the north-western end of the forest you passed through.'

I smiled. 'So much for what was once London,' said I. 'Now tell me about the other towns of the country.'

He said: 'As to the big murky places which were once, as we know, the centres of manufacture, they have, like the brick and mortar desert of London, disappeared; only, since they were centres of nothing but "manufacture", and served no purpose but that of the gambling market, they have left less signs of their existence than London. Of course, the great change in the use of mechanical force made this an easy matter, and some approach to their break-up as centres would probably have taken place, even if we had not changed our habits so much: but they being such as they were, no sacrifice would have seemed too great a price to pay for getting rid of the "manufacturing districts", as they used to be called. For the rest, whatever coal or mineral we need is brought to grass and sent whither it is needed with as little as possible of dirt, confusion, and the distressing of quiet people's lives. One is tempted to believe from what one has read of the condition of those districts in the nineteenth century, that those who had them under their power worried, befouled, and degraded men out of malice prepense: but it was not so; like the miseducation of which we were talking just now, it came of their dreadful poverty. They were obliged to put up with everything, and even pretend that they liked it; whereas we can now deal with things reasonably, and refuse to be saddled with what we do not want.'

I confess I was not sorry to cut short with a question his glorifications of the age he lived in. Said I: 'How about the smaller towns? I suppose you have swept those away entirely?'

'No, no,' said he, 'it hasn't gone that way. On the contrary, there has been but little clearance, though much rebuilding, in the smaller towns. Their suburbs, indeed, when they had any, have melted away into the general country, and space and elbow-room has been got in their centres: but there are the towns still with their streets and squares and market-places; so that it is by means of these smaller towns that we of today can get some kind of idea of what the towns of the older world were like – I mean to say at their best.'

'Take Oxford, for instance,' said I.

'Yes,' said he, 'I suppose Oxford was beautiful even in the nineteenth century. At present it has the great interest of still preserving a great mass of precommercial building, and is a very beautiful place, yet there are many towns which have become scarcely less beautiful.'

Said I: 'In passing, may I ask if it is still a place of learning?'

'Still?' said he, smiling. 'Well, it has reverted to some of its best traditions; so you may imagine how far it is from its nineteenth-century position. It is real learning, knowledge cultivated for its own sake – the Art of Knowledge, in short – which is followed there, not the Commercial learning of the past. Though perhaps you do not know that in the nineteenth century Oxford and its less interesting sister Cambridge became definitely commercial. They (and especially Oxford) were the breeding places of a peculiar class of parasites, who called themselves cultivated people; they were indeed cynical enough, as the so-called educated classes of the day generally were; but they affected an exaggeration of cynicism in order that they might be thought knowing and worldly-wise. The rich middle classes (they had no relation with the working classes) treated them with the kind of contemptuous toleration with which a mediaeval baron treated his jester; though it must be said that they were by no means so pleasant as the old jesters were, being, in fact, *the* bores of society. They were laughed at, despised – and paid. Which last was what they aimed at.'

Dear me! thought I, how apt history is to reverse contemporary judgements. Surely only the worst of them were as bad as that. But I must admit that they were mostly prigs, and that they *were* commercial. I said aloud, though more to myself than to Hammond, 'Well, how could they be better than the age that made them?'

'True,' he said, 'but their pretensions were higher.'

'Were they?' said I, smiling.

'You drive me from corner to corner,' said he, smiling in turn. 'Let me say at least that they were a poor sequence to the aspirations of Oxford of "the barbarous Middle Ages".'

'Yes, that will do,' said I.

'Also,' said Hammond, 'what I have been saying of them is true in the main. But ask on!'

I said: 'We have heard about London and the manufacturing districts and the ordinary towns: how about the villages?'

Said Hammond: 'You must know that toward the end of the nineteenth century the villages were almost destroyed, unless where they became mere adjuncts to the manufacturing districts, or formed a sort of minor manufacturing district themselves. Houses were allowed to fall into decay and actual ruin; trees were cut down for the sake of the few shillings which the poor sticks would fetch; the building became inexpressibly mean and hideous. Labour was scarce; but wages fell nevertheless. All the small country arts of life which once added to the little pleasures of country people were lost. The country produce which passed through the hands of the husbandman never got so far as their mouths. Incredible shabbiness and niggardly pinching reigned over the fields and acres which, in spite of the rude and careless husbandry of the times, were so kind and bountiful. Had you any inkling of all this?'

'I have heard that it was so,' said I, 'but what followed?'

'The change,' said Hammond, 'which in these matters took place very early in our epoch, was most strangely rapid. People flocked into the country villages, and, so to say, flung themselves upon the freed land like a wild beast upon his prey; and in a very little time the villages of England were more populous than they had been since the fourteenth century, and were still growing fast. Of course, this invasion of the country was awkward to deal with, and would have created much misery, if the folk had still been under the bondage of class monopoly. But as it was, things soon righted themselves. People found out what they were fit for, and gave up attempting to push themselves into occupations in which they must needs fail. The town invaded the country; but the invaders, like the warlike invaders of early days, yielded to the influence of their surroundings, and became country people; and in their turn, as they became more numerous than the townsmen, influenced them also; so that the difference between town and country grew less and less; and it was indeed this world of the country vivified by the thought and briskness of town-bred folk which has produced that happy and leisurely but eager life of which you have had a first taste. Again I say, many blunders were made, but we have had time to set them right. Much was left for the men of my earlier life to deal with. The crude ideas of the first half of the twentieth century, when men were still oppressed by the fear

of poverty, and did not look enough to the present pleasure of ordinary daily life, spoilt a great deal of what the commercial age had left us of external beauty: and I admit that it was but slowly that men recovered from the injuries they had inflicted on themselves even after they became free. But slowly as the recovery came, it *did* come; and the more you see of us, the clearer it will be to you that we are happy. That we live amidst beauty without any fear of becoming effeminate; that we have plenty to do, and on the whole enjoy doing it. What more can we ask of life?'

He paused, as if he were seeking for words with which to express his thought. Then he said:

'This is how we stand. England was once a country of clearings amongst the woods and wastes, with a few towns interspersed, which were fortresses for the feudal army, markets for the folk, gathering places for the craftsmen. It then became a country of huge and foul workshops and fouler gambling-dens, surrounded by an ill-kept, poverty-stricken farm, pillaged by the masters of the workshops. It is now a garden, where nothing is wasted and nothing is spoilt, with the necessary dwellings, sheds, and workshops scattered up and down the country, all trim and neat and pretty. For, indeed, we should be too much ashamed of ourselves if we allowed the making of goods, even on a large scale, to carry with it the appearance, even, of desolation and misery. Why, my friend, those housewives we were talking of just now would teach us better than that.'

Said I: 'This side of your change is certainly for the better. But though I shall soon see some of these villages, tell me in a word or two what they are like, just to prepare me.'

'Perhaps,' said he, 'you have seen a tolerable picture of these villages as they were before the end of the nineteenth century. Such things exist.'

'I have seen several of such pictures,' said I.

'Well,' said Hammond, 'our villages are something like the best of such places, with the church or mote-house of the neighbours for their chief building. Only note that there are no tokens of poverty about them: no tumble-down picturesque: which, to tell you the truth, the artist usually availed himself of to veil his incapacity for drawing architecture. Such things do not please us, even when they indicate no

misery. Like the mediaevals, we like everything trim and clean, and orderly and bright; as people always do when they have any sense of architectural power; because then they know that they can have what they want, and they won't stand any nonsense from Nature in their dealings with her.'

'Besides the villages, are there any scattered country houses?' said I.

'Yes, plenty,' said Hammond; 'in fact, except in the wastes and forests and amongst the sand-hills (like Hindhead in Surrey), it is not easy to be out of sight of a house; and where the houses are thinly scattered they run large, and are more like the old colleges than ordinary houses as they used to be. That is done for the sake of society, for a good many people can dwell in such houses, as the country dwellers are not necessarily husbandmen; though they almost all help in such work at times. The life that goes on in these big dwellings in the country is very pleasant, especially as some of the most studious men of our time live in them, and altogether there is a great variety of mind and mood to be found in them which brightens and quickens the society there.'

'I am rather surprised,' said I, 'by all this, for its seems to me that after all the country must be tolerably populous.'

'Certainly,' said he; 'the population is pretty much the same as it was at the end of the nineteenth century; we have spread it, that is all. Of course, also, we have helped to populate other countries – where we were wanted and were called for.'

Said I: 'One thing, it seems to me, does not go with your word of "garden" for the country. You have spoken of wastes and forests, and I myself have seen the beginning of your Middlesex and Essex forest. Why do you keep such things in a garden? and isn't it very wasteful to do so?'

'My friend,' he said, 'we like these pieces of wild nature, and can afford them, so we have them; let alone that as to the forests, we need a great deal of timber, and suppose that our sons and sons' sons will do the like. As to the land being a garden, I have heard that they used to have shrubberies and rockeries in gardens once; and though I might not like the artificial ones, I assure you that some of the natural rockeries of our garden are worth seeing. Go north this summer and look at the Cumberland and Westmorland ones – where, by the

way, you will see some sheep feeding, so that they are not so wasteful as you think; not so wasteful as forcing-grounds for fruit out of season, I think. Go and have a look at the sheep-walks high up the slopes between Ingleborough and Pen-y-gwent, and tell me if you think we *waste* the land there by not covering it with factories for making things that nobody wants, which was the chief business of the nineteenth century.'

'I will try to go there,' said I.

'It won't take much trying,' said he.

CHAPTER II: CONCERNING GOVERNMENT

'Now,' said I, 'I have come to the point of asking questions which I suppose will be dry for you to answer and difficult for you to explain; but I have foreseen for some time past that I must ask them, will I nill I. What kind of a government have you? Has republicanism finally triumphed? or have you come to a mere dictatorship, which some persons in the nineteenth century used to prophesy as the ultimate outcome of democracy? Indeed, this last question does not seem so very unreasonable, since you have turned your Parliament House into a dung-market. Or where do you house your present Parliament?'

The old man answered my smile with a hearty laugh, and said: 'Well, well, dung is not the worst kind of corruption; fertility may come of that, whereas mere dearth came from the other kind, of which those walls once held the great supporters. Now, dear Guest, let me tell you that our present parliament would be hard to house in one place, because the whole people is our parliament.'

'I don't understand,' said I.

'No, I suppose not,' said he. 'I must now shock you by telling you that we have no longer anything which you, a native of another planet, would call a government.'

'I am not so much shocked as you might think,' said I, 'as I know something about governments. But tell me, how do you manage, and how have you come to this state of things?'

Said he: 'It is true that we have to make some arrangements about

our affairs, concerning which you can ask presently; and it is also true that everybody does not always agree with the details of these arrangements; but, further, it is true that a man no more needs an elaborate system of government, with its army, navy, and police, to force him to give way to the will of the majority of his *equals*, than he wants a similar machinery to make him understand that his head and a stone wall cannot occupy the same space at the same moment. Do you want further explanation?'

'Well, yes, I do,' quoth I.

Old Hammond settled himself in his chair with a look of enjoyment which rather alarmed me, and made me dread a scientific disquisition: so I sighed and abided. He said:

'I suppose you know pretty well what the process of government was in the bad old times?'

'I am supposed to know,' said I.

(Hammond) What was the government of those days? Was it really the Parliament or any part of it?

(I) No.

(H.) Was not the Parliament on the one side a kind of watch-committee sitting to see that the interests of the Upper Classes took no hurt; and on the other side a sort of blind to delude the people into supposing that they had some share in the management of their own affairs?

(I) History seems to show us this.

(H.) To what extent did the people manage their own affairs?

(I) I judge from what I have heard that sometimes they forced the Parliament to make a law to legalize some alteration which had already taken place.

(H.) Anything else?

(I) I think not. As I am informed, if the people made any attempt to deal with the *cause* of their grievances, the law stepped in and said, this is sedition, revolt, or what not, and slew or tortured the ring-leaders of such attempts.

(H.) If Parliament was not the government then, nor the people either, what was the government?

(I) Can you tell me?

(H.) I think we shall not be far wrong if we say that government

was the Law Courts, backed up by the executive, which handled the brute force that the deluded people allowed them to use for their own purposes; I mean the army, navy, and police.

(I) Reasonable men must needs think you are right.

(H.) Now as to those Law Courts. Were they places of fair dealing according to the ideas of the day? Had a poor man a good chance of defending his property and person in them?

(I) It is a commonplace that even rich men looked upon a law-suit as a dire misfortune, even if they gained the case; and as for a poor one – why, it was considered a miracle of justice and beneficence if a poor man who had once got into the clutches of the law escaped prison or utter ruin.

(H.) It seems, then, my son, that the government by Law Courts and police, which was the real government of the nineteenth century, was not a great success even to the people of that day, living under a class system which proclaimed inequality and poverty as the law of God and the bond which held the world together.

(I) So it seems, indeed.

(H.) And now that all this is changed, and the 'rights of property', which mean the clenching the fist on a piece of goods and crying out to the neighbours, You shan't have this! – now that all this has disappeared so utterly that it is no longer possible even to jest upon its absurdity, is such a Government possible?

(I) It is impossible.

(H.) Yes, happily. But for what other purpose than the protection of the rich from the poor, the strong from the weak, did this Government exist?

(I) I have heard that it was said that their office was to defend their own citizens against attack from other countries.

(H.) It was said; but was anyone expected to believe this? For instance, did the English Government defend the English citizen against the French?

(I) So it was said.

(H.) Then if the French had invaded England and conquered it, they would not have allowed the English workman to live well?

(I, laughing) As far as I can make out, the English masters of the English workmen saw to that: they took from their workmen as

much of their livelihood as they dared, because they wanted it for themselves.

(H.) But if the French had conquered, would they not have taken more still from the English workmen?

(I) I do not think so; for in that case the English workmen would have died of starvation; and then the French conquest would have ruined the French, just as if the English horses and cattle had died of under-feeding. So that after all, the English *workmen* would have been no worse off for the conquest: their French masters could have got no more from them than their English masters did.

(H.) This is true; and we may admit that the pretensions of the government to defend the poor (i.e., the useful) people against other countries come to nothing. But that is but natural; for we have seen already that it was the function of government to protect the rich against the poor. But did not the government defend its rich men against other nations?

(I) I do not remember to have heard that the rich needed defence; because it is said that even when two nations were at war, the rich men of each nation gambled with each other pretty much as usual, and even sold each other weapons wherewith to kill their own countrymen.

(H.) In short, it comes to this, that whereas the so-called government of protection of property by means of the Law Courts meant destruction of wealth, this defence of the citizens of one country against those of another country by means of war or the threat of war meant pretty much the same thing.

(I) I cannot deny it.

(H.) Therefore the government really existed for the destruction of wealth?

(I) So it seems. And yet –

(H.) Yet what?

(I) There were many rich people in those times.

(H.) You see the consequences of that fact?

(I) I think I do. But tell me out what they were.

(H.) If the government habitually destroyed wealth, the country must have been poor?

(I) Yes, certainly.

(H.) Yet amidst this poverty the persons for the sake of whom the government existed insisted on being rich whatever might happen?

(I) So it was.

(H.) What *must* happen if in a poor country some people insist on being rich at the expense of the others?

(I) Unutterable poverty for the others. All this misery then, was caused by the destructive government of which we have been speaking?

(H.) Nay, it would be incorrect to say so. The government itself was but the necessary result of the careless, aimless tyranny of the times; it was but the machinery of tyranny. Now tyranny has come to an end, and we no longer need such machinery; we could not possibly use it since we are free. Therefore in your sense of the word we have no government. Do you understand this now?

(I) Yes, I do. But I will ask you some more questions as to how you as free men manage your affairs.

(H.) With all my heart. Ask away.

## CHAPTER 12: CONCERNING THE ARRANGEMENT OF LIFE

'WELL,' I said, 'about those "arrangements" which you spoke of as taking the place of government, could you give me any account of them?'

'Neighbour,' he said, 'although we have simplified our lives a great deal from what they were, and have got rid of many conventionalities and many sham wants, which used to give our forefathers much trouble, yet our life is too complex for me to tell you in detail by means of words how it is arranged; you must find that out by living amongst us. It is true that I can better tell you what we don't do, than what we do do.'

'Well?' said I.

'This is the way to put it,' said he: 'We have been living for a hundred and fifty years, at least, more or less in our present manner, and a tradition or habit of life has been growing on us; and that habit has become a habit of acting on the whole for the best. It is easy for us to

live without robbing each other. It would be possible for us to contend with and rob each other, but it would be harder for us than refraining from strife and robbery. That is in short the foundation of our life and our happiness.'

'Whereas in the old days,' said I, 'it was very hard to live without strife and robbery. That's what you mean, isn't it, by giving me the negative side of your good conditions?'

'Yes,' he said, 'it was so hard, that those who habitually acted fairly to their neighbours were celebrated as saints and heroes, and were looked up to with the greatest reverence.'

'While they were alive?' said I.

'No,' said he, 'after they were dead.'

'But as to these days,' I said; 'you don't mean to tell me that no one ever transgresses this habit of good fellowship?'

'Certainly not,' said Hammond, 'but when the transgressions occur, everybody, transgressors and all, know them for what they are; the errors of friends, not the habitual actions of persons driven into enmity against society.'

'I see,' said I: 'you mean that you have no "criminal" classes.'

'How could we have them,' said he, 'since there is no rich class to breed enemies against the state by means of the injustice of the state?'

Said I: 'I thought that I understood from something that fell from you a little while ago that you had abolished civil law. Is that so, literally?'

'It abolished itself, my friend,' said he. 'As I said before, the civil law-courts were upheld for the defence of private property, for nobody ever pretended that it was possible to make people act fairly to each other by means of brute force. Well, private property being abolished, all the laws and all the legal "crimes" which it had manufactured of course came to an end. Thou shalt not steal, had to be translated into, Thou shalt work in order to live happily. Is there any need to enforce that commandment by violence?'

'Well,' said I, 'that is understood, and I agree with it; but how about the crimes of violence? would not their occurrence (and you admit that they occur) make criminal law necessary?'

Said he: 'In your sense of the word, we have no criminal law either. Let us look at the matter closer, and see whence crimes of violence

spring. By far the greater part of these in past days were the result of the laws of private property, which forbade the satisfaction of their natural desires to all but a privileged few, and of the general visible coercion which came of those laws. All *that* cause of violent crime is gone. Again, many violent acts came from the artificial perversion of the sexual passions, which caused overweening jealousy and the like miseries. Now, when you look carefully into these, you will find that what lay at the bottom of them was mostly the idea (a law-made idea) of the woman being the property of the man, whether he were husband, father, brother, or what not. That idea has of course vanished with private property, as well as certain follies about the "ruin" of women for following their natural desires in an illegal way, which of course was a convention caused by the laws of private property.

'Another cognate cause of crimes of violence was the family tyranny, which was the subject of so many novels and stories of the past, and which once more was the result of private property. Of course that is all ended, since families are held together by no bond of coercion, legal or social, but by mutual like and affection, and everybody is free to come or go as he or she pleases. Furthermore, our standards of honour and public estimation are very different from the old ones; success in besting our neighbours is a road to renown now closed, let us hope for ever. Each man is free to exercise his special faculty to the utmost, and everyone encourages him in so doing. So that we have got rid of the scowling envy, coupled by the poets with hatred, and surely with good reason; heaps of unhappiness and ill-blood were caused by it, which with irritable and passionate men – i.e., energetic and active men – often led to violence.'

I laughed, and said: 'So that you now withdraw your admission, and say that there is no violence amongst you?'

'No,' said he, 'I withdraw nothing: as I told you, such things will happen. Hot blood will err sometimes. A man may strike another, and the stricken strike back again, and the result be a homicide, to put it at the worst. But what then? Shall we the neighbours make it worse still? Shall we think so poorly of each other as to suppose that the slain man calls on us to revenge him, when we *know* that if he had been maimed, he would, when in cold blood and able to weigh all the

circumstances, have forgiven his maimer? Or will the death of the slayer bring the slain man to life again and cure the unhappiness his loss has caused?'

'Yes,' I said, 'but consider, must not the safety of society be safe-guarded by some punishment?'

'There, neighbour!' said the old man, with some exultation. 'You have hit the mark. That *punishment* of which men used to talk so wisely and act so foolishly, what was it but the expression of their fear? And they had need to fear, since *they* – i.e., the rulers of society – were dwelling like an armed band in a hostile country. But we who live amongst our friends need neither fear nor punish. Surely if we, in dread of an occasional rare homicide, an occasional rough blow, were solemnly and legally to commit homicide and violence, we could only be a society of ferocious cowards. Don't you think so, neigh-bour?'

'Yes, I do, when I come to think of it from that side,' said I.

'Yet you must understand,' said the old man, 'that when any vio-lence is committed, we expect the transgressor to make any atone-ment possible to him, and he himself expects it. But again, think if the destruction or serious injury of a man momentarily overcome by wrath or folly can be any atonement to the commonwealth? Surely it can only be an additional injury to it.'

Said I: 'But suppose the man has a habit of violence – kills a man a year, for instance?'

'Such a thing is unknown,' said he. 'In a society where there is no punishment to evade, no law to triumph over, remorse will certainly follow transgression.'

'And lesser outbreaks of violence,' said I, 'how do you deal with them? for hitherto we have been talking of great tragedies, I suppose?'

Said Hammond: 'If the ill-doer is not sick or mad (in which case he must be restrained till his sickness or madness is cured) it is clear that grief and humiliation must follow the ill-deed; and society in general will make that pretty clear to the ill-doer if he should chance to be dull to it; and again, some kind of atonement will follow – at the least, an open acknowledgement of the grief and humiliation. Is it so hard to say, I ask your pardon, neighbour? – Well, sometimes it is hard – and let it be.'

'You think that enough?' said I.

'Yes,' said he, 'and moreover it is all that we *can* do. If in addition we torture the man, we turn his grief into anger, and the humiliation he would otherwise feel for *his* wrong-doing is swallowed up by a hope of revenge for *our* wrong-doing to him. He has paid the legal penalty, and can "go and sin again" with comfort. Shall we commit such a folly, then? Remember Jesus had got the legal penalty remitted before he said "Go and sin no more." Let alone that in a society of equals you will not find anyone to play the part of torturer or jailer, though many to act as nurse or doctor.'

'So,' said I, 'you consider crime a mere spasmodic disease, which requires no body of criminal law to deal with it?'

'Pretty much so,' said he; 'and since, as I told you, we are a healthy people generally, so we are not likely to be much troubled with *this* disease.'

'Well, you have no civil law, and no criminal law. But have you no laws of the market, so to say – no regulation for the exchange of wares? for you must exchange, even if you have no property.'

Said he: 'We have no obvious individual exchange, as you saw this morning when you went a-shopping; but of course there are regulations of the markets, varying according to the circumstances and guided by general custom. But as these are matters of general assent, which nobody dreams of objecting to, so also we have made no provision for enforcing them: therefore I don't call them laws. In law, whether it be criminal or civil, execution always follows judgement, and someone must suffer. When you see the judge on his bench, you see through him, as clearly as if he were made of glass, the policeman to imprison, and the soldier to slay some actual living person. Such follies would make an agreeable market, wouldn't they?'

'Certainly,' said I, 'that means turning the market into a mere battlefield, in which many people must suffer as much as in the battlefield of bullet and bayonet. And from what I have seen I should suppose that your marketing, great and little, is carried on in a way that makes it a pleasant occupation.'

'You are right, neighbour,' said he. 'Although there are so many, indeed by far the greater number amongst us, who would be unhappy if they were not engaged in actually making things, and things

which turn out beautiful under their hands – there are many, like the housekeepers I was speaking of, whose delight is in administration and organization, to use long-tailed words; I mean people who like keeping things together, avoiding waste, seeing that nothing sticks fast uselessly. Such people are thoroughly happy in their business, all the more as they are dealing with actual facts, and not merely passing counters round to see what share they shall have in the privileged taxation of useful people, which was the business of the commercial folk in past days. Well, what are you going to ask me next?'

## CHAPTER 13: CONCERNING POLITICS

SAID I: 'How do you manage with politics?'

Said Hammond, smiling: 'I am glad that it is of *me* that you ask the question: I do believe that anybody else would make you explain yourself, or try to do so, till you were sickened of asking questions. Indeed, I believe I am the only man in England who would know what you mean; and since I know, I will answer your question briefly by saying that we are very well off as to politics – because we have none. If ever you make a book out of this conversation, put this in a chapter by itself, after the model of old Horrebow's Snakes in Iceland.'

'I will,' said I.

## CHAPTER 14: HOW MATTERS ARE MANAGED

SAID I: 'How about your relations with foreign nations?'

'I will not affect to know what you mean,' said he, 'but I will tell you at once that the whole system of rival and contending nations which played so great a part in the "government" of the world of civilization has disappeared along with the inequality betwixt man and man in society.'

'Does not that make the world duller?' said I.

'Why?' said the old man.

'The obliteration of national variety,' said I.

'Nonsense,' he said, somewhat snappishly. 'Cross the water and see. You will find plenty of variety: the landscape, the building, the diet, the amusements, all various. The men and women varying in looks as well as in habits of thought; the costume far more various than in the commercial period. How should it add to the variety or dispel the dulness, to coerce certain families or tribes, often heterogeneous and jarring with one another, into certain artificial and mechanical groups, and call them nations, and stimulate their patriotism – i.e., their foolish and envious prejudices?'

'Well – I don't know how,' said I.

'That's right,' said Hammond cheerily; 'you can easily understand that now we are freed from this folly it is obvious to us that by means of this very diversity the different strains of blood in the world can be serviceable and pleasant to each other, without in the least wanting to rob each other: we are all bent on the same enterprise, making the most of our lives. And I must tell you whatever quarrels or misunderstandings arise, they very seldom take place between people of different race; and consequently since there is less unreason in them, they are the more readily appeased.'

'Good,' said I, 'but as to those matters of politics; as to general differences of opinion in one and the same community. Do you assert that there are none?'

'No, not at all,' said he, somewhat snappishly: 'but I do say that differences of opinion about real solid things need not, and with us do not, crystallize people into parties permanently hostile to one another, with different theories as to the build of the universe and the progress of time. Isn't that what politics used to mean?'

'H'm, well,' said I, 'I am not so sure of that.'

Said he: 'I take you, neighbour; they only *pretended* to this serious difference of opinion; for if it had existed they could not have dealt together in the ordinary business of life; couldn't have eaten together, bought and sold together, gambled together, cheated other people together, but must have fought whenever they met: which would not have suited them at all. The game of the masters of politics was to cajole or force the public to pay the expense of a luxurious life and

exciting amusement for a few cliques of ambitious persons: and the *pretence* of serious difference of opinion, belied by every action of their lives, was quite good enough for that. What has all that got to do with us?'

Said I: 'Why, nothing, I should hope. But I fear – In short, I have been told that political strife was a necessary result of human nature.'

'Human nature!' cried the old boy, impetuously: 'what human nature? The human nature of paupers, of slaves, of slave-holders, or the human nature of wealthy freemen? Which? Come, tell me that!'

'Well,' said I, 'I suppose there would be a difference according to circumstances in people's action about these matters.'

'I should think so, indeed,' said he. 'At all events, experience shows that it is so. Amongst us, our differences concern matters of business, and passing events as to them, and could not divide men permanently. As a rule, the immediate outcome shows which opinion on a given subject is the right one; it is a matter of fact, not of speculation. For instance, it is clearly not easy to knock up a political party on the question as to whether haymaking in such and such a countryside shall begin this week or next, when all men agree that it must at latest begin the week after next, and when any man can go down into the fields himself and see whether the seeds are ripe enough for the cutting.'

Said I: 'And you settle these differences, great and small, by the will of the majority, I suppose?'

'Certainly,' said he; 'how else could we settle them? You see in matters which are merely personal which do not affect the welfare of the community – how a man shall dress, what he shall eat and drink, what he shall write and read, and so forth – there can be no difference of opinion, and everybody does as he pleases. But when the matter is of common interest to the whole community, and the doing or not doing something affects everybody, the majority must have their way; unless the minority were to take up arms and show by force that they were the effective of real majority; which, however, in a society of men who are free and equal is little likely to happen; because in such a community the apparent majority *is* the real majority, and the others, as I have hinted before, know that too well to obstruct

from mere pigheadedness; especially as they have had plenty of opportunity of putting forward their side of the question.'

'How is that managed?' said I.

'Well,' said he, 'let us take one of our units of management, a commune, or a ward, or a parish (for we have all three names, indicating little real distinction between them now, though time was there was a good deal). In such a district, as you would call it, some neighbours think that something ought to be done or undone: a new town-hall built; a clearance of inconvenient houses; or say a stone bridge substituted for some ugly old iron one – there you have undoing and doing in one. Well, at the next ordinary meeting of the neighbours, or Mote, as we call it, according to the ancient tongue of the times before bureaucracy, a neighbour proposes the change, and of course, if everybody agrees, there is an end of discussion, except about details. Equally, if no one backs the proposer – "seconds him", it used to be called – the matter drops for the time being; a thing not likely to happen amongst reasonable men, however, as the proposer is sure to have talked it over with others before the Mote. But supposing the affair proposed and seconded, if a few of the neighbours disagree to it, if they think that the beastly iron bridge will serve a little longer and they don't want to be bothered with building a new one just then, they don't count heads that time, but put off the formal discussion to the next Mote; and meantime arguments *pro* and *con* are flying about, and some get printed, so that everybody knows what is going on; and when the Mote comes together again there is a regular discussion and at last a vote by show of hands. If the division is a close one, the question is again put off for further discussion; if the division is a wide one, the minority are asked if they will yield to the more general opinion, which they often, nay, most commonly do. If they refuse, the question is debated a third time, when, if the minority has not perceptibly grown, they always give way; though I believe there is some half-forgotten rule by which they might still carry it on further; but I say, what always happens is that they are convinced, not perhaps that their view is the wrong one, but they cannot persuade or force the community to adopt it.'

'Very good,' said I, 'but what happens if the divisions are still narrow?'

Said he: 'As a matter of principle and according to the rule of such cases, the question must then lapse, and the majority, if so narrow, has to submit to sitting down under the *status quo*. But I must tell you that in point of fact the minority very seldom enforces this rule, but generally yields in a friendly manner.'

'But do you know,' said I, 'that there is something in all this very like democracy; and I thought that democracy was considered to be in a moribund condition many, many years ago.'

The old boy's eyes twinkled. 'I grant you that our methods have that drawback. But what is to be done? We can't get *anyone* amongst us to complain of his not always having his own way in the teeth of the community, when it is clear that *everybody* cannot have that indulgence. What *is* to be done?'

'Well,' said I, 'I don't know.'

Said he: 'The only alternatives to our method that I can conceive of are these. First, that we should choose out, or breed, a class of superior persons capable of judging on all matters without consulting the neighbours; that, in short, we should get for ourselves what used to be called an aristocracy of intellect; or, secondly, that for the purpose of safeguarding the freedom of the individual will, we should revert to a system of private property again, and have slaves and slave-holders once more. What do you think of those two expedients?'

'Well,' said I, 'there is a third possibility – to wit, that every man should be quite independent of every other, and that thus the tyranny of society should be abolished.'

He looked hard at me for a second or two, and then burst out laughing very heartily; and I confess that I joined him. When he recovered himself he nodded at me, and said: 'Yes, yes, I quite agree with you – and so we all do.'

'Yes,' I said, 'and besides, it does not press hardly on the minority: for, take this matter of the bridge, no man is obliged to work on it if he doesn't agree to its building. At least, I suppose not.'

He smiled, and said: 'Shrewdly put; and yet from the point of view of the native of another planet. If the man of the minority does find his feelings hurt, doubtless he may relieve them by refusing to help in building the bridge. But, dear neighbour, that is not a very effective salve for the wound caused by the "tyranny of a majority" in our

society; because all work that is done is either beneficial or hurtful to every member of society. The man is benefited by the bridge-building if it turns out a good thing, and hurt by it if it turns out a bad one, whether he puts a hand to it or not; and meanwhile he is benefiting the bridge-builders by his work, whatever that may be. In fact, I see no help for him except the pleasure of saying "I told you so" if the bridge-building turns out to be a mistake and hurts him; if it benefits him he must suffer in silence. A terrible tyranny our Communism, is it not? Folk used often to be warned against this very unhappiness in times past, when for every well-fed, contented person you saw a thousand miserable starvelings. Whereas for us, we grow fat and well-liking on the tyranny; a tyranny, to say the truth, not to be made visible by any microscope I know. Don't be afraid, my friend; we are not going to seek for troubles by calling our peace and plenty and happiness by ill names whose very meaning we have forgotten!'

He sat musing for a little, and then started and said: 'Are there any more questions, dear Guest? The morning is waning fast amidst my garrulity.'

## CHAPTER 15: ON THE LACK OF INCENTIVE TO LABOUR IN A COMMUNIST SOCIETY

'Yes,' said I. 'I was expecting Dick and Clara to make their appearance any moment: but is there time to ask just one or two questions before they come?'

'Try it, dear neighbour – try it,' said old Hammond. 'For the more you ask me the better I am pleased; and at any rate if they do come and find me in the middle of an answer, they must sit quiet and pretend to listen till I come to an end. It won't hurt them; they will find it quite amusing enough to sit side by side, conscious of their proximity to each other.'

I smiled, as I was bound to, and said: 'Good; I will go on talking without noticing them when they come in. Now, this is what I want to ask you about – to wit, how you get people to work when there is

no reward of labour, and especially how you get them to work strenuously?'

'No reward of labour?' said Hammond gravely. 'The reward of labour is *life*. Is that not enough?'

'But no reward for especially good work,' quoth I.

'Plenty of reward,' said he – 'the reward of creation. The wages which God gets, as people might have said time agone. If you are going to ask to be paid for the pleasure of creation, which is what excellence in work means, the next thing we shall hear of will be a bill sent in for the begetting of children.'

'Well, but,' said I, 'the man of the nineteenth century would say there is a natural desire towards the procreation of children, and a natural desire not to work.'

'Yes, yes,' said he, 'I know the ancient platitude – wholly untrue; indeed, to us quite meaningless. Fourier, whom all men laughed at, understood the matter better.'

'Why is it meaningless to you?' said I.

He said: 'Because it implies that all work is suffering, and we are so far from thinking that, that, as you may have noticed, whereas we are not short of wealth, there is a kind of fear growing up amongst us that we shall one day be short of work. It is a pleasure which we are afraid of losing, not a pain.'

'Yes,' said I, 'I have noticed that, and I was going to ask you about that also. But in the meantime, what do you positively mean to assert about the pleasurableness of work amongst you?'

'This, that *all* work is now pleasurable; either because of the hope of gain in honour and wealth with which the work is done, which causes pleasurable excitement, even when the actual work is not pleasant; or else because it has grown into a pleasurable *habit*, as in the case with what you may call mechanical work; and lastly (and most of our work is of this kind) because there is conscious sensuous pleasure in the work itself; it is done, that is, by artists.'

'I see,' said I. 'Can you now tell me how you have come to this happy condition? For, to speak plainly, this change from the conditions of the older world seems to me far greater and more important than all the other changes you have told me about as to crime, politics, property, marriage.'

'You are right there,' said he. 'Indeed, you may say rather that it is this change which makes all the others possible. What is the object of Revolution? Surely to make people happy. Revolution having brought its foredoomed change about, how can you prevent the counter-revolution from setting in except by making people happy? What! shall we expect peace and stability from unhappiness? The gathering of grapes from thorns and figs from thistles is a reasonable expectation compared with that! And happiness without happy daily work is impossible.'

'Most obviously true,' said I: for I thought the old boy was preaching a little. 'But answer my question, as to how you gained this happiness.'

'Briefly,' said he, 'by the absence of artificial coercion, and the freedom for every man to do what he can do best, joined to the knowledge of what productions of labour we really want. I must admit that this knowledge we reached slowly and painfully.'

'Go on,' said I, 'give me more detail; explain more fully. For this subject interests me intensely.'

'Yes, I will,' said he; 'but in order to do so I must weary you by talking a little about the past. Contrast is necessary for this explanation. Do you mind?'

'No, no,' said I.

Said he, settling himself in his chair again for a long talk: 'It is clear from all that we hear and read, that in the last age of civilization men had got into a vicious circle in the matter of production of wares. They had reached a wonderful facility of production, and in order to make the most of that facility they had gradually created (or allowed to grow, rather) a most elaborate system of buying and selling, which has been called the World-Market; and that World-Market, once set a-going, forced them to go on making more and more of these wares, whether they needed them or not. So that while (of course) they could not free themselves from the toil of making real necessaries, they created in a never-ending series sham or artificial necessaries, which became, under the iron rule of the aforesaid World-Market, of equal importance to them with the real necessaries which supported life. By all this they burdened themselves with a prodigious mass of work merely for the sake of keeping their wretched system going.'

'Yes – and then?' said I.

'Why, then, since they had forced themselves to stagger along under this horrible burden of unnecessary production, it became impossible for them to look upon labour and its results from any other point of view than one – to wit, the ceaseless endeavour to expend the least possible amount of labour on any article made, and yet at the same time to make as many articles as possible. To this "cheapening of production", as it was called, everything was sacrificed: the happiness of the workman at his work, nay, his most elementary comfort and bare health, his food, his clothes, his dwelling, his leisure, his amusement, his education – his life, in short – did not weigh a grain of sand in the balance against this dire necessity of "cheap production" of things, a great part of which were not worth producing at all. Nay, we are told, and we must believe it, so overwhelming is the evidence, though many of our people scarcely *can* believe it, that even rich and powerful men, the masters of the poor devils aforesaid, submitted to live amidst sights and sounds and smells which it is in the very nature of man to abhor and flee from, in order that their riches might bolster up this supreme folly. The whole community, in fact, was cast into the jaws of this ravening monster, "the cheap production" forced upon it by the World-Market.'

'Dear me!' said I. 'But what happened? Did not their cleverness and facility in production master this chaos of misery at last? Couldn't they catch up with the World-Market, and then set to work to devise means for relieving themselves from this fearful task of extra labour?'

He smiled bitterly. 'Did they even try to?' said he. 'I am not sure. You know that according to the old saw the beetle gets used to living in dung; and these people, whether they found the dung sweet or not, certainly lived in it.'

His estimate of the life of the nineteenth century made me catch my breath a little; and I said feebly, 'But the labour-saving machines?'

'Heyday!' quoth he. 'What's that you are saying? the labour-saving machines? Yes, they were made to "save labour" (or, to speak more plainly, the lives of men) on one piece of work in order that it might be expended – I will say wasted – on another, probably

useless, piece of work. Friend, all their devices for cheapening labour simply resulted in increasing the burden of labour. The appetite of the World-Market grew with what it fed on: the countries within the ring of "civilization" (that is, organized misery) were glutted with the abortions of the market, and force and fraud were used unsparingly to "open up" countries *outside* that pale. This process of "opening up" is a strange one to those who have read the professions of the men of that period and do not understand their practice; and perhaps shows us at its worst the great vice of the nineteenth century, the use of hypocrisy and cant to evade the responsibility of vicarious ferocity. When the civilized World-Market coveted a country not yet in its clutches, some transparent pretext was found – the suppression of a slavery different from, and not so cruel as that of commerce; the pushing of a religion no longer believed in by its promoters; the "rescue" of some desperado or homicidal madman whose misdeeds had got him into trouble amongst the natives of the "barbarous" country – any stick, in short, which would beat the dog at all. Then some bold, unprincipled, ignorant adventurer was found (no difficult task in the days of competition), and he was bribed to "create a market" by breaking up whatever traditional society there might be in the doomed country, and by destroying whatever leisure or pleasure he found there. He forced wares on the native which they did not want, and took their natural products in "exchange", as this form of robbery was called, and thereby he "created new wants", to supply which (that is, to be allowed to live by their new masters) the hapless helpless people had to sell themselves into the slavery of hopeless toil so that they might have something wherewith to purchase the nullities of "civilization". Ah,' said the old man, pointing to the Museum, 'I have read books and papers in there, telling strange stories indeed of the dealings of civilization (or organized misery) with "non-civilization"; from the time when the British Government deliberately sent blankets infected with small-pox as choice gifts to inconvenient tribes of Redskins, to the time when Africa was infested by a man named Stanley, who –'

'Excuse me,' said I, 'but as you know, time presses; and I want to keep our question on the straightest line possible; and I want at once to ask this about these wares made for the World-Market – how about

their quality; these people who were so clever about making goods, I suppose they made them well?'

'Quality!' said the old man crustily, for he was rather peevish at being cut short in his story; 'how could they possibly attend to such trifles as the quality of the wares they sold? The best of them were of a lowish average, the worst were transparent makeshifts for the things asked for, which nobody would have put up with if they could have got anything else. It was a current jest of the time that the wares were made to sell and not to use; a jest which you, as coming from another planet, may understand, but which our folk could not.'

Said I: 'What! did they make nothing well?'

'Why, yes,' said he, 'there was one class of goods which they did make thoroughly well, and that was the class of machines which were used for making things. These were usually quite perfect pieces of workmanship, admirably adapted to the end in view. So that it may be fairly said that the great achievement of the nineteenth century was the making of machines which were wonders of invention, skill, and patience, and which were used for the production of measureless quantities of worthless makeshifts. In truth, the owners of the machines did not consider anything which they made as wares, but simply as means for the enrichment of themselves. Of course, the only admitted test of utility in wares was the finding of buyers for them – wise men or fools, as it might chance.'

'And people put up with this?' said I.

'For a time,' said he.

'And then?'

'And then the overturn,' said the old man, smiling, 'and the nineteenth century saw itself as a man who has lost his clothes whilst bathing, and has to walk naked through the town.'

'You are very bitter about that unlucky nineteenth century,' said I.

'Naturally,' said he, 'since I know so much about it.'

He was silent a little, and then said: 'There are traditions – nay, real histories – in our family about it: my grandfather was one of its victims. If you know something about it, you will understand what he suffered when I tell you that he was in those days a genuine artist, a man of genius, and a revolutionist.'

'I think I do understand,' said I: 'but now, as it seems, you have reversed all this?'

'Pretty much so,' said he. 'The wares which we make are made because they are needed: men make for their neighbours' use as if they were making for themselves, not for a vague market of which they know nothing, and over which they have no control: as there is no buying and selling, it would be mere insanity to make goods on the chance of their being wanted; for there is no longer anyone who can be *compelled* to buy them. So that whatever is made is good, and thoroughly fit for its purpose. Nothing *can* be made except for genuine use; therefore no inferior goods are made. Moreover, as aforesaid, we have now found out what we want, so we make no more than we want; and as we are not driven to make a vast quantity of useless things, we have time and resources enough to consider our pleasure in making them. All work which would be irksome to do by hand is done by immensely improved machinery; and in all work which it is a pleasure to do by hand machinery is done without. There is no difficulty in finding work which suits the special turn of mind of everybody; so that no man is sacrificed to the wants of another. From time to time, when we have found out that some piece of work was too disagreeable or troublesome, we have given it up and done altogether without the thing produced by it. Now, surely you can see that under these circumstances all the work that we do is an exercise of the mind and body more or less pleasant to be done: so that instead of avoiding work everybody seeks it: and, since people have got defter in doing the work generation after generation, it has become so easy to do, that it seems as if there were less done, though probably more is produced. I suppose this explains that fear, which I hinted at just now, of a possible scarcity in work, which perhaps you have already noticed, and which is a feeling on the increase, and has been for a score of years.'

'But do you think,' said I, 'that there is any fear of a work-famine amongst you?'

'No, I do not,' said he, 'and I will tell why; it is each man's business to make his own work pleasanter and pleasanter, which of course tends towards raising the standard of excellence, as no man enjoys turning out work which is not a credit to him, and also to greater

deliberation in turning it out; and there is such a vast number of things which can be treated as works of art, that this alone gives employment to a host of deft people. Again, if art be inexhaustible, so is science also; and though it is no longer the only innocent occupation which is thought worth an intelligent man spending his time upon, as it once was, yet there are, and I suppose will be, many people who are excited by its conquest of difficulties, and care for it more than for anything else. Again, as more and more of pleasure is imported into work, I think we shall take up kinds of work which produce desirable wares, but which we gave up because we could not carry them on pleasantly. Moreover, I think that it is only in parts of Europe which are more advanced than the rest of the world that you will hear this talk of the fear of a work-famine. Those lands which were once the colonies of Great Britain, for instance, and especially America – that part of it, above all, which was once the United States – are now and will be for a long while a great resource to us. For these lands, and, I say, especially the northern parts of America, suffered so terribly from the full force of the last days of civilization, and became such horrible places to live in, that they are now very backward in all that makes life pleasant. Indeed, one may say that for nearly a hundred years the people of the northern parts of America have been engaged in gradually making a dwelling-place out of a stinking dust-heap; and there is still a great deal to do, especially as the country is so big.'

'Well,' said I, 'I am exceedingly glad to think that you have such a prospect of happiness before you. But I should like to ask a few more questions, and then I have done for today.'

CHAPTER 16: DINNER IN THE HALL OF THE
BLOOMSBURY MARKET

As I spoke, I heard footsteps near the door; the latch yielded, and in came our two lovers, looking so handsome that one had no feeling of shame in looking on at their little-concealed love-making; for indeed it seemed as if all the world must be in love with them. As for old Hammond, he looked on them like an artist who has just painted a

picture nearly as well as he thought he could when he began it, and was perfectly happy. He said:

'Sit down, sit down, young folk, and don't make a noise. Our guest here has still some questions to ask me.'

'Well, I should suppose so,' said Dick; 'you have only been three hours and a half together; and it isn't to be hoped that the history of two centuries could be told in three hours and a half: let alone that, for all I know, you may have been wandering into the realms of geography and craftsmanship.'

'As to noise, my dear kinsman,' said Clara, 'you will very soon be disturbed by the noise of the dinner-bell, which I should think will be very pleasant music to our guest, who breakfasted early, it seems, and probably had a tiring day yesterday.'

I said: 'Well, since you have spoken the word, I begin to feel that it is so; but I have been feeding myself with wonder this long time past: really, it's quite true,' quoth I, as I saw her smile, O so prettily!

But just then from some tower high up in the air came the sound of silvery chimes playing a sweet clear tune, that sounded to my unaccustomed ears like the song of the first blackbird in the spring, and called a rush of memories to my mind, some of bad times, some of good, but all sweetened now into mere pleasure.

'No more questions now before dinner,' said Clara; and she took my hand as an affectionate child would, and led me out of the room and downstairs into the forecourt of the Museum, leaving the two Hammonds to follow as they pleased.

We went into the market-place which I had been in before, a thinnish stream of elegantly* dressed people going in along with us. We turned into the cloister and came to a richly moulded and carved doorway, where a very pretty dark-haired young girl gave us each a beautiful bunch of summer flowers, and we entered a hall much bigger than that of the Hammersmith Guest House, more elaborate in its architecture and perhaps more beautiful. I found it difficult to keep my eyes off the wall-pictures (for I thought it bad manners to stare at Clara all the time, though she was quite worth it). I saw at a

* 'Elegant', I mean, as a Persian pattern is elegant; not like a rich 'elegant' lady out for a morning call. I should rather call that *genteel*.

glance that their subjects were taken from queer old-world myths and imaginations which in yesterday's world only about half a dozen people in the country knew anything about; and when the two Hammonds sat down opposite to us, I said to the old man, pointing to the frieze:

'How strange to see such subjects here!'

'Why?' said he. 'I don't see why you should be surprised; everybody knows the tales; and they are graceful and pleasant subjects not too tragic for a place where people mostly eat and drink and amuse themselves, and yet full of incident.'

I smiled, and said: 'Well, I scarcely expected to find record of the Seven Swans and the King of the Golden Mountain and Faithful Henry, and such curious pleasant imaginations as Jacob Grimm got together from the childhood of the world, barely lingering even in his time: I should have thought you would have forgotten such childishness by this time.'

The old man smiled, and said nothing; but Dick turned rather red, and broke out:

'What *do* you mean, Guest? I think them very beautiful, I mean not only the pictures, but the stories; and when we were children we used to imagine them going on in every wood-end, by the bight of every stream: every house in the fields was the Fairyland King's House to us. Don't you remember, Clara?'

'Yes,' she said; and it seemed to me as if a slight cloud came over her fair face. I was going to speak to her on the subject, when the pretty waitresses came to us smiling, and chattering sweetly like reed warblers by the riverside, and fell to giving us our dinner. As to this, as at our breakfast, everything was cooked and served with a daintiness which showed that those who had prepared it were interested in it; but there was no excess either of quantity or of gourmandise; everything was simple, though so excellent of its kind, and it was made clear to us that this was no feast, only an ordinary meal. The glass, crockery, and plate were very beautiful to my eyes, used to the study of mediaeval art; but a nineteenth-century club-haunter would, I daresay, have found them rough and lacking in finish; the crockery being lead-glazed pot-ware, though beautifully ornamented; the only porcelain being here and there a piece of old oriental ware. The glass,

again, though elegant and quaint, and very varied in form, was some-
what bubbled and hornier in texture than the commercial articles of
the nineteenth century. The furniture and general fittings of the hall
were much of a piece with the table-gear, beautiful in form and highly
ornamented, but without the commercial 'finish' of the joiners and
cabinet-makers of our time. Withal, there was a total absence of what
the nineteenth century calls 'comfort' – that is, stuffy inconvenience;
so that, even apart from the delightful excitement of the day, I had
never eaten my dinner so pleasantly before.

When we had done eating, and were sitting a little while, with a
bottle of very good Bordeaux wine before us, Clara came back to the
question of the subject-matter of the pictures, as though it had
troubled her.

She looked up at them, and said: 'How is it that though we are so
interested with our life for the most part, yet when people take to
writing poems or painting pictures they seldom deal with our modern
life, or if they do, take good care to make their poems or pictures un-
like that life? Are we not good enough to paint ourselves? How is it
that we find the dreadful times of the past so interesting to us – in
pictures and poetry?'

Old Hammond smiled. 'It always was so, and I suppose always will
be,' said he, 'however it may be explained. It is true that in the nine-
teenth century, when there was so little art and so much talk about it,
there was a theory that art and imaginative literature ought to deal
with contemporary life; but they never did so; for, if there was any
pretence of it, the author always took care (as Clara hinted just now)
to disguise, or exaggerate, or idealize, and in some way or another
make it strange; so that, for all the verisimilitude there was, he might
just as well have dealt with the times of the Pharaohs.'

'Well,' said Dick, 'surely it is but natural to like these things
strange; just as when we were children, as I said just now, we used to
pretend to be so-and-so in such-and-such a place. That's what these
pictures and poems do; and why shouldn't they?'

'Thou hast hit it, Dick,' quoth old Hammond; 'it is the child-
like part of us that produces works of imagination. When we are
children time passes so slow with us that we seem to have time for
everything.'

He sighed, and then smiled and said: 'At least let us rejoice that we have got back our childhood again. I drink to the days that are!'

'Second childhood,' said I in a low voice, and then blushed at my double rudeness, and hoped that he hadn't heard. But he had, and turned to me smiling, and said: 'Yes, why not? And for my part, I hope it may last long; and that the world's next period of wise and unhappy manhood, if that should happen, will speedily lead us to a third childhood: if indeed this age be not our third. Meantime, my friend, you must know that we are too happy, both individually and collectively, to trouble ourselves about what is to come hereafter.'

'Well, for my part,' said Clara, 'I wish we were interesting enough to be written or painted about.'

Dick answered her with some lover's speech, impossible to be written down, and then we sat quiet a little.

## CHAPTER 17: HOW THE CHANGE CAME

DICK broke the silence at last, saying: 'Guest, forgive us for a little after-dinner dulness. What would you like to do? Shall we have out Greylocks and trot back to Hammersmith? or will you come with us and hear some Welsh folk sing in a hall close by here? or would you like presently to come with me into the City and see some really fine building? or – what shall it be?'

'Well,' said I, 'as I am a stranger, I must let you choose for me.'

In point of fact, I did not by any means want to be 'amused' just then; and also I rather felt as if the old man, with his knowledge of past times, and even a kind of inverted sympathy for them caused by his active hatred of them, was as it were a blanket for me against the cold of this very new world, where I was, so to say, stripped bare of every habitual thought and way of acting; and I did not want to leave him too soon. He came to my rescue at once, and said:

'Wait a bit, Dick; there is someone else to be consulted besides you and the guest here, and that is I. I am not going to lose the pleasure of his company just now, especially as I know he has something else to ask me. So go to your Welshmen, by all means; but first of all bring

us another bottle of wine to this nook, and then be off as soon as you like; and come again and fetch our friend to go westward, but not too soon.'

Dick nodded smilingly, and the old man and I were soon alone in the great hall, the afternoon sun gleaming on the red wine in our tall quaint-shaped glasses. Then said Hammond:

'Does anything especially puzzle you about our way of living, now you have heard a good deal and seen a little of it?'

Said I: 'I think what puzzles me most is how it all came about.'

'It well may,' said he, 'so great as the change is. It would be difficult indeed to tell you the whole story, perhaps impossible: knowledge, discontent, treachery, disappointment, ruin, misery, despair – those who worked for the change because they could see further than other people went through all these phases of suffering; and doubtless all the time the most of men looked on, not knowing what was doing, thinking it all a matter of course, like the rising and setting of the sun – and indeed it was so.'

'Tell me one thing, if you can,' said I. 'Did the change, the "revolution" it used to be called, come peacefully?'

'Peacefully?' said he; 'what peace was there amongst those poor confused wretches of the nineteenth century? It was war from beginning to end: bitter war, till hope and pleasure put an end to it.'

'Do you mean actual fighting with weapons?' said I, 'or the strikes and lock-outs and starvation of which we have heard?'

'Both, both,' he said. 'As a matter of fact, the history of the terrible period of transition from commercial slavery to freedom may thus be summarized. When the hope of realizing a communal condition of life for all men arose, quite late in the nineteenth century, the power of the middle classes, the then tyrants of society, was so enormous and crushing, that to almost all men, even those who had, you may say despite themselves, despite their reason and judgement, conceived such hopes, it seemed a dream. So much was this the case that some of those more enlightened men who were then called Socialists, although they well knew, and even stated in public, that the only reasonable condition of Society was that of pure Communism (such as you now see around you), yet shrunk from what seemed to them the barren task of preaching the realization of a happy dream. Looking back

now, we can see that the great motive-power of the change was a longing for freedom and equality, akin if you please to the unreasonable passion of the lover; a sickness of heart that rejected with loathing the aimless solitary life of the well-to-do educated men of that time: phrases, my dear friend, which have lost their meaning to us of the present day; so far removed we are from the dreadful facts which they represent.

'Well, these men, though conscious of this feeling, had no faith in it, as a means of bringing about the change. Nor was that wonderful: for looking around them they saw the huge mass of the oppressed classes too much burdened with the misery of their lives, and too much overwhelmed by the selfishness of misery, to be able to form a conception of any escape from it except by the ordinary way prescribed by the system of slavery under which they lived; which was nothing more than a remote chance of climbing out of the oppressed into the oppressing class.

'Therefore, though they knew that the only reasonable aim for those who would better the world was a condition of equality; in their impatience and despair they managed to convince themselves that if they could by hook or by crook get the machinery of production and the management of property so altered that the "lower classes" (so the horrible word ran) might have their slavery somewhat ameliorated, they would be ready to fit into this machinery, and would use it for bettering their condition still more and still more, until at last the result would be a practical equality (they were very fond of using the word "practical"), because "the rich" would be forced to pay so much for keeping "the poor" in a tolerable condition that the condition of riches would become no longer valuable and would gradually die out. Do you follow me?'

'Partly,' said I. 'Go on.'

Said old Hammond: 'Well, since you follow me, you will see that as a theory this was not altogether unreasonable; but "practically", it turned out a failure.'

'How so?' said I.

'Well, don't you see,' said he, 'because it involved the making of a machinery by those who didn't know what they wanted the machines to do. So far as the masses of the oppressed class furthered this scheme

of improvement, they did it to get themselves improved slave-rations
– as many of them as could. And if those classes had really been in-
capable of being touched by that instinct which produced the passion
for freedom and equality aforesaid, what would have happened, I
think, would have been this: that a certain part of the working classes
would have been so far improved in condition that they would have
approached the condition of the middling rich men; but below them
would have been a great class of most miserable slaves, whose slavery
would have been far more hopeless than the older class-slavery had
been.'

'What stood in the way of this?' said I.

'Why, of course,' said he, 'just that instinct for freedom aforesaid.
It is true that the slave-class could not conceive the happiness of a free
life. Yet they grew to understand (and very speedily too) that they
were oppressed by their masters, and they assumed, you see how
justly, that they could do without them, though perhaps they scarce
knew how; so that it came to this, that though they could not look
forward to the happiness or peace of the freeman, they did at least
look forward to the war which a vague hope told them would bring
that peace about.'

'Could you tell me rather more closely what actually took place?'
said I; for I thought *him* rather vague here.

'Yes,' he said, 'I can. That machinery of life for the use of people
who didn't know what they wanted of it, and which was known at
the time as State Socialism, was partly put in motion, though in a very
piecemeal way. But it did not work smoothly; it was, of course, re-
sisted at every turn by the capitalists; and no wonder, for it tended
more and more to upset the commercial system I have told you of,
without providing anything really effective in its place. The result was
growing confusion, great suffering amongst the working classes, and,
as a consequence, great discontent. For a long time matters went on
like this. The power of the upper classes had lessened, as their com-
mand over wealth lessened, and they could not carry things wholly by
the high hand as they had been used to in earlier days. So far the State
Socialists were justified by the result. On the other hand, the working
classes were ill-organized, and growing poorer in reality, in spite of
the gains (also real in the long run) which they had forced from the

masters. Thus matters hung in the balance, the masters could not re-
duce their slaves to complete subjection, though they put down some
feeble and partial riots easily enough. The workers forced their
masters to grant them ameliorations, real or imaginary, of their con-
dition, but could not force freedom from them. At last came a great
crash. To explain this you must understand that very great progress
had been made amongst the workers, though as before said but little
in the direction of improved livelihood.'

I played the innocent and said: 'In what direction could they im-
prove, if not in livelihood?'

Said he: 'In the power to bring about a state of things in which
livelihood would be full, and easy to gain. They had at least learned
how to combine after a long period of mistakes and disasters. The
workmen had now a regular organization in the struggle against their
masters, a struggle which for more than half a century had been ac-
cepted as an inevitable part of the conditions of the modern system of
labour and production. This combination had now taken the form of
a federation of all or almost all the recognized wage-paid employ-
ments, and it was by its means that those betterments of the condition
of the workmen had been forced from the masters: and though they
were not seldom mixed up with the rioting that happened, especially
in the earlier days of their organization, it by no means formed an
essential part of their tactics; indeed at the time I am now speaking of
they had got to be so strong that most commonly the mere threat of
a "strike" was enough to gain any minor point: because they had
given up the foolish tactics of the ancient trades unions of calling out
of work a part only of the workmen of such and such an industry, and
supporting them while out of work on the labour of those that re-
mained in. By this time they had a biggish fund of money for the sup-
port of strikes, and could stop a certain industry altogether for a time
if they so determined.'

Said I: 'Was there not a serious danger of such moneys being mis-
used – of jobbery, in fact?'

Old Hammond wriggled uneasily on his seat, and said:

'Though all this happened so long ago, I still feel the pain of mere
shame when I have to tell you that it was more than a danger: that
such rascality often happened; indeed more than once the whole com-

bination seemed dropping to pieces because of it: but at the time of which I am telling, things looked so threatening, and to the workmen at least the necessity of their dealing with the fast-gathering trouble which the labour-struggle had brought about, was so clear, that the conditions of the times had begot a deep seriousness amongst all reasonable people; a determination which put aside all non-essentials, and which to thinking men was ominous of the swiftly-approaching change: such an element was too dangerous for mere traitors and self-seekers, and one by one they were thrust out and mostly joined the declared reactionaries.'

'How about those ameliorations,' said I; 'what were they or rather of what nature?'

Said he: 'Some of them, and these of the most practical importance to the men's livelihood, were yielded by the masters by direct compulsion on the part of the men; the new conditions of labour so gained were indeed only customary, enforced by no law: but, once established, the masters durst not attempt to withdraw them in face of the growing power of the combined workers. Some again were steps on the path of "State Socialism"; the most important of which can be speedily summed up. At the end of the nineteenth century the cry arose for compelling the masters to employ their men a less number of hours in the day: this cry gathered volume quickly, and the masters had to yield to it. But it was, of course, clear that unless this meant a higher price for work per hour, it would be a mere nullity, and that the masters, unless forced, would reduce it to that. Therefore after a long struggle another law was passed fixing a minimum price for labour in the most important industries; which again had to be supplemented by a law fixing the maximum price on the chief wares then considered necessary for a workman's life.'

'You were getting perilously near to the late Roman poor-rates,' said I, smiling, 'and the doling out of bread to the proletariat.'

'So many said at the time,' said the old man drily; 'and it has long been a commonplace that that slough awaits State Socialism in the end, if it gets to the end, which as you know it did not with us. However, it went further than this minimum and maximum business, which by the bye we can now see was necessary. The government now found it imperative on them to meet the outcry of the master

class at the approaching destruction of commerce (as desirable, had they known it, as the extinction of the cholera, which has since happily taken place). And they were forced to meet it by a measure hostile to the masters, the establishment of government factories for the production of necessary wares, and markets for their sale. These measures taken altogether did do something: they were in fact of the nature of regulations made by the commander of a beleaguered city. But of course to the privileged classes it seemed as if the end of the world were come when such laws were enacted.

'Nor was that altogether without a warrant: the spread of communistic theories, and the partial practice of State Socialism, had at first disturbed, and at last almost paralysed the marvellous system of commerce under which the old world had lived so feverishly, and had produced for some few a life of gambler's pleasure, and for many, or most, a life of mere misery: over and over again came "bad times" as they were called, and indeed they were bad enough for the wage-slaves. The year 1952 was one of the worst of these times; the workmen suffered dreadfully: the partial inefficient government factories, which were terribly jobbed, all but broke down, and a vast part of the population had for the time being to be fed on undisguised "charity" as it was called.

'The Combined Workers watched the situation with mingled hope and anxiety. They had already formulated their general demands; but now by a solemn and universal vote of the whole of their federated societies, they insisted on the first step being taken towards carrying out their demands: this step would have led directly to handing over the management of the whole natural resources of the country, together with the machinery for using them, into the power of the Combined Workers, and the reduction of the privileged classes into the position of pensioners obviously dependent on the pleasure of the workers. The "Resolution", as it was called, which was widely published in the newspapers of the day, was in fact a declaration of war, and was so accepted by the master class. They began henceforward to prepare for a firm stand against the "brutal and ferocious communism of the day", as they phrased it. And as they were in many ways still very powerful, or seemed so to be, they still hoped by means of brute force to regain some of what they had lost, and perhaps in the

end the whole of it. It was said amongst them on all hands that it had been a great mistake of the various governments not to have resisted sooner; and the liberals and radicals (the name as perhaps you may know of the more democratically inclined part of the ruling classes) were much blamed for having led the world to this pass by their mistimed pedantry and foolish sentimentality: and one Gladstone, or Gledstein (probably, judging by this name, of Scandinavian descent), a notable politician of the nineteenth century, was especially singled out for reprobation in this respect. I need scarcely point out to you the absurdity of all this. But terrible tragedy lay hidden behind this grinning through a horse-collar of the reactionary party. "The insatiable greed of the lower classes must be repressed" – "The people must be taught a lesson" – these were the sacramental phrases current amongst the reactionists, and ominous enough they were.'

The old man stopped to look keenly at my attentive and wondering face, and then said:

'I know, dear Guest, that I have been using words and phrases which few people amongst us could understand without long and laborious explanation; and not even then perhaps. But since you have not yet gone to sleep, and since I am speaking to you as to a being from another planet, I may venture to ask you if you have followed me thus far?'

'O yes,' said I, 'I quite understand: pray go on; a great deal of what you have been saying was commonplace with us – when – when –'

'Yes,' said he gravely, 'when you were dwelling in the other planet. Well, now for the crash aforesaid.

'On some comparatively trifling occasion a great meeting was summoned by the workmen leaders to meet in Trafalgar Square (about the right to meet in which place there had for years and years been bickering). The civic bourgeois guard (called the police) attacked the said meeting with bludgeons, according to their custom; many people were hurt in the *mêlée*, of whom five in all died, either trampled to death on the spot, or from the effects of their cudgelling; the meeting was scattered, and some hundred of prisoners cast into gaol. A similar meeting had been treated in the same way a few days before at a place called Manchester, which has now disappeared. Thus

the "lesson" began. The whole country was thrown into a ferment by this; meetings were held which attempted some rough organization for the holding of another meeting to retort on the authorities. A huge crowd assembled in Trafalgar Square and the neighbourhood (then a place of crowded streets), and was too big for the bludgeon-armed police to cope with; there was a good deal of dry-blow fighting; three or four of the people were killed, and half a score of policemen were crushed to death in the throng, and the rest got away as they could. This was a victory for the people as far as it went. The next day all London (remember what it was in those days) was in a state of turmoil. Many of the rich fled into the country; the executive got together soldiery, but did not dare to use them; and the police could not be massed in any one place, because riots or threats of riots were everywhere. But in Manchester, where the people were not so courageous or not so desperate as in London, several of the popular leaders were arrested. In London a convention of leaders was got together from the Federation of Combined Workmen, and sat under the old revolutionary name of the Committee of Public Safety; but as they had no drilled and armed body of men to direct, they attempted no aggressive measures, but only placarded the walls with somewhat vague appeals to the workmen not to allow themselves to be trampled upon. However, they called a meeting in Trafalgar Square for the day fortnight of the last-mentioned skirmish.

'Meantime the town grew no quieter, and business came pretty much to an end. The newspapers – then, as always hitherto, almost entirely in the hands of the masters – clamoured to the Government for repressive measures; the rich citizens were enrolled as an extra body of police, and armed with bludgeons like them; many of these were strong, well-fed, full-blooded young men, and had plenty of stomach for fighting; but the Government did not dare to use them, and contented itself with getting full powers voted to it by the Parliament for suppressing any revolt, and bringing up more and more soldiers to London. Thus passed the week after the great meeting; almost as large a one was held on the Sunday, which went off peaceably on the whole, as no opposition to it was offered, and again the people cried "victory". But on the Monday the people woke up to find that they were hungry. During the last few days there had been groups of

men parading the streets asking (or, if you please, demanding) money to buy food; and what for goodwill, what for fear, the richer people gave them a good deal. The authorities of the parishes also (I haven't time to explain that phrase at present) gave willy-nilly what provisions they could to wandering people; and the Government, by means of its feeble national workshops, also fed a good number of half-starved folk. But in addition to this, several bakers' shops and other provision stores had been emptied without a great deal of disturbance. So far, so good. But on the Monday in question the Committee of Public Safety, on the one hand afraid of general unorganized pillage, and on the other emboldened by the wavering conduct of the authorities, sent a deputation provided with carts and all necessary gear to clear out two or three big provision stores in the centre of the town, leaving papers with the shop managers promising to pay the price of them; and also in the part of the town where they were strongest they took possession of several bakers' shops and set men at work in them for the benefit of the people – all of which was done with little or no disturbance, the police assisting in keeping order at the sack of the stores, as they would have done at a big fire.

'But at this last stroke the reactionaries were so alarmed, that they were determined to force the executive into action. The newspapers next day all blazed into the fury of frightened people, and threatened the people, the Government, and everybody they could think of, unless "order were at once restored". A deputation of leading commercial people waited on the Government and told them that if they did not at once arrest the Committee of Public Safety, they themselves would gather a body of men, arm them, and fall on "the incendiaries", as they called them.

'They, together with a number of the newspaper editors, had a long interview with the heads of the Government and two or three military men, the deftest in their art that the country could furnish. The deputation came away from that interview, says a contemporary eye-witness, smiling and satisfied, and said no more about raising an anti-popular army, but that afternoon left London with their families for their country seats or elsewhere.

'The next morning the Government proclaimed a state of siege in

281

London – a thing common enough amongst the absolutist govern-
ments on the Continent, but unheard of in England in those days.
They appointed the youngest and cleverest of their generals to com-
mand the proclaimed district; a man who had won a certain sort of
reputation in the disgraceful wars in which the country had been long
engaged from time to time. The newspapers were in ecstasies, and all
the most fervent of the reactionaries now came to the front; men who
in ordinary times were forced to keep their opinions to themselves or
their immediate circle, but who began to look forward to crushing
once for all the Socialist, and even democratic tendencies, which, said
they, had been treated with such foolish indulgence for the last sixty
years.

'But the clever general took no visible action; and yet only a few
of the minor newspapers abused him; thoughtful men gathered from
this that a plot was hatching. As for the Committee of Public Safety,
whatever they thought of their position, they had now gone too far
to draw back; and many of them, it seems, thought that the Govern-
ment would not act. They went on quietly organizing their food
supply, which was a miserable driblet when all is said; and also as a
retort to the state of siege, they armed as many men as they could in
the quarter where they were strongest, but did not attempt to drill or
organize them, thinking, perhaps, that they could not at the best turn
them into trained soldiers till they had some breathing space. The
clever general, his soldiers, and the police did not meddle with all this
in the least in the world; and things were quieter in London that
week-end; though there were riots in many places of the provinces,
which were quelled by the authorities without much trouble. The
most serious of these were at Glasgow and Bristol.

'Well, the Sunday of the meeting came, and great crowds came to
Trafalgar Square in procession, the greater part of the Committee
amongst them, surrounded by their band of men armed somehow or
other. The streets were quite peaceful and quiet, though there were
many spectators to see the procession pass. Trafalgar Square had no
body of police in it; the people took quiet possession of it, and the
meeting began. The armed men stood round the principal platform,
and there were a few others armed amidst the general crowd; but by
far the greater part were unarmed.

'Most people thought the meeting would go off peaceably; but the members of the Committee had heard from various quarters that something would be attempted against them; but these rumours were vague, and they had no idea of what threatened. They soon found out.

'For before the streets about the Square were filled, a body of soldiers poured into it from the north-west corner and took up their places by the houses that stood on the west side. The people growled at the sight of the redcoats; the armed men of the Committee stood undecided, not knowing what to do; and indeed this new influx so jammed the crowd together that, unorganized as they were, they had little chance of working through it. They had scarcely grasped the fact of their enemies being there, when another column of soldiers, pouring out of the streets which led into the great southern road going down to the Parliament House (still existing, and called the Dung Market), and also from the embankment by the side of the Thames, marched up, pushing the crowd into a denser and denser mass, and formed along the south side of the Square. Then any of those who could see what was going on, knew at once that they were in a trap, and could only wonder what would be done with them.

'The closely-packed crowd would not or could not budge, except under the influence of the height of terror, which was soon to be supplied to them. A few of the armed men struggled to the front, or climbed up to the base of the monument which then stood there, that they might face the wall of hidden fire before them; and to most men (there were many women amongst them) it seemed as if the end of the world had come, and today seemed strangely different from yesterday. No sooner were the soldiers drawn up aforesaid than, says an eye-witness, "a glittering officer on horseback came prancing out from the ranks on the south, and read something from a paper which he held in his hand; which something, very few heard; but I was told afterwards that it was an order for us to disperse, and a warning that he had legal right to fire on the crowd else, and that he would do so. The crowd took it as a challenge of some sort, and a hoarse threatening roar went up from them; and after that there was comparative silence for a little till the officer had got back into the ranks. I was near the edge of the crowd, towards the soldiers," says this eye-witness,

"and I saw three little machines being wheeled out in front of the ranks, which I knew for mechanical guns. I cried out, 'Throw yourselves down! they are going to fire!' But no one scarcely could throw himself down, so tight as the crowd were packed. I heard a sharp order given, and wondered where I should be the next minute; and then – It was as if the earth had opened, and hell had come up bodily amidst us. It is no use trying to describe the scene that followed. Deep lanes were mowed amidst the thick crowd; the dead and dying covered the ground, and the shrieks and wails and cries of horror filled all the air, till it seemed as if there was nothing else in the world but murder and death. Those of our armed men who were still unhurt cheered wildly and opened a scattering fire on the soldiers. One or two soldiers fell; and I saw the officers going up and down the ranks urging the men to fire again; but they received the orders in sullen silence, and let the butts of their guns fall. Only one sergeant ran to a machine-gun and began to set it going; but a tall young man, an officer too, ran out of the ranks and dragged him back by the collar; and the soldiers stood there motionless whilst the horror-stricken crowd, nearly wholly unarmed (for most of the armed men had fallen in that first discharge), drifted out of the Square. I was told afterwards that the soldiers on the west side had fired also, and done their part of the slaughter. How I got out of the Square I scarcely know: I went, not feeling the ground under me, what with rage and terror and despair."

'So says our eye-witness. The number of the slain on the side of the people in that shooting during a minute was prodigious; but it was not easy to come at the truth about it; it was probably between one and two thousand. Of the soldiers, six were killed outright, and a dozen wounded.'

I listened, trembling with excitement. The old man's eyes glittered and his face flushed as he spoke, and told the tale of what I had often thought might happen. Yet I wondered that he should have got so elated about a mere massacre, and I said:

'How fearful! And I suppose that this massacre put an end to the whole revolution for that time?'

'No, no,' cried old Hammond; 'it began it!'

He filled his glass and mine, and stood up and cried out, 'Drink this

glass to the memory of those who died there, for indeed it would be a long tale to tell how much we owe them.'

I drank, and he sat down again and went on.

'That massacre of Trafalgar Square began the civil war, though, like all such events, it gathered head slowly, and people scarcely knew what a crisis they were acting in.

'Terrible as the massacre was, and hideous and overpowering as the first terror had been, when the people had time to think about it, their feeling was one of anger rather than fear; although the military organization of the state of siege was now carried out without shrinking by the clever young general. For though the ruling-classes when the news spread next morning felt one gasp of horror and even dread, yet the Government and their immediate backers felt that now the wine was drawn and must be drunk. However, even the most reactionary of the capitalist papers, with two exceptions, stunned by the tremendous news, simply gave an account of what had taken place, without making any comment upon it. The exceptions were one, a so-called "Liberal" paper (the Government of the day was of that complexion), which, after a preamble in which it declared its undeviating sympathy with the cause of labour, proceeded to point out that in times of revolutionary disturbance it behoved the Government to be just but firm, and that by far the most merciful way of dealing with the poor madmen who were attacking the very foundations of society (which had made them mad and poor) was to shoot them at once, so as to stop others from drifting into a position in which they would run a chance of being shot. In short, it praised the determined action of the Government as the *acmé* of human wisdom and mercy, and exulted in the inauguration of an epoch of reasonable democracy free from the tyrannical fads of Socialism.

'The other exception was a paper thought to be one of the most violent opponents of democracy, and so it was; but the editor of it found his manhood, and spoke for himself and not for his paper. In a few simple, indignant words he asked people to consider what a sociey was worth which had to be defended by the massacre of unarmed citizens, and called on the Government to withdraw their state of siege and put the general and his officers who fired on the people on their trial for murder. He went further, and declared that whatever

his opinion might be as to the doctrines of the Socialists, he for one should throw in his lot with the people, until the Government atoned for their atrocity by showing that they were prepared to listen to the demands of men who knew what they wanted, and whom the decrepitude of society forced into pushing their demands in some way or other.

'Of course, this editor was immediately arrested by the military power; but his bold words were already in the hands of the public, and produced a great effect: so great an effect that the Government, after some vacillation, withdrew the state of siege; though at the same time it strengthened the military organization and made it more stringent. Three of the Committee of Public Safety had been slain in Trafalgar Square: of the rest, the greater part went back to their old place of meeting, and there awaited the event calmly. They were arrested there on the Monday morning, and would have been shot at once by the general, who was a mere military machine, if the Government had not shrunk before the responsibility of killing men without any trial. There was at first a talk of trying them by a special commission of judges, as it was called – i.e., before a set of men bound to find them guilty, and whose business it was to do so. But with the Government the cold fit had succeeded to the hot one; and the prisoners were brought before a jury at the assizes. There a fresh blow awaited the Government; for in spite of the judge's charge, which distinctly instructed the jury to find the prisoners guilty, they were acquitted, and the jury added to their verdict a presentment, in which they condemned the action of the soldiery, in the queer phraseology of the day, as "rash, unfortunate, and unnecessary". The Committee of Public Safety renewed its sittings, and from thenceforth was a popular rallying-point in opposition to the Parliament. The Government now gave way on all sides, and made a show of yielding to the demands of the people, though there was a widespread plot for effecting a *coup d'état* set on foot between the leaders of the two so-called opposing parties in the parliamentary faction fight. The well-meaning part of the public was overjoyed, and thought that all danger of a civil war was over. The victory of the people was celebrated by huge meetings held in the parks and elsewhere, in memory of the victims of the great massacre.

'But the measures passed for the relief of the workers, though to the upper classes they seemed ruinously revolutionary, were not thorough enough to give the people food and a decent life, and they had to be supplemented by unwritten enactments without legality to back them. Although the Government and Parliament had the Law Courts, the army, and "society" at their backs, the Committee of Public Safety began to be a force in the country, and really represented the producing classes. It began to improve immensely in the days which followed on the acquittal of its members. Its old members had little administrative capacity, though with the exception of a few self-seekers and traitors, they were honest, courageous men, and many of them were endowed with considerable talent of other kinds. But now that the times called for immediate action, came forward the men capable of setting it on foot; and a new network of workmen's associations grew up very speedily, whose avowed single object was the tiding over of the ship of the community into a simple condition of Communism; and as they practically undertook also the management of the ordinary labour-war, they soon became the mouthpiece and intermediary of the whole of the working classes; and the manufacturing profit-grinders now found themselves powerless before this combination; unless *their* committee, Parliament, plucked up courage to begin the civil war again, and to shoot right and left, they were bound to yield to the demands of the men whom they employed, and pay higher and higher wages for shorter and shorter day's work. Yet one ally they had, and that was the rapidly approaching breakdown of the whole system founded on the World-Market and its supply; which now became so clear to all people, that the middle classes, shocked for the moment into condemnation of the Government for the great massacre, turned round nearly in a mass, and called on the Government to look to matters, and put an end to the tyranny of the Socialist leaders.

'Thus stimulated, the reactionist plot exploded probably before it was ripe; but this time the people and their leaders were forewarned, and, before the reactionaries could get under way, had taken the steps they thought necessary.

'The Liberal Government (clearly by collusion) was beaten by the Conservatives, though the latter were nominally much in the

minority. The popular representatives in the House understood pretty well what this meant, and after an attempt to fight the matter out by divisions in the House of Commons, they made a protest, left the House, and came in a body to the Committee of Public Safety: and the civil war began again in good earnest.

'Yet its first act was not one of mere fighting. The new Tory Government determined to act, yet durst not re-enact the state of siege, but it sent a body of soldiers and police to arrest the Committee of Public Safety in the lump. They made no resistance, though they might have done so, as they had now a considerable body of men who were quite prepared for extremities. But they were determined to try first a weapon which they thought stronger than street fighting.

'The members of the Committee went off quietly to prison; but they had left their soul and their organization behind them. For they depended not on a carefully arranged centre with all kinds of checks and counter-checks about it, but on a huge mass of people in thorough sympathy with the movement, bound together by a great number of links of small centres with very simple instructions. These instructions were now carried out.

'The next morning, when the leaders of the reaction were chuckling at the effect which the report in the newspapers of their stroke would have upon the public – no newspapers appeared; and it was only towards noon that a few straggling sheets, about the size of the gazettes of the seventeenth century, worked by policemen, soldiers, managers, and press-writers, were dribbled through the streets. They were greedily seized on and read; but by this time the serious part of their news was stale, and people did not need to be told that the GENERAL STRIKE had begun. The railways did not run, the telegraph-wires were unserved; flesh, fish, and green stuff brought to market was allowed to lie there still packed and perishing; the thousands of middle-class families, who were utterly dependent for the next meal on the workers, made frantic efforts through their more energetic members to cater for the needs of the day, and amongst those of them who could throw off the fear of what was to follow, there was, I am told, a certain enjoyment of this unexpected picnic – a forecast of the days to come, in which all labour grew pleasant.

'So passed the first day, and towards evening the Government grew

quite distracted. They had but one resource for putting down any popular movement – to wit, mere brute-force; but there was nothing for them against which to use their army and police: no armed bodies appeared in the streets; the offices of the Federated Workmen were now, in appearance, at least, turned into places for the relief of people thrown out of work, and under the circumstances, they durst not arrest the men engaged in such business, all the more, as even that night many quite respectable people applied at these offices for relief, and swallowed down the charity of the revolutionists along with their supper. So the Government massed soldiers and police here and there – and sat still for that night, fully expecting on the morrow some manifesto from "the rebels", as they now began to be called, which would give them an opportunity of acting in some way or another. They were disappointed. The ordinary newspapers gave up the struggle that morning, and only one very violent reactionary paper (called the *Daily Telegraph*) attempted an appearance, and rated "the rebels" in good set terms for their folly and ingratitude in tearing out the bowels of their "common mother", the English Nation, for the benefit of a few greedy paid agitators, and the fools whom they were deluding. On the other hand, the Socialist papers (of which three only, representing somewhat different schools, were published in London) came out full to the throat of well-printed matter. They were greedily bought by the whole public, who, of course, like the Government, expected a manifesto in them. But they found no word of reference to the great subject. It seemed as if their editors had ransacked their drawers for articles which would have been in place forty years before, under the technical name of educational articles. Most of these were admirable and straightforward expositions of the doctrines and practice of Socialism, free from haste and spite and hard words, and came upon the public with a kind of May-day freshness amidst the worry and terror of the moment; and though the knowing well understood that the meaning of this move in the game was mere defiance, and a token of irreconcilable hostility to the then rulers of society, and though, also, they were meant for nothing else by "the rebels", yet they really had their effect as "educational articles". However, "education" of another kind was acting upon the public with irresistible power, and probably cleared their heads a little.

'As to the Government, they were absolutely terrified by this act of "boycotting" (the slang word then current for such acts of abstention). Their counsels became wild and vacillating to the last degree: one hour they were for giving way for the present till they could hatch another plot; the next they all but sent an order for the arrest in the lump of all the workmen's committees; the next they were on the point of ordering their brisk young general to take any excuse that offered for another massacre. But when they called to mind that the soldiery in that "Battle" of Trafalgar Square were so daunted by the slaughter which they had made, that they could not be got to fire a second volley, they shrank back again from the dreadful courage necessary for carrying out another massacre. Meantime the prisoners, brought the second time before the magistrates under a strong escort of soldiers, were the second time remanded.

'The strike went on this day also. The workmen's committees were extended, and gave relief to great numbers of people, for they had organized a considerable amount of production of food by men whom they could depend upon. Quite a number of well-to-do people were now compelled to seek relief of them. But another curious thing happened: a band of young men of the upper classes armed themselves, and coolly went marauding in the streets, taking what suited them of such eatables and portables that they came across in the shops which had ventured to open. This operation they carried out in Oxford Street, then a great street of shops of all kinds. The Government, being at that hour in one of their yielding moods, thought this a fine opportunity for showing their impartiality in the maintenance of "order", and sent to arrest these hungry rich youths; who, however, surprised the police by a valiant resistance, so that all but three escaped. The Government did not gain the reputation for impartiality which they expected from this move; for they forgot that there were no evening papers; and the account of the skirmish spread wide indeed, but in a distorted form; for it was mostly told simply as an exploit of the starving people from the East-end; and everybody thought it was but natural for the Government to put them down when and where they could.

'That evening the rebel prisoners were visited in their cells by *very* polite and sympathetic persons, who pointed out to them what a

suicidal course they were following, and how dangerous these extreme courses were for the popular cause. Says one of the prisoners: "It was great sport comparing notes when we came out anent the attempt of the Government to 'get at' us separately in prison, and how we answered the blandishments of the highly 'intelligent and refined' persons set on to pump us. One laughed; another told extravagant long-bow stories to the envoy; a third held a sulky silence; a fourth damned the polite spy and bade him hold his jaw – and that was all they got out of us."

'So passed the second day of the great strike. It was clear to all thinking people that the third day would bring on the crisis; for the present suspense and ill-concealed terror was unendurable. The ruling classes, and the middle-class non-politicians who had been their real strength and support, were as sheep lacking a shepherd, they literally did not know what to do.

'One thing they found they had to do: try to get the "rebels" to do something. So the next morning, the morning of the third day of the strike, when the members of the Committee of Public Safety appeared again before the magistrate, they found themselves treated with the greatest possible courtesy – in fact, rather as envoys and ambassadors than prisoners. In short, the magistrate had received his orders; and with no more to do than might come of a long stupid speech which might have been written by Dickens in mockery, he discharged the prisoners, who went back to their meeting-place and at once began a due sitting. It was high time. For this third day the mass was fermenting indeed. There was, of course, a vast number of working people who were not organized in the least in the world: men who had been used to act as their masters drove them, or rather as the system drove, of which their masters were a part. That system was now falling to pieces, and the old pressure of the master having been taken off these poor men it seemed likely that nothing but the mere animal necessities and passions of men would have any hold on them, and that mere general overturn would be the result. Doubtless this would have happened if it had not been that the huge mass had been leavened by Socialist opinion in the first place, and in the second place by actual contact with declared Socialists, many or indeed most of whom were members of those bodies of workmen above said.

'If anything of this kind had happened some years before, when the masters of labour were still looked upon as the natural rulers of the people, and even the poorest and most ignorant men leaned upon them for support, while they submitted to their fleecing, the entire break-up of all society would have followed. But the long series of years during which the workmen had learned to despise their rulers, had done away with their dependence upon them, and they were now beginning to trust (somewhat dangerously, as events proved) in the non-legal leaders whom events had thrust forward; and though most of these were now become mere figure-heads, their names and reputations were useful in this crisis as a stop gap.

'The effect of the news, therefore, of the release of the Committee gave the Government some breathing time: for it was received with the greatest joy by the workers, and even the well-to-do saw in it a respite from the mere destruction which they had begun to dread, and the fear of which most of them attributed to the weakness of the Government. As far as the passing hour went, perhaps they were right in this.'

'How do you mean?' said I. 'What could the Government have done? I often used to think that they would be helpless in such a crisis.'

Said old Hammond: 'Of course I don't doubt that in the long run matters would have come about as they did. But if the Government could have treated their army as a real army, and used them strategically as a general would have done, looking on the people as a mere open enemy to be shot at and dispersed wherever they turned up, they would probably have gained the victory at the time.'

'But would the soldiers have acted against the people in this way?' said I.

Said he: 'I think from all I have heard that they would have done so if they had met bodies of men armed however badly, and however badly they had been organized. It seems also as if before the Trafalgar Square massacre they might as a whole have been depended upon to fire upon an unarmed crowd, though they were much honeycombed by Socialism. The reason for this was that they dreaded the use by apparently unarmed men of an explosive called dynamite, of which many loud boasts were made by the workers on the eve of these

events; although it turned out to be of little use as a material for war in the way that was expected. Of course the officers of the soldiery fanned this fear to the utmost, so that the rank and file probably thought on that occasion that they were being led into a desperate battle with men who were really armed, and whose weapon was the more dreadful, because it was concealed. After that massacre, however, it was at all times doubtful if the regular soldiers would fire upon an unarmed or half-armed crowd.'

Said I: 'The regular soldiers? Then there were other combatants against the people?'

'Yes,' said he, 'we shall come to that presently.'

'Certainly,' I said, 'you had better go on straight with your story. I see that time is wearing.'

Said Hammond: 'The Government lost no time in coming to terms with the Committee of Public Safety; for indeed they could think of nothing else than the danger of the moment. They sent a duly accredited envoy to treat with these men, who somehow had obtained dominion over people's minds, while the formal rulers had no hold except over their bodies. There is no need at present to go into the details of the truce (for such it was) between these high contracting parties, the Government of the empire of Great Britain and a handful of working-men (as they were called in scorn in those days), amongst whom, indeed, were some very capable and "square-headed" persons, though, as aforesaid, the abler men were not then the recognized leaders. The upshot of it was that all the definite claims of the people had to be granted. We can now see that most of these claims were of themselves not worth either demanding or resisting; but they were looked on at that time as most important, and they were at least tokens of revolt against the miserable system of life which was then beginning to tumble to pieces. One claim, however, was of the utmost immediate importance, and this the Government tried hard to evade; but as they were not dealing with fools, they had to yield at last. This was the claim of recognition and formal status for the Committee of Public Safety, and all the associations which it fostered under its wing. This it is clear meant two things: first, amnesty for "the rebels", great and small, who, without a distinct act of civil war, could no longer be attacked; and, next, a continuance of

293

the organized revolution. Only one point the Government could gain, and that was a name. The dreadful revolutionary title was dropped, and the body, with its branches, acted under the respectable name of the "Board of Conciliation and its local offices". Carrying this name, it became the leader of the people in the civil war which soon followed.'

'O,' said I, somewhat startled, 'so the civil war went on, in spite of all that had happened?'

'So it was,' said he. 'In fact, it was this very legal recognition which made the civil war possible in the ordinary sense of war; it took the struggle out of the element of mere massacres on one side, and endurance plus strikes on the other.'

'And can you tell me in what kind of way the war was carried on?' said I.

'Yes,' he said; 'we have records and to spare of all that; and the essence of them I can give you in a few words. As I told you, the rank and file of the army was not to be trusted by the reactionists; but the officers generally were prepared for anything, for they were mostly the very stupidest men in the country. Whatever the Government might do, a great part of the upper and middle classes were determined to set on foot a counter revolution; for the Communism which now loomed ahead seemed quite unendurable to them. Bands of young men, like the marauders in the great strike of whom I told you just now, armed themselves and drilled, and began on any opportunity or pretence to skirmish with the people in the streets. The Government neither helped them nor put them down, but stood by, hoping that something might come of it. These "Friends of Order", as they were called, had some successes at first, and grew bolder; they got many officers of the regular army to help them, and by their means laid hold of munitions of war of all kinds. One part of their tactics consisted in their guarding and even garrisoning the big factories of the period: they held at one time, for instance, the whole of that place called Manchester which I spoke of just now. A sort of irregular war was carried on with varied success all over the country; and at last the Government, which at first pretended to ignore the struggle, or treat it as mere rioting, definitely declared for "the Friends of Order", and joined to their bands whatsoever of the regu-

lar army they could get together, and made a desperate effort to overwhelm "the rebels", as they were now once more called, and as indeed they called themselves.

'It was too late. All ideas of peace on a basis of compromise had disappeared on either side. The end, it was seen clearly, must be either absolute slavery for all but the privileged, or a system of life founded on equality and Communism. The sloth, the hopelessness, and, if I may say so, the cowardice of the last century, had given place to the eager, restless heroism of a declared revolutionary period. I will not say that the people of that time foresaw the life we are leading now, but there was a general instinct amongst them towards the essential part of that life, and many men saw clearly beyond the desperate struggle of the day into the peace which it was to bring about. The men of that day who were on the side of freedom were not unhappy, I think, though they were harassed by hopes and fears, and sometimes torn by doubts, and the conflict of duties hard to reconcile.'

'But how did the people, the revolutionists, carry on the war? What were the elements of success on their side?'

I put this question, because I wanted to bring the old man back to the definite history, and take him out of the musing mood so natural to an old man.

He answered: 'Well, they did not lack organizers; for the very conflict itself, in days when, as I told you, men of any strength of mind cast away all consideration for the ordinary business of life, developed the necessary talent amongst them. Indeed, from all I have read and heard, I much doubt whether, without this seemingly dreadful civil war, the due talent for administration would have been developed amongst the working men. Anyhow, it was there, and they soon got leaders far more than equal to the best men amongst the reactionaries. For the rest, they had no difficulty about the material of their army; for that revolutionary instinct so acted on the ordinary soldier in the ranks that the greater part, certainly the best part, of the soldiers joined the side of the people. But the main element of their success was this, that wherever the working people were not coerced, they worked, not for the reactionists, but for "the rebels". The reactionists could get no work done for them outside the districts where they were all-powerful: and even in those districts they were harassed by continual

risings; and in all cases and everywhere got nothing done without obstruction and black looks and sulkiness; so that not only were their armies quite worn out with the difficulties which they had to meet, but the non-combatants who were on their side were so worried and beset with hatred and a thousand little troubles and annoyances that life became almost unendurable to them on those terms. Not a few of them actually died of the worry; many committed suicide. Of course, a vast number of them joined actively in the cause of reaction, and found some solace to their misery in the eagerness of conflict. Lastly, many thousands gave way and submitted to "the rebels"; and as the numbers of these latter increased, it at last became clear to all men that the cause which was once hopeless, was now triumphant, and that the hopeless cause was that of slavery and privilege.'

## CHAPTER 18: THE BEGINNING OF THE NEW LIFE

'WELL,' said I, 'so you got clear out of all your trouble. Were people satisfied with the new order of things when it came?'

'People?' he said. 'Well, surely all must have been glad of peace when it came; especially when they found, as they must have found, that after all, they – even the once rich – were not living very badly. As to those who had been poor, all through the war, which lasted about two years, their condition had been bettering, in spite of the struggle; and when peace came at last, in a very short time they made great strides towards a decent life. The great difficulty was that the once-poor had such a feeble conception of the real pleasure of life: so to say, they did not ask enough, did not know how to ask enough, from the new state of things. It was perhaps rather a good than an evil thing that the necessity for restoring the wealth destroyed during the war forced them into working at first almost as hard as they had been used to before the Revolution. For all historians are agreed that there never was a war in which there was so much destruction of wares, and instruments for making them as in this civil war.'

'I am rather surprised at that,' said I.

'Are you? I don't see why,' said Hammond.

'Why,' I said, 'because the party of order would surely look upon the wealth as their own property, no share of which, if they could help it, should go to their slaves, supposing they conquered. And on the other hand, it was just for the possession of that wealth that "the rebels" were fighting, and I should have thought, especially when they saw that they were winning, that they would have been careful to destroy as little as possible of what was so soon to be their own.'

'It was as I have told you, however,' said he. 'The party of order, when they recovered from their first cowardice of surprise – or, if you please, when they fairly saw that, whatever happened, they would be ruined, fought with great bitterness, and cared little what they did, so long as they injured the enemies who had destroyed the sweets of life for them. As to "the rebels", I have told you that the outbreak of actual war made them careless of trying to save the wretched scraps of wealth that they had. It was a common saying amongst them, Let the country be cleared of everything except valiant living men, rather than that we fall into slavery again!'

He sat silently thinking a little while, and then said:

'When the conflict was once really begun, it was seen how little of any value there was in the old world of slavery and inequality. Don't you see what it means? In the times which you are thinking of, and of which you seem to know so much, there was no hope; nothing but the dull jog of the mill-horse under compulsion of collar and whip; but in that fighting-time that followed, all was hope: "the rebels" at least felt themselves strong enough to build up the world again from its dry bones – and they did it, too!' said the old man, his eyes glittering under his beetling brows. He went on: 'And their opponents at least and at last learned something about the reality of life, and its sorrows, which they – their class, I mean – had once known nothing of. In short, the two combatants, the workman and the gentleman, between them –'

'Between them,' said I, quickly, 'they destroyed commercialism!'

'Yes, yes, YES,' said he; 'that is it. Nor could it have been destroyed otherwise; except, perhaps, by the whole of society gradually falling into lower depths, till it should at last reach a condition as rude as barbarism, but lacking both the hope and the pleasures of barbarism. Surely the sharper, shorter remedy was the happiest?'

'Most surely,' said I.

'Yes,' said the old man, 'the world was being brought to its second birth; how could that take place without a tragedy? Moreover, think of it. The spirit of the new days, of our days, was to be delight in the life of the world; intense and overweening love of the very skin and surface of the earth on which man dwells, such as a lover has in the fair flesh of the woman he loves; this, I say, was to be the new spirit of the time. All other moods save this had been exhausted: the unceasing criticism, the boundless curiosity in the ways and thoughts of man, which was the mood of the ancient Greek, to whom these things were not so much a means, as an end, was gone past recovery; nor had there been really any shadow of it in the so-called science of the nineteenth century, which, as you must know, was in the main an appendage to the commercial system; nay, not seldom an appendage to the police of that system. In spite of appearances, it was limited and cowardly, because it did not really believe in itself. It was the outcome, as it was the sole relief, of the unhappiness of the period which made life so bitter even to the rich, and which, as you may see with your bodily eyes, the great change has swept away. More akin to our way of looking at life was the spirit of the Middle Ages, to whom heaven and the life of the next world was such a reality, that it became to them a part of the life upon the earth; which accordingly they loved and adorned, in spite of the ascetic doctrines of their formal creed, which bade them contemn it.

'But that also, with its assured belief in heaven and hell as two countries in which to live, has gone, and now we do, both in word and in deed, believe in the continuous life of the world of men, and as it were, add every day of that common life to the little stock of days which our own mere individual experience wins for us: and consequently we are happy. Do you wonder at it? In times past, indeed, men were told to love their kind, to believe in the religion of humanity and so forth. But look you, just in the degree that a man had elevation of mind and refinement enough to be able to value this idea, was he repelled by the obvious aspect of the individuals composing the mass which he was to worship; and he could only evade that repulsion by making a conventional abstraction of mankind that had little actual or historical relation to the race; which to his eyes was

divided into blind tyrants on the one hand and apathetic degraded slaves on the other. But now, where is the difficulty in accepting the religion of humanity, when the men and women who go to make up humanity are free, happy, and energetic at least, and most commonly beautiful of body also, and surrounded by beautiful things of their own fashioning, and a nature bettered and not worsened by contact with mankind? This is what this age of the world has reserved for us.'

'It seems true,' said I, 'or ought to be, if what my eyes have seen is a token of the general life you lead. Can you now tell me anything of our progress after the years of the struggle?'

Said he: 'I could easily tell you more than you have time to listen to; but I can at least hint at one of the chief difficulties which had to be met: and that was, that when men began to settle down after the war, and their labour had pretty much filled up the gap in wealth caused by the destruction of that war, a kind of disappointment seemed coming over us, and the prophecies of some of the reactionists of past times seemed as if they would come true, and a dull level of utilitarian comfort be the end for a while of our aspirations and success. The loss of the competitive spur to exertion had not, indeed, done anything to interfere with the necessary production of the community, but how if it should make men dull by giving them too much time for thought or idle musing? But, after all, this dull thundercloud only threatened us, and then passed over. Probably, from what I have told you before, you will have a guess at the remedy for such a disaster; remembering always that many of the things which used to be produced – slave-wares for the poor and mere wealth-wasting wares for the rich – ceased to be made. That remedy was, in short, the production of what used to be called art, but which has no name amongst us now, because it has become a necessary part of the labour of every man who produces.'

Said I: 'What! Had men any time or opportunity for cultivating the fine arts amidst the desperate struggle for life and freedom that you have told me of?'

Said Hammond: 'You must not suppose that the new form of art was founded chiefly on the memory of the art of the past; although, strange to say, the civil war was much less destructive of art than of other things, and though what of art existed under the old forms,

revived in a wonderful way during the latter part of the struggle, especially as regards music and poetry. The art or work-pleasure, as one ought to call it, of which I am now speaking, sprung up almost spontaneously, it seems, from a kind of instinct amongst people, no longer driven desperately to painful and terrible overwork, to do the best they could with the work in hand – to make it excellent of its kind; and when that had gone on for a little, a craving for beauty seemed to awaken in men's minds, and they began rudely and awkwardly to ornament the wares which they made; and when they had once set to work at that, it soon began to grow. All this was much helped by the abolition of the squalor which our immediate ancestors put up with so coolly; and by the leisurely, but not stupid, country-life which now grew (as I told you before) to be common amongst us. Thus at last and by slow degrees we got pleasure into our work; then we became conscious of that pleasure, and cultivated it, and took care that we had our fill of it; and then all was gained, and we were happy. So may it be for ages and ages!'

The old man fell into a reverie, not altogether without melancholy I thought; but I would not break it. Suddenly he started, and said: 'Well, dear Guest, here are come Dick and Clara to fetch you away, and there is an end of my talk; which I daresay you will not be sorry for; the long day is coming to an end, and you will have a pleasant ride back to Hammersmith.'. . .

[Chapters 19 to 32 describe Morris's journey up the River Thames past Hampton Court and Runnymede, the characters he met and the sights he saw. The book ends with a feast at Kelmscott and his sudden return from utopia to the nineteenth century, from the world of 'joyous, beautiful people' to the 'dirt and rags' of his own time. He ends with these reflections.]

. . . I LAY in my bed in my house at dingy Hammersmith thinking about it all; and trying to consider if I was overwhelmed with despair at finding I had been dreaming a dream; and strange to say, I found that I was not so despairing.

Or indeed *was* it a dream? If so, why was I so conscious all along that I was really seeing all that new life from the outside, still wrapped

up in the prejudices, the anxieties, the distrust of this time of doubt and struggle?

All along, though those friends were so real to me, I had been feeling as if I had no business amongst them: as though the time would come when they would reject me, and say, as Ellen's last mournful look seemed to say, 'No, it will not do; you cannot be of us; you belong so entirely to the unhappiness of the past that our happiness even would weary you. Go back again, now you have seen us, and your outward eyes have learned that in spite of all the infallible maxims of your day there is yet a time of rest in store for the world, when mastery has changed into fellowship – but not before. Go back again, then, and while you live you will see all round you people engaged in making others live lives which are not their own, while they themselves care nothing for their own real lives – men who hate life though they fear death. Go back and be the happier for having seen us, for having added a little hope to your struggle. Go on living while you may, striving, with whatsoever pain and labour needs must be, to build up little by little the new day of fellowship, and rest, and happiness.'

Yes, surely! and if others can see it as I have seen it, then it may be called a vision rather than a dream.

# SIX ❧ EPILOGUE: PROTEST AND REST

# 51: THE LAST MAY DAY

CERTAINLY May Day is above all days of the year fitting for the protest of the disinherited against the system of robbery that shuts the door betwixt them and a decent life; the day when the promise of the year reproaches the waste inseparable from the society of inequality, the waste which produces our artificial poverty of civilization, so much bitterer for those that suffer under it than the natural poverty of the rudest barbarism. For it is undoubtedly true that full-blown capitalism makes the richest country in the world as poor as, nay poorer than, the poorest, for the life of by far the greater part of its people.

Are we to sit down placidly under this, hoping that some blessing will drop down from heaven upon us which will bring content and self-respect and a due share of the beauties and joys of the earth to the classes that produce all that is produced, while it will bring no lessening of the dignity and ease and sweetness of life with which the possessing (and wasting) classes are now endowed?

Most of you will smile at that question, but remember that this opinion was not long ago universally held, and is still held by many.

They think that civilization will grow so speedily and triumphantly, and production will become so easy and cheap, that the possessing classes will be able to spare more and more from the great heap of wealth to the producing classes, so that at least these latter will have nothing left to wish for, and all will be peace and prosperity. A futile hope indeed! and one which a mere glance at past history will dispel. For we find as a matter of fact that when we were scarcely emerging from semi-barbarism, when open violence was common, and privilege need put on no mask before the governed classes, the workers were not worse off than now, but better. In short, not all the discoveries of science, not all the tremendous organization of the factory and the market will produce true wealth, so long as the end and aim of it all is the production of profit for the privileged classes.

Nothing better will happen than more waste and more, only perhaps exercised in different directions than now it is. Waste of material,

waste of labour (for few indeed even of the genuine wage-earners are engaged in the production of utilities). Waste, in one word, of LIFE.

But again there are some who will say, 'Yes indeed, the capitalist system can come to no good end, death in a dust-bin is its doom, but will not its end be at least speedy even without any help of ours?' My friends: I fear not. The capitalist classes are doubtless alarmed at the spread of Socialism all over the civilized world. They have at least an instinct of danger; but with that instinct comes the other one of self-defence. Look how the whole capital world is stretching out long arms towards the barbarous world and grabbing and clutching in eager competition at countries whose inhabitants don't want them; nay, in many cases, would rather die in battle, like the valiant men they are, than have them. So perverse are these wild men before the blessings of civilization which would do nothing worse for them (and also nothing better) than reduce them to a propertyless proletariat.

And what is all this for? For the spread of abstract ideas of civilization, for pure benevolence, for the honour and glory of conquest? Not at all. It is for the opening of fresh markets to take in all the fresh profit-producing wealth which is growing greater and greater every day; in other words, to make fresh opportunities for *waste*; the waste of our labour and our lives.

And I say this is an irresistible instinct on the part of the capitalists, an impulse like hunger, and I believe that it can only be met by another hunger, the hunger for freedom and fair play for all, both people and peoples. Anything less than that the capitalist power will brush aside. But that they cannot; for what will it mean? The most important part of their machinery, the 'hands' becoming MEN, and saying, 'Now at last we will it; we will produce no more for profit but for *use*, for *happiness*, for LIFE.'

(From an article in *Justice*, 1 May 1896)

## 52: THE EXPERTS OF EPPING

SIR,

I venture to ask you to allow me a few words on the subject of the present treatment of Epping Forest. I was born and bred in its neighbourhood (Walthamstow and Woodford), and when I was a boy and young man knew it yard by yard from Wanstead to the Theydons, and from Hale End to the Fairlop Oak. In those days it had no worse foes than the gravel stealer and the rolling fence maker and was always interesting and often beautiful. From what I can hear it is years since the greater part of it has been destroyed, and I fear, Sir, that in spite of your late optimistic note on the subject, what is left of it now runs the danger of further ruin.

The special character of it was derived from the fact that by far the greater part was a wood of hornbeams, a tree not common save in Essex and Herts. It was certainly the biggest hornbeam wood in these islands, and I suppose in the world. The said hornbeams were all pollards, being shrouded every four or six years, and were interspersed in many places by holly thickets; and the result was a very curious and characteristic wood, such as can be seen nowhere else. And I submit that no treatment of it can be tolerable which does not maintain this hornbeam wood intact.

But the hornbeam, though an interesting tree to an artist and reasonable person, is no favourite with the landscape gardener, and I very much fear that the intention of the authorities is to clear the forest of its native trees, and to plant vile weeds like deodars and outlandish conifers instead.

We are told that a committee of 'experts' has been formed to sit in judgement on Epping Forest: but, Sir, I decline to be gagged by the word 'expert', and I call on the public generally to take the same position. An 'expert' may be a very dangerous person, because he is likely to narrow his views to the particular business (usually a commercial one) which he represents. In this case, for instance, we do not want to be under the thumb of either a wood bailiff, whose business is to grow timber for the market, or of a botanist whose business is to collect specimens for a botanical garden; or of a landscape gardener

whose business is to vulgarize a garden or landscape to the utmost extent that his patron's purse will allow of. What we want is reasonable men of real artistic taste to take into consideration what the essential needs of the case are, and to advise accordingly.

Now it seems to me that the authorities who have Epping Forest in hand may have two intentions as to it. First, they may intend to landscape garden it, or turn it into golf grounds (and I very much fear that even the latter nuisance may be in their minds); or second, they may really think it necessary (as you suggest) to thin the hornbeams, so as to give them a better chance of growing. The first alternative we Londoners should protest against to the utmost for, if it be carried out, then Epping Forest is turned into a mere piece of vulgarity, is destroyed in fact.

As to the second, to put our minds at rest, we ought to be assured that the cleared spaces would be planted again, and that almost wholly with hornbeam. And, further, the greatest possible care should be taken that not a single tree should be felled, unless it were necessary for the growth of its fellows. Because, mind you, with comparatively small trees, the really beautiful effect of them can only be got by their standing as close together as the exigencies of growth will allow. We want a thicket, not a park, from Epping Forest.

In short, a great and practically irreparable mistake will be made, if under the shelter of the opinion of the experts, from mere carelessness and thoughtlessness, we let the matter slip out of the hands of the thoughtful part of the public: the essential character of one of the greatest ornaments of London will disappear, and no one will have even a sample left to show what the great north-eastern forest was like.

(Letter to the *Daily Chronicle*, 23 April 1895)

THE wind's on the wold
And the night is a-cold,
And Thames runs chill
'Twixt mead and hill.
But kind and dear
Is the old house here
And my heart is warm
'Midst winter's harm.
Rest then and rest,
And think of the best
'Twixt summer and spring,
When all birds sing
In the town of the tree,
And ye lie in me
And scarce dare move,
Lest earth and its love
Should fade away
Ere the full of the day.
I am old and have seen
Many things that have been;
Both grief and peace
And wane and increase.
No tale I tell
Of ill or well,
But this I say:
Night treadeth on day,
And for worst or best
Right good is rest.

(Lines written for an embroidered hang-
ing, designed and worked by his daughter
May, for his bed at Kelmscott, 1891)

# THE WILLIAM MORRIS SOCIETY

THE life, work and ideas of William Morris are as important today as they were in his lifetime. The William Morris Society exists to make them as widely known as possible.

The many-sidedness of Morris and the variety of his activities bring together in the Society those who are interested in him as designer, craftsman, poet, socialist, or who admire his robust and generous personality, his creative energy and courage. Morris wanted all to enjoy the potential richness of life. His thought on how we live and how might live, on creative work, leisure and machinery, on ecology and conservation, on the place of the arts in our lives and their relation to politics, as on much else, remains as challenging now as it was a century ago.

The Society provides information on topics of interest to its members and arranges lectures, visits, exhibitions and other events through its Committee. It also encourages the re-publication of Morris's works and the continued manufacture of his textile and wallpaper designs. It publishes a *Journal* twice a year, free to members, which carries articles across the field of Morris scholarship, and includes book reviews and illustrative material. It also publishes a quarterly *Newsletter* giving details of its programme, new publications and other matters of interest concerning Morris and his circle. Members are invited to contribute items both to the *Journal* and to the *Newsletter*.

Although London-based, the William Morris Society has a world-wide membership. It offers the chance to make contact with fellow Morrisians both in Britain and abroad.

Regular events include a Kelmscott Lecture, a birthday party held in March, and visits to exhibitions and to such places as the William Morris Gallery, Red House, Kelmscott Manor and Standen. These visits and our short residential study courses enable members living abroad or outside London to participate in the Society's activities.

The Society's headquarters are at Kelmscott House, Hammersmith, Morris's home for the last eighteen years of his life. Kelmscott House was named after Morris's country home, Kelmscott Manor: in the coach house alongside, Hammersmith carpets were woven and later the Hammersmith Socialist Society met.

For further details, write to:

The Hon. Membership Secretary,
Kelmscott House,
26 Upper Mall,
Hammersmith,
London w6 9TA

# MORE ABOUT PENGUINS, PELICANS
# AND PUFFINS

For further information about books available from Penguins please write to Dept EP, Penguin Books Ltd, Harmondsworth, Middlesex UB7 0DA.

*In the U.S.A.*: For a complete list of books available from Penguins in the United States write to Dept DG, Penguin Books, 299 Murray Hill Parkway, East Rutherford, New Jersey 07073.

*In Canada*: For a complete list of books available from Penguins in Canada write to Penguin Books Canada Ltd, 2801 John Street, Markham, Ontario L3R 1B4.

*In Australia*: For a complete list of books available from Penguins in Australia write to the Marketing Department, Penguin Books Australia Ltd, P.O. Box 257, Ringwood, Victoria 3134.

*In New Zealand*: For a complete list of books available from Penguins in New Zealand write to the Marketing Department, Penguin Books (N.Z.) Ltd, P.O. Box 4019, Auckland 10.

*In India*: For a complete list of books available from Penguins in India write to Penguin Overseas Ltd, 706 Eros Apartments, 56 Nehru Place, New Delhi 110019.

THE PENGUIN ENGLISH LIBRARY

THOMAS DE QUINCEY
## RECOLLECTIONS OF THE LAKES
## AND THE LAKE POETS
*Edited by David Wright*

Thomas De Quincey, best known perhaps as the author of *Confessions of an English Opium-Eater*, wrote most of the work in this volume for *Tait's Magazine* between 1834 and 1840. It is immensely readable and alive – an anecdotal, conversational, contemporaneous portrait and account of Grasmere, Wordsworth, Coleridge and Southey, and so near the bone that Wordsworth and his family would have nothing further to do with De Quincey after it appeared. Within this first-hand biographical/critical discussion of the lives and works of these poets, De Quincey's life of Wordsworth may still be the best we have.

EDWARD JOHN TRELAWNY
## RECORDS OF SHELLEY, BYRON,
## AND THE AUTHOR
*Edited by David Wright*

Edward John Trelawny was one of the most curious figures of the English Romantic Movement and his *Records* is one of its oddest and most entertaining documents. An ill-educated adventurer and incorrigible romancer, he was fascinated, almost hypnotized, by the two poets when he joined them in Italy in 1822. His account of them, which includes the death of both, is the end-product of an obsession. Its concern is less with the accuracy of detailed observation than with the creation of myth, including the myth of himself as a Romantic hero. He belongs to that fellowship of writers who 'take truth as the warp into which a weft of imagination may be woven'. But the embroidery that results often 'makes explicit or at least illuminates some inherent truth or quality that strict facts may sometimes obscure'.

# THE PENGUIN ENGLISH LIBRARY

THOMAS HOBBES
## LEVIATHAN
*Edited by C. B. Macpherson*

From the turmoil of the English Civil War, when life was truly 'nasty, brutish, and short', Hobbes's *Leviathan* (1651) speaks directly to the twentieth century. In its over-riding concern for peace, its systematic analysis of power and its elevation of politics to the status of a science, it mirrors much modern thinking. And despite its contemporary notoriety – Pepys called it 'a book the Bishops will not let be printed again' – it was also, as Professor Macpherson shows, a convincing apologia for the emergent seventeenth-century market society.

WILLIAM HAZLITT
## SELECTED WRITINGS
*Edited by Ronald Blythe*

With his uncompromising contempt for lies, cant, and injustice, William Hazlitt (1778–1830) notably contributed to the literature of radical protest by flaying the standards of a depraved age. Never a good-natured man, he embarrassed his contemporaries by his fierce personal involvement in what he wrote and dismayed them by his unbudging championship of Bonaparte. Hazlitt's catholicity and that magnificent style which at once makes a friend or an enemy of the reader are well represented among these autobiographical pieces, essays and extracts on literature, art, religion, and philosophy, portraits (of Pitt, Wordsworth, Coleridge, Lamb, and others), and in his racy report of a fight between Bill Neate and the Gasman, or his obituary of a famous fives-player.

THOMAS CARLYLE
## SELECTED WRITINGS
*Edited by Alan Shelston*

Now remembered mainly as the impressionistic historian of the French Revolution and as a forerunner of the authoritarian ideologies of the twentieth century, Carlyle enjoyed in his long lifetime an immense reputation as a prophet and preacher. For an anonymous correspondent he was 'an honoured and trusted teacher', for Charles Dickens the man who 'knows everything', for Matthew Arnold a 'moral desperado'. Certainly the voice of Thomas Carlyle is one of the most compelling of nineteenth-century England.

This selection is intended to be representative of all stages of his career, rather than a 'Best of Carlyle'. It includes the whole of *Chartism* and chapters from *Sartor Resartus*, *The French Revolution*, *Heroes and Hero-Worship*, *Past and Present* and the history of *Frederick the Great*.

J. S. MILL
## ON LIBERTY
*Edited by Gertrude Himmelfarb*

'The only purpose for which power can be rightfully exercised over any member of a civilized community, against his will, is to prevent harm to others . . . Over himself, over his own body and mind, the individual is sovereign.'

To this 'one very simple principle' the whole of Mill's essay *On Liberty* is dedicated. If liberty has come to be the God to whom we all, from the anarchist to the communist, pay lip-service today, it is worth looking back at the text of the man who first supplied it with a Bible.

# THE PENGUIN ENGLISH LIBRARY

ELIZABETH GASKELL

## MARY BARTON

*Edited by Stephen Gill*

*Mary Barton* was only one of several books written in the 1840s about what came to be known as the 'condition of England' question. It is a tale of Dives and Lazarus, of the comfortable pinnacle and the miserable base of the Victorian social pyramid. It is told, however, without over-simplification, without bigotry, and, above all, without hatred. With an artist's sensitivity not just to economic and social facts but to individual human responses, Mrs Gaskell diagnoses men's tragic ignorance of each other as the root of the evil. *Mary Barton*, as Stephen Gill writes in his Introduction, is 'social history as it should be understood, on the pulses of the people who made it'.

## WIVES AND DAUGHTERS

*With an Introduction by Laurence Lerner*

'The most underrated novel in English' is how Laurence Lerner describes *Wives and Daughters*, Mrs Gaskell's last work: and certainly the story of Mr Gibson's new marriage and its influence on the lives of those closest to him is a work of rare charm, combining pathos with wit, intelligence, and a perceptiveness about people and their relationships equalled only by Jane Austen and George Eliot. As in *Cranford* she surrounds her fiction with a fragrant evocation of English village life, but in *Wives and Daughters* this is underpinned by a sense of social change and of the more basic realities of birth and death.

*Also published*

THE LIFE OF CHARLOTTE BRONTË
CRANFORD *and* COUSIN PHILLIS
NORTH AND SOUTH

# VICTORIAN CITIES

ASA BRIGGS

'Our age is pre-eminently the age of great cities' – Robert Vaughan (1843)

In 1837 England and Wales boasted only five provincial cities of more than 100,000 inhabitants: by 1891 there were twenty-three and they housed nearly a third of the nation. Meantime London had expanded two-and-a-third times.

Neither were these Victorian cities 'insensate' ant-heaps, as Lewis Mumford has called them. As this century progresses we can better appreciate the energy and civic purpose which created the cities of the nineteenth century.

In this revised and augmented edition of his companion to *Victorian People*, Professor Asa Briggs concentrates his inquiry on Manchester, Leeds, Birmingham, Middlesbrough, Melbourne (representing Victorian communities overseas), and London, the world city. Between these cities of the age of railways, trams, drains, and gas there are superficial resemblances in their problems of housing and sanitation, location of suburbs, schools, town halls, and churches: but Professor Briggs points up the differences too, and he provides us with a fascinating contrast between Manchester and Birmingham, as their civic courses diverged economically, socially, and politically.

# VICTORIAN PEOPLE

ASA BRIGGS

'With this book Asa Briggs makes good his right to be regarded and respected as one of the leading historians of the Victorian Age' – G. M. Young, author of *Victorian England*

That 'Victorian' need no longer be considered a derogatory word is made very plain by Professor Briggs's reassessments of people, ideas, and events between the Great Exhibition of 1851 and the Second Reform Act of 1867.

A few of his chapter headings indicate the type of personality on whom the author has based a fresh viewpoint of the period: 'John Arthur Roebuck and the Crimean War', 'Samuel Smiles and the Gospel of Work', 'Thomas Hughes and the Public Schools', 'Robert Applegarth and the Trade Unions', 'John Bright and the Creed of Reform', 'Benjamin Disraeli and the Leap in the Dark'.

Recounted with unusual clarity and humour, the story of their achievements conjures up an enviable picture of progress and independence and adds substantially to the ordinary reader's knowledge of the last century.

'A warm and vivid book, as readable as it is well informed' – *New York Herald Tribune*